Dallas Museum of Art

A GUIDE TO THE COLLECTION

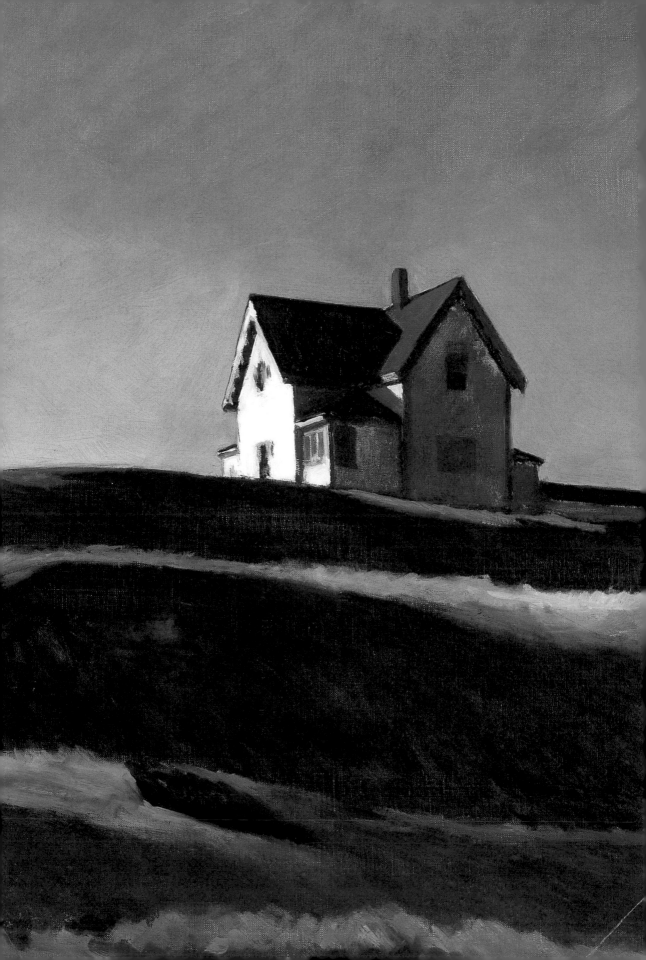

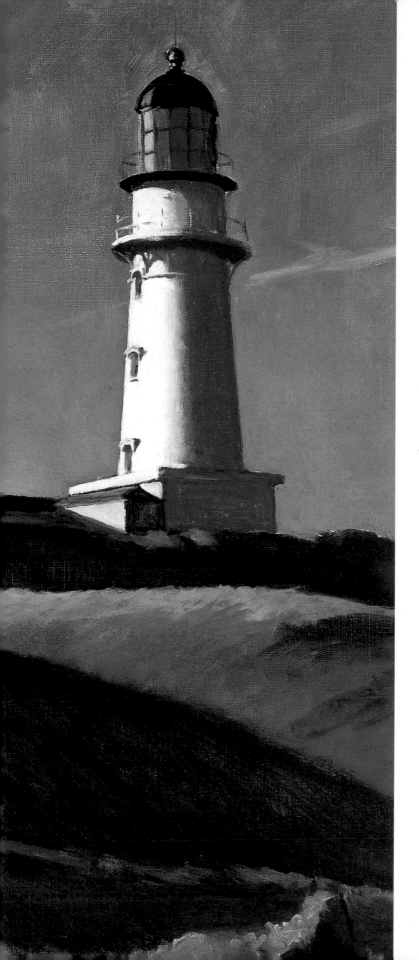

Dallas Museum of Art

A GUIDE TO THE COLLECTION

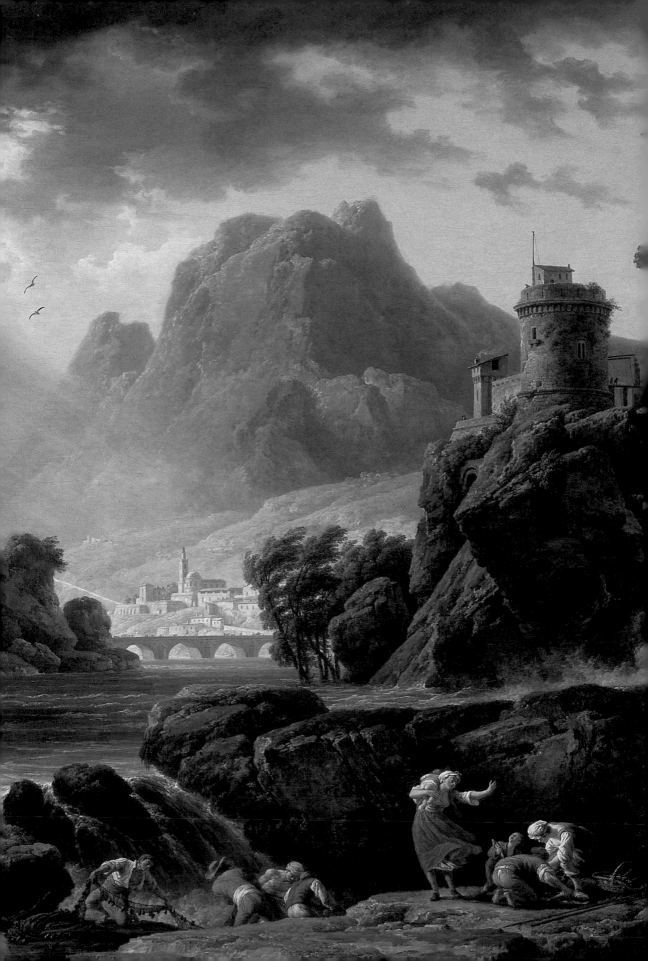

*The preparation and publication of this volume
were underwritten by a generous gift from*

MICHAEL L. ROSENBERG

patron and trustee of the Dallas Museum of Art

DMA Managing Editor: Debra Wittrup
Publications Assistant: Suzy Sloan Jones
Visual Resources Manager: Rita Bibb
Rights and Reproductions Manager: Jeanne Lil Chvosta

Edited by Suzanne Kotz
Designed by Susan E. Kelly
Produced by Marquand Books, Inc., Seattle
Printed and bound by C & C Offset Printing Co., Ltd.,
 Hong Kong

Library of Congress Cataloging-in-Publication Data
Dallas Museum of Art.
 Dallas Museum of Art : a guide to the collection /
[edited by Charles Venable].
 p. cm.
 ISBN 0-936227-23-0 (hardcover : alk. paper)—
ISBN 0-936227-22-2 (softbound : alk. paper)
 1. Dallas Museum of Art—Catalogs. 2. Art—Texas—
Dallas—Catalogs. I. Venable, Charles. II. Title.
N558.A538 1997
708.164'2812—dc21 97-14332

Hardbound jacket: John Singleton Copley, *Sarah Sherburne
 Langdon* (detail), p. 217.
Softbound cover: Maurice de Vlaminck, *Bougival* (detail), p. 119.
Frontispiece: Edward Hopper, *Lighthouse Hill* (detail), p. 252.
Pages 4–5: Claude-Joseph Vernet, *Mountain Landscape with
 Approaching Storm* (detail), p. 95.
Pages 10–11: Frederic Edwin Church, *The Icebergs* (detail), p. 228.
Page 13: Rufino Tamayo, *El Hombre* (detail), p. 260.
Page 14: Piet Mondrian, *Windmill*, p. 121.

Contents

Foreword

IT IS NOW more than a dozen years since *Dallas Museum of Art, Selected Works* first appeared, on the occasion of the opening of a new downtown building in 1984. Designed by Edward Larrabee Barnes and built through the goodwill of a vibrant and generous community, this impressive structure provided an elegant setting for collections in need of expansive spaces and quickly became the emblem of a confident and ambitious city. Few could then have foreseen that the momentous events of 1984 would initiate a period of extraordinary and sustained growth, impressive even by Dallas standards. Mr. Barnes has been called on twice to provide designs to expand the museum, first in 1985 for galleries to accommodate the remarkable gift from Wendy Reves of European art, and again for the Nancy and Jake Hamon building, whose doors opened to the public eight years later. Hence Dallas now claims a new museum twice enlarged to house collections that over the same period of time had doubled in size, encompassing an extraordinary range from the traditional arts of Africa to Monet and Mondrian, from Indonesian textiles to the triumph of American contemporary art.

Invariably this astonishing growth resulted from the marriage of public and private generosity. The long-term support of the City of Dallas has, at every juncture, been met with gifts large and small from families, foundations, corporations, and individual citizens.

This volume records selected works that represent the full range and exceptional quality of the holdings of the Dallas Museum of Art, and it documents the singular generosity for which Dallas is so well known. The artworks give testimony to a community of donors whose collective goodwill has added immeasurably to the cultural fabric of this city. The distinguished collections of this museum reflect, in particular, the leadership of a generation of Texans who took up the challenge to build a great museum. McDermott, Meadows, Munger, Reves, Clark, Camp, O'Hara, Hamon, Green, Murchison, Marcus, Levy, Owsley, Nasher, Bromberg, and Boeckman are names, among many others, that will be forever associated with the Dallas Museum of Art. This volume is dedicated to them, not just for the history they have made, but also for the challenge they offer to the future.

JAY GATES
The Eugene McDermott Director

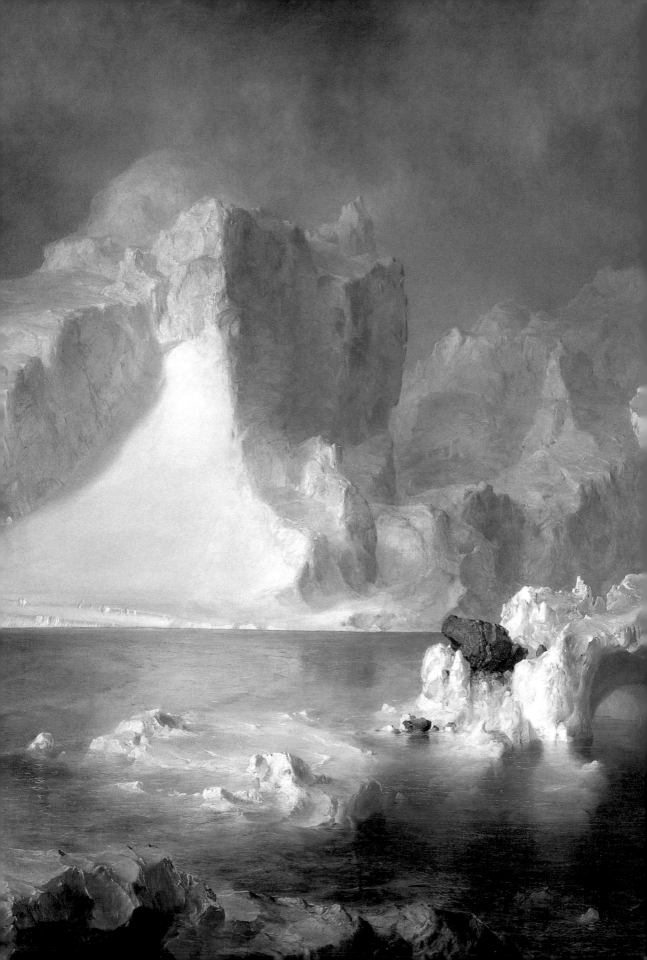

Introduction to the Collections

THE COLLECTIONS OF the Dallas Museum of Art have grown dramatically since the museum's inception. At present they consist of approximately twenty-two thousand objects and include works from diverse cultures around the globe. The building of these holdings was not a simple or linear task. Like those of most museums, Dallas's collections at first grew sporadically, with the most dramatic development taking place from the 1960s onward. As with most other institutions, the taste and generosity of numerous private collectors and patrons have profoundly shaped the museum.

During the first two decades following its founding in 1903, the Dallas Art Association, parent body of the Dallas Museum of Art, initiated a permanent collection by both purchase and gift. While the number of pieces acquired was relatively small, several items of lasting significance were obtained. This is especially true in the area of what then was considered contemporary art. Childe Hassam's *September Moonrise* (1900), for example, was purchased in 1903. Robert Henri's *Dutch Boy Laughing* (1907) followed in 1909.

In 1925 Mrs. S. I. Munger greatly enhanced acquisition efforts by establishing the Munger Fund with a $50,000 endowment. This fund, the first of its kind at the museum, has purchased numerous important works for the collection. One of its most notable early acquisitions was Claude Monet's *The Seine at Lavacourt* (1880) in 1938. More recently the Munger Fund added Narcisse Diaz de La Peña's *Forest of Fontainebleau* (1868) to the collection.

Because its collection was small and its means limited, the Dallas Art Association exhibited its works in a series of spaces provided by other institutions during the first three decades of this century. The first of these was the Carnegie Library. In 1909 the Fair Park Free Public Art Gallery was erected, but in 1928 its glass dome was destroyed by hail and the collection had to be moved to the Majestic Theatre. By the early 1930s, however, growth of the collection and the hiring of John Sites Ankeney as the first professional director encouraged the creation of a permanent home. In 1936, as part of the Texas Centennial Exposition, a sizable building in the art deco style was erected at the Dallas fairgrounds for use as an art museum. This facility greatly enhanced the role of the museum within the community. After the centennial celebration, Dallas philanthropists Esther and Karl Hoblitzelle placed on long-term loan their collection of Old Master pictures, including Paolini's *Bacchic Concert* (c. 1630). Those

works, plus a significant collection of English and Irish silver, were given to the museum in 1987 by the Hoblitzelle Foundation.

In 1943 the artist Jerry Bywaters became director of the museum. During his twenty-one-year tenure, the institution emerged as an important regional center. Its collections of Southwestern and Mexican art were enhanced, most significantly by Rufino Tamayo's masterpiece *El Hombre* (1953). A bequest of thirty-six paintings from Joel T. Howard substantially increased the representation of American impressionists, while purchases and gifts strengthened the collection of more contemporary work. During the 1940s and 1950s important works by George Bellows, Thomas Hart Benton, Ernst Blumenschein, Charles Burchfield, George Grosz, Alexandre Hogue, Edward Hopper, Reginald Marsh, and William Zorach were acquired. Avant-garde trends were represented by works like Jackson Pollock's drip painting *Cathedral* (1947) and Alexander Calder's mobile *Flower* (1949).

The 1960s and 1970s witnessed the maturation of the Dallas Museum of Art as a professional institution. In 1960 Margaret and Eugene McDermott established a fund for the acquisition of art. This fund, as well as other generous gifts from the McDermotts, proved to be central to the growth of the collection at a high level. With McDermott support, Dallas's core collections in ancient American, Indonesian, and African art have been built. The acquisition of other works as diverse as sculpture by Degas and David Smith, classical jewelry from ancient Greece, and nineteenth-century American silver also have been made possible by the generosity of the McDermotts. A particularly important aspect of much of the McDermotts' largess is that it came in the form of challenges to other major museum benefactors, such as the Murchison, Meadows, and Hamon families.

In 1963 the museum merged with the Dallas Museum for Contemporary Arts, which had been founded in 1956. Under the enlightened directorship of Douglas MacAgy, that institution had amassed a collection of significant works including important examples by Redon,

Matisse, Bacon, and Nicholson, as well as two famous works by the American expatriate modernist Gerald Murphy. With the merger of the two museums, all these works and many others were transferred to a new legal entity called the Foundation for the Arts, which placed the collection on permanent deposit at the Dallas Museum of Art.

Merrill Rueppel assumed the directorship of the museum in 1964 and worked to broaden the collection during his nine years in Dallas. Especially noteworthy were the strides made in ancient American, African, and ancient Mediterranean art, including masterworks of Greek and Roman sculpture acquired through the generosity of Ida and Cecil Green. Major contemporary works by Jean Arp, Jim Dine, Arshile Gorky, Adolph Gottlieb, Barbara Hepworth, Franz Kline, Henry Moore, and Robert Motherwell were also added to the collection during the Rueppel years.

Harry S. Parker III was appointed director in 1973 and proceeded to lead the museum through a momentous period of building construction and art acquisition. Among the most significant acquisitions made during the 1970s were the Schindler Collection of African Art (1975) and the Wise Collection of Ancient American Art (1976). A bequest in 1977 to the Foundation for the Arts from Mrs. John B. O'Hara made possible the addition of numerous European works including Vernet's *Mountain Landscape with Approaching Storm* (1775), Turner's *Bonneville, Savoy, with Mont Blanc* (1803), and Courbet's *Fox in the Snow* (1860). More recently the O'Hara Fund has added major canvases by Pierre, Giroust, and Liebermann. Just as significant have been important impressionist and modernist works given by the Meadows Foundation, Incorporated, and the James H. and Lillian Clark Foundation. Especially noteworthy among the Clark gifts are paintings and works on paper by Piet Mondrian and Constantin Brancusi's masterpiece *Beginning of the World* (c. 1920). Frederic Church's masterpiece *Icebergs* (1861) was given to the museum by an anonymous donor in 1979.

The 1980s saw Dallas's facility and collections

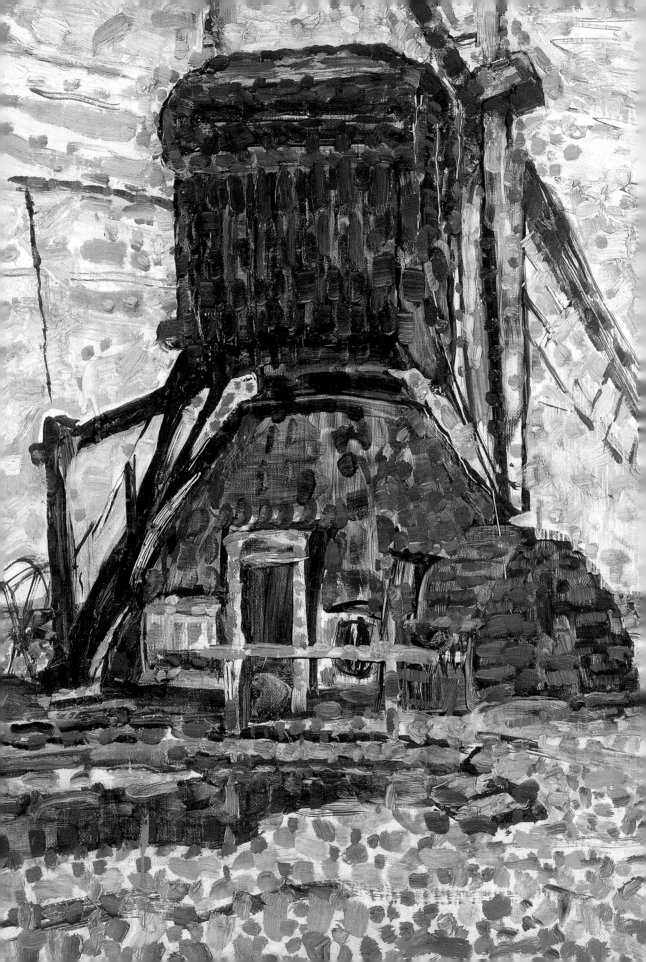

expand greatly. Before his departure in 1987, Parker oversaw the 1984 opening of a spacious new facility in downtown Dallas designed by Edward Larrabee Barnes and Associates. During Parker's directorship, textiles became an important focus of the museum with the coming of the Williams and Nasher Collections of Guatemalan Textiles (1982 and 1983) and the Alpert Collection of Indonesian Textiles (1983). A fund for the purchase of textiles was also established at that time. Beyond textiles, important works by Claes Oldenburg, Ellsworth Kelly, Richard Fleischner, and Scott Burton were commissioned for the opening of the new building. In 1985 Wendy Reves presented the museum with the extraordinary Wendy and Emery Reves Collection of European Art. Included in this gift were superb works by Bonnard, Cézanne, Corot, Gauguin, Manet, Pissarro, Redon, Renoir, Rodin, van Gogh, and Vlaminck. Important examples of European and Asian export decorative art also came with the collection and became the basis for a department of decorative arts. This area was further strengthened in 1985 by the purchase of the Faith P. and Charles L. Bybee Collection of American Furniture. In 1987 the estate of Ida Green established an endowment for the purchase of ancient Mediterranean art.

With the arrival of Richard R. Brettell as director in 1987, the collections expanded in new ways. Dallas's collection of Mediterranean gold jewelry was acquired in 1991 in honor of Virginia Lucas Nick through the generosity of the McDermott and Green families and the Museum League. Important holdings in American silver dating from the nineteenth and early twentieth centuries were amassed, and the 20th-Century Design Fund was established by Elizabeth and Duncan Boeckman in 1991. This fund has allowed rapid expansion into the design field. Significant growth in the field of prehistoric Native American ceramics occurred thanks to the generosity of an anonymous collector. Simultaneously the groundwork was laid for the acquisition of the John R. Young Collection of Meiji-period Japanese decorative arts, which came to the museum through the Foundation for the Arts in the early 1990s. Similarly the

collecting of Spanish Colonial art was initiated under Dr. Brettell. A gallery devoted to this material was incorporated in the reinstallation of the museum's holdings of American art in the Jake and Nancy Hamon Building, which opened in 1993.

Jay Gates's directorship, which began in 1993, has seen steady growth in the permanent collection. Especially noteworthy have been additions to the museum's five principal areas of specialization—African, ancient American, Indonesian, American decorative, and contemporary art. Among these new acquisitions have been an extraordinary standing male figure with nails from Zaire (nineteenth century); a checkerboard-patterned Inca tunic (c. 1500); a pair of carved mythological animals from Sarawak (nineteenth century); the Vanderbilt console by the Herter Brothers (c. 1881); and the painting *Äpfel* by Gerhard Richter (1988). Beyond these fine works, important pieces of ancient Mediterranean, European, and American art have come to the museum in recent years, including a large Greek krater (c. 340–330 B.C.); Sir Edward Coley Burne-Jones's *The Pilgrim at the Gate of Idleness* (1884); and John Singleton Copley's portraits of Sarah and Woodbury Langdon (1767). Of special note has been the rapid and unexpected growth in the area of South and Southeast Asian art. The collectors Alta Brenner and especially David T. Owsley have been instrumental in the development of these holdings.

As this brief overview demonstrates, the sources for art collecting at the Dallas Museum of Art have been diverse and often unexpected. Over nearly a century, private collectors, generous funders, directors, curators, and numerous other staff members, in partnership with the City of Dallas, have expended enormous amounts of time, energy, and resources on building and refining the museum's holdings. The citizens of Dallas can be proud of their accomplishments.

DR. CHARLES VENABLE
Associate Director for Collections
 and Exhibitions
Chief Curator

Contributors

RAMONA AUSTIN
Associate Curator of African Art

DR. ANNE BROMBERG
Curator of Ancient Art and South Asian Art

KRISTIN HELMICK-BRUNET
Intern

JAY GATES
The Eugene McDermott Director

STEPHEN HARRISON
Assistant Curator of Decorative Arts

ELEANOR JONES-HARVEY
Associate Curator of American Art

DOUGLAS HAWES
former Assistant Curator of Decorative Arts

SHIRLEY REECE-HUGHES
McDermott Curatorial Assistant

MELINDA KLAYMAN
Edward and Betty Marcus Curatorial Intern

DR. DOROTHY KOSINSKI
The Barbara Thomas Lemmon Curator of European Art

CAROL ROBBINS
Curator of New World and Pacific Cultures

DR. CHARLES VENABLE
Associate Director for Collections and Exhibitions/Chief Curator

SUZANNE WEAVER
Assistant Curator of Contemporary Art

DEBRA WITTRUP
Head of Exhibitions and Managing Editor

CHARLES WYLIE
Lupe Murchison Curator of Contemporary Art

Principal photography by TOM JENKINS

The Ancient Mediterranean

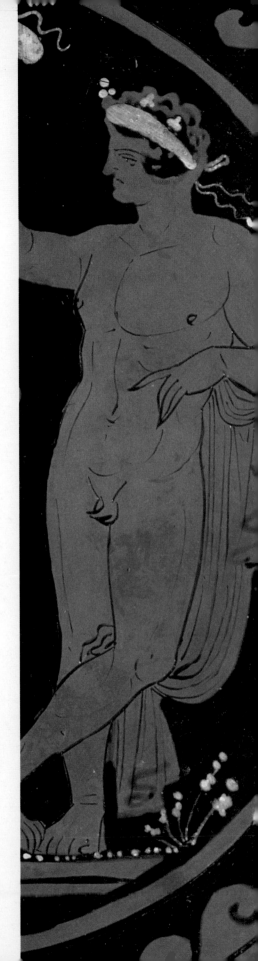

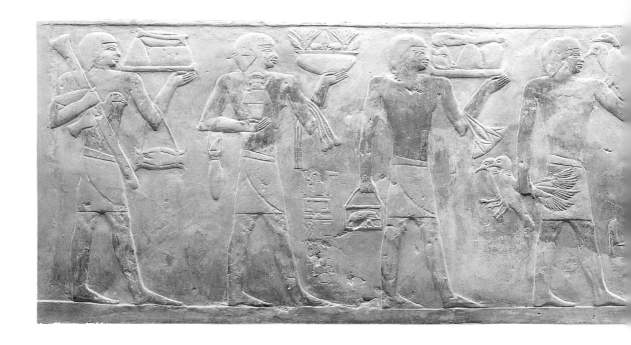

Procession of offering bearers

Tomb of Nyankhnesut
Egyptian, late 5th–6th Dynasty, c. 2300 B.C.
Limestone and paint
17½ × 66¾ × 3½ in. (44.5 × 169.5 × 8.9 cm)
Munger Fund, 1965.28.M

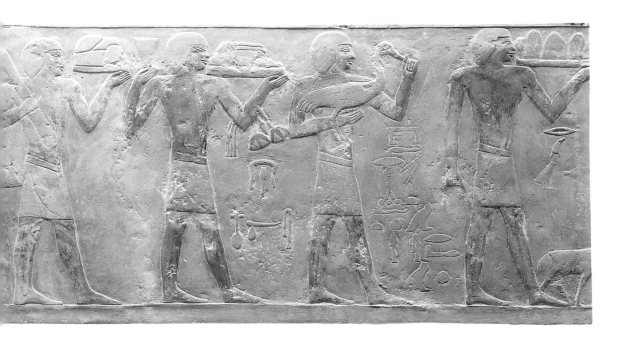

Nyankhnesut was an important official in Egypt during the late 5th or early 6th Dynasty. (Many other reliefs from his tomb are displayed in American museums, notably the Cleveland Museum of Art.) This relief consists of a group of servant figures who move from left to right carrying offerings for the owner of the tomb. They are depicted in the customary Egyptian convention for walking figures, with a combination of profile and frontal views of the body.

Offering scenes like this one reflect the Egyptian idea that the dead person lived in the afterworld much as a priest or noble did in life. In effect, the work of art is a form of pictorial magic, supplying ducks, geese, bread, flowers, cloth, and even a caged hedgehog for the tomb's owner. Soon after the entombment, relatives of the dead person might leave food offerings, and in later years, priests might also leave such offerings, but when it was immortalized by art in scenes like this one, the food supply would last for eternity.

The magical nature of this handsome scene explains its hieroglyphic purity of form. Each person or object is modeled with extreme clarity of form and outline, as if the procession were a text to be read. The basic conventions of Egyptian art, as they developed during the Old Kingdom, fused written symbols and pictorial form. The whole of Nyankhnesut's tomb was a house for the dead person, and each of its elements ensured a luxurious way of life in the afterworld.

AB

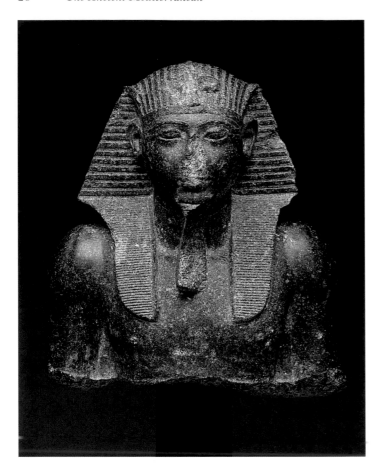

Head and upper torso of Seti I

Egyptian, 19th Dynasty, c. 1303–1290 B.C.
Black granite
15 × 11¾ × 7⅜ in. (38.1 × 29.9 × 18.7 cm)
Purchased in honor of Betty Marcus with the Art
Museum League Funds, the Melba Davis Whatley
Fund, and the General Acquisition Fund, 1984.50

This superb sculpture is a rare portrait of one of
the great kings of Egyptian history. Seti I was
the first important pharaoh of the 19th Dynasty.
Following the upheavals caused by Akhenaten's
religious revolution in the late 18th Dynasty,
Seti established a firm military control over all
of Egypt and led its armies to conquest in Pales-
tine. He set the pattern for an aggressive Egyp-
tian rule that reached its climax under the long
reign of his son Ramses II.

 Relief portraits of Seti I occur at Abydos, Kar-
nak, and in his tomb in the necropolis at Thebes,
but this is one of the few three-dimensional por-
traits of him. It adheres to the classical Egyp-

tian conventions of royal art, showing the king
as a vital, muscular man dressed in the ruler's
nemes headcloth and false beard. Supporting the
back of the bust is the king's cartouche with his
regal names. The boldly plastic modeling of the
figure indicates the king's divine majesty and
his role as a bringer of prosperity to his people.
The columnar neck, lifted chin, and gripping
gaze of the eyes give the portrait a remarkable
sense of living force, thereby equating Seti with
Osiris, the undying Lord of the Afterworld.
Since Egyptian rulers belonged to the realm
of the gods, they were represented as eternally
strong and youthful.

 Seti I's rule initiated a revival of Egyptian
splendor. Art under Seti emphasized a grandiose
monumentality without sacrificing the courtly
elegance so notable under the kings of the 18th
Dynasty. This portrait bust expresses this union
of dynamic power and suave line. AB

Coffin of Horankh

Egyptian, 25th Dynasty, c. 700 B.C.
Wood, gesso, paint, obsidian, calcite, and bronze
H. 30¼ in. (76.8 cm)
Green Estate Acquisition Fund, 1994.184

In the Egyptian cult of the dead, the survival of
the dead person's body was critically important
because it was believed that after death, people
lived physically in the afterworld as they did in
this one. While fashions in coffins and portraits
of the dead person changed throughout Egyp-
tian history, the idea of bodily survival remained
constant. This Late Period coffin identifies the
dead man, Horankh, with Osiris, Lord of the
Afterworld. Osiris is shown as a royal mummy;
his green face signifies the growth of plants and
new life in spring. The aesthetic emphasis is
placed on life and undying vitality rather than
on death. The figure's brilliant calcite and obsid-
ian eyes shine with glittering force. The forms
of the body are clearly and powerfully delineated
under the representation of linen mummy wrap-
pings. The colors on the molded gesso (linen
impregnated with plaster) have survived in
excellent condition, which adds to the dramatic
effect. In style the coffin recreates the pure, pow-
erful forms of Egyptian Middle Kingdom art.
This archaizing taste is typical of the Nubian
and Saite rulers of Egypt, who wished to restore
the glories of Egypt's past. The inscription on
the base includes a prayer to Osiris and the
name of the dead man. AB

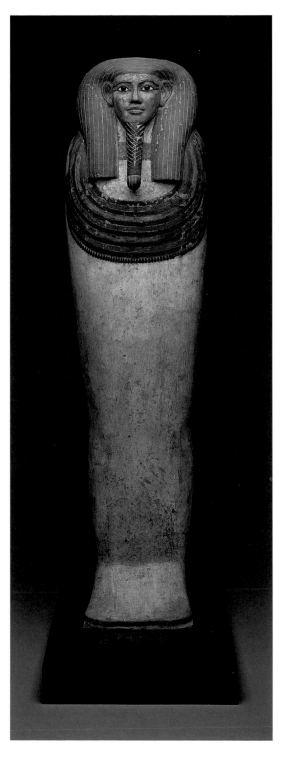

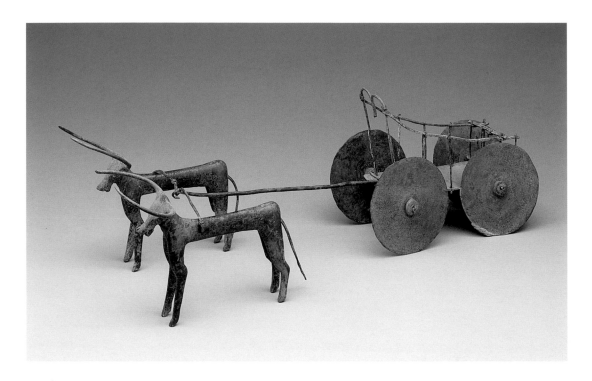

Oxen and cart

Proto-Hittite, Turkey, c. 2000–1800 B.C.
Bronze
5⅞ × 8¾ × 4 in. (14.8 × 22.2 × 10.3 cm)
Irvin L. and Meryl P. Levy Endowment Fund, 1972.38.a–d

This bronze cart drawn by a pair of long-horned oxen is one of many ex-
amples of an artistic type well known from the early second millennium B.C.
Such models were probably votive offerings, to be left in shrines, sacred
caches, or tombs. They reflect the distinctive moment when men first used
domesticated horses or cattle to draw wheeled vehicles, creating the begin-
ning of powered transport on land. Although drawings of wheeled vehicles
occur all over Eurasia, this seminal development in human culture probably
originated in Mesopotamia or the Russian steppes in the late third millen-
nium B.C. Models similar to this one occur in Syria and in the eastern part
of Anatolia. Both the combination of cold hammering and lost-wax casting
used to make the piece and the new technology of wheeled transport repre-
sent the leading edge of civilization in the eastern Mediterranean during
the Bronze Age. The models show both farm carts for carrying produce
and war chariots. This example is a formally dazzling work that shapes the
little wagon with its high railings and the oxen with their great, outflung
horns to a linear design in three dimensions. Like a tracery in space, the
clean-cut cart moves forward, a paradigm of intelligent craftsmanship.

AB

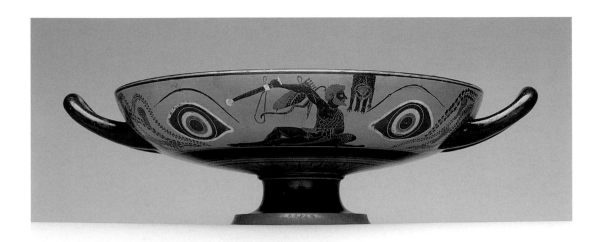

Black-figure kylix

Greek, 6th century B.C.
Ceramic
4⅞ × 12½ in. diam. without handles (12.3 × 31.7 cm)
Gift of Mr. and Mrs. Cecil H. Green, 1972.5

This kylix, or drinking cup, is one of the finest Greek vases in the museum. Simply as a pottery form, the vessel has a notable architectonic structure, cleanly articulated in a crisp and elegant way. The ornamentation defining the handles, base, and sections of the cup is equally clearly cut. Like the best Greek vases, this piece resembles a small building. The figural scenes are adapted to the cup with a fine economy of design. On the bowl's exterior, both sides of the lip have vignettes of Herakles: in one, a satyr pours him a cup of wine; in the other, he reaches for his sword that hangs on the wall before him. Herakles, a skilled athlete and warrior, was one of the most popular of Greek heroes. He was also one of the rare human heroes to join the immortal gods on Mount Olympus, and the scene of the hero reclining with a wine cup may suggest this apotheosis. The rest of the ornamentation suggests the wine-party setting where the cup would have been used. The eyes on the exterior are magical motifs that protect the drinker, as is the gorgon head in the circular medallion inside the cup. The painted designs are in black-figure style, where decorations are painted on the vase in a slip that appears black against the natural red background of the clay body. AB

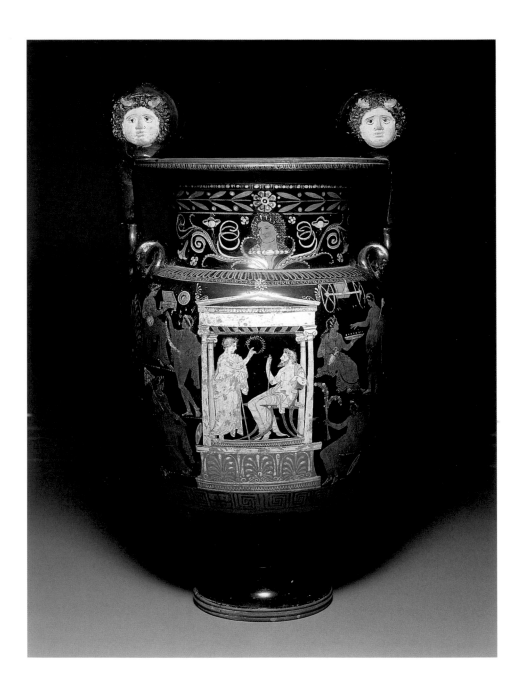

Red-figure krater

Greek, Apulia, c. 340–330 B.C.
Attributed to the Metope Group
Ceramic and pigment
31¼ × 19¾ × 17 in. (79.4 × 50.2 × 43.2 cm)
The Melba Davis Whatley Fund and the Green
Estate Acquisition Fund, 1996.147

The Greek states in south Italy created a rich style of ceramics that was based on techniques of Attic red-figure pottery, but which emphasized complex figural compositions, added colors, and a monumentality of conception and scale. Many vessels were designed for funerary rites and burial with the dead. These two examples are decorated with funerary imagery. Both are from Apulia, the southeastern area of south Italy settled by Greek colonists. They are closely related in date and come from important Apulian workshops.

The krater has impressive central scenes on the front and the reverse. In the main scene, a woman is giving a seated man a wreath. The two figures are framed by a *naiskos*, or funerary shrine. On the reverse, the *naiskos* holds a heroic nude figure of an athlete. Subsidiary figures hold objects associated with Greek funerary rituals— fans, sashes, caskets, and offering bowls. On the neck, the graceful bust of a crowned woman surrounded by tendrils of leaves and flowers may be Persephone, Queen of the Underworld. The vase is highly sculptural, with handsome mask ornaments instead of volutes on the handles, and it has modeled ducks on the shoulder.

The *patera*, or offering bowl, is a rare type with a sculptural handle in the form of a male nude. It is probably related to Atlas, the giant of Greek mythology who held up the heavens. The temple of Zeus at Akragas, in Sicily, used such Atlantid figures as architectural supports, and this handle may have been inspired by sculptural prototypes. The figures in the bowl of this vessel are similar to those on the krater, suggesting funerary rituals. These figures and the rich floral designs may refer to cults promising initiates immortality. In south Italy these cults were associated with Persephone, Dionysos, and the mythic poet Orpheus. Presumably the dead person was imagined as living in the Elysian Fields, the Greek Afterworld. AB

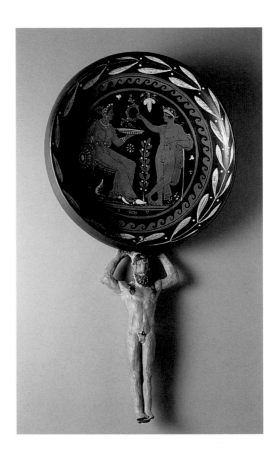

Red-figure patera with Atlas handle

Greek, Apulia, last third of 4th century B.C.
Attributed to the Painter of Louvre 1148
Ceramic
15⅞ × 2⅜ × 9 in. diam. at rim
(40.3 × 6 × 22.8 cm)
Gift of the Junior Associates, 1996.34.a–b

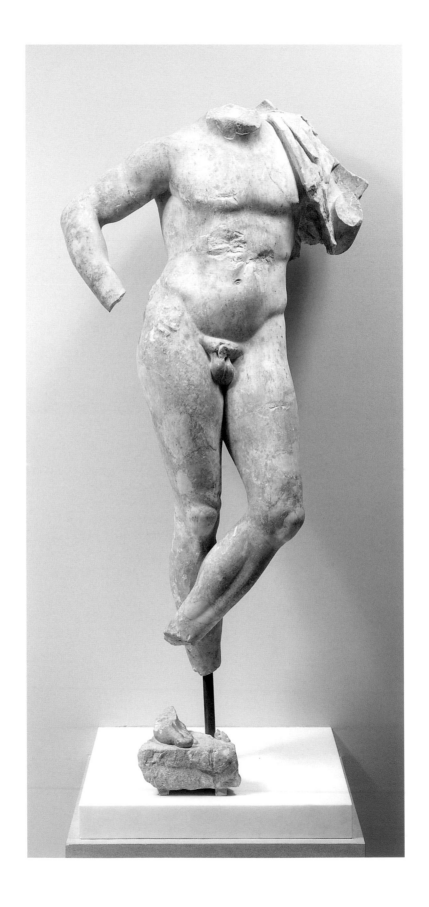

Figure of a young man from a funerary relief
Greek, Attic, 4th century B.C.
Marble
63⅛ × 30¾ × 18¾ in. (161.3 × 78.1 × 47.6 cm)
Gift of Mr. and Mrs. Cecil H. Green, 1966.26

Classical Greek sculpture celebrated the human body. In architectural
sculptures such as the works ornamenting the Parthenon temple in Athens,
or in single votive statues, the nude male figure achieved heroic beauty of
form. In the later stages of classical Greek art, at the end of the fifth and
during the fourth centuries B.C., the great families of Athens turned to a
more private kind of art, the grave sculpture. These artistic memorials to
the dead shared a general loosening of classic form and a more human,
emotional approach to art. This figure of a young man comes from an
elaborate grave memorial. Originally, the figure of the youth would have
been framed by an architectural shrine that also included other figures,
such as the boy's aged father. A very similar composition appears on the
Ilissos relief (now in the National Museum in Athens). The young man
stands in a contrapposto position, turning on the axis of his body and
looking out of the sculptural space at the viewer. His nude body has the
radiant purity of an athlete in his prime, although implicit in the work
is a sense of tragedy, as the young man has died in the flower of youth
and beauty. AB

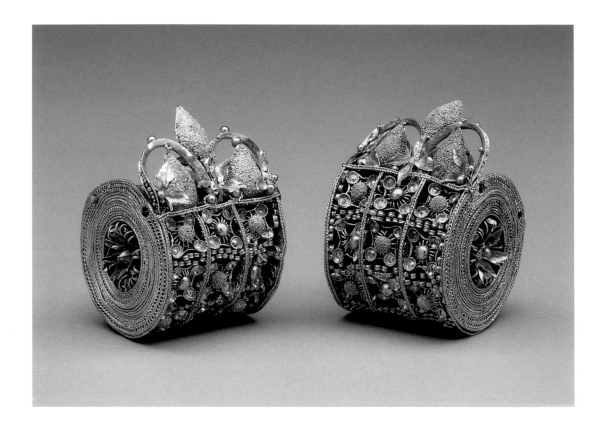

Pair of a bauletto earrings
Etruscan, 6th–early 5th century B.C.
Gold
H. 1⅞ in. (4.5 cm)
Gift of Mr. and Mrs. James H. Clark, 1968.13.a–b

These very elaborate Etruscan earrings are called "little bag" *(a bauletto)*
in Italian to describe their cylindrical shape. Attached to one end of each
gold cylinder is a large rose made of filigree wire and sheet gold. A series
of compartments formed by plaits and ribbons ornaments the cylinders'
surface. Each is filled with filigree rosettes or a granulated boss. The
granulation, formed by the adhesion of tiny gold globules to the gold base,
is exceptionally fine in both pieces. Originally the earrings would have been
suspended on hooks, now missing. Such pieces are among the most intri-
cate creations of ancient goldsmiths. AB

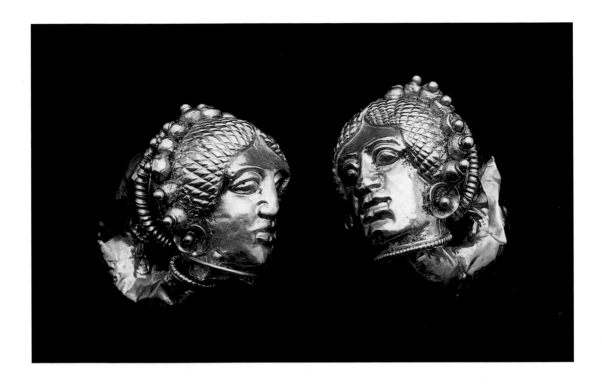

Pair of tubular earrings with female heads

Etruscan, mid-5th century B.C.
Gold
H. 1⅛ in (2.5 cm)
Museum League Purchase Funds, The Eugene and
Margaret McDermott Art Fund, Inc., and Cecil H.
and Ida M. Green in honor of Virginia Lucas Nick,
1991.75.29.a–b

This handsome pair of earrings relates to far
larger works in stone. The character of the
female heads reflects the severe style in Greek
art, between 480 and 450 B.C. Their calm, serene
features and smooth masses of heavy hair give
the women's heads, small though they are, a
grave nobility. This is one of several examples
in the museum's jewelry collection that show
how Etruscan goldsmiths interpreted Greek
motifs to their own taste. Chaste as is this classi-
cal Greek style, the heads' beading-frame orna-
mentation gives them an impression of richness.

AB

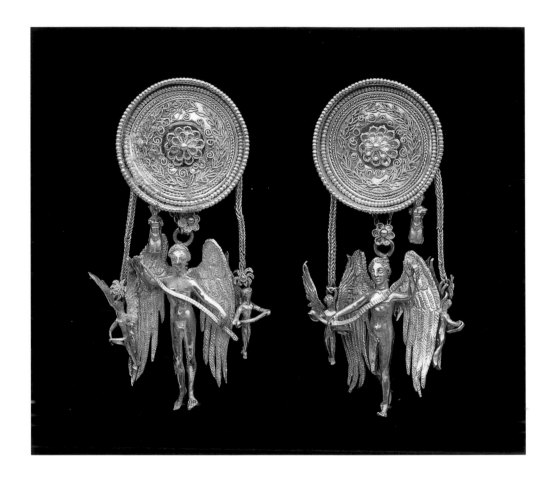

Eros earrings

Greek, late 4th century B.C.
Gold
2⅛ × ⅞ in. diam. (5.4 × 2.2 cm)
Green Estate Acquisitions Fund, 1995.25.a–b

Classical Greek jewelry was often closely tied to sculpture. The fine detail
of these Eros earrings, which includes the feathers on the wings and
carefully modeled torsos, creates miniature versions of much larger Eros
statues. Eros, the god of desire and the child of Aphrodite, was a popular
motif on women's earrings, as he promised success in love and attainment
of beauty. The amuletic character of the jewelry is also indicated by the
small torsos attached to each piece, which have been interpreted as sexual
charms. The delicate filigree work on the disk from which the figures
dangle adds to the pair's refined charm. Similar complex earrings with
dangling figures of Nike, or Victory, are included in the museum's
collections. AB

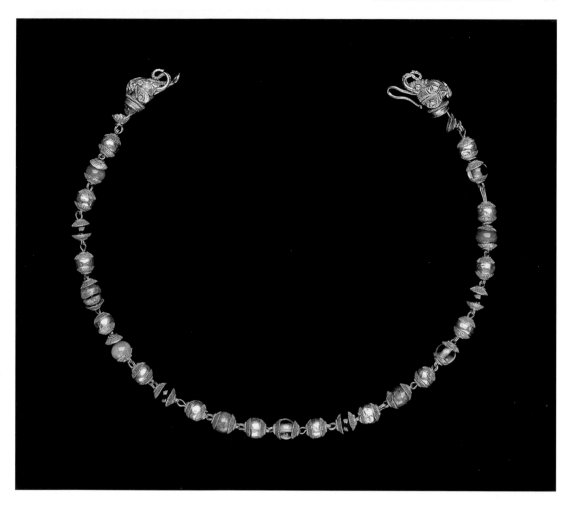

Elephant-head necklace

Greek, 2nd century B.C.
Gold, emerald, garnet, and rock crystal
L. 15⅜ in. (39 cm)
Museum League Purchase Funds, The Eugene and
Margaret McDermott Art Fund, Inc., and Cecil H.
and Ida M. Green in honor of Virginia Lucas Nick,
1991.75.79

The bravura coloristic style of Hellenistic
Greek jewelry is ideally represented by this
lavish necklace with elephant-head finials. The
necklace itself makes a rich play of contrasting
emeralds, garnets, and rock crystals, while the
elephant heads are meticulously modeled in
repoussé and heavy wire to suggest the charac-
ter of their rugged skin and the lively curves of
their trunks. Such necklaces were probably worn
with the finials on the wearer's chest to display
these fine sculptural attachments. The remnants
of wreaths that once crowned the elephants'
heads suggest that the animals were associated
with the cult of the god Dionysos, scenes of
whose ceremonial procession from India to the
Mediterranean often included animals like pan-
thers and elephants. The realism of the elephant
heads is also typical of Hellenistic style.

AB

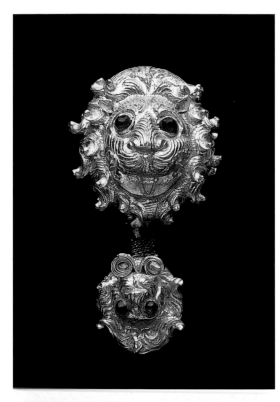

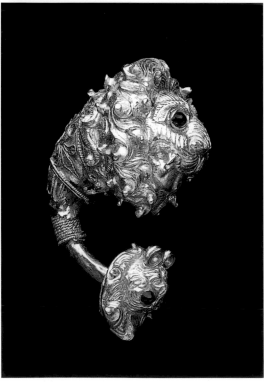

Lion-head earring
Greek, 3rd century B.C.
Gold, garnet, enamel, and filigree
H. 1⅝ in. (3.9 cm)
Museum League Purchase Funds, The Eugene and
Margaret McDermott Art Fund, Inc., and Cecil H.
and Ida M. Green in honor of Virginia Lucas Nick,
1991.75.64

This is a classic example of the baroque style of
jewelry common in the wealthy cities of Greek
southern Italy during the Hellenistic age. The
earring's construction is quite complex: the
smaller of the two lion heads is removable, and
the larger lion's ears are also separately at-
tached. Technically, both lions are marvels of
ingenuity; the teeth, tongues, and fur of the
stylized animals are carefully detailed. Traces
remain of the green enamel that once filled
cloisons on the decorative collar. The larger
lion head is especially dramatic, with its glow-
ing red garnet eyes and flamelike mane. Lions
were popular subjects in Greek jewelry, since
they symbolized fertility and regal power.

AB

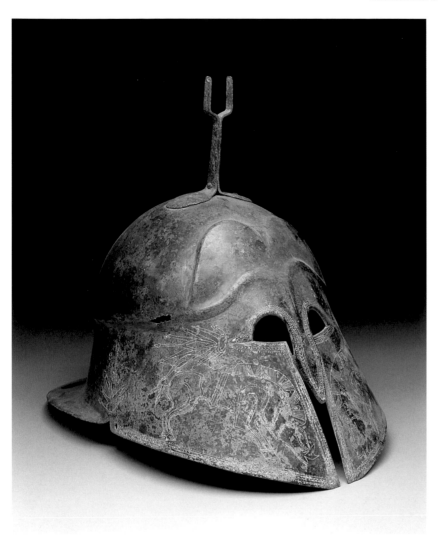

Corinthian-type helmet with boars

Etruscan, early 5th century B.C.
Bronze
$10\frac{5}{8} \times 12 \times 8\frac{5}{8}$ in. (27.1 × 30.5 × 22.1 cm)
Dallas Art Association Purchase, Edwin J. Kiest
Memorial Fund, 1966.8

Helmets designed at the major Greek commercial city of Corinth were popular throughout the archaic period (sixth–early fifth century B.C.). A variant of the later type of Corinthian helmet was produced in the Greek settlements of southern Italy, under strong Etruscan and Italic influence. Such helmets were part of elaborate ceremonial armor and as such were often buried with the dead in the Greek areas of Magna Graecia and in Etruria, where magnates were commonly buried with Greek-style luxury objects. This type of helmet was not worn over the face, but pushed back on the top of the head, with the rear plate protecting the warrior's neck. The piece is cold hammered. Its crest holder is attached with rivets, and there are also rivets for attaching a helmet liner. The outside of the helmet is elegantly ornamented with an incised herringbone pattern and palmettes. Two rampant boars are incised on the cheek pieces. These incised decorations are related to contemporary drawings on vases as well as to similar examples of ornamental metalwork. In the clarity of the decoration and the crisp purity of shape, this helmet is a masterpiece of military display. AB

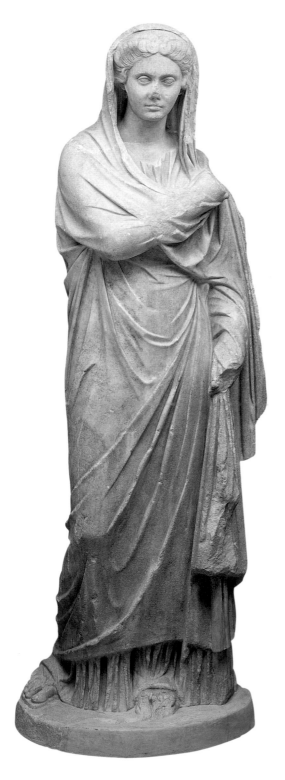

Figure of a woman
Roman, 2nd century A.D.
Marble
69¼ × 28¼ × 17⅝ in. (175.9 × 71.8 × 44.8 cm)
Gift of Mr. and Mrs. Cecil H. Green, 1973.11

This nobly restrained figure of a woman, from
the middle of the second century A.D., contrasts
with the luxuriant Roman portrait head of a
youth (p. 35). The dignified status of an aristo-
cratic lady is fully embodied in this majestic
work. The body type, often found in imperial fe-
male portrait statues, is based on Greek draped
figures from the fourth century B.C. Associated
with the work of late classical sculptors such
as Praxiteles or Lysippus, figures of the so-
called Small Herculaneum type were frequently
adapted in Roman art. Here, the heavily draped
figure suggests the virtuous character of the
commemorated woman. The portrait head used
with this standard body type is graceful and
pensive. The complete figure radiates a gentle
nobility that embodies the best traditions of
Roman family life and the high value accorded
to distinguished Roman women. In appearance,
the lady recalls imperial Antonine women such
as the younger Faustina, wife of Marcus
Aurelius, though the figure is not sufficiently
close to either her or her daughter, Lucilla, to
be an actual royal portrait. AB

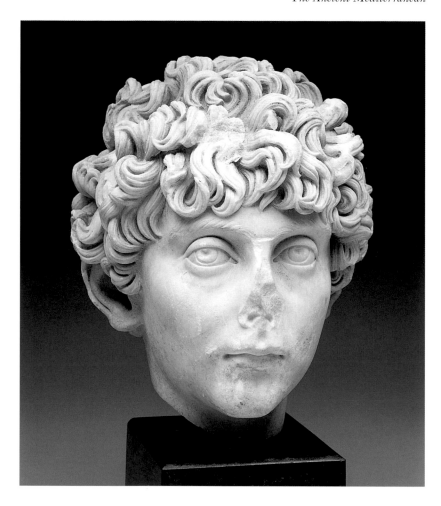

Head of a youth

Roman, 2nd century A.D.
Marble
11 × 8½ in (27.9 × 21.6 cm)
Gift of Norbert Schimmel in memory of Betty Marcus, 1984.163

Portraiture was one of the most distinctive types of Roman art. In early
Roman religion, wax death masks or realistic portraits of the dead were
left in family tombs as ancestral memorials. Under the impact of idealizing
Greek portrait sculpture, Roman portraits of the Empire became rich,
subtle, and sophisticated images, blending the psychological realism of
Roman art with the sensuous forms of Greek modeling. A superb example
of this brilliant portraiture appears in the head of a young man. His soft,
dreamy features are almost weighed down by a gorgeous mass of curly
hair. This bravura sculptural style, with its extensive use of the drill and
its strong modeling with shadows, is typical of early Antonine art in the
middle years of the second century A.D. The boy's head is close to the type
of the young Marcus Aurelius, the future philosopher-emperor, and prob-
ably indicates the influence of imperial prototypes on sculpture made for
people associated with the Roman court. AB

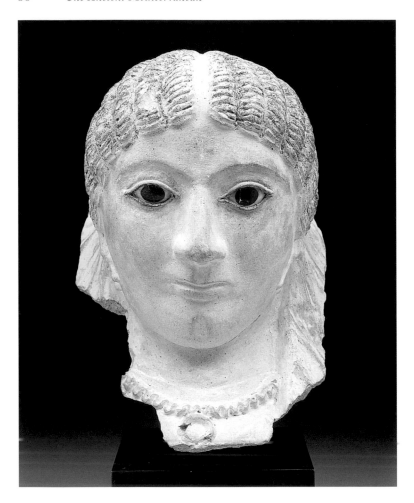

Mummy portrait

Egyptian, Roman period, late 2nd century A.D.
Cartonnage, paint, bronze, and glass
9¾ × 7 in. (24.8 × 17.8 cm)
Green Estate Acquisition Fund, 1995.82

The practice of making plaster mummy masks to place over the face and neck of the embalmed body had a long tradition in Egypt. Ultimately it goes back to the sculptured heads left in tombs of the Old Kingdom. When the Greeks of the Hellenistic age and, later, the Romans of the Empire ruled Egypt, they adopted this custom. The well-to-do Greco-Roman elite ordered such plaster or cartonnage masks to suit their own artistic tastes. This Roman portrait mask is an interesting counterpoint to the museum's marble figure of a standing woman (p. 34). The mask blends the idealism of Greek art with realistic Roman style, creating a head that is both beautiful and psychologically forceful. The woman wears recognizable types of later second-century A.D. earrings and necklace, similar examples of which are in the museum's ancient jewelry collection. The inlaid eyes and remains of paint on the cartonnage give the portrait a remarkably lifelike appearance. While the style of the head is Roman, the funerary symbolism of the portrait head, which implies eternal life, is Egyptian. Like the museum's Syro-Roman head of a priest in limestone, this work illustrates the way in which Roman ideas of portraiture blended with native religious concepts in the eastern Empire. AB

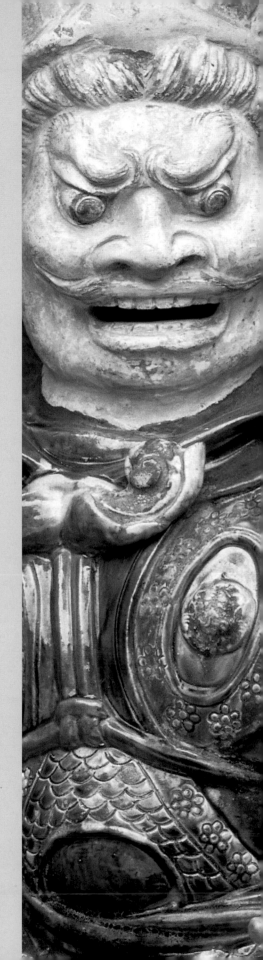

*Asia and
the Pacific*

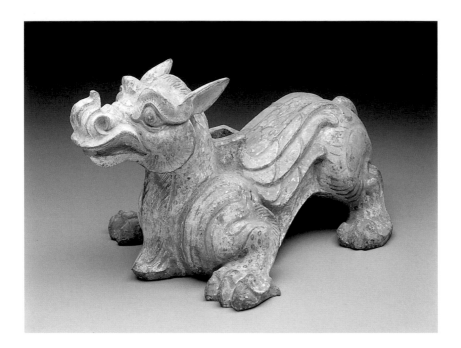

Chimera

Chinese, Eastern Han dynasty (A.D. 25–220)
Earthenware and paint
8½ × 10 × 16 in. (22 × 25 × 41 cm)
Anonymous gift, 1995.66

The Han dynasty was one of China's most dynamic eras. Except for a
brief interruption in the first century A.D., the country was strong and
unified, experiencing great power and prestige in military, diplomatic,
and cultural fields. The territory of the empire expanded in all directions,
while overland trade routes and sea lanes took precious silk to the Western
world. Despite political and social changes, the ancient tradition requiring
elaborate burial rituals and funerary complexes continued to be followed
throughout the Han dynasty. Burial objects have been found in large quan-
tities in tomb excavations throughout China. Many were made of gray
earthenware and painted with unfired colored pigments. The splendor of
such objects can be surmised from the lively surface decoration found on
the museum's chimera.

 Representations of fantastic beasts such as the chimera were placed in
Chinese tombs to protect the dead from evil in the afterlife. With its highly
sculpted surface and animated painting, swirling mane, crouching stance,
pointed ears, and bulging eyes, this guardian confronts the viewer, daring
him to pass. The square socket behind the neck indicates that the beast
originally supported something, perhaps a standard. DW

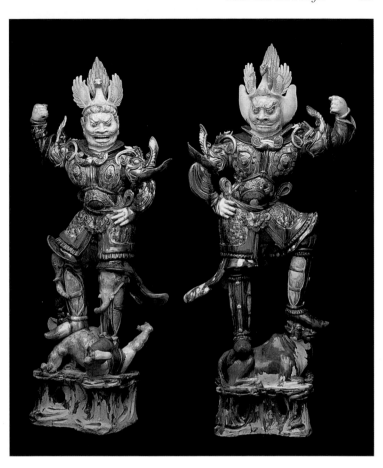

Pair of Lokapala (heavenly guardians)

Chinese, Tang dynasty, c. 700–750
Earthenware with three-colored *(sancai)* lead glazes
40⅞ × 16½ × 11¾ in. each
(103.8 × 41.9 × 29.8 cm)
The Eugene and Margaret McDermott Art Fund,
Inc., in honor of Ellen and Harry S. Parker III,
1987.360.1–2.McD

These Buddhist guardians known as *lokapala* are the protective deities of the four directions. The figures belong to a general class of grave goods known as *mingqi*, or spirit objects, which were buried with the deceased in subterranean tombs in China from as early as 1000 B.C. According to ancient Chinese belief, the spirit that remains with the human body at death must be humored with familiar surroundings and protected from evil forces. To this end, clay or wood *mingqi* in the form of attendants, animals, and representations of objects from daily life were placed in the tombs of royalty and noblemen. The practice reached a peak during the Tang dynasty, but continued on a lesser scale for several centuries. *Mingqi* production attained the height of sophistication and magnificence in the first half of the eighth century, when the simple green- or brown-glazed wares and painted pottery types of earlier centuries evolved into elaborately sculpted figures such as these guardians, naturalistic in detail and dynamically colored.

Shown as ferocious foreign physical types, the guardians wear fanciful armor and fantastic helmets; one arm is raised to hold a spear, now lost. The figures gain associated power through exotic animal symbolism: the heads of mythical creatures decorate the upper armor, and the legs of one *lokapala* emerge from the mouths of elephants. They express their ultimate triumph as guardians symbolically, in one case, by trampling a struggling demon and, in the other, by balancing on a reclining bull. DW

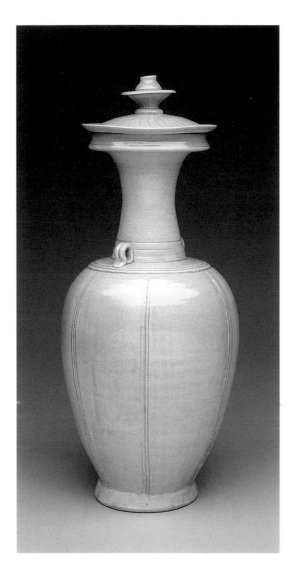

Tall bottle with lid

Chinese, Northern Song dynasty (960–1126)
Porcelaneous stoneware
17 × 7 × 7 in. (43.2 × 17.8 × 17.8 cm)
The Meryl P. Levy Memorial Fund, 1989.101.a–b

The glassy, pale green glaze covering this hand-
some jar is typical of early Song-dynasty works
and a precursor to the thick, opaque celadon
glazes of the later Song period. The elongated,
ovoid body was incised with vertical grooves
to produce the gently lobed, six-sectioned form,
which is modeled after silver vessels from the
Near East. The bottle is unusual in that the
trumpet neck, which flares to a sharply formed,
dish-shaped mouth, is surmounted by a lid with
an upturned rim.

The shape and glaze of this elegant piece sug-
gest an attribution to the Yue kilns in northern
Zhejiang province. But other features, such as
the quality of the clay body and the glassy glaze,
as well as the irregularity of the glaze color,
indicate that the bottle may be an early product
of the Longquan kilns in southern Zhejiang
province. In the tenth or early eleventh century,
when this jar was manufactured, those kilns
experienced strong influences from the more
ancient and time-honored traditions of the Yue
potters farther north. DW

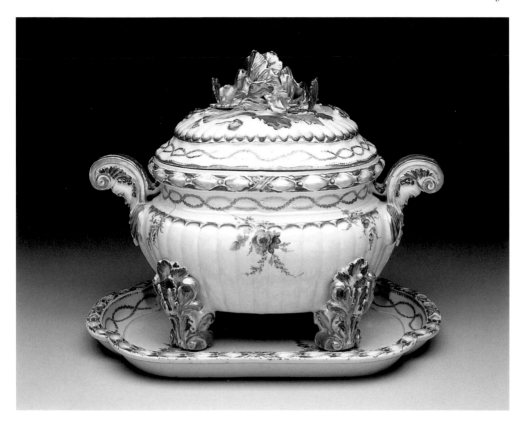

Tureen on stand

Chinese, Qing dynasty, c. 1775
Jingdezhen, China
Enameled and gilt porcelain
Tureen: 9½ × 14⅜ × 11½ in.
(24.1 × 36.5 × 29.2 cm)
Stand: 1¼ × 12 × 16 in. (3.8 × 30.5 × 40.6 cm)
The Wendy and Emery Reves Collection,
1985.R.873.a–c

This tureen on a stand was modeled after a European prototype. Although the actual model sent to China could have been made of pottery, wax, wood, or pewter, the ultimate inspiration was likely a French silver tureen in the late rococo taste. During the third quarter of the eighteenth century, French silversmiths produced many tureens featuring elaborate finials, handles, and feet. The fluted top and sides are also suggestive of metal examples in the emerging neoclassical taste. A date of 1775 for the manufacture of this porcelain example is suggested by the fact that a tureen of the same form was part of the Royal Swedish Gripsholm Service given in 1775 to King Gustav III by the Swedish East India Company.

Even though tureens of this model must have been expensive because of the large amount of labor required to produce porcelain of such complexity, they were popular among Europe's wealthy, and examples with various decorative schemes are known. The Dallas version features neoclassical-style garlands and sprigs of flowers similar to painting found on contemporary French porcelain made at the Sèvres factory, but the masks on the scrolled handles relate more closely to earlier work done at Meissen, Germany. CV

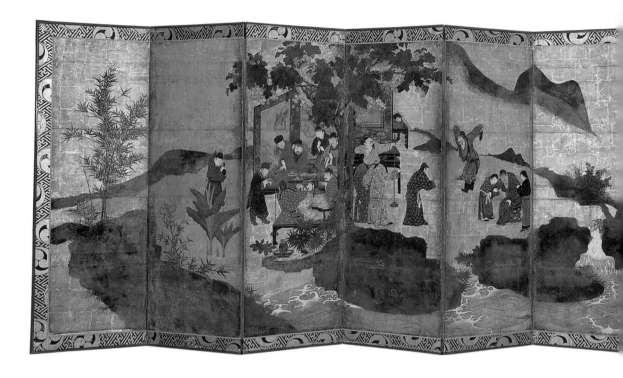

The Eight Immortals of the Wine Cup
Japanese, Momoyama period, c. 1600
Pair of six-fold screens: ink, mineral colors, gold leaf, and wood
Each screen: 65¾ × 133 in. (167 × 338 cm)
The Eugene and Margaret McDermott Art Fund, Inc., 1989.78.a–b.McD

The Momoyama period marks the political unification of Japan and the end to nearly one hundred years of continual warfare. Enjoying the relative stability and improved economic climate of the country, rulers, warriors, aristocrats, and the emerging merchant class spent lavishly on pleasurable pursuits, building, and decorative arts. Enormous and ostentatious castles and villas demanded equally impressive wall-panel paintings and folding screens. To light the massive interiors of these new buildings, the uniquely Japanese technique of applying strong mineral colors to gold leaf came into fashion.

These screens, painted around 1600 by an anonymous artist, take their theme from a

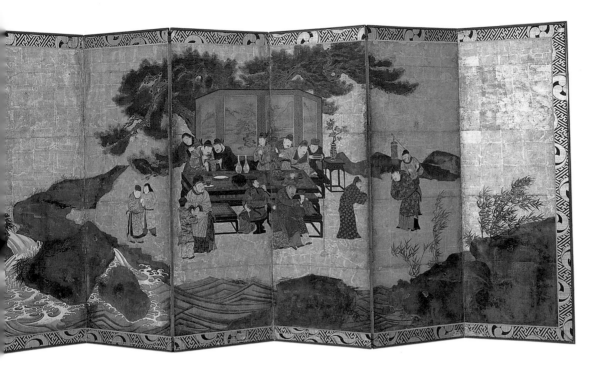

classical eighth-century Chinese poem, "Eight Immortals of the Wine Cup." It portrays the geniality and excessive drinking of eight members of high society, including a prince, a prime minister, a Buddhist monk, a Daoist, poets, and artists. The poem describing their decadence is meant to be read as a protest against accepted rules of decorum and social behavior.

In subsequent generations, the identity of the eight revelers became legendary, and the subject became popular in both Chinese and Japanese painting. The use of the tree, screen, tables, and chairs as characteristically Chinese compositional devices suggests that the Japanese artist based these screens on an actual Chinese model. The elegantly detailed and colorful garments worn by the gentlemen, however, are indicative of the high level of manufacture of and interest in sumptuous clothes by the Japanese at the turn of the seventeenth century. DW

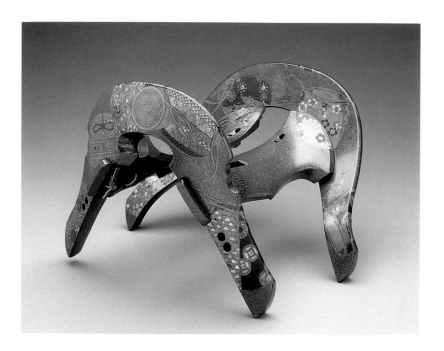

Saddle

Japanese, Edo period, 17th century
Wood with sprinkled gold *(maki-e)* lacquer,
metal, and mother-of-pearl
10⅝ × 16½ × 15¼ in. (27 × 41.9 × 38.7 cm)
Foundation for the Arts Collection,
Boeckman-Mayer Fund, 1991.2.FA

The making of high-quality objects in the difficult lacquer technique
can take months to years to complete. Raw lacquer is thinly applied to a
prepared surface and hardens in an atmosphere of high humidity. Once
it has set, the lacquer must be polished, usually with water and pieces of
soft stone or charcoal. Layer upon layer is applied until the proper surface
has been created. The decorative technique on this magnificent ceremonial
saddle is a traditional Japanese method called *maki-e*, meaning "sprinkled
design." The composition was first drawn in moist lacquer, then metal
powders or flakes were sprinkled over the drawing before the surface hard-
ened. To achieve different tones and textures in the decoration, the artist
varied the kinds of powder or flakes he applied.

 The saddle consists of four pieces of lacquered wood tied together. It
was probably created as a presentation piece and not intended for use. The
primary decoration is a pattern of small brocade bags with drawstring
tops, the elegant *fukuro* that are used to hold containers of powdered tea
for the tea ceremony. The textile patterns of the bags, created with inlays
of gold and silver sheet metal and mother-of-pearl, exhibit a variety of
geometric and floral patterns that were typical of the rich textiles made
during the late Momoyama and early Edo periods. DW

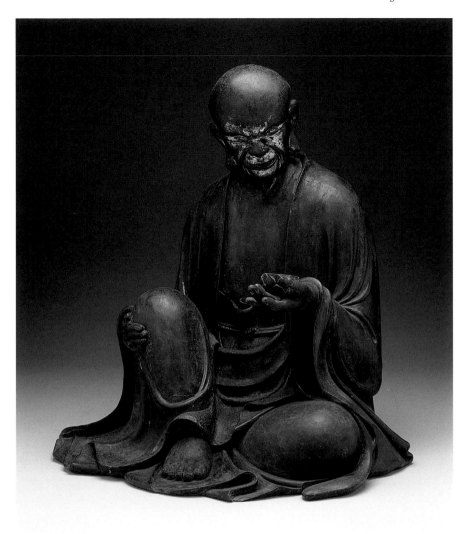

Portrait of an arhat (rakan)

Japanese, Edo period, 17th century
Lacquered wood, pigment, and gold
32 × 28½ × 25 in. (81.3 × 72.4 × 63.5 cm)
The Roberta Coke Camp Fund and gift of
Lillian B. Clark, 1991.381

This compelling figure of a monk contemplat-
ing a lotus flower is a representation of an arhat
(Japanese: *rakan*), one of a group of holy men
who were originally disciples of the historical
Buddha, Shakyamuni. Arhats were regarded as
having achieved extraordinary spiritual levels
but, like bodhisattvas, have put off their own
enlightenment to help others.

Usually appearing in painted or sculptural
groups—from as few as four, sixteen, or eigh-
teen, to as many as five hundred or one thou-
sand—the arhats were depicted with portraitlike
fidelity as monks and ascetics. Although lists
that identify each arhat exist, the descriptions
are too vague to allow precise identifications of
individual figures.

This arhat sits casually with the left leg
folded under and the right knee raised. The face
is that of a mature man, beardless, and the head
is shaven. The realism and individuality of the
face are accomplished through the generous
modeling of facial features. The same fullness
and generosity of carving characterizes the
treatment of the robe that covers his shoulders
and legs. DW

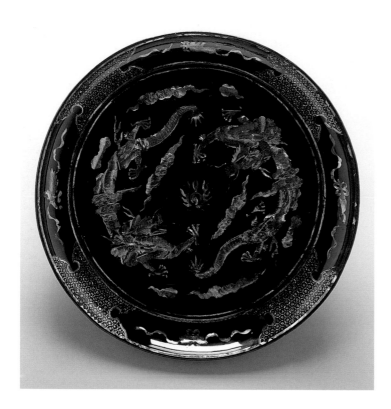

Charger with dragons and flaming jewel
Japanese, Ryukyu Islands, Edo period, 18th century
Lacquer and mother-of-pearl
2½ × 27 in. diam. (6.4 × 68.6 cm)
The Roberta Coke Camp Fund, 1989.140

The Ryukyu Island chain in the East China Sea follows the curve of the Chinese coast from Taiwan to Japan's southernmost island, Kyushu. Throughout their history the islands were subject to influences from both China and Japan, and in 1609 Japan annexed their territory. After the demise of its native monarchy in 1872, the islands became known as Japan's Okinawa Prefecture.

The development of Ryukyu lacquerware began in earnest in the fifteenth century under Chinese guidance and flourished through the eighteenth century. This spectacular charger is from one of several lacquer sets commissioned by the Ryukyu kings as presentation pieces for the Chinese Qing dynasty court. A contemporary record describes sets of thirty plates and thirty bowls decorated with a design of the five-clawed Chinese dragon chasing a flaming jewel which were sent to China in 1725, 1740, and 1788.

The position of the Ryukyu Islands in warm tropical waters assured an abundance of shell for inlaid decoration. This charger is not only exceptionally large, but the shell dragons and geometric patterns are thinly cut, precisely executed, and beautifully preserved, retaining their sparkle and lush pink, blue, and green colors. Such superior craftsmanship and delicacy of ornamental design elevated mother-of-pearl inlay to the most distinctive lacquer form of the Ryukyu Islands. DW

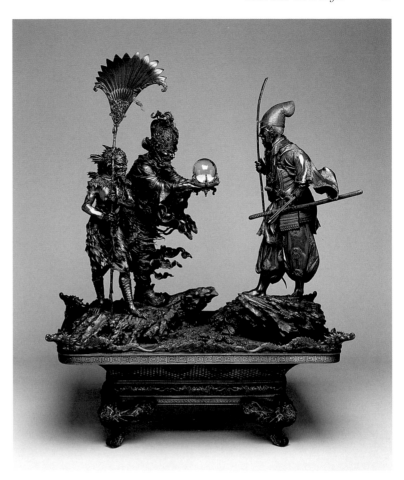

*Takenouchi no Sukune Meets the
Dragon King of the Sea*

Japanese, Meiji period, 1879–81
Bronze
54 × 40 × 26 in. (137.2 × 101.6 × 66 cm)
Foundation for the Arts Collection, The John R.
Young Collection, gift of M. Frances and John R.
Young, 1993.86.11.FA

The extraordinary Takenouchi no Sukune, a
famous warrior-statesman, is said to have lived
as long as 360 years and to have served as a
counselor or minister to as many as six mon-
archs. Among these was the empress Jingo
Kogo, whom he accompanied on an expedition
to Korea. Upon their return, he became guard-
ian to the empress's son, the future emperor
Ojin, who ascended to the throne in the
year 270.

The meeting between Takenouchi and the
dragon king Ryujin was a popular subject in
Meiji-period art. Takenouchi dreamed that he
was ordained by heaven to destroy a monster
that was terrorizing the waters for humans and
sea creatures alike. He accomplished the task
with great valor, and Ryujin, emerging from the
deep to thank him, presents Takenouchi with a
jewel that promises him control over the seas.

In this imaginative design, every detail of
the figures, such as Takenouchi's armor and the
ferocious fish-form mask and spiny lobsterlike
girdle worn by the king's attendant, is elegantly
and precisely defined. The rocks on which the
figures stand teem with the life of the sea. An
amazing tour de force of bronze casting, this
piece is a great tribute to the artistry of Japa-
nese metal craftsmen. From an inscription, we
know that a bronze master and two assistants
labored for two years to create the piece, which
was displayed in 1881 at the Second Domestic
Industrial Exhibition in Tokyo. DW

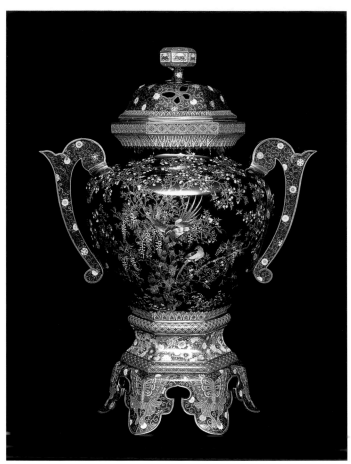

Koro and cover

Japanese, Meiji period, c. 1900
Enamel, gold, and silver wire
18½ × 13½ × 9 in. (47 × 34.3 × 22.9 cm)
Foundation for the Arts Collection, The John R.
Young Collection, gift of M. Frances and John R.
Young, 1993.86.15.a–b.FA

The arts of Japan during the last half of the
nineteenth century experienced a momentous
change when nearly 250 years of isolation from
Western influences ended with the arrival of
Admiral Perry in 1853. In the rush to adopt and
assimilate Western ways, many Japanese customs
were nearly swept aside, but fortunately artistic
traditions of the past often prevailed over the
desire to modernize. Now, however, in place of
the ancient system of government and aristo-
cratic patronage, artists and artisans were pro-
ducing items primarily for export. As a result,
much of their output was influenced by West-
ern taste.

While decorative arts such as metal and
lacquerwares were direct descendants of Edo-
period skills, the art of cloisonné was a relatively
new industry. Cloisonné makers of anything of
significant scale are not recorded in Japan until
the 1830s. Nevertheless the craft developed at
a remarkable level during the late nineteenth
and early twentieth centuries, when three major
workshops of cloisonné enamel were located
in Nagoya. This large covered *koro*, or incense
burner, has been attributed to the Nagoya work-
shop of Ando Jubei.

The decorative program of the *koro* is very
intricate. Pheasants under a flowering cherry
tree intertwined with wisteria, on one side, and
pigeons and sparrows in a maple tree, on the re-
verse, are worked in many colors on a dark blue
ground. The perforated cover, through which
smoke escaped, features butterflies on a ground
of scrolls and flowers, while the shaped foot is
decorated with bands of flowers and geometric
patterns above large butterflies. DW

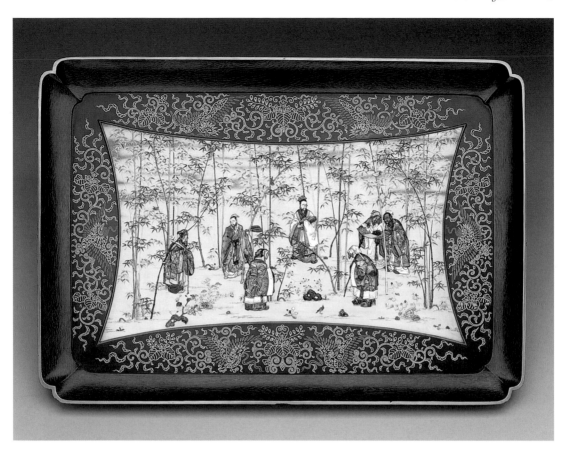

Tray

Japanese, Meiji period (1868–1912)
Lacquer, gold, and mother-of-pearl
1¾ × 24 × 16¾ in. (4.5 × 61 × 42.6 cm)
Foundation for the Arts Collection, The John R.
Young Collection, gift of M. Frances and John R.
Young, 1993.86.43.FA

Shibayama is a type of decorative inlay in which fine pieces of shell, ivory, tortoise shell, coral, bone, and other materials form a pictorial relief pattern on wood, lacquer, ivory, or other medium. The style is named for the family of Shibayama Senzo, who originated it, but encompasses the work of competitors and imitators.

 The restrained style and the conservative subject of the seven sages of the bamboo grove mark this tray as one of the finer, perhaps earlier pieces by the Shibayama family. Although signed solely "Shibayama," it may be the work of the master himself. The rich and intricate inlay of the sages' robes, some bamboo leaves, and other details contrasts beautifully with the otherwise open appearance of the scene. DW

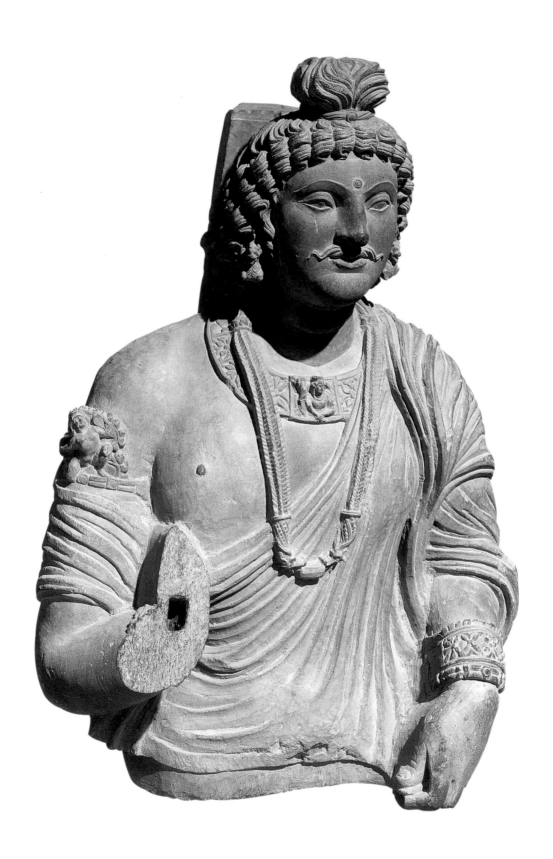

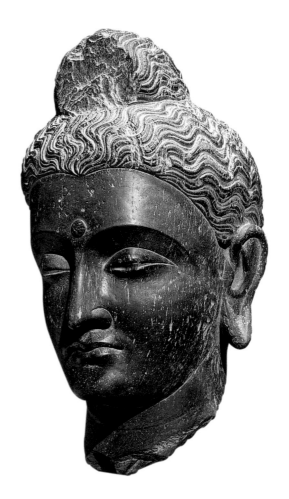

Head of the Buddha (right)

Indian, Gandharan, 3rd century
Schist
H. 18¾ in. (47.6 cm)
Gift of David T. Owsley through the Alvin and
Lucy Owsley Foundation, 1993.7

Bust of a bodhisattva (left)

Pakistani, Gandharan, 2nd–3rd century
Schist
28⅜ × 19¾ × 8¼ in. (72 × 50.1 × 20.9 cm)
Gift of Margaret J. and George V. Charleton, 1973.81

Gandharan Buddhist art was made in Afghani-
stan, Pakistan, and northern India between the
second and fourth centuries A.D. It was strongly
influenced by Greco-Roman art, partly through
the influence of Alexander the Great's follow-
ers in this area and partly through later trade
contacts with the Roman Empire. Thus the
bodies of Buddhist holy figures have a Mediter-
ranean plasticity and tactile modeling. Even
their clothes are similar to Greek and Roman
costumes, but their sculptural effect is one of
inwardness and otherworldliness, in keeping
with Buddhist doctrine. This Buddha head looks
very Greek in its pure oval forms, but the closed
eyes suggest meditation and enlightenment.
The elongated earlobes, stretched by wearing
heavy jewelry, express Prince Siddhartha
Gautama's royal rank.

 Bodhisattvas are beings who renounced
the attainment of pure enlightenment to help
struggling mankind. Their princely status in
the mundane world is expressed by their jewels
and rich garb. Of particular interest is this fig-
ure's arm ornament, which has a classical Atlas
figure. Such cross-cultural contacts between the
Mediterranean and India occurred throughout
antiquity. AB

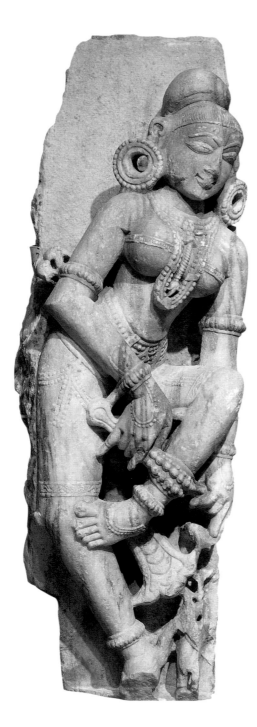

Dancer
Indian, Rajasthan, Mount Abu, 10th–12th century
Marble
42½ × 14 × 9½ in. (107.8 × 35.5 × 24.1 cm)
Gift of the Alvin and Lucy Owsley Foundation,
1973.98

Though most of the works in the museum's
South Asian collection are Hindu or Buddhist,
this sculpture may be Jain. It is said to come
from the Mount Abu area in Rajasthan, a center
of Jain worship. In appearance the figure could
belong to any of the three great religions of
India—Hinduism, Buddhism, or Jainism, which
all represent inspired dancers as part of their
iconography. Such entertainers are the descen-
dants of earlier fertility deities like *yakshis* and
are represented in a lush, voluptuous manner.
The dancer's serpentine curves suggest the
rhythms of her performance. She is shown fas-
tening on the heavily jeweled ankle bracelet
with its tiny bells, whose tinkling also forms
part of her temple dance. AB

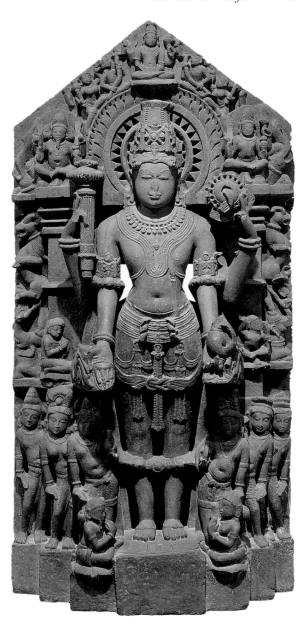

Vishnu and attendants

Indian, Gujarat, 1026
Sandstone
54 × 11 × 27 in. (137.2 × 27.9 × 68.6 cm)
Gift of Mrs. John Leddy Jones, 1963.29

By the medieval period, the two leading deities of Hinduism were Vishnu, the Preserver of the older Hindu trinity, and Shiva, the Destroyer. In keeping with his role as a bringer of blessings and prosperity to his followers, Vishnu was usually shown as a calm, upright figure surrounded by his heavenly court. This is a classic relief of the god, who appears handsome, vital, and beneficent. Like earlier Buddhist sculptures he is richly jeweled, as a king would be. In three hands he holds the traditional attributes of mace, conch shell, and sun wheel, or *chakra*. The fourth hand is extended, offering prosperity. The deep carving of the sandstone relief would have given the sculpture a strong play of light and shadow in its original setting as an architectural decoration. The attendant figures and animals form the setting of Vishnu's divine kingdom. AB

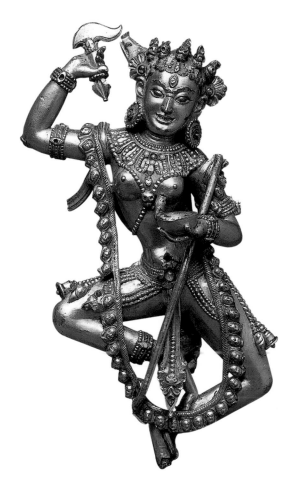

Dakini vajravarahi

Tibetan, c. 1600
Gilt bronze and gemstones
15 × 4½ × 4⅜ in. (38.1 × 11.4 × 11.1 cm)
Foundation for the Arts Collection, gift of the
Virginia C. and Floyd C. Ramsey Fund of Communities Foundation of Texas, Inc., 1982.9.FA

A *dakini* is a Buddhist female deity who reveals
the violent aspects of existence to her priestly
worshipers and who is also an intermediary between the Buddhist heavens and mankind. In the
Tantric Buddhist beliefs of the Himalayas, she
is a demonic force, as evidenced by the necklace
of skulls she wears and the cup of blood and the
executioner's ax that she carries. Yet she also
averts evil and brings wisdom. Like the Hindu
mother goddesses Durga and Parvati, whom she
resembles, she is an embodiment of the cycle of
life, death, and rebirth. Her dancing pose recalls
Hindu dancer figures, though in Buddhist belief
it also implies her ability to fly between realms
of the universe. The striking gilt bronze figure
radiates primordial energy. AB

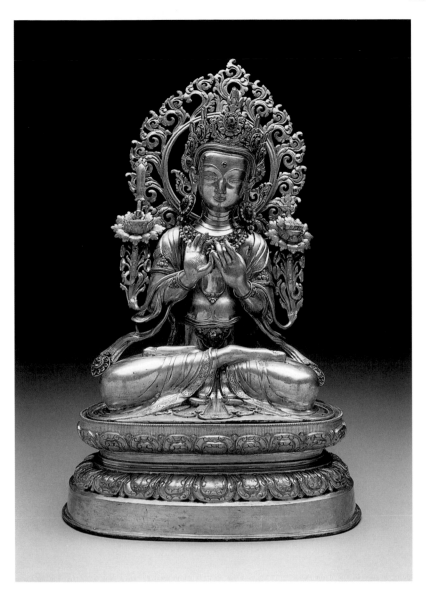

Manjusri

Nepali, 18th century
Gilt bronze and gemstones
22⅞ × 15 × 13 in. (58.1 × 38.1 × 33 cm)
Bequest of Mrs. E. R. Brown, 1955.19

Manjusri is the bodhisattva of divine wisdom. In Nepal, he is considered
to be the founder of Buddhist culture in Kathmandu. He carries traditional
emblems: the Buddhist scriptures on a lotus flower, and the sword that
cuts ignorance. His left hand is raised in a gesture of teaching. He is always
shown as a youthful crowned prince. This gem-encrusted, gilded statue
would have been created to inspire meditation among the monks in a
Buddhist monastery. Its sweet and placid character embodies peaceful
consolation. AB

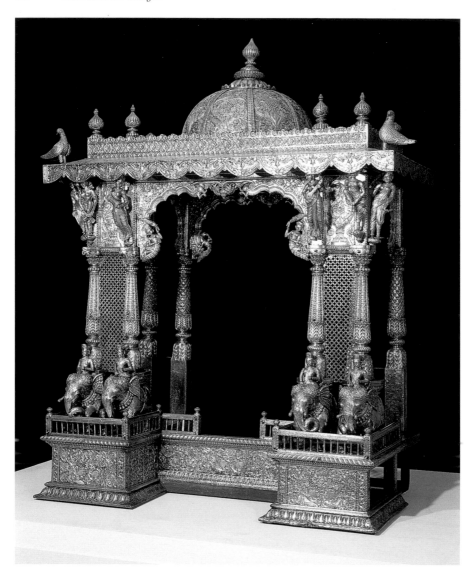

Shrine

West Indian, Gujarat, late 18th–19th century
Wood and silver
90 × 69 × 32 in. (228.6 × 175.2 × 81.3 cm)
Gift of David T. Owsley through the Alvin and
Lucy Owsley Foundation, 1995.77.a–gg

This complex silver-over-wood shrine may
have been made for a merchant patron, as an
inscription on the piece details how much each
part of the templelike structure cost. Such
shrines were used as private chapels and also
as smaller offertory structures within a large
temple. The style of the piece is Indo-Mughal,
with a striking dome and a facade lined with
courtiers on elephants. Birds and divine enter-
tainers *(gandharvas)* ornament the parapet. The
bold forms and delicate silver details give the
museum-goer a good sense of the majesty of
Islamic-period architecture, with its mixture of
Hindu sculptural form and the majestic simplic-
ity of Muslim art. Thin chased sheet silver has
been carefully modeled over the carved wooden
forms of the shrine, giving it an airy lightness.
The idea of conceiving a decorative object as a
work of sculpture and architecture was applied
by artists of the period to a variety of types,
including thrones, palanquins, and howdahs.

AB

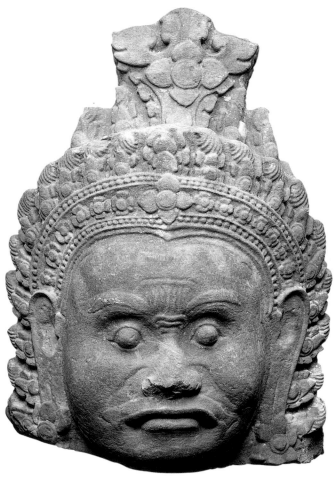

Figure of a dvarapala

Kampuchean (Cambodian), Angkor,
Bayon period, late 12th–early 13th century
Sandstone
32¼ × 22 × 15 in. (81.9 × 55.8 × 38.1 cm)
Gift of the Alvin and Lucy Owsley Foundation
through the David T. Owsley Fund in honor of
Mrs. Eugene McDermott, 1994.256

Between 1100 and 1400 A.D., the artists and builders of the great temples
and sculptures created for Khmer rulers at Angkor produced many master-
pieces of religious art. In them Hindu and Buddhist religious images were
blended in a unique Kampuchean style. This outsize head resembles the
great line of demon *(asura)* figures lining the bridge at Angkor that leads
to Angkor Thom and the Bayon temple. In that sculptural complex, the
demons balance a line of gods *(devas)* on the opposite parapet. These two
forces are engaged in a struggle over the elixir of immortality, in a myth
relating to the Hindu god Vishnu, a patron deity of the Khmer kings.
Dvarapalas are beneficent protective spirits and gate guardians whose fero-
cious appearance drives off evil. The dramatic power of this head reflects a
later period of Khmer art at Angkor than the classically calm figures of
Angkor-period art. AB

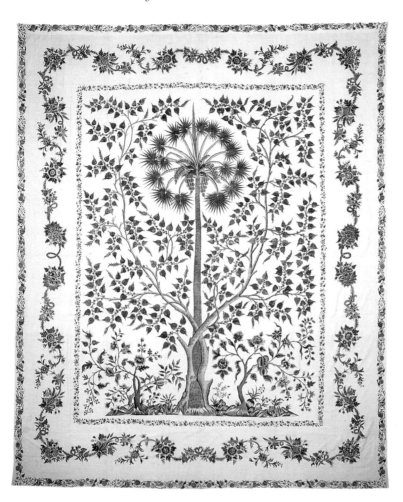

Palampore

Indian, c. 1750
Cotton
128 × 104 in. (525.1 × 264.2 cm)
Gift of Mrs. Addison L. Gardner Jr. in memory
of Richard W. and Anna L. Sears and of Mr. and
Mrs. Alfred L. Bromberg in memory of Mr. and
Mrs. I. G. Bromberg by exchange, 1992.9

The word *palampore* is derived from the Persian
and Hindi *palangposh*, or bedcover. Typically one
is composed of a single chintz panel hemmed
around the edges. This example, featuring a
central palm tree rather than the more usual
tree of life motif, is an exception both in design
and quality. Producing chintz fabrics by tradi-
tional methods requires many steps in dyeing
and printing. Although these techniques had
been well established for many years in India,
it was in the seventeenth century that chintz,

either painted or printed on cotton, began to be
exported to many other parts of the world as
trade goods. *Palampores* are first mentioned in
the records of the English East India Company
in 1614 and were first recorded in colonial
American inventories soon after 1700.

Because cotton was considered a luxury
fabric and because Indian *palampores* were so
widely exported, these bedcovers influenced
many other textile traditions. In the eighteenth
century English textile manufacturers adapted
their design to machine-printed fabrics and pro-
duced a virtual craze for chintz among Anglo-
American consumers. Some handmade textiles
were also influenced by *palampores*. A bed rug
in the museum's collection (p. 221), for example,
derives its scrolled floral borders and central
tree of life motif from this source. CV

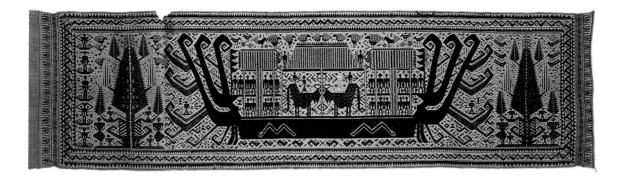

Ceremonial hanging (palepai)

Indonesia, southern Sumatra, Lampung province, c. 1900

Cotton and metal-wrapped cotton yarns

24¼ × 95¾ in. (61.6 × 243.2 cm)

The Steven G. Alpert Collection of Indonesian Textiles, gift of The Eugene McDermott Foundation, 1983.79

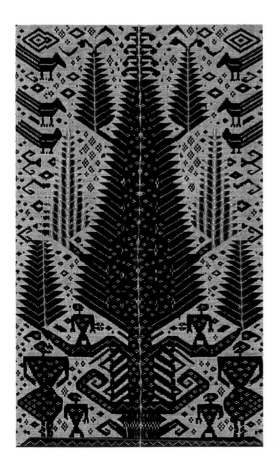

The islands of Indonesia form the heartland of the Pacific culture area called Island Southeast Asia. A location at the crossroads of ancient trade routes and natural resources greatly desired in the West—spices, resins, and tropical hardwoods—brought contact through commercial traders with foreign goods and metalworking and weaving technologies. The distinguished weaving traditions that developed in the Indonesian islands produced clothing for everyday and ceremonial use and a rich variety of textiles that functioned symbolically in ritual contexts. The lavishly embroidered skirts and dramatically patterned ceremonial cloths of the Lampung region represent one of Indonesia's most appealing textile styles.

The *palepai*, a ceremonial hanging, is a long, horizontal cloth whose principal motifs are a ship with scrolled prows, animals bearing riders, and trees. Ships are symbols of transition, of auspicious passage for the vulnerable human spirit during moments of crisis. The trees probably represent the tree of life, although the elegant triangular shape may also allude to the pyramidal cosmic mountain. Use of the *palepai* was restricted to titled members of Lampung aristocracy, who had the right to hang the textile during rituals that commemorated major life events—as a backdrop for the bride during a wedding ceremony, for the presentation of a child to the maternal grandparents at a naming ceremony, and for a funeral. On occasions when several *palepai* were hung together, the placement of a particular textile reflected its owner's rank and relationship to other members of the social group. CR

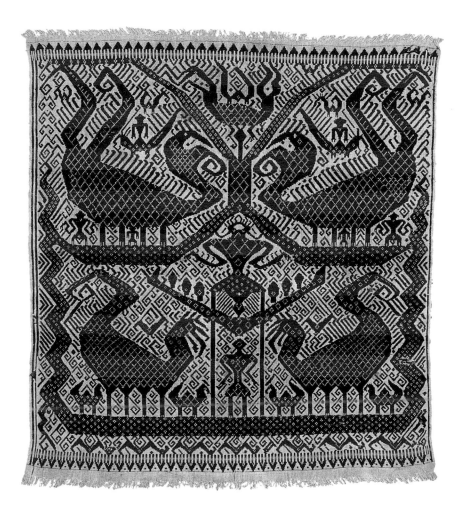

Ceremonial cloth (tampan darat)

Indonesia, southern Sumatra, Lampung province,
late 19th century
Cotton
30 × 27¼ in. (76.2 × 69.2 cm)
The Steven G. Alpert Collection of Indonesian
Textiles, gift of The Eugene McDermott Foundation,
1990.201

Square textiles of the type called *tampan* were
used in all ranks of Lampung society, and their
presence always indicated a ceremonial occasion.
Tampan wrapped the gifts of food and mats that
were exchanged during marriage negotiations,
provided a seat for the bride during the marriage
ceremony, encircled the ridge pole to consecrate
a house, and bound the handles of the funeral
bier.

This example represents the *darat* or inland
style, which is characterized by bold, silhouetted
forms whose identities are often obscure. Here,
the complex composition is framed by a simple
ship that extends across the lower edge of the
cloth, its prows zigzagging vertically along the
sides. Four birdlike creatures, each with four
legs, flank a frontal humanlike figure who stands
in a diamond-shaped enclosure at the center of
the textile. The surrounding space, which har-
bors smaller figures, some riding animals, is
enlivened by angular scrolls and by diagonal
lines that seem to emanate from the edges of the
birdlike forms. CR

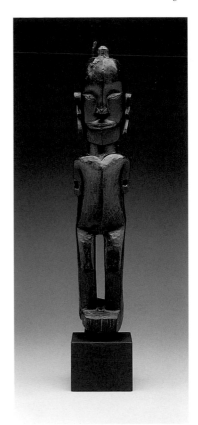

Male ancestor figure

Indonesia, North Sumatra, Lake Toba region,
Toba Batak people, 19th century or earlier
Wood
21 × 4⅝ × 4½ in. (53.3 × 11.8 × 11.4 cm)
The Eugene and Margaret McDermott Art Fund,
Inc., 1995.33.McD

Lake Toba in the highlands of North Sumatra is
the mythical home of six ethnic groups known
as the Batak, of which the Toba are the most
numerous. Toba villages are distinguished by
three-level houses with boat-shaped roofs and
facade ornaments that depict the composite
mythical animal called *singa*. Textiles—which
once derived a severe elegance from a restricted
palette of dark blue, maroon red, and white—are
essential elements of Batak social and religious
life. Sculpture includes a variety of representa-
tions of the human figure; most are associated
with an ancestral presence and the potential to
protect or inflict harm. One of these occurs in
male and female pairs, which are said to repre-
sent the ancestral couple *(debata idup)*. The two
figures were often bound together with a third
sculpture, as this one was bound originally. They
formed a trinity that was preserved in the upper
level of the house of the lineage founder. Only a
privileged few could see or touch them.

In characteristic Batak style, this figure stands
erect, his abstract body depicted frontally. The
legs are slightly flexed, the feet square, with
incised lines suggesting toes. The holes at the
elbow area of each arm probably once supported
forearms with large hands. It is likely that the
figure wore a cloth around the hips and a tur-
banlike headdress. As with other examples, the
head was the sculptor's primary focus. Seen
from the front, the watchful eyes and wide
mouth suggest benevolence, while the angular-
ity of the profile evokes an inherent dark side.

CR

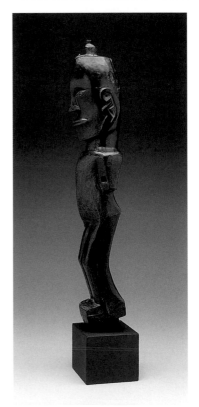

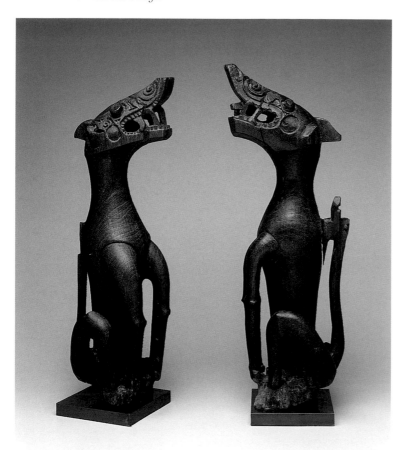

Pair of mythical animals (aso)

Malaysia, Sarawak, middle Rajang River region,
Kayan or Kenyah people, 19th century
Wood
Each: 30½ × 8 × 10 in. (77.5 × 20.3 × 25.4 cm)
The Roberta Coke Camp Fund and the Museum
League Purchase Fund, 1995.34.1–2

Art styles are continuous across modern politi-
cal boundaries on Borneo, an island shared by
Indonesia's Kalimantan provinces, Malaysia's
Sarawak and Sabah, and the Sultanate of Brunei.
Numerous ethnic groups collectively called
Dayak live in the island's heavily forested
interior. The textiles of the Iban people, the
beadwork of the Maloh, and the sculpture in
wood and metal of the Modang, Kayan, and
Kenyah exemplify the aesthetic diversity of
this style area.

A prominent and widespread theme of Dayak
art is a mythical animal that combines attributes
of the dog and serpent or dragon in a single
creature called *aso.* This animal signifies protec-
tion and status, and use of the image is tradi-
tionally restricted to the upper class. Although
these mythical animals are clearly doglike—they
sit upright, and long, upturned tails emphasize
their vigilance—the graceful curves and sleek
surface of their bodies are rather serpentine, and
dragonlike spirals surround their open mouths.

The animals' notched tails suggest that the
objects functioned as supports for another ele-
ment, perhaps flat and horizontal. The dogs, two
of an original group of four sculptures, would
have faced outward at the corners, their tails
supporting the horizontal member with pegs or
dowels. Although tables are not associated with
longhouse culture (meals were traditionally
served on rattan mats on the floor), low tablelike
forms might have been used to display treasured
heirlooms such as Asian ceramic jars, metal
gongs, swords, and kettles. CR

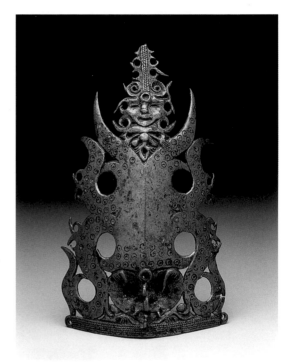

Warrior's headdress element with frontal figure

Indonesia, East Kalimantan, upper Mahakam
River region, Modang or Bahau people(?),
18th–19th century
Brass
6½ × 3⅞ × ⅞ in. (16.5 × 9.9 × 2.2 cm)
The Roberta Coke Camp Fund, 1994.248

Metal ornaments, or frontlets, of this type were
attached to a warrior's helmetlike basketry head-
dress and were worn centered above his fore-
head. At once emblems of rank and protective
charms, these objects were generally made of
brass (cast by the lost-wax process), and they
seem always to depict a stylized frontal figure.
This example is unusual for its iconographic
complexity. A heart-shaped face, perhaps a leg-
acy from the Bronze Age Dongson culture that
flourished in Vietnam from about 600 B.C. to
A.D. 100, dominates the lower portion of the or-
nament. Delicate hands grasp the upper edges
of this face, which seems to belong to a writhing
beast whose body is depicted by S-shaped spi-
rals (another Dongson motif) along the outer
edges. The profusion of spirals and curves
forms a triangle with a human figure at its apex.
The triumphant expression on the human face
of this figure suggests martial prowess or the
apprehension of power from a totemic animal,
perhaps embodied by the heart-shaped face
below. CR

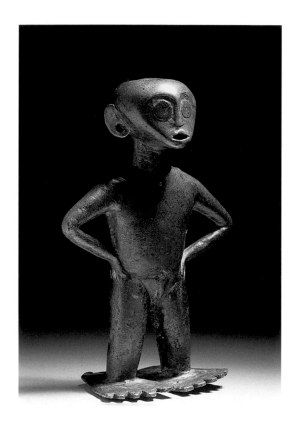

Standing female figure

Indonesia, Central Sulawesi, 14th–15th century(?)
Copper alloy
4⅜ × 2¾ × 1⅝ in. (11.1 × 7 × 4.1 cm)
The Roberta Coke Camp Fund, 1994.253

The best-known metal objects from Sulawesi (Celebes), the large island east of Borneo, are brass pendants *(tanjanja)*, serpent-form head-dress ornaments *(sanggori)*, and small figures of humans and water buffalo, all from the province of Central Sulawesi. The solid brass figures, which were made in male and female pairs, seem to have functioned variously as gifts in marriage negotiations, amulets to ward off misfortune, and fertility charms for a newly married couple. They are often thought to date from the nine-teenth century, for the technology of lost-wax casting was reportedly disappearing in that area around 1900.

This figure, which is hollow and cast from a primarily copper alloy, represents an earlier tradition that has not yet been identified. The figure's arms-akimbo pose conveys a timeless self-confidence, while her large flat feet are eminently functional, enabling her to stand alone. The heart-shaped face and circular eyes recall the faces on Dongson-style bronze axes found on the island of Roti in eastern Indonesia. Designs associated with that style, named for the site in the Tonkin region of Vietnam, where the Dongson culture (c. 600 B.C.–A.D. 100) was first identified, are found on artworks through-out Island Southeast Asia, often on heirloom objects and textiles that embody the traditional animist beliefs of regional cultures. CR

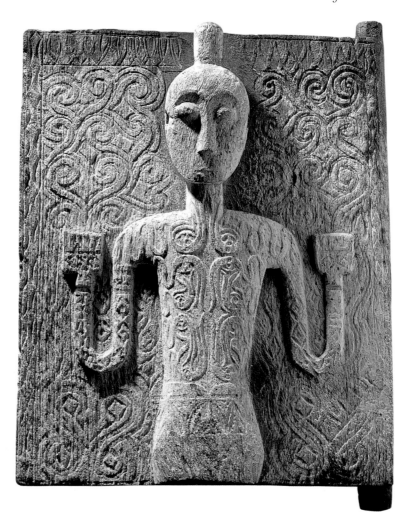

Door with human figure

Indonesia, South Sulawesi, Sa'dan Toraja people,
18th or 19th century
Wood
21¾ × 16½ × 4½ in. (55.2 × 41.9 × 11.5 cm)
Gift of The Eugene McDermott Foundation,
1991.362

In the mountainous central region of the island
of Sulawesi live the agricultural peoples who
have been collectively called Toraja, "men of the
mountains," or "men dwelling in the interior."
In the high valleys, the Sa'dan Toraja grow rice,
their primary staple and a plant of great reli-
gious significance; they also raise water buffalo
and pigs, which they sacrifice on ceremonial
occasions. They build striking noble houses
with boat-shaped roofs and carved and painted
facades—the *tongkonan* that represents the cos-
mos in miniature and is the focus of ritual life.

And in keeping with their traditional belief sys-
tem—*aluk to dolo,* "the ways of the ancestors"—
they honor their dead with spectacular funerals.

Since the seventeenth century, the Sa'dan
Toraja people have buried their elite dead in
vaults chiseled in the face of steep limestone
cliffs—"the house from which no smoke rises."
Hardwood doors carved with an image of the
head of the prestigious water buffalo or, less
frequently, a human figure, seal the tombs and
protect their contents. On this example, a serene
yet powerful figure emerges from a field of inter-
locking scrolls. Elaborate tattoos cover the torso
and stylized arms. Once the mark of the most
successful Toraja warrior, these tattoos and
the knot of hair atop the head suggest warrior
status for the figure and for the occupant of
the tomb. CR

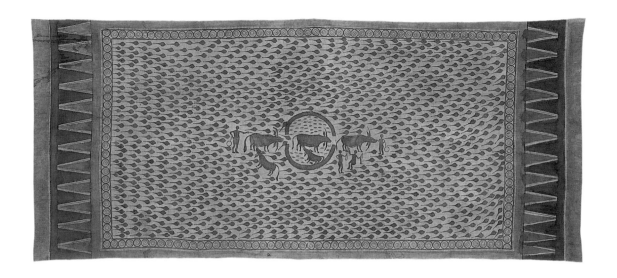

Sacred textile (mawa') *depicting tadpoles and water buffalo*

Indonesia, South Sulawesi, Ma'kale area, Sa'dan
Toraja, early 20th century
Cotton
35 × 80¼ in. (88.9 × 203.8 cm)
The Steven G. Alpert Collection of Indonesian
Textiles, gift of The Eugene McDermott Foundation,
1983.116

The word *mawa'* (or *maa'*) designates a large, rectangular textile that the Sa'dan Toraja consider sacred. Whether imported patterned cloth from India or the stamped and painted type once made locally, *mawa'* were thought to have extraordinary powers and were often given personal names. They were stored in baskets or wooden chests in the southwestern part of the traditional house, an area associated with the ancestors. *Mawa'* were worn by the primary participants in feasts of purification and thanksgiving. They also adorned altars, defined the space for ritual, and enshrouded the dead.

The indigenous stamped and painted *mawa'* embody the intimate relationship between the Sa'dan Toraja people and their environment. On this example, myriad tadpoles swim from left to right across the surface, which probably depicts a rice field, while five water buffalo, the most prestigious Toraja animal, move through a split circular enclosure at the center. Although the area seems to function as a corral, it may also allude to the circular fish pond at the center of Toraja rice fields. Outside the enclosure, a buffalo offers her milk to human figures holding bamboo containers. Field research by scholar Eric Crystal has revealed that the water buffalo is vulnerable to the bite of a venomous snake that frequents rice fields. Tadpoles are often described as good-luck charms for the treasured animals, for in rice fields abounding with tadpoles, the snakes gorge themselves on the aquatic creatures, allowing the water buffalo to pass undisturbed. CR

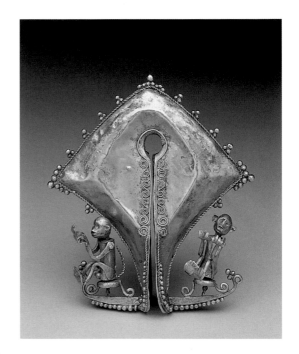

Ear ornament or pendant (mamuli)
Indonesia, Lesser Sunda Islands, East Sumba,
Pau, early 20th century
Gold
3¾ × 3¼ × ⅞ in. (9.6 × 8.3 × 2.1 cm)
Gift of Sarah Dorsey Hudson, 1991.370

On the small island of Sumba, in the Lesser
Sunda chain (Nusa Tenggara) that extends
eastward from Bali, the quintessential ritual
is the elaborately structured transfer of valu-
ables that accompanies weddings, funerals, and
feasts, and that also marks the transfer of land
or property. On these occasions, heirloom tex-
tiles and jewelry are displayed, ancestral spirits
are addressed, and sacrifices are offered to se-
cure the blessings of the ancestors. Textiles and
metalwork, especially gold ornaments, are in-
dispensable components in the exchange, metal
being the male element in this complementary
male-female system, and textiles the female
counterpart.

In the *mamuli*, the classic simplicity of a basic
cleft-diamond shape, which resembles the Greek
letter omega, is complemented by clusters of
tiny balls or by lively figures such as the mon-
keys depicted here. Formerly worn as an ear
ornament but now used most often as a pendant,
the *mamuli* exemplifies the multilayered signifi-
cance attributed to certain metal objects in
Indonesia. Depending on the type, *mamuli* are
considered prestige items used for dancing and
other rituals, sacred altar objects that aid priests
in contacting ancestral spirits *(marapu)*, or sacred
heirlooms that are rarely removed from their
special storage containers. CR

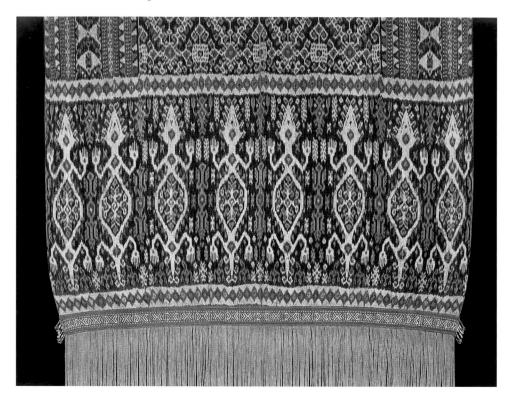

Man's shoulder or hip cloth (hinggi) (detail)
Indonesia, Lesser Sunda Islands, East Sumba,
Kanatang, late 19th century
Cotton
104 × 43¾ in. (264.2 × 111.1 cm)
The Steven G. Alpert Collection of Indonesian Textiles,
gift of The Eugene McDermott Foundation, 1983.91

In East Sumba's gender-associated system of gift exchange, metal weapons
and jewelry are considered male and textiles female. When a gift includes
more than one textile, the complementary requirement is fulfilled by pair-
ing the *hinggi*, the man's hip cloth or mantle, with the *lau*, the woman's
tubular skirt or sarong. These two textiles—untailored garments made by
seaming together rectangular cloths woven on a simple body-tension loom
—are the standard forms of dress on Sumba, as they are (with different
names) on many other islands.

 Hinggi are woven and worn in pairs, one wrapped around the hips and
the other draped across a shoulder. The primary means of patterning these
textiles is the tedious process called ikat, which involves tying and dyeing
the lengthwise (warp) yarns before weaving begins. Older examples such
as this one are characterized by a broad center field with wide flanking
borders. The schematic floral design of the center field was inspired by silk
textiles woven in Gujarat, India, whose double-ikat patterns required the
tying and dyeing of both the warp and the weft yarns. Called *patola*, these
cloths were traded throughout Indonesia, where they were treasured as
sacred heirlooms. CR

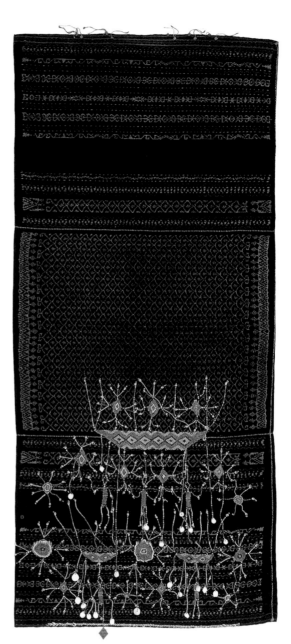

Ceremonial skirt (lawo butu)

Indonesia, Lesser Sunda Islands, central Flores,
Ngada regency, Ngadha people, 19th century
Cotton, glass beads, shell, and metal
68½ × 31¼ in. (174 × 79.4 cm)
The Steven G. Alpert Collection of Indonesian
Textiles, gift of The Eugene McDermott Foundation,
1990.205

The sarong, or tubular skirt, is the standard
garment for men and women on the mountain-
ous island of Flores, in eastern Indonesia. Men
tend to wear shorter and wider sarongs, usually
rolled tightly at the waist as a lower body gar-
ment. They also drape the sarong diagonally
on the torso, over one shoulder and under the
other arm, atop a commercial shirt and pants.
Women wear longer and narrower sarongs,
often with commercial blouses. In keeping with
personal preference or local tradition, women
secure this versatile garment by rolling it under
the arms or at the waist, supporting it over one
shoulder, or, among the Ngadha, tying it at the
shoulders by attached cotton cords.

Glass beads form the skeletal human figures,
spidery creatures, and ships that glisten in low
relief against the indigo ground of Ngadha cere-
monial skirts. Although the type is no longer
made, and explanations of the designs are mostly
speculative, glass beads are widely associated
with fertility, prosperity, and abundance, and
they are often considered heirlooms. Women of
high social status wove the ikat-patterned cotton
cloth and wore the beaded skirts, but only on the
most important ceremonial occasions. The ritu-
als that accompany birth, marriage, house build-
ing, and death are occasions for such elaborate
dress, as are ceremonies for planting and har-
vesting in the agricultural cycle. CR

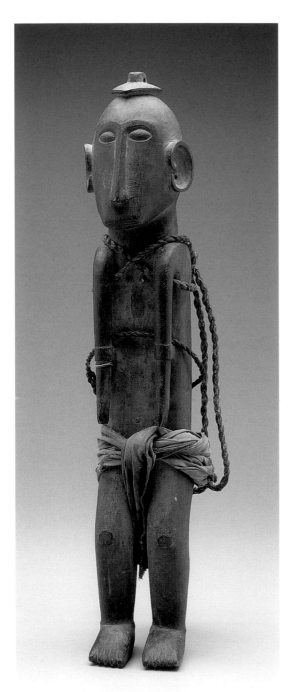

Ancestor figure
Indonesia, Lesser Sunda Islands,
Atauro, early 20th century
Wood, fiber, and cloth
19½ × 3¾ × 3¾ in. (49.5 × 9.6 × 9.6 cm)
The Art Museum League Fund, 1981.15

Figures of family ancestors are the best known
sculpture from Atauro, a tiny island north of
Timor. Carved in pairs, one male and one female,
the figures are called *itara* after the cords that
encircle them. *Itara* are hung from the sacred
hook *(ruma-tara)* in each house, and the status
of the house is determined by the number of
figures it contains. If something is stolen, the
itara are given offerings of corn, fish, and betel
and are placed on the threshold in the hope that
they will find the thief. The distinctive posture
of these figures suggests detachment, that of a
trance or deep sleep—the eyes appear closed;
the arms hang straight; the legs seem not to
support any weight. This figure, which embod-
ies relaxation without sacrificing volume and
gesture, is a particularly distinguished example
of the type. CR

Mask

Indonesia, Lesser Sunda Islands, West Timor,
Atoni people(?), 19th century or earlier
Wood, shells, and lime
9¼ × 6¾ × 2¾ in. (23.5 × 17.2 × 7 cm)
The Roberta Coke Camp Fund, 1994.254

When the Portuguese reached Timor around
1500, attracted by its stands of sandalwood, they
found dozens of independent warring chiefdoms.
On the western half of the island, these included
the Atoni, the indigenous inhabitants, and the
Tetum (or Belu) peoples who had invaded Timor
in the preceding century. The two groups have
produced Timor's most distinguished sculpture
and textiles.

The age and function of masks from Timor
are now uncertain. The characteristic patina,
which often includes an accumulation of soot,
suggests they were stored for many years in
the lofts of traditional houses, probably as
power-laden family heirlooms. One example was
reportedly worn in ceremonies that followed a
military victory. Animal skin and hair often
frame these masks, and the tiny nails protruding
from the perimeter of this one may have origi-
nally secured a beard or similar attachments.
Although the eyes are usually hollow, the eyes of
this mask are inset with two shells that differ in
color. The contrast creates a disturbing asym-
metry that heightens the intensity of its primal
stare. CR

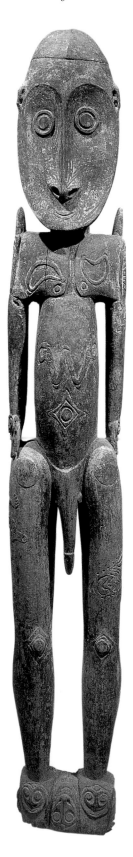

Male ancestor figure named Malabi
Oceania, Melanesia, Papua New Guinea, Middle
Sepik River region, Yamok village, Sawos people,
c. 1890–1910
Wood and paint
89½ × 13¼ × 9 in. (227.3 × 33.7 × 22.9 cm)
The Eugene and Margaret McDermott Art Fund,
Inc., 1974.5.McD

Within the culture area of Oceania, Melanesia
encompasses the huge island of New Guinea
in the western Pacific Ocean and smaller islands
to the east. On New Guinea, the middle reaches
of the long Sepik River form a hot, humid area
of marshy grassland and sago swamps. Research
by Marian Pfeiffer and Barry Craig traced this
larger-than-life sculpture to the Yamok area,
north of the Sepik River, where it was reportedly
carved in an effort to make the swampy land firm
for the founding of a village. The monumental
sculpture, which represented a named male an-
cestor, was kept in the interior space of a men's
ceremonial house, where it was probably lashed
to the supporting architectural posts.

Malabi stands tall and erect, seemingly on
tiptoe. His large oval face shows remnants of
curvilinear painting, probably a reference to
headhunting, and the spikes on his shoulders
may once have supported skulls taken in head-
hunting raids. Several motifs suggest the ritual
scarification that was part of a young man's
initiation into the secret and exclusively male
world of the ceremonial house. Crescents appear
on the breast area and a serpentine form on the
torso. Concentric diamonds surround the navel,
and parallel zigzag elements appear on his back
and left thigh. The crocodile on Malabi's right
thigh may signify a clan totem, while the mask-
like faces on his hands and feet represent bush
or tree spirits *(winjembu)* associated with the
hunting of wild pigs, which the Sawos consid-
ered a legitimate substitute for a human victim.

CR

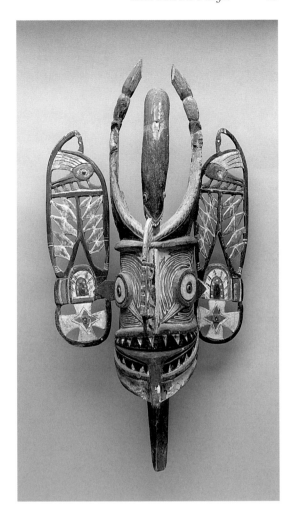

Head for a malagan figure
Oceania, Melanesia, northern New Ireland,
early 20th century
Wood, paint, and sea snail opercula
38½ × 18¼ × 12¼ in. (97.8 × 46.4 × 31.1 cm)
The Roberta Coke Camp Fund, 1975.13

On northern New Ireland, an island east of New Guinea in the Bismarck Archipelago, rites for the dead consist of a funeral accompanied by a period of mourning (the nature of which varies according to local tradition) and the subsequent memorial festival called *malagan* (or *malanggan*). Depending on the family's financial resources, the *malagan* may occur several months or even several years after death, for the sponsors must be able to provide large amounts of food for the many guests. They must also arrange for the carving of the figures, horizontal friezes, vertical poles, and masks whose ritual display is central to the festival. Although the function of the *malagan* is primarily religious, to commemorate the deceased and to aid the soul in moving from the world of the living to that of the dead, it is also crucial to the social, economic, and artistic life of the community.

Malagan sculpture is notable for its openwork carving, projecting forms, and lively painting. Ambiguous images of fish, snakes, and birds often converge in these objects, perhaps with mythic references. The convex valve of a sea snail forms distinctive eyes for many of these creatures. Heads such as this were the major sculptural components of large seated figures assembled from vines and other plant materials for the *malagan*. Although most *malagan* objects were ephemeral, traditionally discarded at the end of the festivities and allowed to disintegrate, heads of this type and certain kinds of masks were kept for reuse in subsequent ceremonies.

CR

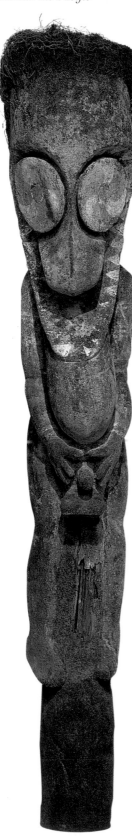

Standing male figure

Oceania, Melanesia, Vanuatu, Ambrym island,
c. 1945–55
Tree fern and pigment
140 × 24 × 26 in. (355.6 × 61 × 66.1 cm)
Anonymous gift, 1996.33

The republic of Vanuatu (formerly New Hebrides) is a chain of some seventy islands that extends for about 500 miles in the southwestern Pacific Ocean, southeast of New Guinea and northeast of mainland Australia. Vanuatu's most significant art styles developed on the larger islands of Ambrym and Malekula and on the outlying Banks Islands, essentially in conjunction with the exclusively male secret societies *(sukwe)* that regulated almost all social life. At considerable personal expense, members progressed through a series of graded initiations and thereby enhanced their status within the community, ensuring their rank and well-being after death. Each initiation required the sacrifice of pigs and the carving of commemorative sculpture. This figure originally stood before a men's ceremonial house, its body encased (and shielded) by vines, its head obscured by a large fern.

Like much of the sculpture of this area, the figure is carved from the lower part of a tree-fern stem (inverted in the finished piece), which consists of a wood core surrounded by an interlocking mass of fibers. Easily carved soon after cutting, the tree fern hardens with age to become a very durable material. The porous surface does not permit refined sculptural detail and dictates the bold forms. Although the sculptures were often coated with a paste and painted, the paint rarely survives intact. The monumental scale, expressive vigor, and overt sexuality of this figure are characteristic of sculpture from Vanuatu and from Melanesia as a whole. CR

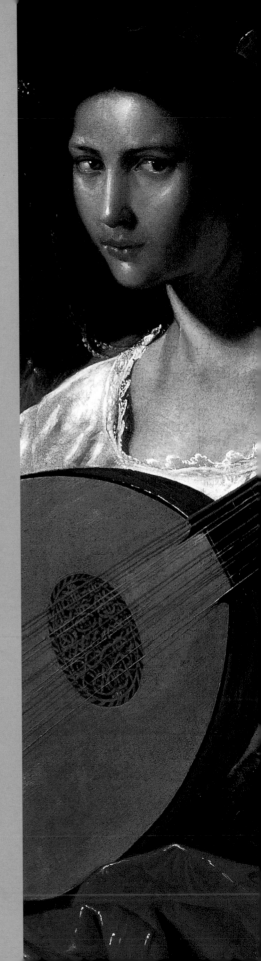

Europe

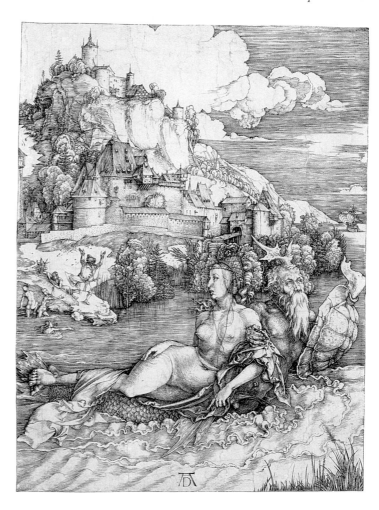

ALBRECHT DÜRER
(German, 1471–1528)

The Sea Monster, c. 1498
Engraving on paper
9⅞ × 7⅜ in. (25.1 × 18.7 cm)
Bequest of Calvin J. Holmes, 1971.80

One of the most significant artists of the North-ern Renaissance, Albrecht Dürer achieved suc-cess as a painter, printmaker, and theorist. In the fifteenth century, reproducible woodcuts and en-gravings were accessible to a fairly wide audi-ence, and Dürer's fame was first established in this medium.

 The Sea Monster is a striking example of the artist's early mastery of engraving. Its remark-able detail, with the elaborate Nuremberg castle and meticulously rendered foliage, illustrates Dürer's deft handling of the burin, an engraver's tool which cuts the design into the metal plate.

Dürer created plasticity in the maiden's body by delicately shading her rounded contours with linear hatches and crosshatching. Ornamental linear patterns enhance the pictorial drama. The rigorous rhythm of rippling lines in the water, for instance, emphasizes the movement of the Triton-like monster, who abducts the maiden from the company of her bathing companions.

 Dürer was deeply fascinated with the nude and human anatomy, an interest in part derived from his knowledge of Italian humanist scholars who had extolled man as God's most perfect creation. Dürer absorbed these ideas during visits in 1494 and 1505 to Italy, where he copied the precise, geometrically conceived paintings of Andrea Mantegna. Created after Dürer re-turned from Italy, *The Sea Monster* may reveal Mantegna's influence in the well-defined vol-umes of the maiden and her abductor. SRH

ALBRECHT ALTDORFER
(German, c. 1480–1538)

Christ among the Doctors, c. 1515
Woodcut on paper
3½ × 2½ in. (8.9 × 6.4 cm)
Gift of the Dallas Print Society, 1937.4

Albrecht Altdorfer painted some of the first
pure landscapes in the art of northern Europe.
As an illuminator, draftsman, printmaker,
painter, and architect, he was one of the lead-
ing artists of his native Regensburg. His fame
derives from a period of concentrated activity
between 1506 and 1522, during which time he
created his powerfully imaginative landscapes
and received some of his most important reli-
gious commissions.

 Christ among the Doctors illustrates Altdorfer's
detailed treatment of religious themes. Within
an extraordinarily diminutive format, Altdorfer
depicted the complex biblical narrative in
which the twelve-year-old Jesus learns from
the elders in the temple at Jerusalem. In the
gospel according to Luke, Jesus had accompa-
nied his parents to the city for Passover. Mary
and Joseph left for home, not realizing their
son had remained in the city. They returned and
searched for him for three days before finding
him in the temple. Altdorfer placed Jesus at the
center of the composition, seated on the ground
and pointing to a page in a book held by an
elder. The teachers at the left, listening intently,
seem perplexed by the young boy's knowledge,
while the robed figures behind Jesus clasp their
hands in prayer. Altdorfer's precise depiction of
the temple's vaulted ceilings and Gothic pillars
adds great depth and realism to the scene, and
his hatches and crosshatches intensify its three-
dimensionality by contrasting light with dark
and by creating form-defining contours. Widely
distributed throughout the fifteenth and six-
teenth centuries, prints such as *Christ among
the Doctors* were instrumental as educational
devices. SRH

GIULIO CESARE PROCACCINI
(Italian, 1574–1625)

Ecce Homo, c. 1615–18
Oil on canvas
92⅝ × 65⅝ in. (235.3 × 166.1 cm)
Gift of Mr. and Mrs. Algur H. Meadows and the
Meadows Foundation, Incorporated, 1969.16

Procaccini's *Ecce Homo* is a grandiose depiction
of the flagellated Christ presented to the masses
by Pontius Pilate, whose visage, at the upper left,
is a study of disdainful indifference. The wildly
dramatic gestures and faces of the other figures
contrast starkly with the suffering Christ,
restrained by ropes, his face bowed in gentle
acceptance of his fate. Christ's nude body—
contorted with a physically impossible but not
inelegant torsion—is bathed in a golden light.

Consistent with the spiritually instructive
goals of ecclesiastical art of the Counter-
Reformation, everything in this painting is
intended to heighten its emotional charge and
to underline especially the contrast between the
noble pathos of Christ's suffering and the crude
reactions of the surrounding figures. The exag-
gerated gestures and the peculiar contrapposto
are telling indications of the mannerist style,
which also informs the compositional structure.
There is no illusion of deeply receding space;
instead a complex set of overlapping geometries
function within a shallow plane. These aesthetic
characteristics of the late Renaissance are im-
bedded in an atmosphere of dramatic emotional-
ism and expansive theatricality typical of the
early baroque. *Ecce Homo*, probably painted
as an altarpiece for a church in Genoa, where
Procaccini worked as of 1618, may be seen as a
major monument of this artist's important con-
tribution to baroque art in northern Italy.

DK

PIETRO PAOLINI
(Italian, 1603–1681)

Bacchic Concert, c. 1630
Oil on canvas
46¼ × 68¾ in. (117.5 × 174.6 cm)
The Karl and Esther Hoblitzelle Collection,
gift of the Hoblitzelle Foundation, 1987.17

Pietro Paolini's *Bacchic Concert* reveals the powerful influence of Caravaggio on the seventeenth-century baroque style. A native of Lucca, Paolini had worked in Rome where he fully experienced the impact of Caravaggio's manipulation of the light and dark of chiaroscuro as well as his new emphasis on reality. Paolini's half-length figures of musicians, bathed in a golden light, emerge dramatically from a shadowy, ill-defined background. The narrative of the painting is ambiguous, hinging perhaps on the sidelong glance of the figure at the right and the turned back of the woman at the far left. The text that she studies with rapt attention is apparently a sonnet by Petrarch, a detail which reinforces an aura of mystery or even erotic tension.

The visual focus of the composition is surely the nude torso of the pipe-playing "bacchus," his head crowned with grapes and vine leaves. Dramatic chiaroscuro emphasizes the undulating musculature of his body, which seems to almost sway to the music. Indeed, the textures of brocade, the shimmering grapes, the smooth surfaces of the wooden instruments, and the glistening skin, moist with perspiration, all act to reinforce the sensual force of the painting. A possible key to the peculiar (and typically Caravaggist) mixture of the everyday—the group of musicians—and the mythological—the god of wine—apparently lies in the typical entertainments at grand weddings in seventeenth-century Rome where musicians frequently donned costumes from the wine harvest. DK

REMBRANDT VAN RIJN
(Dutch, 1606–1669)

The Angel Appearing to the Shepherds, 1634
Etching, engraving, and drypoint on paper
10¼ × 8⅝ in. (26 × 22 cm)
Gift of Calvin J. Holmes, 1963.38

Rembrandt van Rijn's fertile imagination and versatility are evident in the more than three hundred etchings he created during his lifetime. Dissatisfied with the limitations of conventional etching, Rembrandt often combined its process with engraving and drypoint techniques.

The Angel Appearing to the Shepherds illustrates the rich tonalities and textural effects that Rembrandt was able to achieve through his experimental methods. In contrast to the typical etching process, working from light to dark, Rembrandt conceived the composition as essentially dark with highlighted areas, thereby intensifying the scene. By effacing the lines on the plate with a burnisher, he created the glowing highlights on the town in the background and the dazzling effects of the angels' light.

Rembrandt was apparently fascinated by stories in which God's will is communicated through angels, and when depicting such scenes he stressed their sudden and miraculous aspects. In this print the angels appear in a burst of light which illuminates the otherwise shadowy landscape below. The dramatic gestures of the angels may reflect the influence of Rembrandt's contemporary Peter Paul Rubens, the Flemish master known for his baroque stylization of exuberant and dynamic figures. At the same time, the meticulously detailed landscape reveals the importance of the realist tradition in seventeenth-century Holland. *The Angel Appearing to the Shepherds* is a particularly strong image, printed when the etched surface of the plate was still thoroughly saturated with the black ink. SRH

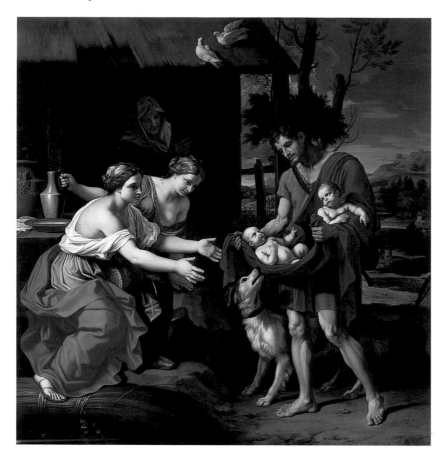

NICOLAS MIGNARD
(French, 1606–1668)

*The Shepherd Faustulus Bringing Romulus
and Remus to His Wife*, 1654
Oil on canvas
58½ × 57⅛ in. (148.6 × 145.1 cm)
Gift of Mr. and Mrs. Algur H. Meadows and the
Meadows Foundation, Incorporated, 1970.25

Mignard's painting is typical of the Italian-ate classicizing aesthetic that dominated seventeenth-century France. The subject itself is derived from the Roman myth of the twins Romulus and Remus, who were suckled by a she-wolf, saved by a shepherd, and survived to found the city of Rome. Mignard's depiction of the shepherd Faustulus handing the twins over to the care of his wife is characterized by precision and clarity. The figures, with their crisp gestures, distinct silhouettes, and skin aglow with a milky white light, have the appearance of a monumental classical marble relief. The dominant palette of primary colors, especially pure red and blue, is an indication of the profound impact of the great master of French classical baroque painting, Nicolas Poussin. Mignard's scene includes a fine bucolic landscape, and he does not neglect details such as the tender gestures, attentive gazes of man and beast, and two white doves which have alighted on the roof of the shepherd's hut. This painting, executed in Avignon where Mignard was active, is entirely consistent with the classical and idealizing tendencies favored in the France of Louis XIV, and is compelling testimony of the vitality of painting throughout France in the seventeenth century. DK

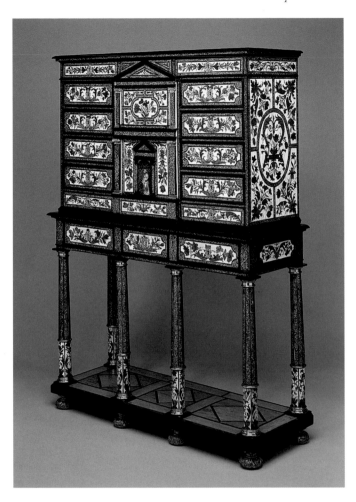

Cabinet on stand

French, c. 1660–80
Probably Pierre Gole (French, c. 1620–1684), Paris
Wood, tortoiseshell, ivory, shell, and gilt bronze
68¼ × 49½ × 17 in. (173.4 × 125.7 × 43.2 cm)
The Wendy and Emery Reves Collection,
1985.R.573.a–c

During the first half of the seventeenth century, the cabinet on stand became an important furniture form in Italy; it was soon imitated in both western and northern Europe. While many Italian examples are sheathed in the patterned hard stonework called *pietra dura*, examples from elsewhere in Europe typically employ wood marquetry to achieve similar decorative effects. Here the woodworker used a veneer saw guided by a template to produce hundreds of intricate elements. To create a sense of realism, these pieces were slightly burned in hot sand to pro-vide shading and dyed various colors before being assembled into bouquets and garlands of flowers. These wooden parts were then placed into a background veneer of ivory, which was surrounded by bands created from crushed mother-of-pearl set in mastic. The combination of colored woods, white ivory, and reflective shell ensured that this cabinet would have glistened like a jewel in the dim candlelight of the seventeenth century.

Because of the presence of French inscriptions, and because it is known that ivory-veneered furniture was made in Paris, this example can be assigned to that city with relative certainty. The Dallas cabinet has been attributed to Pierre Gole, Louis XIV's master cabinet-maker, because he was the only one recorded in the royal building records as producing marquetry on an ivory ground. CV

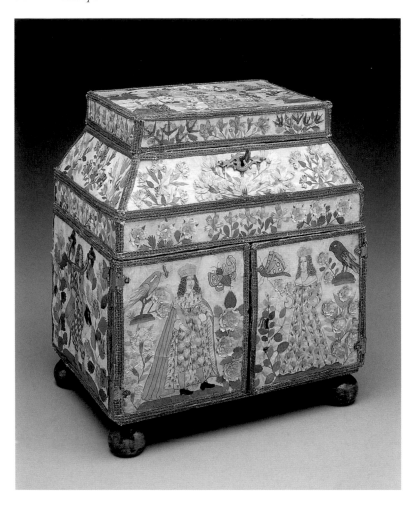

Paper work cabinet

British, London, c. 1660
Wood, silk, glass, and paper
11⅞ × 10⅞ × 8 in.
(30.2 × 27.6 × 20.3 cm)
Gift of Mrs. Addison L. Gardner Jr. in memory
of Richard W. and Anna L. Sears, and of Mr. and
Mrs. Alfred L. Bromberg in memory of Mr. and
Mrs. I. G. Bromberg by exchange, 1992.12

An important aspect of a young girl's educa-
tion in the seventeenth century was learning
the art of fancywork, including sewing, em-
broidery, needlework, and cutwork. Schools
and private schoolmistresses taught their
female charges how to embroider panels to be
kept as samplers of their talents or made into
objects for sale. Cabinets such as this one
were popular creations in the mid-seventeenth
century. They were made to sit atop a dress-
ing table to hold a lady's jewels and precious
keepsakes in the interior silk-lined drawers.
Unfortunately most of these cabinets do not
survive with a documented history, so it is
impossible to say with certainty whether they
were made specifically for an occasion or just
as a useful ornament for a lady of wealth.

This particular cabinet is unique among those
that survive in its method of decoration. While
most employ techniques of standard embroidery,
the museum's example is decorated with cut
paper that has been gummed and covered in
colored silk fibers. Originally the shimmering
surface would have been protected with sheets
of mica, long since lost. The floral and figural
scenes on this cabinet are typical of the decora-
tive motifs found on surviving examples and
are based on printed sources that were widely
available at the time. SH

Wine cistern

Irish, 1727
Thomas Sutton, Dublin
Silver
9½ × 19 × 14 in. (24.1 × 48.3 × 35.6 cm)
The Karl and Esther Hoblitzelle Collection,
gift of the Hoblitzelle Foundation, 1987.179

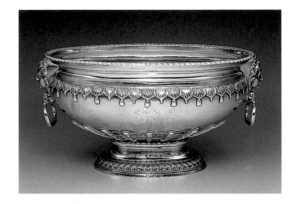

Large wine cisterns of ceramic, copper, and silver were made during the seventeenth and eighteenth centuries in Europe for cooling wine bottles before opening. While they could have sat upon a piece of furniture, contemporary paintings often show them on the floor near the dining table. Examples in any material are rare, but cisterns made of silver are extremely uncommon and would only have been found in the households of very wealthy families.

The Dallas cistern is one of only two Irish examples known. It was made by the Dublin silversmith Thomas Sutton for Robert Fitzgerald, nineteenth earl of Kildare (1675–1744), and his wife, Mary, daughter of William O'Brien, third earl of Inchiquin. It is engraved with the coat-of-arms of Fitzgerald impaling O'Brien. In keeping with its Irish origins, the masks at each end of this cistern may represent Hibernia, the female figure embodying the poetic nature of Ireland. The composition is further enlivened by a band of cast tassels along the vessel's shoulder. This type of decoration originated on the Continent during the seventeenth century. It first appeared in international style centers such as Paris and only later reached Dublin and other more provincial cities. CV

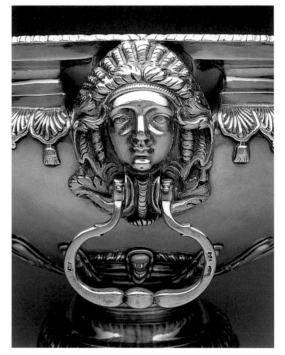

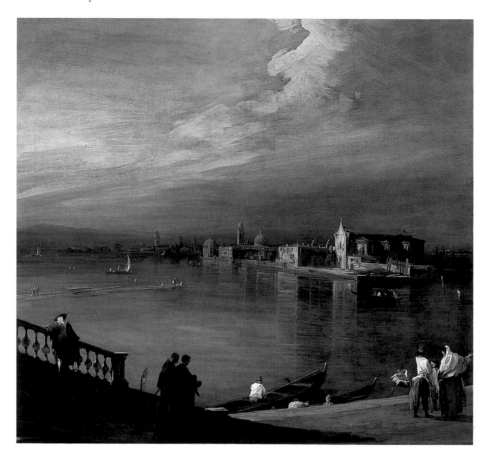

ANTONIO CANAL
("Canaletto," Italian, 1697–1768)

*A View from the Fondamenta Nuova
Looking towards Murano*, 1722–23
Oil on canvas
56½ × 59½ in. (143.5 × 151.1 cm)
Foundation for the Arts Collection, Mrs. John B.
O'Hara Fund, 1984.51.FA

Canaletto was renowned in his lifetime for his city views, a subject he embraced early in his career. *View from the Fondamenta Nuova Looking towards Murano* is an early landscape representing the first phase of the artist's mature work. He had yet to develop the distinguishing features of his distinctive views: a crisp delineation of details, a fascination with light and reflection, and a composition organized with geometrical clarity. In this painting the approach is looser, with less emphasis on the precise rendering of monuments and the details of costumes and pageants. Only a few figures gather on the embankment on the northern shore of Venice, obscured by shadows at the left, bathed in brilliant light on the right. Like the arms of a broad V, the expansive composition opens up from the embankment to the horizon. The overall mood is somber, even brooding, with a gray-white light darting from behind passing clouds and illuminating the facades on the islands of St. Cristoforo and St. Michele. In the far distance is the island of Murano. This early and therefore somewhat atypical work of the great master of the eighteenth-century city view invites comparison with the landscapes of nineteenth-century romanticism. DK

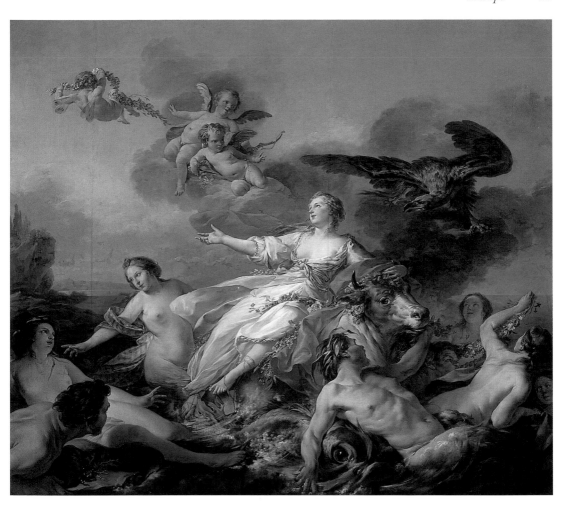

JEAN–BAPTISTE–MARIE PIERRE
(French, 1714–1789)

The Abduction of Europa, 1750
Oil on canvas
96 × 108½ in. (243.8 × 275.6 cm)
Foundation for the Arts Collection, Mrs. John B.
O'Hara Fund, 1989.133.FA

In 1770 Pierre succeeded his famed older rival, François Boucher, as First Painter to King Louis XV. He was also named director of the French academy and hence occupied the pinnacle of the French art world during the last decades of the monarchy. Commissioned by a prestigious collector, *The Abduction of Europa* was intended as a pendant to a painting by Boucher (Wallace Collection, London). Boucher's painting depicts Jupiter in the guise of a bull gently winning

Europa's confidence; she drapes his horns with a crown of flowers. Pierre focuses on the next moment in the narrative when Europa mounts the bull, who carries her off across the water.

Europa's distress, as recounted, for instance, by the Roman poet Ovid, is not evident in this interpretation of the story. The darker side of the narrative is dominated by the rococo penchant for a decorative orchestration of delicate colors, harmonious composition, and elegant postures. Serious drama cedes to a lighthearted atmosphere, colored surely by the frivolous, even amoral recklessness of the court at the end of the ancien régime. The only indication of the enormous passion of the moment is perhaps found in the energetic torsion of the male figure riding on the dolphin amid the waves. DK

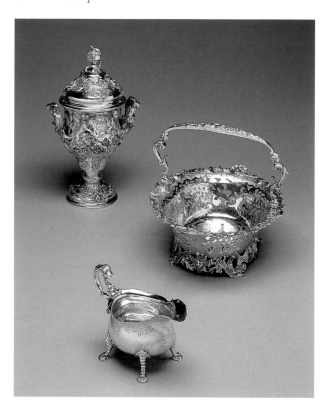

Cake basket, covered cup, and sauceboat
(one of a pair)

British, 1739, 1742, and 1745
Paul de Lamerie (British, born The Netherlands,
1688–1751), London
Silver
Basket: 11 × 14¾ × 12½ in. (27.9 × 37.5 × 31.8 cm)
Cup: 15 × 9⅜ × 6¾ in. (38.1 × 23.8 × 17.2 cm)
Sauceboat: 5 × 8¼ × 4¼ in. (12.7 × 20.1 × 10.8 cm)
The Karl and Esther Hoblitzelle Collection,
gift of the Hoblitzelle Foundation, 1987.185.2,
1987.186.1.a–b, 1987.168.1

Originating in France in the 1720s, the rococo
taste for naturalistic details and undulating
forms had spread across Europe by 1740. Al-
though English consumers tended to be more
conservative than their Continental counter-
parts, some exceptional examples of flamboyant
rococo silverwork were made there. Paul de
Lamerie, in whose shop the Dallas examples
were made, was one of Great Britain's most dis-
tinguished silversmiths. Born of French Hugue-
not parents, de Lamerie worked deftly in the
French taste, becoming a primary exponent of
the rococo style in England.

The cake basket and covered cup shown here
are of particular importance. Both were part
of the silver that Algernon Coote, sixth earl of
Mountrath (1689–1744), commissioned over
several years from de Lamerie. The quality of
the pieces created for the earl is truly extraordi-
nary. For example, the cake basket and its mate,
which is in a New York private collection, fea-
ture wonderful cast scrolls and masks on their
handles and foot rims. Dallas's covered cup
and its mate, now owned by the Indianapolis
Museum of Art, are even more exceptional; they
are the finest of all de Lamerie's covered cups.
The Dallas and Indianapolis examples are more
refined than other examples closely related
in form. Here the writhing rococo ornament,
which includes grapevines, snails, and a sala-
mander, is slightly more controlled and balanced
than in the other versions. Cast on the side of
the cups are the Mountrath arms surmounted
by a coronet and the motto *Vincit Veritas* (Truth
Conquers). CV

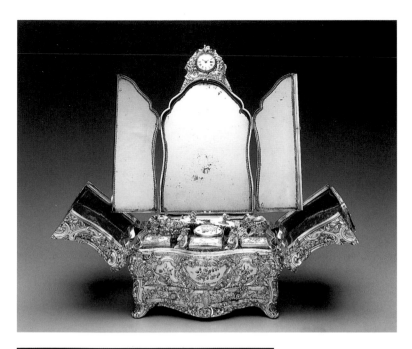

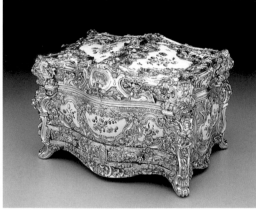

Dressing casket with accessories

British, c. 1755
Attributed to Charles Gouyn (British,
act. c. 1735–84), designer; St. James's Factory
(act. 1750s), maker, London
Silver, silver gilt, soft-paste porcelain, enamels,
glass, garnets, and velvet
17½ × 21¼ × 13 in. (44.5 × 54 × 33 cm)
The Esther and Karl Hoblitzelle Collection,
gift of the Hoblitzelle Foundation by exchange,
1995.22.1–22

By the mid-eighteenth century, ladies' dressing tables displayed the height of exotic luxury in the rococo taste. With its fine draperies and expensive accoutrements, the dressing table rivaled the state bed and sideboard as a stage for dazzling extravagance. This lavish porcelain and gilded silver dressing box is of exceptional importance in its combination of English silver-work and porcelain on the highest artistic level. The casket is decorated in the round with elegantly chased scrolls and floral enameled porcelain plaques. The mirror back is in three parts, the center surmounted by a watch intricately framed with figures of Cupid, Chronos, and a cockerel. The unfolding casket lids cover exquisite dressing and writing apparatus, all specially fitted and neatly arranged. Though this casket lacks heraldic devices, objects of this quality are usually associated with aristocratic commissions.

Recent scholarship suggests that Charles Gouyn established the Chelsea factory but left around 1749 to found another porcelain factory in London, where he made the so-called Girl-in-a-Swing class of porcelains. Although known for his porcelain toys, Gouyn designated his trade as "jeweler." The fine silver chased work of a jeweler and the fine enamel work so characteristic of the Girl-in-a-Swing type are combined here in this monumental casket. DH

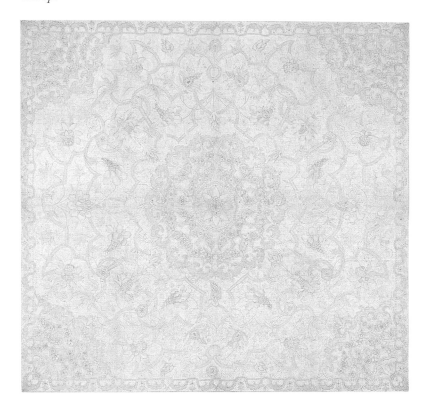

Coverlet

British, London, c. 1710
Silk on linen
58 × 60½ in. (147.3 × 153.4 cm)
Gift of Mrs. Addison L. Gardner Jr., in memory
of Richard W. and Anna L. Sears, and of Mr. and
Mrs. Alfred L. Bromberg in memory of Mr. and
Mrs. I. G. Bromberg by exchange, 1992.13.1–5

The design of this coverlet derives from three great textile traditions—
that of China, Europe, and India. Both the quilting pattern and central
medallion with corner quadrants composed of flower heads are based on
Chinese embroideries, while the delicate banding that fills the remaining
space is purely Western in inspiration. The exotic flowers entwined within
this banding have their origins in Indian painted *palampores* (p. 58).

Quilting and embroidery worked in yellow silk on linen grounds were
fashionable in England during the late seventeenth and early eighteenth
centuries, for both furnishings and dress. This particular example (whose
matching pillow shams are not illustrated here) is part of a small group of
truly exceptional yellow and white textiles made in London in the early
eighteenth century. All are bed sets, and their extraordinary quality sug-
gests that they were intended for display on marriage beds. Of the two
most closely related sets, the one at Glynde Place, Sussex, is nearly identi-
cal, while the other, at the Metropolitan Museum of Art, New York, shares
many of the same design elements and has an identical quilted ground.

CV

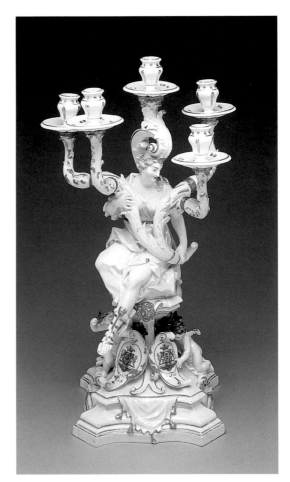

Candelabrum for the Sulkowsky service

German, 1736
Johann Joachim Kaendler (German, 1706–75),
modeler; Meissen Porcelain Factory (est. 1710),
maker, Meissen, Germany
Porcelain and enamels
24½ × 12 × 14 in. (62.2 × 30.5 × 35.6 cm)
Foundation for the Arts Collection, Mrs. John B.
O'Hara Fund, 1992.5.FA

This breathtaking feat of ceramic design is cred-
ited to Johann Joachim Kaendler, a sculptor of
genius who became master modeler at Meissen
in 1733, a position he held until his death. It is
a monument to the artistic and technical skill
that Meissen commanded during the first half
of the eighteenth century. The candelabrum
was part of the celebrated Sulkowsky Service.
Commissioned in 1736, it was the first special-
order private armorial dinner service produced
at Meissen. The service so impressed other
German nobles that they quickly ordered similar
personalized sets. Other examples of this model
were made for Count Johann Christian von Hen-
nicke (c. 1738) and for Prince Joseph Wenzel of
Liechtenstein (c. 1737–40).

 The candelabra are exceptional for their
scale and complexity. Modeling dominates,
with enameling and giltwork added only for
embellishment. Elaborate draped figures sit
on stepped bases with putti supporting rococo
shields, each bearing the coats of arms of Count
Alexander Joseph von Sulkowsky and his wife
Maria Anna Franziska von Stain. The mate to
this particular example, the only other known
in the United States, is at the Metropolitan
Museum of Art, New York. DH

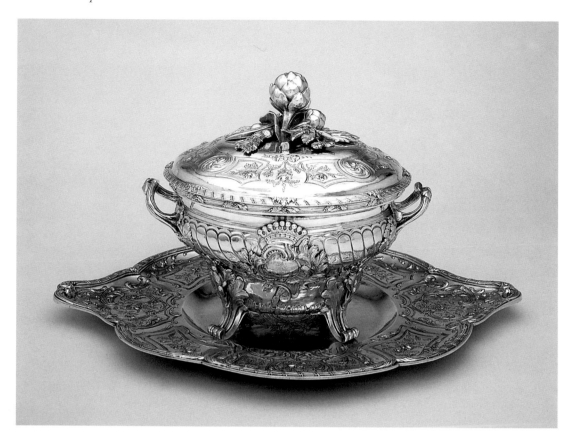

Tureen on stand

French, 1787
Claude-Hyacinthe Nicolas Souchet (French,
act. 1777–91), Paris
Silver
10½ × 19¼ × 16 in. (26.7 × 48.9 × 40.6 cm)
Gift of the Alvin and Lucy Owsley Foundation,
1985.94.a–d

Noted for swirling shapes and naturalistic ornament, the rococo style originated in France during the 1720s and 1730s in the work of artisans such as the great silversmith Juste-Aurèle Meissonnier (1695–1750), designer to the king of France. Through the production of actual objects and the publication of pattern books, the rococo taste spread throughout Europe and even to the British, Spanish, and Portuguese colonies in the Americas during the eighteenth century.

With its extremely fine chased decoration of scrolls and leaves and the wonderful cast vegetables atop the lid, this tureen on stand is of exceptional quality. Its date of 1787 is curious: by the 1780s, the neoclassical style, based on

the revival of antique Greek and especially Roman art and architecture, was well advanced in Europe, and the sinuous rococo taste was out of fashion. Evidently the Chabenat de Bonneuil family of Berry, France, who ordered this tureen wanted it to match the silver they already owned. Because the tureen's double-belled form, outline of the stand, and use of vegetables as a finial are all seen on porcelain examples produced at the Sèvres factory, this late example of rococo silver was possibly meant to harmonize with ceramic versions. Most popular in the second quarter of the eighteenth century, such tureens on stands were produced at Sèvres as late as the 1790s. CV

Decagonal bowl

French, 1752–53
Vincennes Factory (act. late 1730s–1756),
Vincennes, France
Soft-paste porcelain, enamel, and gilding
4¼ × 11¼ in. diam. (12.2 × 28.6 cm)
Foundation for the Arts Collection, anonymous gift
by exchange, 1991.39.FA

The Vincennes porcelain factory was established
at the Château de Vincennes in the late 1730s,
assisted by workmen from the Chantilly porce-
lain manufactory. The enterprise moved to
Sèvres, southwest of Paris, in 1756. This large
bowl is among the finest and rarest known from
Vincennes. The uncommon decagonal shape is
based on Japanese Kakiemon porcelain bowls
imported in the late seventeenth century. The
Chinese-inspired blue and gilt scale decoration
is unrecorded in any other example of Vincennes
porcelain. The polychrome birds and flowers are
exquisite accomplishments of the enameler's
art. Yet the white porcelain body, treasured by
royalty in the West, is integral to the design.

It is likely that this bowl was one of two *"jattes
forme d'ancien"* (bowls of antique shape) docu-
mented as having been sold in 1752 and 1753,
respectively, to Marchault d'Arnouville, Louis
XV's Keeper of Seals and an important share-
holder in the Vincennes factory. The bowl
descended in his family until, through marriage,
it came into the collection of the famous scholar
of French porcelains, Xavier de Chavagnac. It
was sold by his estate in 1911, passed through
several private collections, and finally came to
the Dallas Museum of Art in 1991. DH

JEAN-ANTOINE-THÉODORE GIROUST
(French, 1753–1817)

Oedipus at Colonus, 1788
Oil on canvas
64⅝ × 76⅜ in. (164 × 194 cm)
Foundation for the Arts Collection, Mrs. John B.
O'Hara Fund, 1992.22.FA

Giroust trained in the studio of Joseph-Marie Vien, a pioneer of neoclassicism. Among the other students was Jacques-Louis David, who would emerge as the leading artist of his generation. In 1775 Vien became director of the French academy in Rome, taking David with him. Giroust was awarded the Prix de Rome in 1778, and his sojourn at the French Academy once again brought him in contact with David.

Oedipus at Colonus, the work with which Giroust earned entrance to the academy, embodies the formal, thematic, and ethical issues of neoclassicism. The painting depicts the climactic confrontation between the blind king Oedipus and his son Polynices, who had sent him into exile. Aware that the place of his father's demise will be blessed, Polynices, with his sisters Antigone and Ismene, entreats the aged Oedipus to return to Thebes. But Oedipus rejects his son and forsakes his last chance to return to the city he had once ruled.

Giroust's choice of a blind hero as the subject for his masterpiece was surely informed by David's famous depiction of the blind Belsarius, completed in 1780. Indeed, in style and content Giroust's Oedipus is a paradigm of Davidian neoclassicism. Depicted with enormous clarity and concision, the drama unfolds on a shallow stagelike space parallel to the picture plane. The gestures and facial expressions of the characters—especially the outstretched arm of Oedipus at the center of the composition—are extremely eloquent. The architectural severity of the Doric temple at right as well as the stringent purity of the primary colors of the garments further enhance the intense drama.

DK

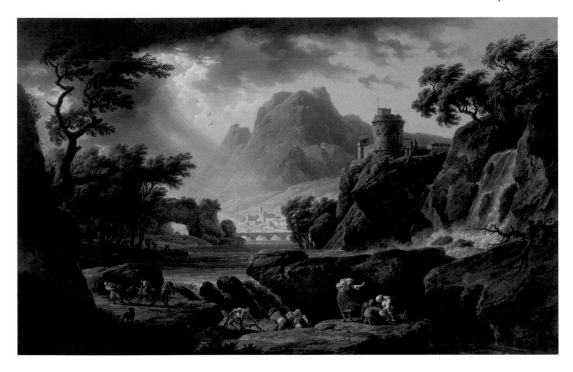

CLAUDE-JOSEPH VERNET
(French, 1714–1789)

Mountain Landscape with Approaching Storm, 1775
Oil on canvas
64½ × 103¼ in. (163.8 × 262.3 cm)
Foundation for the Arts Collection, Mrs. John B.
O'Hara Fund, 1983.41.FA

In the eighteenth century landscape painting was generally considered merely decorative and decidedly secondary to religious and mythological subjects. Vernet's extraordinarily successful career was surely an exception to this. Sponsored by a local collector in his native Avignon, Vernet worked in Rome from 1734 to 1753, and his patrons included members of the British and French nobility whom he met during their travels on the grand tour of Europe. Vernet brought together his fascination with the careful observation of nature with the great landscape tradition of the previous century—the idealizing poetry of Claude Lorrain, the drama of Salvator Rosa, and the grandeur of Nicolas Poussin. Indeed, Vernet's grand visions of nature claim a pivotal position in the great tradition of landscape painting.

Mountain Landscape with Approaching Storm is one of a pair of monumental landscapes com-missioned by the marquis of Lansdowne for his famous collection at Berkeley Square in London. The two paintings focus on contrasting meteorological extremes: one presents a tranquil harbor at sunset, the other, the terrifying drama of a storm. Vernet's cultivated patron would have understood these images in terms of the aesthetic themes of the late eighteenth century: one a paradigm of the "beautiful," and the Dallas picture an awe-inspiring vision of the "sublime."

The dramatic presentation of thundering waterfall, craggy coast, and glowering storm clouds anticipates the emotional intensity of romanticism. The legacy of Vernet's painting can be traced within the museum collections in works such as Thomas Cole's *Landscape— The Fountain of Vaucluse* (p. 222) and Frederic Church's *The Icebergs* (p. 228). DK

JOSEPH MALLORD WILLIAM TURNER
(British, 1775–1851)

Bonneville, Savoy, with Mont Blanc, 1803
Oil on canvas
36¼ × 48½ in. (92.1 × 123.2 cm)
Foundation for the Arts Collection, gift of Nancy
Hamon in memory of Jake L. Hamon with additional
donations from Mrs. Eugene D. McDermott, Mrs.
James H. Clark, Mrs. Edward Marcus, and the Leland
Fikes Foundation, Inc., 1985.97.FA

Acknowledged as one of the most original and influential artists of the nineteenth century, Turner bridged the traditions of classical and romantic landscape painting to create visionary depictions of nature's lasting beauty and awesome power. *Bonneville, Savoy, with Mont Blanc,* an early work, fuses the serene and the sublime in the natural landscape. The subdued mood of the foreground is communicated by rich vegetation along the riverbanks, gently rippling water, and reclining peasants. The mood shifts dramatically as the land slopes upward into a majestic panorama of awe-inspiring mountains, their summits sometimes eclipsed by cumulus clouds. The structure and the compositional balance of the painting reflect Turner's lifelong veneration of the landscape tradition, particularly the work of the seventeenth-century master Claude Lorrain.

As he matured, Turner increasingly infused his works with his own imagination and deft technique, and although *Bonneville, Savoy, with Mont Blanc* is an early work, it reveals his masterful handling of light, textures, colors, and moods. His unique treatment of light—a hallmark of his later style—is apparent in the subtle modulations of lights and darks, the shimmering reflections on the water, and the brighter palette animating the distance. Landscapes, including seascapes, remained the dominant genre of Turner's entire work, which eventually approached near abstraction as he gave expression to the visionary and the sublime in radical depictions of atmosphere and light. SRH

GIOVANNI BATTISTA PIRANESI
(Italian, 1720–1778)

Prisons VII from *Carceri d'Invenzione*, c. 1761
Etching on paper
27¼ × 19 in. (69.2 × 48.3 cm)
Gift of Mrs. John William Rogers, 1980.56

Piranesi, best known for his many etchings
and engravings, was also an influential designer,
architect, archaeologist, and theorist. His life-
long passion for Roman architecture defined
and inspired his career. He invented countless
variations on classical antiquity, ranging from
recreations of ancient Roman scenes, to building
plans based on antique designs, to architectural
fantasies.

The *Carceri d'Invenzione*, one of Piranesi's
most renowned works, is a series of sixteen
dramatic and fantastic prison scenes. It is his
second publication on the theme, and is in fact a
reworking of the first suite, *Invenzioni Caprice di
Carceri* (c. 1750). The second *Carceri*, informed
by his increased technical skill and encyclopedic
knowledge of Roman architecture, includes two
completely new images. Piranesi repeated the
complex process of varnishing, drawing, and
etching on the original plates, resulting in the
darker and more detailed quality of the second
set of prints. Dense, heavily worked black tones,
dramatic contrasts, as well as the inclusion of
frighteningly menacing instruments, create a
heightened nightmarish quality.

Prisons VII of the *Carceri* depicts a bafflingly
complex system of bridges and staircases, col-
umns and arches, integrated at intricate and
irrational angles. A rope hanging from a pulley
at the top of the composition sweeps through
the space, accentuating the erratic intricacy
of the structure. The spatial ambiguity of the
incredible architecture confounds the viewer
attempting to navigate it. The spiked wheel
at lower left only intensifies the frightful
environment. MK

FRANCISCO JOSÉ DE GOYA Y LUCIENTES
(Spanish, 1746–1828)

La Muerte de Pépé Illo, c. 1816
Plate E of *Tauromaquia*, published by Loizelet,
Paris, 1876
Etching with aquatint and drypoint on paper
12⅞ × 19⅞ in. (35.2 × 50.5 cm)
Gift of the Junior League of Dallas, 1940.8

Goya captures the drama and fury of the bullfight in *La Muerte de Pépé Illo* (The Death of Pépé Illo). During the eighteenth century bullfighting evolved from an elitist diversion into a popular spectacle, and it figured prominently in Goya's life and work. He was an avid fan and even practiced bullfighting techniques in his youth. In his artwork Goya exploited the ritualistic aspects, aesthetic flourishes, and dramatic suspense of the sport.

Goya's *Tauromaquia* (Art of Bullfighting) was first published in 1816 as a suite of thirty-three prints. The third edition, printed in 1876, included seven additional prints (including this one), which Goya had etched on the reverse of the plates. These are the work of a mature artist. Though different from the biting social and political commentary of his earlier print series, *Caprichos* or *Disasters of War*, the *Tauromaquia* series forcefully explores the spectacle of life-and-death encounters in the bullring.

This print depicts a popular *torero*, Pépé Illo, in the Madrid *plaza de toros* at the moment of his defeat by the bull in 1801, a scene Goya may have witnessed but surely knew through the enormous publicity it engendered. Goya experimented with three variations on this dramatic death scene. Tense, frozen gestures of man and beast convey the terror and frenzy of the event. Goya's masterful manipulation of chiaroscuro emphasizes the drama of the encounter, ennobling both the *torero* and his powerful opponent.

MK

WILLIAM BLAKE
(British, 1757–1827)

Satan before the Throne of God, from the *Book of Job*,
1825
Engraving and chine collé on paper
11¾ × 9⅛ in. (29.9 × 23.2 cm)
Gift of the Junior League of Dallas, 1940.1

William Blake came from a working-class background, and it is perhaps these humble origins and his fervent Christianity that inform his poetry and visual imagery with a sense of ethical responsibility and high moral code. Blake transformed the biblical and moralizing subjects that dominate his work with fantastic and metaphorical imagery. His illuminated books bring together the two important focuses of his artistry: text and visual image.

In the last years of his life, Blake found an encouraging patron in the painter John Linnell, whose most significant commission was the

Book of Job, comprising twenty-two engravings. The images are based on a set of watercolors Blake had painted for another patron some years earlier. To the watercolor compositions Blake added linear designs, and he integrated phrases of biblical text within the borders.

The Old Testament recounts Job's enduring faith in God even when subjected to extraordinary suffering. Here, in the second plate in the book, God agrees to allow Satan to test Job's righteousness. Curiously, God has the same face as Job, who appears below with his family, comfortable and healthy, all unaware of their fate. Pastoral designs at the bottom of the border soar upward into a cathedral-like pattern, distinguishing God's realm in heaven and Job's place on earth. Sleeping dogs at the bottom of the central image and within the border are iconographic details that add charm and unify the entire composition. MK

SIR THOMAS LAWRENCE
(British, 1769–1830)

Portrait of the Honorable Mrs. Seymour Bathurst, 1828
Oil on canvas
56 × 44⅛ in. (142.2 × 112.1 cm)
Foundation for the Arts Collection, Mrs. John B.
O'Hara Fund, 1986.56.FA

Sir Thomas Lawrence, master of elegant society
portraiture in late Georgian England, was par-
ticularly gifted at lively characterization and col-
orful dramatic composition. A precocious talent,
at age eighteen he was already determined to
become a portrait painter. By twenty-five he
was named a full member of the Royal Academy.
He attracted the patronage of the most eminent
aristocratic figures of his day, and his profes-
sional success was crowned when, following the
death of Sir Joshua Reynolds in 1792, he was
named Painter-in-Ordinary to the King by
George III. In 1820 he succeeded Benjamin
West as president of the Royal Academy.

This portrait of Julia Hankey was likely com-
missioned as a betrothal image in anticipation of
her marriage to Thomas Seymour Bathurst in
1829. The picture, which was delivered in 1830
shortly after Lawrence's death, remained in the
Bathurst family until 1956, and its condition is
unusually fresh. The face is exceptionally ani-
mated, with insouciantly tilted head, lively eyes,
and parted lips. Surely this element of the com-
position was executed directly before the sitter.
The image is further enhanced with richly de-
tailed, elegant clothes and jewels as well as a
freely painted landscape background. DK

HONORÉ DAUMIER
(French, 1808–1879)

Outside the Print-Seller's Shop, c. 1860–63
Oil on panel
19½ × 15¾ in. (49.5 × 40 cm)
Foundation for the Arts Collection,
Mrs. John B. O'Hara Fund, 1981.33.FA

Daumier's small oil on panel, *Outside the Print Seller's Shop*, offers an apparently casual and unposed glimpse of an urban street scene. The attention of passersby is attracted by prints displayed in a street-side art shop. Some peer with earnest intensity, others gaze with only mild curiosity. Another leafs somewhat gingerly through the sheets in a giant portfolio as a child strolls by, barely registering interest. The true subject of the work can be described as the act of looking, involving not only the various degrees of interest of those depicted but also the animating gaze of the artist, a keen observer of the bustling street life of nineteenth-century Paris, as well as our own attentive scrutiny. This is, in fact, a dominant leitmotif of Daumier's oeuvre. A major focus of his massive graphic production, for instance, are faces and gestures keenly observed and often ruthlessly satirized. Politicians, professionals, members of the ruling class, the middle-class—all fall victim to his probing glance. In his paintings—and distinct from the sharply critical attitude of his graphic work—Daumier casts a curious but gentle gaze upon the anonymous actors on the rapidly changing nineteenth-century urban stage. DK

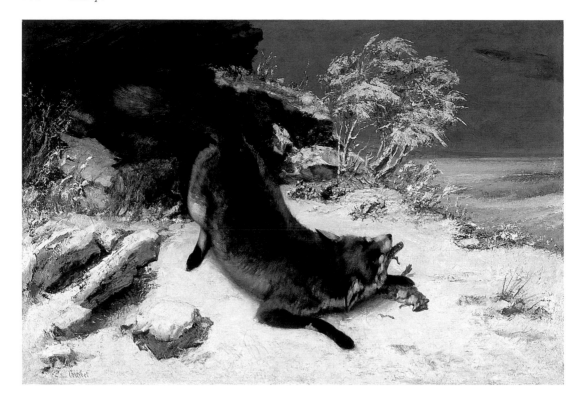

GUSTAVE COURBET
(French, 1819–1877)

Fox in the Snow, 1860
Oil on canvas
33¾ × 50¼ in. (85.7 × 127.6 cm)
Foundation for the Arts Collection, Mrs. John B.
O'Hara Fund, 1979.7.FA

Gustave Courbet's *Fox in the Snow* depicts the animal mauling its prey, the rodent's blood spilling onto the blanket of snow. The brutal directness of the image is intensified by the brilliance and explicitness of Courbet's brushstroke. The artist deftly wielded brush and palette knife to differentiate the softness of the animal's fur and the crispness of the frozen ground. The painting is a quintessential example of Courbet's realism: he refused to depict traditional subjects of mythology or history; he was intensely fascinated, instead, with subjects of everyday life. The accuracy of this scene surely derives from Courbet's own experiences as an avid hunter in the rugged countryside of his native Franche-Comté. The painting, along with four other works, was submitted to the Paris Salon to great acclaim in 1861.

Courbet's aesthetic program had a sociopolitical dimension that engaged a range of radical issues. His portrait of the socialist philosopher Pierre-Joseph Proudhon (Petit Palais, Paris) or the menial labor depicted in the *Stonebreakers* (destroyed during World War II) reveal this socially critical facet of his work. An artistic and political rebel, Courbet was imprisoned for his role in the felling of the Vendôme Column during the ill-fated insurrection of the Paris Commune in 1871. The museum's collection includes a ruddy still life of fruit painted during his incarceration in the prison of Ste.-Pélagie, not far from the Jardin des Plantes in Paris. DK

NARCISSE DIAZ DE LA PEÑA
(French, 1808–1876)

Forest of Fontainebleau, 1868
Oil on canvas
33¼ × 43¾ in. (84.5 × 111.1 cm)
Munger Fund, 1991.14.M

Narcisse Diaz de La Peña's *Forest of Fontaine-bleau* is prototypical of the landscapes of the Barbizon school. The subject is a grove of oaks, their gnarled trunks dramatically illuminated by a few shafts of light that penetrate the otherwise somber forest. A dense canopy of branches entwines overhead into an oval which seems to frame the forest enclave.

The painters of the Barbizon school worked in the forest of Fontainebleau and village of Barbizon, southeast of Paris, in the mid-nineteenth century. Influenced by John Constable, Richard Bonington, and the seventeenth-century Dutch landscape tradition, they reveled in the quiet beauty of rural France, preferring its landscape to the Italian countryside or Alpine vistas that had fascinated earlier artists. Their goals were to rediscover the magic of untouched nature and to celebrate the natural world in all its commonplace, unembellished details. Perhaps the most prominent proponent of this new mode of landscape painting was Pierre-Étienne-Théodore Rousseau, who had a profound influence on Diaz.

The Barbizon artists worked out of doors, *en plein air*, to create the drawings and oil sketches that became the basis for oil paintings finished in the studio. Their work before the motif and their attention to ephemeral conditions of light and weather are consistent with the naturalist reevaluation of landscape painting at midcentury which informed the evolution of impressionism.

DK

MAX LIEBERMANN
(German, 1847–1935)

Im Schwimmbad, 1875–78
Oil on canvas
71¼ × 88½ in. (181 × 224.8 cm)
Foundation for the Arts Collection, Mrs. John B.
O'Hara Fund, 1988.16.FA

One of the foremost figures of nineteenth-century German painting, Max Liebermann is traditionally described as an impressionist and frequently compared with his French counterparts such as Manet. *Im Schwimmbad* exemplifies Liebermann's modern style. He chose a contemporary subject of youths dressing after a swim rather than a more traditional mythological or historical theme. Indeed, Liebermann's focus on leisure is consonant with the aesthetic preoccupations of his realist and impressionist generation and their determination to embrace everyday subjects. Spontaneity is communicated, too, by means of the vigorous brushwork as well as the casual poses of the figures which convey a snapshot immediacy.

Traditional compositional formats give way to a painting in which space is flattened, thereby emphasizing a sense of directness. This compression of pictorial space is rooted in a rejection of traditional Renaissance perspective. Instead, for instance, the emphatic parallel diagonals of roof and deck seem inspired by the aesthetic principles of Japanese prints, an interest Liebermann apparently shared with his French contemporaries. The lack of an identifiable light source and the manipulation of shadow as pattern further contribute to this effect of flatness.

In another departure from aesthetic norm, Liebermann depicted adolescent boys in various stages of undress instead of the more typical female nudes favored by the official academies of the time. The male nude, however, inevitably alludes to sculptural traditions of the classical and Renaissance eras. DK

PIERRE-AUGUSTE RENOIR
(French, 1841–1919)

Lise Sewing, 1866–68
Oil on canvas
22 × 18 in. (55.9 × 45.7 cm)
The Wendy and Emery Reves Collection, 1985.R.59

Tradition has it that Renoir was in love with Lise Tréhot, the woman he portrays in this work. From 1866 through early 1872 he painted Lise again and again, until, in 1872, their relationship came to an abrupt end with her marriage to another man. A second portrait of Lise in the museum's collection, dating from 1872, may in its poignant directness be interpreted as a painterly adieu to the artist's beloved.

In its informality *Lise Sewing* is not a strictly traditional portrait, but its casual intimacy and lack of pose are what make it so engaging. The artist caught the girl in a pensive moment, absorbed in her stitching. Her face is down-turned, her lips parted in sheer concentration on her task. Renoir lavished attention on the details of her features: her dark brow, her ear adorned with a modish red drop-earring, her ample mass of raven black hair, tied with a red ribbon. His keen observation of detail is especially evident in her nimble fingers, poised at work with cloth, needle, thread, and thimble. The gray and pale blue stripes of Lise's dress, as well as the swatch of royal blue material on which she works, are passages of pure painterly delectation. The background is roughly filled in with patches of blue, gray, and brown. DK

ÉDOUARD MANET
(French, 1832–1883)

Brioche with Pears, 1876
Oil on canvas
28 × 31½ in. (71.1 × 80 cm)
Lent by the Wendy and Emery Reves Foundation,
66.1985

A simple but elegant still life, Manet's *Brioche with Pears* is a bravura painterly performance. Bathed with a pearly morning light from an unseen window, the composition is deceptively simple. A crisp and shiny brioche is centered on a tabletop decked in white damask; to the right are three still-green pears and a baguette emerging from a basket. A golden knife points to the massive brioche. One pale pink rose lies on the tablecloth; another pierces the heart of the brioche. The wall behind the table is covered with a flower-and-trellis wallpaper, which continues the floral theme and augments the golden brown, pearlescent gray, and rosy pink tonalities. Indeed, the wallpaper is a crucial element of the composition, investing it with a sense of

grandeur through the geometry of the trellis bars, which should cross just beyond the top margin of the canvas, thereby crowning the entire still life with the stable geometry of an isosceles triangle. The crisscross pattern of the wallpaper is echoed, too, in the sharp lines of the crisply folded tablecloth and in the angle formed by the brioche and the knife. A brioche still life by Chardin from 1763, which entered the collection of the Louvre in 1869, was very likely the inspiration for this painting as well as two other versions by Manet. With incredible insouciance the painting conjures up the elegance of a bourgeois table. Above all, however, it is alive with the vigor and sheer beauty of pure painting.

DK

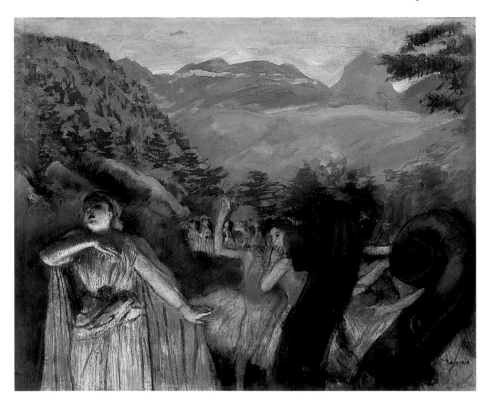

EDGAR DEGAS
(French, 1834–1917)

Aria After the Ballet, 1879
Pastel and gouache over monotype mounted on board
23½ × 29½ in. (59.7 × 75 cm)
The Wendy and Emery Reves Collection, 1985.R.26

Aria After the Ballet, presented at the fourth impressionist exhibition in 1879, has all the drama typical of Edgar Degas's theater subjects. The dancers, but especially the singer at the left, are flooded with light projected from below. At lower right protrude the curving forms of the bass instruments, emerging like comic periscopes from the orchestra pit. Degas manipulated perspective and played with a disparity of scale: the stringed instruments appear to be the same height as the expressively posed opera singer to whom their "heads" turn, as if in rapt attention. Though the work was exhibited with the title *Ballet de l'Africaine*, a particular opera has not yet been identified.

This work reveals, too, Degas's attention to experimentation with various media. Rich pastel captures the radiant, shimmering effect of the costumes of the performers. In contrast, matte gouache defines the forested and mountainous scenery, thereby approximating the drab, sketchy painting of a stage backdrop. Plate marks just visible along the edges of the paper suggest that the pastel and gouache mask a monotype print, which provided the basis of the composition. A monotype of such an unusually large size would have been an audacious experiment on the part of the artist. DK

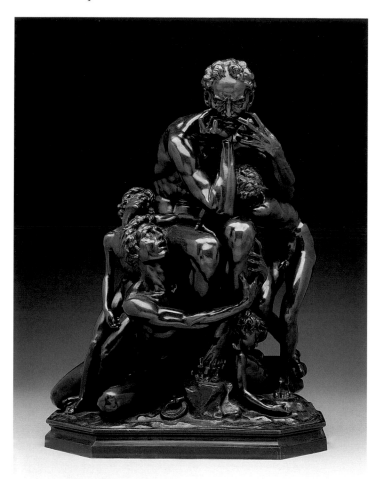

JEAN-BAPTISTE CARPEAUX
(French, 1827–1875)

Ugolino and His Sons, 1860 (cast c. 1871)
Bronze
19 × 14¾ × 10⅝ in. (48.3 × 37.5 × 27 cm)
Foundation for the Arts Collection, Mrs. John B.
O'Hara Fund, 1981.42.FA

A pupil of sculptor François Rude and an early teacher of Rodin, Carpeaux holds a central position in the history of French romantic sculpture of the nineteenth century. *Ugolino and His Sons* is clearly informed by the masterworks of Michelangelo as well as the Hellenistic and Roman sculpture Carpeaux studied during his year in Italy as the recipient of the coveted Prix de Rome in 1854. The dramatic and macabre subject drawn from Dante's *Inferno* is typical of romanticism: Count Ugolino della Gherardesca, the tyrannical thirteenth-century master of

Pisa, has been condemned to starve, and he staves off hunger by devouring his sons. Carpeaux struggled with this exceedingly complex figural group, producing a number of versions. The French academy attacked his emphasis on the male nude as well as the bizarre theme, but in the end accepted a bronze version of the sculpture.

Ironically the controversy around the Ugolino sculpture boosted Carpeaux's career, leading to prominent public commissions such as *The Dance* for the facade of the Paris Opera. Meanwhile, demand for the Ugolino group continued. In addition to full-scale versions in plaster, terracotta, and marble, Carpeaux executed a smaller-scale model, which was cast in various media in several editions dating from the artist's lifetime until well into our century. DK

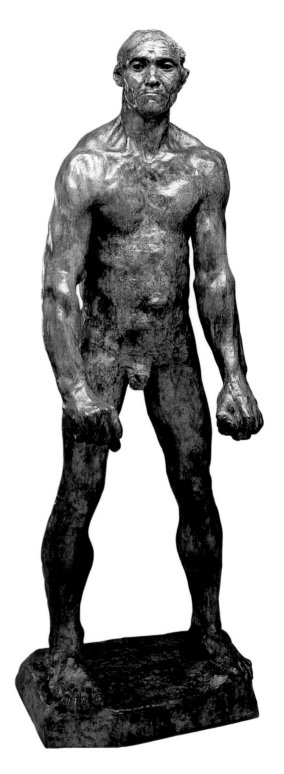

AUGUSTE RODIN
(French, 1840–1917)
Jean d'Aire from the *Burghers of Calais*,
completed 1895 (plaster by 1886, cast in the
early 20th century)
Bronze
81 × 28 × 24 in. (205.7 × 71.1 × 61 cm)
Given in memory of Louie N. Bromberg and Mina
Bromberg by their sister Essie Bromberg Joseph,
1981.1

Jean d'Aire is a study for one of the figures in
Rodin's monumental *Burghers of Calais*. This
sculptural group commemorates the heroic
surrender by six of the leading citizens of Calais,
whose city had been subjected to a yearlong
siege by England's Edward III. Dressed in sack-
cloth, with ropes around their necks, their feet
bare, the men presented the king with the key
to the city. Impressed by their courage, Edward
spared their lives and Calais. Rodin, however,
chose to depict their anguish as the men antici-
pate execution. The monument's emotional
power is invested directly in the gestures and
postures of each figure rather than in conven-
tional symbols of the patriot or hero.

Rodin discovered the facial expressions and
bodily gestures which mirror each individual's
inner world through painstaking trial and error.
Indeed, although the commission was awarded
in 1884, the monument was not unveiled until
1895, after years of experimentation with stud-
ies in plaster and terra-cotta after nude models,
as well as additional detailed studies of faces and
hands. The Dallas sculpture is an early bronze
casting of the nude study for the burgher Jean
d'Aire. Owing to the profound psychological and
emotional authenticity of Rodin's plastic forms,
even without the contextualizing elements of
sackcloth and key, this single figure—his face
and body rigid with stoic determination—is
movingly eloquent. By determinedly eschewing
conventional allegory, Rodin reinvents our basic
notion of the sculptural image of the hero.

DK

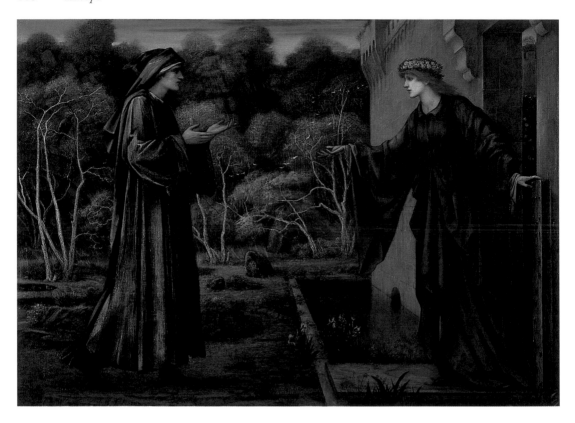

SIR EDWARD COLEY BURNE-JONES
(British, 1833–1898)

The Pilgrim at the Gate of Idleness, 1884
Oil on canvas
38 × 51½ in. (96.5 × 130.8 cm)
Foundation for the Arts Collection, Mrs. John B.
O'Hara Fund, 1996.44.FA

This composition is a masterwork by the pre-
eminent British Victorian painter, Sir Edward
Coley Burne-Jones. It is loosely based on
Chaucer's poem, *Romance of the Rose*, which
follows a pilgrim's allegorical search for virtue.
Reflecting the artist's general fascination with
medieval themes, the painting forms a trilogy,
along with the monumental *Love Leading the
Pilgrim* (Tate Gallery, London) and *Heart of the
Rose* (private collection). In the Dallas picture,
the pilgrim meets Idleness personified as a
beguiling maiden. After escaping that tempta-
tion, the pilgrim is led by Love through a briar
thicket, the scene depicted in the Tate painting.
The third moment in the narrative depicts a
winged figure leading the pilgrim to the rose.

The painting exemplifies Burne-Jones's
literary romanticism, which is typified by an
exaggerated stylization of gesture, expressive
poses, and a strangely asceticized or androgy-
nous sensualism. The linear precision reveals
the artist's admiration of the masters of the
Italian Renaissance, including Botticelli. The
stylistic refinement, aura of mystery, and sense
of psychological tension which characterize
this painting had a profound impact on the
upcoming generation of symbolist artists.

Burne-Jones was a close friend of William
Morris, the founder of the arts and crafts move-
ment. This composition was originally conceived
in collaboration with Morris as the subject of an
embroidered wall-hanging, and can be consid-
ered an important example of the arts and crafts
ideal of the synthesis of painting, architecture,
and design. Burne-Jones produced the same
subjects and themes again as illustrations for an
1896 edition of Chaucer published by Morris's
Kelmscott Press, the artist's final collaboration
with Morris, who died later that year. DK

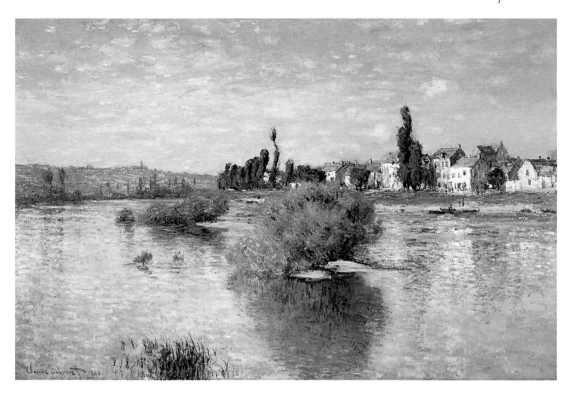

CLAUDE MONET
(French, 1840–1926)

The Seine at Lavacourt, 1880
Oil on canvas
38¾ × 58¾ in. (98.4 × 149.2 cm)
Munger Fund, 1938.4.M

Monet executed *The Seine at Lavacourt* while living in Vétheuil, outside
Paris, during the 1880s. This relatively large-scale composition was surely
completed in the studio, based on initial plein-air sketches. Indeed, by the
late 1870s and 1880s, the aesthetic principles originally at the heart of the
impressionist movement—a focus on plein-air composition and the captur-
ing of fleeting effects of light and color with deftly orchestrated individual
brushstrokes—lost some of their importance as the artists followed their
individual courses of development.

 The strong horizontal axis of *The Seine at Lavacourt* is interrupted by
the central inverted-pyramid of trees and their reflection on the water's
surface. This geometric structure invests the painting with calm and order,
complementing the harmonious overall palette of spring green and delicate
shades of blue. There was, perhaps, a practical inspiration for the careful
structure in this composition. Monet struggled financially during these
years, and to expand his public market, he attempted to reenter the official
painting Salons. The central motif of shrubbery and its reflection should
remind us, however, of the almost abstract compositions—haystacks, pop-
lars, water lilies—which came to dominate Monet's development in the
1880s, 1890s, and first decades of the twentieth century. DK

VINCENT VAN GOGH
(Dutch, 1853–1890)

Sheaves of Wheat, 1890
Oil on canvas
19⅞ × 39¾ in. (50.5 × 101 cm)
The Wendy and Emery Reves Collection, 1985.R.80

Van Gogh painted *Sheaves of Wheat* in midsummer 1890, not long before his suicide on July 27. It is one of thirteen large, double-square-format canvases that may have been intended as a series, perhaps to decorate the home of Dr. Paul Gachet, the physician who treated van Gogh in the village of Auvers-sur-Oise. With the exception of a vertical portrait of Mlle Gachet (Kunstmuseum, Basel), all the canvases are horizontal landscapes whose dominant theme is wheat fields.

Fields of grain, specifically scenes of harvest, are traditional landscape subjects, and van Gogh's older contemporaries Charles-François Daubigny and Camille Pissarro had painted the fields near Auvers decades earlier. But van Gogh's painting transcends the conventions of the landscape tradition. He offers neither a vast panorama nor the genre elements of workers in the fields but an immediate and sensual image that embodies, rather than symbolizes, the powerful richness of nature. Van Gogh depicted the sheaves of wheat close-up, filling the canvas from top to bottom. The towering bundles of grain are animated by the artist's energetic, elongated brushstrokes. These nervous slashes define not only the wheat bundles but the entire landscape. The wheat, the surrounding terrain, the distant landscape, and the sky are all bathed in a golden light. This golden yellow and its complement, lavender, dominate the canvas. Their vibrant contrast creates the impression of blinding sunlight and stifling heat radiating from the sun-drenched fields. This powerful image has an almost synaesthetic impact, conjuring up the odor of freshly mowed fields, by which color, paint, light, and wheat become one.

DK

PAUL GAUGUIN
(French, 1848–1903)

I Raro te Oviri (Under the Pandanus), 1891
Oil on canvas
26½ × 35¾ in. (67.3 × 90.8 cm)
Foundation for the Arts Collection, gift of the
Adele R. Levy Fund, Inc., 1963.58.FA

In Tahiti Gauguin sought an exotic world far
from Western civilization, a distant place of
brilliant colors, luscious vegetation, and foreign
custom. There he found both the real and psy-
chological distance to pursue his radical aes-
thetic goal of an art that does not copy nature.
In *I Raro te Oviri,* Gauguin suppressed spatial
illusionism and instead constructed the land-
scape with horizontal bands of colors which
reinforce the two-dimensionality of the canvas.
The figures are dressed in *pareos,* skirts of flow-
ered cotton wrapped around the waist. The red
fabric forms a bold contrast to the brilliant
green field to the left, a daring manipulation of
complementary colors which is repeated in the

fruits balanced on the shoulders of the figure at
the right. The reddish brown earth bears a calli-
graphic pattern of undulating yellow—fallen
palm leaves—that gives the impression of hot,
molten material.

 The stiff, wooden stances of the women recall
the importance of the Buddhist bas-reliefs at
Borobudur in Java (which he knew from photo-
graphs) as a specific source for Gauguin's primi-
tivizing rendering of figures. Even the black dog
at the center of the composition seems to tran-
scend mere genre, suggesting the animalistic or
barbaric qualities that Gauguin imagined he had
discovered in the South Pacific. The seductive
aura of the exotic undoubtedly served as a pow-
erful catalyst for Gauguin's bold redefinition of
painting. Gauguin clearly prized this painting.
He adopted its imagery in a woodcut and for a
monotype which he used as the frontispiece to
his semi-autobiographical account of his first
Tahitian journey, *Noa Noa.* DK

ÉMILE BERNARD
(French, 1868–1941)

Breton Women at Prayer, 1892
Oil on cardboard
32⅜ × 45¾ in. (82.2 × 116.2 cm)
The Art Museum League Fund, 1963.34

Working with Paul Gauguin at Pont-Aven, in Brittany, in the late 1880s, Émile Bernard developed the synthetist style, which emphasizes decorative forms and surface harmony. Descriptive details are suppressed in favor of broad areas of intensely saturated color and sinuous outlines. In *Breton Women at Prayer*, the field on which the women have gathered is a plane of bright green. The yellow areas have no descriptive function but rather introduce a sinuous art nouveau–inspired pattern. The praying women, too, are reduced to schematic mounds of white and blue-black, the colors of their traditional bonnets and dresses. Similarly, trees in the background are rendered as masses of green-blue, punctuated by the cigarlike shapes of three ochre yellow cedars at the left and right. More distant hills, depicted in uncompromising red, do not recede in space but rise up steeply parallel to the surface of the canvas.

These compositional devices, especially the lack of spatial illusionism and the emphasis on flat decorative patterns, were surely influenced by the aesthetic principles of Japanese printmaking which were so admired in France during the nineteenth century. Similarly, medieval stained glass was an inspiration for the broad color areas and distinct outlines that characterize Bernard's so-called cloisonism of the late 1880s. The Pont-Aven artists turned away from the realist tradition of Western art and instead embraced more "primitive" art forms and styles. Indeed, the profound attraction of the remote villages of Brittany for Bernard, Gauguin, and their friends, was their less civilized and therefore unspoiled and spiritually authentic culture.

DK

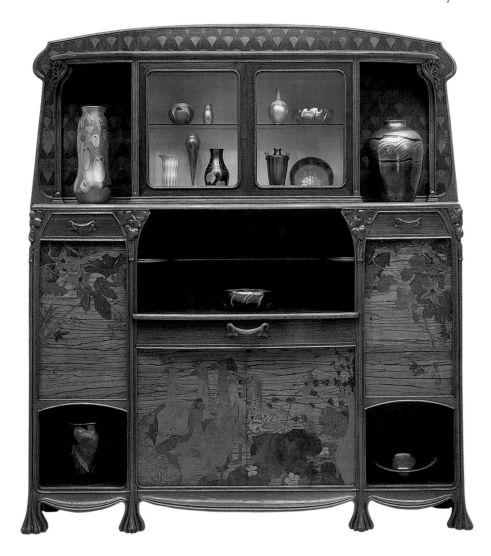

Sideboard

French, c. 1900–10
Louis Majorelle (French, 1859–1926), Nancy, France
Various woods, bronze, and glass
93 × 84 × 20½ in. (236.2 × 213.4 × 52.1 cm)
Gift of the Alvin and Lucy Owsley Foundation in
memory of Constance Owsley Garrett, 1989.40

The French city of Nancy in the eastern prov-
ince of Lorraine was one of the most important
centers of art nouveau design around the turn
of the century. The leaders of the "School of
Nancy" were Émile Gallé (1846–1904) and
Louis Majorelle. This sideboard is a significant
example from the Majorelle workshop and was
originally part of a suite of dining room furni-
ture that included another sideboard, table, and
chairs. Some of Majorelle's finest work took the
form of suites of furniture, each dominated by a
single theme. At the International Exposition
of 1900 in Paris, for example, Majorelle showed
furniture with a water lily theme for a library
and salon, while a bedroom suite used orchids as
its focus. In the Dallas example, the use of wood
marquetry on the cabinet doors and backboard
is especially fine and in keeping with the strong
naturalistic tendencies of the art nouveau style.
Here passionflower vines cascade across the side
doors, while a gaggle of geese peer out at the
viewer from below. Majorelle's signature can be
seen worked into the design at the lower right
corner of the lower right door. CV

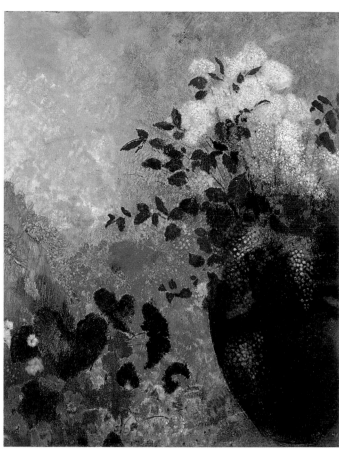

ODILON REDON
(French, 1840–1916)

Flowers in a Black Vase, c. 1909–1910
Pastel on paper
47 × 39 in. (87.3 × 68.5 cm)
The Wendy and Emery Reves Collection, 1985.R.55

Odilon Redon's *Flowers in a Black Vase* challenges in many ways the conventional still life. The vase at the right is defined by an elegant curve that establishes its profile amid the cascading yellow, blue, and white flowers which flow across the surface of the paper. The work depicts no interior; there is, for instance, no trace of a tabletop. Rather, an amorphous and luminescent environment suggests simultaneously still life and landscape, or perhaps more accurately—because of the soft velvety surface—a dreamscape.

This pastel is paradigmatic of Redon's discovery of color in the 1890s. His previous works were all black: charcoals, chalk drawings, or lithographic compositions, often exploring themes from Wagner, Poe, and Flaubert, and creating mysterious and evocative fantasies. It was precisely this dreamlike aspect that delighted the symbolist novelist and critic Joris-Karl Huysmans, who championed Redon's work in his "decadent" novel *À Rebours* (Against the Grain; 1884). Redon's earlier black, nightmare-like images of grinning spiders and floating heads ceded to images that are almost nondescriptive and certainly distant from specific narrative. Redon's still life reflects the symbolist aesthetic of the late nineteenth century in its otherworldly quality and in the way in which color becomes an expressive element independent of form, emulating the nondescriptiveness of music and evoking correspondences between color and smell. The art historical context of this still life includes Monet's *Nymphéas* series, Degas's late pastels, and Vuillard's psychologically charged interiors. DK

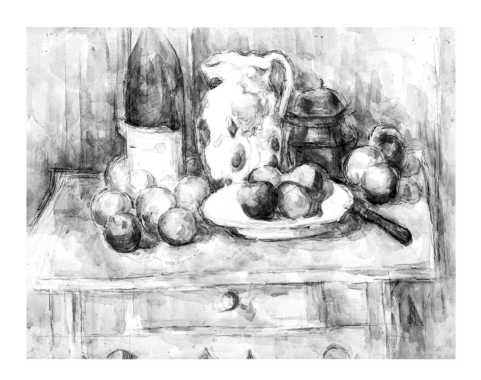

PAUL CÉZANNE
(French, 1839–1906)

Still Life with Apples on a Sideboard, 1902–6
Watercolor on paper
18⅞ × 24¾ in. (47.9 × 62.9 cm)
The Wendy and Emery Reves Collection, 1985.R.12

Linked to their fascination with light and study of color, watercolor was an important medium for all the impressionist artists, but it was fundamental to the work of Paul Cézanne. The fluidity and facility of the technique especially inform his late work, such as the large-scale *Still Life with Apples on a Sideboard*. Translucent slabs of pure color are juxtaposed with untouched passages of white paper, which is integrated as a powerful positive element of the composition. Light, fragmentary brushstrokes infuse the painting with a spontaneous, air-filled quality. With a celebratory, almost baroque splendor,

the watercolor is animated by the floral pattern decorating the white pitcher, the fluted edge of the vessel's mouth and curvilinear handle, and the full, rounded forms of the ginger pot and fruit. The yellow and russet fruit has a solidity and density that goes beyond realism and is typical of the artist's careful contemplation and deliberate rendering of ordinary still-life objects. These fruits contrast with the light-filled, almost insubstantial pale yellow sideboard and the background wall. This resolved watercolor is a magnificent example of the artist's mature work.

DK

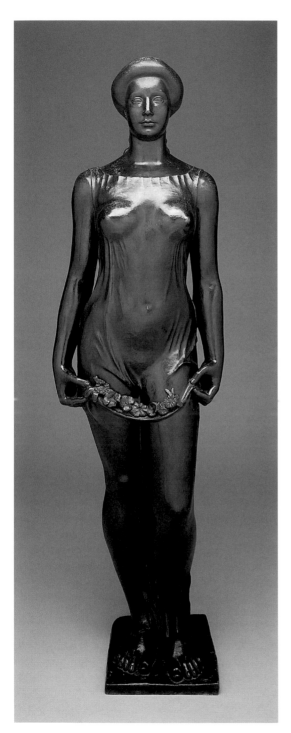

ARISTIDE MAILLOL
(French, 1861–1944)

Flora, 1911
Bronze
65 × 19 × 13½ in. (165.1 × 48.3 × 34.3 cm)
Gift of Mr. and Mrs. Eugene McDermott, 1960.70

Aristide Maillol began his career as a painter and tapestry designer working in the decorative style of the Nabis, a group of artists inspired by the simplicity of line, flat patterning, and expressive color theory of Paul Gauguin's work in Brittany. By the latter half of the 1890s, however, the intricacy of Maillol's tapestry work was threatening his eyesight, and he turned entirely to sculpture.

At the turn of the century, Auguste Rodin's highly naturalistic and emotionally charged work was the dominant force in the revival of sculpture. While undoubtedly inspired to observe nature by Rodin's example, Maillol was primarily concerned with a classical purity of line and form. This emphasis is readily apparent in *Flora*, where the figure's graceful pose, emotional tranquility, and clinging, translucent drapery recall ancient statuary. Typical of Maillol's idealized female figures, *Flora* fuses the serenity and monumental presence of the classical tradition with the immediacy and vitality of a naturalistic depiction. *Flora*, however, is no mere pastiche of styles and vocabulary. The symbolic significance of *Flora*—an embodiment of the bounty of nature—finds direct expression in the figure's full, rounded torso and sturdy limbs. By balancing real, human characteristics with eternal, idealized forms, Maillol dynamically reinvented the classical tradition with a modern sensibility. SRH

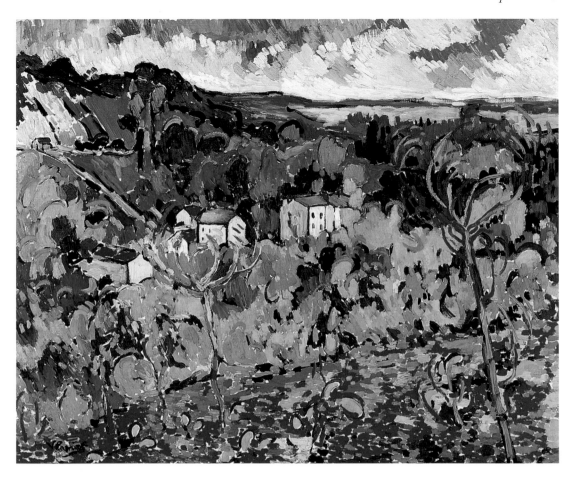

MAURICE DE VLAMINCK
(French, 1876–1958)

Bougival, c. 1905
Oil on canvas
32½ × 39⅝ in. (82.6 × 100.7 cm)
The Wendy and Emery Reves Collection, 1985.R.82
© 1997 Artists Rights Society (ARS), New York/ADAGP, Paris

The term "fauvism" was coined in 1905 when
a critic used "wild beasts" *(les fauves)* to describe
a group of artists who employed pure, nonrealis-
tic color and aggressive brushwork. Vlaminck,
along with Henri Matisse and André Derain,
were the major proponents of this movement.
They sought to rejuvenate painting and to dis-
tinguish themselves from the legacy of impres-
sionism and postimpressionism, by regarding
nature not as the subject of their art but as a
vehicle for the release of their imagination.

Bougival is one of the finest compositions
Vlaminck painted during his brief yet prolific
period as a fauve painter. It is characterized by
a strong compositional balance, harmony of
vibrant colors, and confident placement of
brushstrokes. Following the French classical
tradition of landscape painting, Vlaminck orga-
nized the canvas into three zones. Vibrant yel-
lows and reds, highlighted by dashes of pink,
animate the foreground, while deeper greens,
blues, and yellows dominate the middle of the
picture. In the background, a softer blend of
colors creates an impression of deeper spatial
recession in the river and sky. While the palette
indicates his reverence for Vincent van Gogh's
emotional use of color, Vlaminck's compositional
format reflects his awareness of Paul Cézanne's
classically structured landscapes. Fusing these
two contradictory traditions, Vlaminck trans-
lated the environs of Bougival into an expressive
vision that allows us to feel the immediacy of
his response to the landscape. SRH

WASSILY KANDINSKY
(Russian, active in France, 1866–1944)
Houses in Murnau, 1908
Oil on paper mounted on Masonite
19⅞ × 25 in. (50.5 × 63.5 cm)
Dallas Art Association Purchase, 1963.31

Kandinsky was one of the first artists of the early twentieth century to produce abstract paintings. Inspired by mysticism, his ultimate goal was to invest his work with spiritual meaning but without directly representing a subject. His style progressed rapidly as he learned to capture the essence of a subject through printmaking with woodcut, and from the dynamic palette of the fauve painters, he realized the expressive potential of color.

It was shortly after Kandinsky discovered Murnau, a village at the foot of the Bavarian Alps, that the artist made a revolutionary breakthrough to abstraction. The pristine beauty of this landscape apparently exerted a liberating influence on his painting style which is evident in the slashing and swirling brushstrokes that create both identifiable elements as well as areas of pure color in *Houses in Murnau*. Using luminous pinks, yellows, blues, and greens and casting deep shadows at the right, Kandinsky conveyed the intense subalpine sunlight striking the village. The high-keyed palette, flattened forms, and nonillusionistic space reflect Kandinsky's belief in expressing his emotions through a subjective use of color, line, and form. Working in the brilliant light of Murnau, Kandinsky experimented increasingly with two-dimensionality and the freeing of color from line to create abstract forms, the first steps in his path toward nonobjective painting. *Houses in Murnau* marks a critical stage when the artist was evidently giving freer expression to his mystical feelings and imagination, and shortly thereafter, between 1910 and 1914, Kandinsky created some of his first abstract paintings. SRH

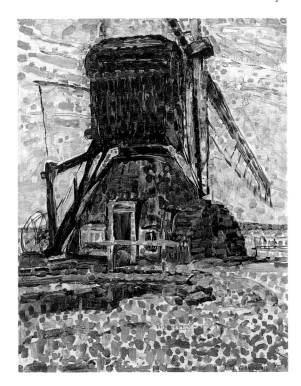

PIET MONDRIAN
(Dutch, 1872–1944)

Windmill, 1908
Oil on canvas
17¼ × 13½ in. (43.8 × 34.3 cm)
Foundation for the Arts Collection, gift of
the James H. and Lillian Clark Foundation,
1982.25.FA
© 1997 Mondrian estate/Holtzman Trust

Recently discovered contemporary photographs reveal that this painting
apparently depicts a specific windmill in the countryside not far from
Amsterdam, where Mondrian lived from 1892 to 1912. The painting
demonstrates Mondrian's experimentation with a broad postimpressionist-
inspired pointillist technique and also his manipulation of bright, non-
descriptive colors. Another version of the subject (Gemeentemuseum,
The Hague) is even more striking in its brilliant palette of primary colors
and in fact caused a critical stir during the artist's 1909 retrospective in
Amsterdam. The more subdued coloration of the Dallas version embraces
a range of orange, green, and purple.

In these works, Mondrian discovered the essential pictorial vocabulary
that would become the basis of his later abstract works: pure color is
applied in individual patches, which here function like building blocks.
Moreover, the imposing verticality of the windmill against the radiant,
sky-dominated landscape must be understood within the process by which
Mondrian extrapolated his radically reductive abstract vocabulary from
the essential forms in nature. In studies of windmills, church facades, light-
houses, dunes, and trees, Mondrian discovered the eloquence of basic verti-
cals and horizontals, which are expressive of stasis, of expansion, and of
the vast and opposing forces of nature. DK

KÄTHE KOLLWITZ
(German, 1867–1945)

Memorial Sheet to Karl Liebknecht, 1919–20
Woodcut on paper
17½ × 22⅜ in. (44.5 × 56.8 cm)
Gift of Mrs. A. E. Zonne, 1942.109

The German expressionist artist Käthe Kollwitz intended to become a painter, but devoted her career to drawing, printmaking, and sculpture. While other artists of her generation experimented with abstraction, Kollwitz never swayed from studying the human form. Her intensely expressive figures communicate strong emotions through facial expressions and gestures.

Kollwitz believed that art should serve a noble and ulterior purpose—it should speak to the people. She preferred etchings and lithographs so that her work could be reproduced and distributed widely and cheaply. She continually repeated favored themes and forms as the basis of her social commentary: images of mother and child, her own self-portrait, and images of death, endurance, war, and suffering.

This woodcut depicts workers gathered to mourn their dead leader, Karl Liebknecht, a leftist revolutionary who was assassinated in 1919 during the turbulent years of Germany's Weimar Republic. The facial expressions and general composition recall traditional images of the Lamentation of Christ, an allusion further emphasized by the halo of bright marks around Liebknecht's head.

Memorial Sheet to Karl Liebknecht exemplifies Kollwitz's two passions: printmaking and social engagement. The death of her son in World War I and the atrocities associated with the political strife of the Weimar Republic moved Kollwitz to seek new artistic and technical means. Inspired by the expressionist woodcuts of Ernst Barlach, she was convinced that the woodcut technique would communicate her message most clearly. This print was her first experiment in the medium, and its simplicity and stark contrasts emphasize Kollwitz's essential emotional eloquence. MK

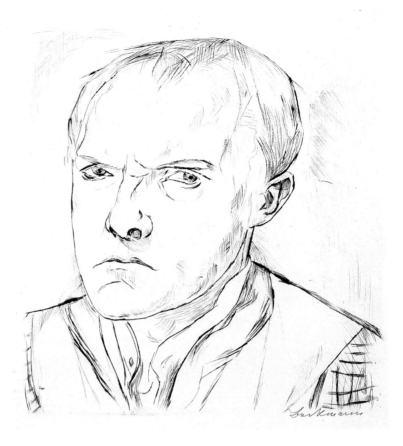

MAX BECKMANN
(German, 1884–1950)

Self-Portrait, 1918
Drypoint on paper
18¾ × 13¼ in. (47.6 × 33.7 cm)
Junior League of Dallas Purchase Fund, 1953.5

Beckmann was a respected and successful artist even at an early age. Ironically, his prestige led to his inclusion in 1937 in the infamous *Degenerate Art* exhibition organized by the National Socialists to single out and belittle artists whose aesthetics were unacceptable to Nazi politics. This brought his career in Germany to an abrupt halt, and thereafter he worked in Amsterdam and the United States, winning recognition as one of the most influential, prolific, and substantial artists of the twentieth century.

An important leitmotif throughout his career, the self-portrait offers insight not only to Beckmann's personality but to his notion of the importance of the artist to society as a prophet of truth. The bold, confident poses in his early self-portraits contrast with the alternately stern or meek postures he depicted during and after World War I. The self-portraits dating from his final years in America reveal Beckmann's regained confidence and artistic and emotional maturity.

This self-portrait dates from 1918, after Beckmann's service in World War I. In reaction to his traumatic experiences of the horror and brutality of war, Beckmann created a series of distressed self-portraits which range in emotion from moody and depressive to bitter and stern. In this image, Beckmann confronts the viewer with dramatic intensity. His stubbornly set chin, furrowed brow, and seething eyes are drawn with a firm, unhesitating line. The head dominates the paper, suggesting a sense of confinement which may parallel the bitter resentment and alienation that Beckmann felt after the war.

MK

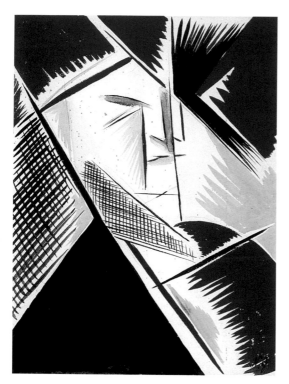

NATALIA GONCHAROVA
(Russian, active in France, 1881–1962)

Maquillage, 1913
Gouache on paper
6⅜ × 4¾ in. (16.2 × 12.1 cm)
General Acquisitions Fund, 1981.37
© 1997 Artists Rights Society (ARS), New York/ADAGP, Paris

The lively *Maquillage* is a tangible example of
the artistic forces surrounding the origins of
the Russian avant-garde and its technical inno-
vations. Fragmented volumes represent cubism;
deeply saturated yellow, red, and black are evi-
dence of fauvism's influence; and the violent
intersections of arcs and rays point to Italian
futurism. But *Maquillage* is no simple hybrid; it
is a pictorial bridge, linking those artistic trends
to a new expression of Russian artistic culture,
rayism.

Established in 1912 by Goncharova's lifelong
companion, Mikhail Larionov, rayism focused
its artistic eye on the rays of color and light that
emanate from an object. By manipulating the
intersection of these rays in space, the artist
created new forms and planes. *Maquillage* beauti-
fully illustrates this novel concept. The seem-
ingly banal subject of a woman making up her
face, barely discernible at the center of the work,
has greater impact amid the explosion of color
and line. Her visage appears and disappears
among needle-sharp rays, which shatter both its
figurative integrity and the pictorial space that
surrounds it. Red, yellow, and black heighten the
intensity of the new forms created by various
combinations of line. Through this novel use
of color and line, Goncharova invents a fourth
dimension punctuated by energetic dynamism
and violent movement. Yet its technical value
serves to make it a work of significant historical
importance. In Russia, rayism was the first step
toward completely nonobjective art. This work
represents the Russian avant-garde's distinctive
contribution toward the revolutionary evolution
of total abstraction. KHB

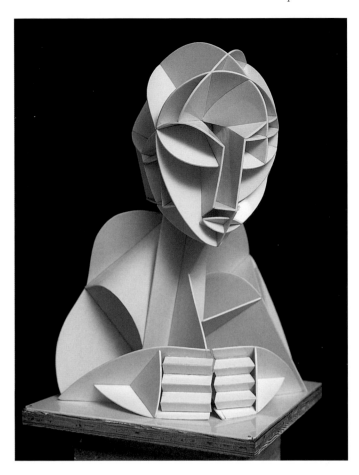

NAUM GABO
(Naum Neemia Pevsner, Russian, active in
America, 1890–1977)

Constructed Head No. 2, original design 1916,
celluloid version 1923–24
Celluloid
17 × 12¼ × 12¼ in. (43.2 × 31.1 × 31.1 cm)
Edward S. Marcus Memorial Fund, 1981.35
© 1997 Nina Williams

Naum Gabo, one of the leading proponents of
constructivism, was among a generation of art-
ists who sought new visual forms and materials
to express the enormous changes of the modern
world at the beginning of the twentieth century.
He studied engineering in Munich from 1910
to 1914 but quickly became interested in art
through his brother Antoine Pevsner, who was
active as a painter and who introduced Gabo
to the Parisian avant-garde in 1913–14. Gabo's
first important series of sculpture constructions
includes *Constructed Head No. 2*. It is a paradigm
of the artist's radical constructivist approach to
structure and movement and, in its material and
form, embodies his fascination with technologi-
cal innovations and modern concepts of the
nature of space. Instead of modeling the figure
from a solid mass in the traditional method, he
built the head and torso by attaching curved and
flat planes to a common core, evoking a sense of
motion. Although the influence of the cubists'
fragmentation of human anatomy is clear, Gabo
is even more radical in abstracting the figure.
Space becomes an expressive element in the
figure's design, which he based on a carefully
conceived geometric diagram.

The sculpture exists in several versions: dur-
ing World War I, perhaps due to the scarcity
of materials, Gabo created the initial maquette
in cardboard and later, in 1917, he made a ver-
sion in galvanized iron. In 1923–24 Gabo used
the same measurements for this model, which
represents a pioneering use of celluloid plastic
in sculptural form. SRH

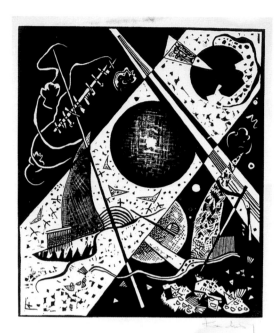

WASSILY KANDINSKY
(Russian, active in France 1866–1944)
Kleine Welten VI (Small Worlds VI), 1922
Woodcut on paper
10⅞ × 9¼ in. (27.6 × 23.5 cm)
Given in memory of Sydney Hobart Carter by
his wife, 1972.34.1

In 1921 Wassily Kandinsky took a teaching
position at the newly formed school of modern
design, the Bauhaus, in Weimar. A portfolio of
twelve prints, *Kleine Welten*, or *Small Worlds*,
was Kandinsky's first creation after joining the
school. As a group, the images create a dialogue,
although as the title suggests, each also func-
tions as a microcosm.

Small Worlds VI represents Kandinsky's view
that art should express an inner life through a
vocabulary of cosmic forms. Within his oeuvre it
is both retrospective and forward-looking, for it
forges a link between the more representational
works of the artist's earlier years and the new
vision of the Bauhaus era.

Traces of readable imagery are found in
the double sails that flank the scene and in the
elemental landscape motifs scattered through-
out. The impact of Russian constructivism is
clear in the orchestration of geometric elements,
although by infusing each element of the image
with meaning, Kandinsky departs from the
constructivists, who actively discouraged such
expressiveness.

The dark circle at the center of the image
serves as a visual anchor for the free-floating
circles, triangles, and diagonals. There is an illu-
sion of movement, as though each form pulsates
with its own internal energy. Nondescriptive
hues and abstract shapes are juxtaposed with
representational forms. The opposition of black
and white accentuates the sense of playful, fluc-
tuating movement. In contrast, the circle, sym-
bol of perfection and the cosmos, establishes a
calm center and contributes to the spiritual aura
of the work. This woodcut presents, perhaps, an
image of the confrontation of the material world
with the transcendental. KHB

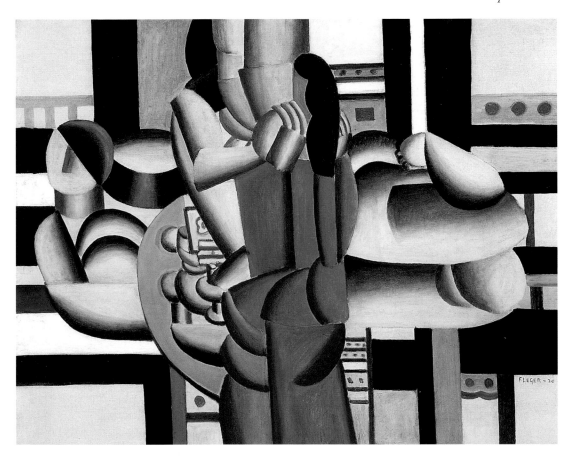

FERNAND LÉGER
(French, 1881–1955)

Three Women and Still Life, Déjeuner, 1920
Oil on canvas
39¼ × 46¾ in. (99.7 × 118.8 cm)
Foundation for the Arts Collection, gift of the
James H. and Lillian Clark Foundation, 1982.27.FA
© 1997 Artists Rights Society (ARS), New York/ADAGP, Paris

The dominant element of *Three Women and Still Life, Déjeuner*, is the female odalisque—at once modern in its stylization and yet suggestive of the classical aesthetic tradition. The massive figures are colored a cool, sleek, gun metal gray, which can be tied to the subdued tones of analytical cubism but also evokes the marbles of antique sculpture.

Léger's dialogue with tradition is always balanced, however, with the artist's unceasing exploration of an inventive pictorial vocabulary of machine-inspired objects and fragments whose clarity and precision were key elements of the painting style known as purism. The distortion of anatomy is readily apparent in the two women standing at the center of the composition, reduced to a columnar assemblage of gently convex elements. The monumental female figures are characterized by a certain impassivity or emotional neutrality. Their limbs are exaggerated; body parts are isolated. Anatomical elements take on the same pictorial significance as the essentially abstract forms of the background or the generic, purist-inspired objects of the still life toward the center of the composition. Léger never forsakes the principle of plastic contrasts which guided his earlier, almost purely abstract paintings. Not only is human anatomy dissected and distorted, but it is audaciously set against the juxtaposed color planes of the architectural background, a passage clearly inspired by the reductive aesthetic principles of the de Stijl movement. DK

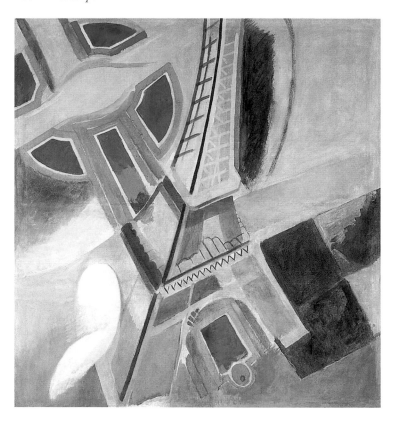

ROBERT DELAUNAY
(French, 1885–1941)

The Eiffel Tower, 1924
Oil on canvas
72½ × 68⅝ in. (184.2 × 174.3 cm)
Gift of the Meadows Foundation, Incorporated,
1981.105

The Eiffel Tower with its soaring wrought iron girders, erected for the Paris International Exposition in 1900, was already an icon of modernity when Delaunay painted it in 1924. The whirling propeller forms at the upper left are also symbols of technological advancement, an allusion to pilot Louis Blériot and his unprecedented flight across the English Channel in 1909. Beginning in 1910 Delaunay painted a series of works devoted to the Eiffel Tower, Blériot's flight, the great Ferris wheel, and the city of Paris. These paintings occurred in the context of other contemporary literary and artistic masterworks created as paeans of optimistic belief in the achievements of the modern industrial world.

With the pastichelike jumble of multiple perspectives—bird's-eye view toward the tower; down on the Champ de Mars; head-on toward the cruciform pattern of the propellers—the artist attempts to capture the dizzying effects of height and speed. Delaunay communicated his euphoric attitude toward the modern world most directly, however, in the explosive symphony of nondescriptive color—pink and green, saffron and orange, purple and blue—which floats in patches that emphasize the two-dimensional surface of the canvas. Delaunay's audacious use of bright colors articulated independently of form inspired the avant-garde poet Guillaume Apollinaire to coin the term "orphic cubism" in 1912. Indeed, by that time Delaunay was experimenting with purely abstract disks and circular forms in which color, entirely free from descriptive function, rhythmically interacts in ways not unlike the simultaneity of music.

DK

JACQUES LIPCHITZ
(French, born Lithuania, 1891–1973)

The Bather, 1923–25
Bronze
78⅛ × 31⅛ × 27¾ in. (198.4 × 79.1 × 70.5 cm)
Gift of Mr. and Mrs. Algur H. Meadows and the
Meadows Foundation, Incorporated, 1967.20

Lipchitz's *Bather* combines cubist-inspired
stylization and abstraction with a nod to the
French classicist figural tradition that extends
even to the choice of material and technique—
cast bronze. The massive limbs of this figure
are comparable to the geometricized and frag-
mented body parts in Fernand Léger's monu-
mental odalisques (p. 127). *The Bather* can also
be situated close to Pablo Picasso's classically
inspired and equally massive bathers executed
in 1922.

An assemblage of distinct and reductive ele-
ments, this sculpture is an interplay of concave
and convex forms. The relative readability of
a few important details reveals its identity as
human figure: the small round "eye," for instance,
helps to articulate the face; the gentle slope of an
almost horizontal line suggests a shoulder; and
a slight bend in the profile of the legs connotes
knees. The manner in which the legs are trun-
cated by the bronze base suggests, uncannily,
that the figure is wading through water, even
holding up skirts above an aqueous surface. The
artist achieves a delicate balance, then, between
descriptive details and broader abstract forms.

DK

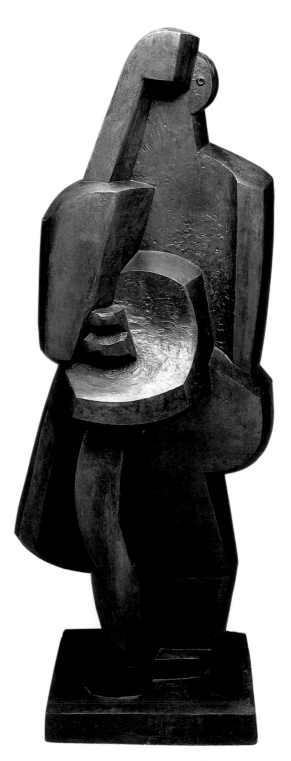

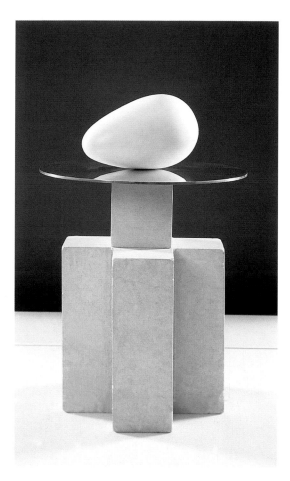

CONSTANTIN BRANCUSI
(Romanian, active in France, 1876–1957)

Beginning of the World, c. 1920
Marble, metal, and stone
30 × 20 × 20 in. (76.2 × 50.8 × 50.8 cm)
Foundation for the Arts Collection, gift of
Mr. and Mrs. James H. Clark, 1977.51.FA

A contemplative examination of elemental forms drawn from an elegant manipulation of basic materials, *Beginning of the World* is exemplary of Brancusi's oeuvre. In his quiet consideration of essential metaphysical issues, Brancusi clung to a relatively narrow range of identifiable forms—eggs, heads, heads resting on necks, birds, columns—and their nonobjective counterparts—ovoids, arching streamlined shapes, mounting stacked objects. Each shape is infused with meaning to reveal its inner significance through the artist's humble attention to the inherent qualities and demands of shape and material.

Like so many of his contemporaries at the turn of the century—the symbolists, the early abstractionists including Piet Mondrian, František Kupka, and Kasimir Malevich—as Brancusi strove to give expression to spiritual themes and philosophical issues, he discovered the most eloquent means of expression in nondescriptive or totally abstract forms. Here the marble ovoid rests delicately, even precariously, on a round, polished metal surface. The sculpture is redolent with a diverse range of associations: new life, a precious newborn resting on a birthing dish or a severed head on a salver, an image comparable to the tiny disembodied elements that float in the works of Odilon Redon. The marble ovoid and mirrored metal disk are not anchored but rest on the cruciform limestone base, which reinforces an aura of solemnity. Indeed, Brancusi's sober reexamination of the basics of sculpture, the essence of its materials, and the subtle relationship of object to base/pedestal, constitutes his crucial contribution to modern sculpture in the twentieth century. DK

PIET MONDRIAN
(Dutch, 1872–1944)

Self-Portrait, 1942
Ink and charcoal on paper
25 × 19 in. (63.5 × 48.3 cm)
Foundation for the Arts Collection, gift of the
James H. and Lillian Clark Foundation, 1982.23.FA

Striving to express unity and order, Piet
Mondrian evolved an abstract vocabulary by
reducing features in nature to elemental forms,
lines, and colors. Eventually he eliminated all
references to the natural world, achieving an
entirely nonrepresentational, nonobjective
art, which he called neoplasticism. In his early
career, Mondrian embraced in rapid succession
impressionism and an expressionist style influ-
enced by the works of Vincent van Gogh and
other postimpressionists. After he moved to
Paris in 1909, his work was dramatically influ-
enced by the paintings of Paul Cézanne and,
in particular, the cubism of Pablo Picasso,
Georges Braque, and Juan Gris, whose impact
is especially evident in this self-portrait.

Mondrian created a number of revealing
self-portrait drawings. His earlier, more repre-
sentational portraits, which tend to focus on
the expression of his eyes, appear to be exercises
in self-examination. Increasingly, however, he
experimented with simplifying and distilling his
visage. Repeatedly reworking his image in the
half-profile pose, Mondrian seemed to heighten
the degree of abstraction with each portrait.
For this composition, Mondrian adopted the
cubists' fragmentation of form for the treatment
of the head and shoulders, reducing his profile
to a network of lines and angles, which inter-
sect and overlap in the head and upper body to
create planes suggesting volume. Yet through
the sharp interplay of lines, the artist's physical
characteristics and personality appear. The
tightly closed lips and square jawbone mirror
Mondrian's pronounced facial features, while the
raised eyebrow and glance toward the viewer
project his confident disposition. SRH

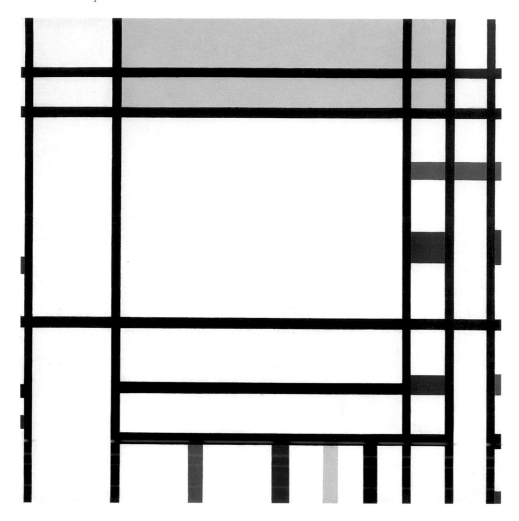

PIET MONDRIAN
(Dutch, 1872–1944)

Place de la Concorde, 1938–43
Oil on canvas
37 × 37¼ in. (94 × 94.3 cm)
Foundation for the Arts Collection, gift of the
James H. and Lillian Clark Foundation, 1982.22.FA

Piet Mondrian's *Place de la Concorde* is a master-
work of the artist's mature style, a completely
nonrepresentational art which he called neo-
plasticism. He established a dynamic balance be-
tween a system of horizontal and vertical black
stripes, and yellow, red, and blue rectangular
blocks of color. The black lines and the areas
they enclose are not standardized; each is care-
fully modulated with subtle differences in den-
sity and width. This linear network, neither
rigid nor static, constitutes an animated and
energetic pattern with irregular sequences. The
way in which a line stops or addresses either
adjacent lines or the edges of the composition is
especially charged.

Even with its geometric simplicity and
balance, the composition seems to pulsate with
the energy of the city it celebrates. It is eloquent
testimony of Mondrian's enduring idealistic
faith in the expressive power of a radically
reduced vocabulary of vertical and horizontal
lines, primary colors, and planes. Consistent
with the neoplastic aesthetic he had developed
in the 1920s, this painting is remote from any
notion of realistic reproduction. It is a mode
of expression that transcends particular or
individual emotions. DK

RENÉ MAGRITTE
(Belgian, 1898–1967)

The Light of Coincidences, 1933
Oil on canvas
23⅝ × 28¾ in. (60 × 73 cm)
Gift of Mr. and Mrs. Jake L. Hamon, 1981.9

For the surrealist René Magritte, painting was a means of transcending reality to probe the mysteries of life. In contrast to other members of the surrealist movement who probed the subconscious through trance states and automatic techniques, creating fantastic creatures and bizarre forms, Magritte developed a form of magic realism. He removed familiar objects, images, and sometimes words from their normal functions, arranged them in uncommon ways, and painted them with a precise realism or literalness that defies common sense and assaults the viewer's preconceived notions of the everyday world.

In *The Light of Coincidences* Magritte questions the nature of art and reality. The antique torso and baroque motif of the candlelit interior are symbols of the representational traditions in art that had been cast aside by modernism. Magritte toys with the ambiguity between real space and spatial illusion by incorporating a picture of a sculpted woman's torso within the painting. The torso, which in reality would be a three-dimensional object in space, is depicted instead as the subject of a framed painting on an easel. This "painting," however, is highly realistic and introduces, via its trompe l'oeil precision, another "space" within Magritte's composition.

The Light of Coincidences can be seen as an answer to Magritte's questions concerning the nature of light. According to Magritte, light is only real when received by an object. In this way, by illuminating the woman's torso with a candle flame, he has made light visible. Moreover, the candle establishes a mood of quietude and heightens the mysterious aura that was critical to his paintings. SRH

ALBERTO GIACOMETTI
(Swiss, 1901–1966)

Three Men Walking, 1948–49
Bronze
29¾ × 12½ × 13⅛ in. (75.6 × 31.8 × 33.3 cm)
Foundation for the Arts Collection, gift of Mr. and
Mrs. Stanley Marcus, 1975.86.FA

After initially creating works under the influence of primitive art, cubism, and surrealism, in 1935 Giacometti shifted to an almost exclusive preoccupation with the human figure which endured throughout his life. Through the figure he sought to convey his perceptions of the world and the reality of human existence, a theme enriched in the postwar years by existentialist philosophy. It was during these years that Giacometti developed his mature style of figure sculptures that often stand alone or are separated from one another in groups, suggesting comparison with existentialism's emphasis on the isolation of individual experience.

Three Men Walking is an early example of Giacometti's group compositions and reveals the artist's powerful vision of the human body moving through space. Fragile yet dramatic in stature, the attenuated figures confront the viewer as powerful symbols of alienation and anxiety. The directness and simplicity of their handling seem to derive from Giacometti's admiration for primitive art, while their haunting presence reflects his own surrealist phase of expressing irrational themes. Giacometti created these figures by repeatedly building, destroying, and rebuilding them from wet clay, later casting them in bronze. Ravaged and emaciated, they may symbolize the terrors of World War II and its aftermath, although their elongated forms seem to suggest a spirit of survival. SRH

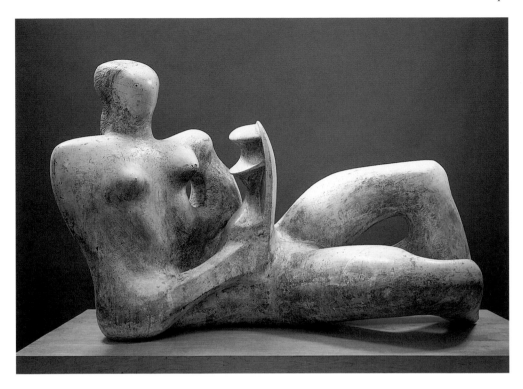

HENRY MOORE
(British, 1898–1986)

Reclining Mother and Child, 1974–76
Plaster
51½ × 80 × 40½ in. (130.8 × 203.2 × 102.9 cm)
Lent by the Henry Moore Foundation, 2.1979

Henry Moore was Great Britain's preeminent sculptor of the twentieth century. Throughout his career, which spanned more than sixty years, the human figure was the dominant theme of his work. In his formative years he was interested in cubism, constructivism, and surrealism, incorporating, for instance, the surrealists' notion of hidden meanings in primal shapes into his own highly personal aesthetic. Important influences on Moore's sculpture included tribal and classical art as well as the contemporary sculpture of Constantin Brancusi (p. 130). His most crucial source of inspiration, however, was nature, particularly the rolling hills and caverns of his native landscape.

In *Reclining Mother and Child*, Moore fused the two ideas that he referred to as his obsessions: the subject of a mother and child, and the figure in the reclining position. The theme of a mother and child provided Moore with numerous aesthetic and psychological possibilities for infusing his sculpture with vitality. In this work the mother's full forms and flowing lines, from her curving shoulders to her powerfully arched legs, suggest maternal energy and, at the same time, recall undulating hillsides. The radically simplified figure of the child cradled in its mother's arms has a powerful, almost primitive symbolism. Consistent with his idea that sculpture should be viewed from all angles, Moore established voids between the limbs and body, making space continuous from one side of the image to the other. This is the original plaster from which later bronzes were cast. It reveals the raw power of Moore's modeling and the timeless and monumental qualities of his style. SRH

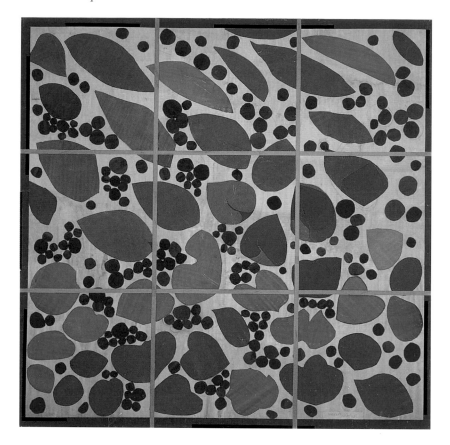

HENRI MATISSE
(French, 1869–1954)

Ivy in Flower, 1953
Colored paper, watercolor, pencil, and brown paper
tape on paper mounted on canvas
112 × 112 in. (284.5 × 284.5 cm)
Foundation for the Arts Collection, gift of the Albert
and Mary Lasker Foundation, 1963.68.FA

The exuberance of the pattern of leaves and
flowers in Matisse's *Ivy in Flower* is held in check
by its grid of nine paper "panels." The composi-
tion is a maquette for a stained glass window
intended for the mausoleum of Albert Lasker,
which accounts for the structure, and especially
for the vine motif, symbol of eternal life. The
work is, however, neither anecdotal nor descrip-
tive, and if it carries a message of everlasting
life, it is through a radiance suggesting an inner
light.

For Matisse the work was a personal victory
over the adversity of failing eyesight. Assistants
provided him with stacks of paper densely
painted with gouache. He cut the forms with
scissors, thereafter orchestrating color shapes
into a composition that integrated the negative
space of the background. With this pasted paper
technique, the stroke of pen or brush is replaced
by the cut of the scissors, allowing for an imme-
diate coordination of mind, eye, and hand. Each
leaf and flower—or "sign" of leaf or flower, for
these shapes are elegant distillations from real-
ity—is charged with a physicality derived from
Matisse's powerfully intuitive gesture. Using
this technique, Matisse created compositions
for commissions which were carried out eventu-
ally in different media (as here, in stained glass).
It was at this time that Matisse created his
famous designs for tiles, windows, and vest-
ments for the Dominican Chapelle du Rosaire
in Vence in the south of France. Matisse was the
brilliant colorist, the master of line, the deter-
mined sculptor. His pasted paper compositions
unite all these aspects of his career. DK

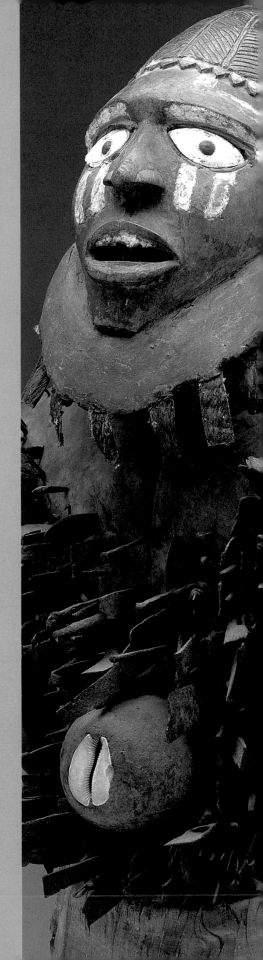

Sub-Saharan
Africa

Figure of a standing woman

Mali, Dogon people or possibly Djenné culture,
possibly 15th century
Wood
36⅜ × 6⅜ × 6¾ in. (92.4 × 16.2 × 17.2 cm)
The Gustave and Franyo Schindler Collection of
African Sculpture, gift of the McDermott Foundation
in honor of Eugene McDermott, 1974.SC.1

Style, condition, and patination establish the
great age of this work. It is related stylistically
to terra-cottas from the archaeological site of
Old Djenné. Djenné terra-cottas are provision-
ally dated from the tenth to seventeenth centu-
ries. This figure can also be linked to ancient
wood sculptures from Djenné and the Bandia-
gara escarpment, home to the Tellem and later
Dogon peoples, only 100 miles to the east. Cli-
matic conditions in much of sub-Saharan Africa
limit the quantity of wood sculpture that has
survived more than a century. The arid condi-
tions, however, of the Djenné area and the caves
of the Bandiagara escarpment preserved rare
and extraordinary examples of what may be the
oldest surviving wood sculpture in Africa.

This figure is immediately recognizable as
Western Sudanic in its long torso, columnar
neck, and elongated head. Its lines and slender
masses point to centuries of shared traditions of
artistic development and culture, resulting in a
homogeneity that can be observed across styles
of the region: those of the ancient cultures of the
Djenné and Bankoni areas, and of the Dogon,
Senufo, Bamana, Mossi, and Lobi peoples. Its
fluid, asymmetrical pose and the sense of a per-
sonage caught in a heightened state of interior
contemplation is reminiscent of the ancient
Djenné style. The glistening surface patination
links it with the oldest wood sculptures known
from this region which have been dated by car-
bon 14 testing from the twelfth to early six-
teenth centuries. RA

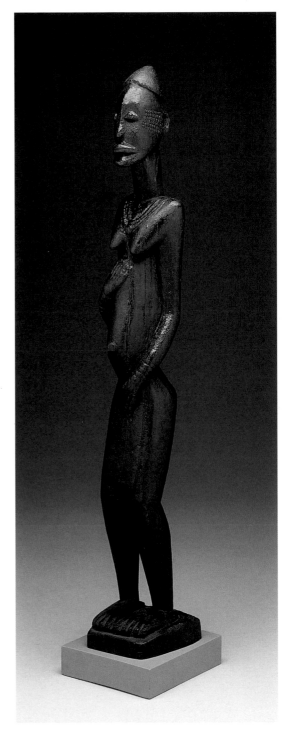

Spirit figure (deble)
Southeastern Mali, northern Senufo people,
19th–20th century
Wood, resin, and seeds
36⅜ × 8¼ × 6 in. diam. (92.4 × 21 × 15.2 cm)
The Gustave and Franyo Schindler Collection of
African Sculpture, gift of the McDermott Foundation
in honor of Eugene McDermott, 1974.SC.15.McD

There are two categories of Senufo spirit
figures: those used by the Poro society for static
displays and those used for dance and proces-
sion. This female figure of monumental dignity
and composure is a spirit figure in the black-
smith style, meaning that it has no feet and
minimally articulated hands. In the dialects of
the Senufo language, such sculpture has many
names. In the literature it has almost always
been called *deble*, meaning spirit figure. It is a
general term for all figural images referring to
otherworldly matters. Sculptures such as the
above are used by members of the Poro society
during funerals and initiation rites. In some
groups such figures are carried in procession
by initiates honoring elders gone to dwell in
the underworld among the honored dead. This
female figure would have been part of a pair,
carved and used with a male figure.

 During funeral ceremonies, as the body is
carried to the grave, several *deble* figures are
held at mid-arm by Poro associates and their
heavy bases are struck against the ground in
time to the dirge of large horns and drums.
This rhythmic pounding purifies the earth and
calls for the ancestors to participate in the cer-
emonies. When the earth is heaped on the body,
a male initiate may decisively pound it in place
with seven beats. RA

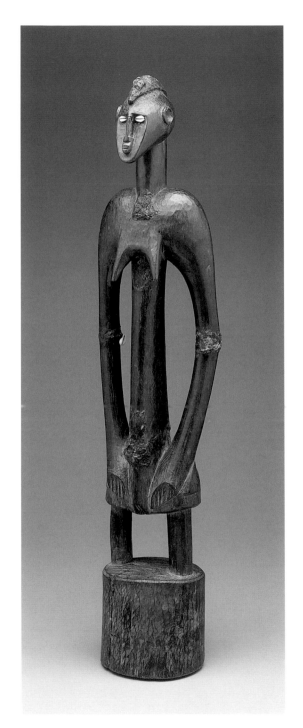

Drum

Côte d'Ivoire (Ivory Coast), central Senufo people,
Korhogo region, 1900–1930
Wood and hide
41⅛ × 16½ in. diam. (104.5 × 41.9 cm)
The Foundation for the Arts Collection, gift of
Mr. and Mrs. Stanley Marcus, 1981.139.FA

Drums serve a variety of purposes in African
societies. They assist in communication during
rites and ceremonies. They are not only musical
instruments but objects of prestige, and are an
integral part of the orchestras of chiefs. Like
other sculptural forms, drums are decorated
with pictographs and geometric motifs that
carry meanings linking them to important
cultural concepts.

Most Senufo sculpture is commissioned by
members of two gender-linked institutions
that, along with matrilineal kinship structures,
are the foundation of traditional society. These
are the Poro initiation and regulatory society,
and the Sandogo organization of women divin-
ers who facilitate communication between
human society and the spirit world. Accord-
ing to one scholar, this four-legged drum with
motifs carved in bas-relief is a type used in sev-
eral different contexts: the champion cultivator
contests for songs of praise; advancement cere-
monies for junior initiates, who "insult" senior
initiates through song; the funerals of descen-
dants of ruling or founding families; the com-
memorative funerals of the Tyekpa society
(women's Poro); and as war drums. RA

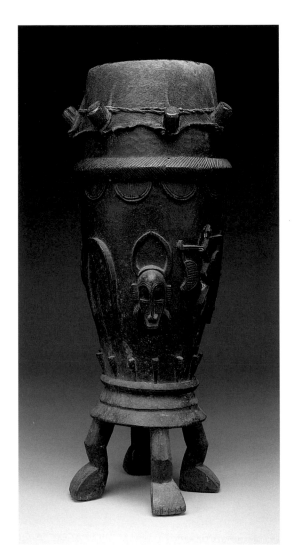

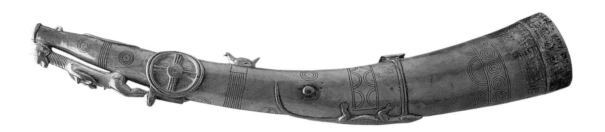

Trumpet (ho bului)

Sierra Leone, Tcham, Mende people, late 18th–
early 19th century

Ivory

23⅞ × 3 × 5⅜ in. (60.5 × 7.5 × 13.5 cm)

The Eugene and Margaret McDermott Art Fund,
Inc., 1994.198.McD

This unique and magnificent war horn *(ho bului)*
once belonged to a Mende chief. Its age and
fineness are attested by its lustrous, mellow
red-brown patina and the three-dimensionality
of its motifs. Its exceptional quality, refined styl-
ization, and the elaboration of its pictographs
suggest a date as early as the eighteenth century.

The Mende migrated into Sierra Leone
around the seventeenth century aggressively
displacing the conquered peoples. Warriors
scaled the walls of stockade towns and blew on a
small elephant-tusk trumpet to alert their com-
rades to come inside. Today trumpets are used
at certain celebrations and to warn of emergen-
cies; they are known as *ndolo maha bului* (para-
mount chief horns) for their association with
paramount chiefs. Contemporary Mende chiefs
carry horns and staffs as signs of office.

This trumpet is the only known example with
a complete figure, one which is closely related to
themes of female beauty in classic Mende figures
and Bundu masks. This is not surprising since
carvers of Bundu masks often sculpt ivory trum-
pets. The meaning of the other motifs, such as
the wheel, the lizard or crocodile, and what
might be a packet, perhaps an amulet, have pro-
tective connotations for the chief. The image of
the female figure holding her breasts, a sign of
nurturance or benediction, underscores the
theme of protection. RA

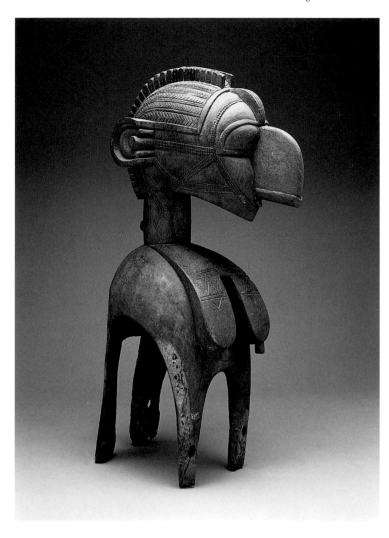

Headdress (nimba)

Guinea, Baga people, the Siremu, Pukur, or Bulunits
subgroup, 19th–20th century
Wood
48¾ × 16⅛ × 27¾ in. (123.8 × 41 × 70.5 cm)
The Gustave and Franyo Schindler Collection of
African Sculpture, gift of the McDermott Foundation
in honor of Eugene McDermott, 1974.SC.18

The *nimba* head and shoulder mask of the Baga
people has been erroneously described as repre-
senting a goddess. It symbolizes instead Baga
notions of feminine fecundity, a Baga mother,
and the quintessential woman. In Baga culture
the female is often a metaphor for the establish-
ment of culture. Most Baga claim that the *nimba*
or *d'mba* headdress was created after they ar-
rived on the coast of Guinea. The headdress and

the dance in which it was worn were noted
by observers as early as 1886; a seventeenth-
century Portuguese source possibly contains
the earliest reference to a *nimba*-like figure.

The great and pendulous breasts of the
museum's mask indicate that for a period
of years a mother gave nourishment and atten-
tion to her young. The breasts, delicate neck,
crested coiffure, and incised geometric patterns
representing scarifications together manifest
femaleness and fertility. Her crested coiffure, in
its preciseness and patterns, recalls one scholar's
assertion that for the Baga the civilized earth is
the "place of braiding." In masquerade the *nimba*
dancer is shrouded in raffia and/or cloth, and the
mask is petitioned for the fertility of the fields as
well as for the fertility of women. RA

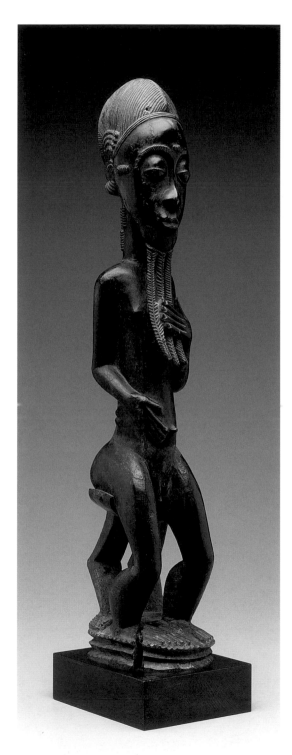

Seated Male Figure (blolo bian)

Côte d'Ivoire (Ivory Coast), Baule people,
late 19th century
Wood
H. 23¼ in. (59.1 cm)
The Eugene and Margaret McDermott Art Fund,
Inc., 1994.200.McD

The Baule, one of the Akan-related peoples who
reside along the coastal regions of the Ivory
Coast and Ghana, are an individualistic people
whose traditional government was decentralized
and without a paramount leader. Their figural
sculpture depicts nature spirits *(asie usu)* as well
as spirit spouses *(blolo bian* and *blolo bla)*, part-
ners the Baule believe everyone has in the spirit
world before they are born. The personal
shrines made for these figures are not used
for the public and communal worship of deities
or of royal or lineage ancestors. The figures
of nature spirits are almost identical to spirit
spouses and are distinguished only by the
sacrificial matter covering their surfaces.

 The spirit spouse is carved upon the recom-
mendation of a diviner when the otherworldly
spouse is thought to be causing problems for
the living spouse. Communication with the
otherworldly spouse comes in the form of
dreams. The shrine serves as a residence for the
troublemaking spirit spouse and becomes a focal
point where he or she can be appeased when
necessary. Not everyone is advised to make such
a shrine, but marital or fertility problems may
cause a diviner to suggest construction of one.
This figure would have been owned by a woman
who had it carved according to Baule ideals of
physical beauty and moral character. RA

Male figure

Northwestern Nigeria, Sokoto state, Yelwa,
Nok-related culture, 600–400 B.C.
Terra-cotta
19¼ × 9 × 8 in. (48.9 × 22.9 × 20.3 cm)
The Eugene and Margaret McDermott Art Fund,
Inc., 1994.195.McD

An image of great presence, age, and quality,
this large terra-cotta torso may have been an
altarpiece. It is certainly the image of a person
of authority. He rests one hand on his abdomen,
and with the other drapes an adze or ax over
his right shoulder. Beads encircle his neck. His
hooded eyes and pursed mouth emanate a con-
centrated force. The success and coherence
of gesture and attitude make it an object of
refinement.

The torso raises intriguing questions. It was
found in Nigeria in the northern state of Sokoto.
It relates stylistically to the oldest of the known
Niger River Complex terra-cotta traditions, the
ancient Nok culture (500 B.C.–A.D. 200), located
in central Nigeria on the Jos Plateau. The Sokoto
find is a new subdivision in the Nok corpus, and
the torso represents the best of this, as yet, little
known style.

The Sokoto torso is presently among the
earliest known images of authority — male and
female—destined for special village settings,
sacred spaces, or shrines. It is part of a long tra-
dition spanning a number of cultures through-
out Nigeria. Its beaded circlet with pectoral
pendant beads relates it most closely to similar
regalia in Nok, Ife, and, later, Yoruba art. Such
regalia is the signature of divine kingship in the
image of the priest/king. Accordingly, the figure
may have held a ram's horn in its missing hand.
The Sokoto torso also offers valuable informa-
tion about the longevity of certain customs asso-
ciated with the institution of chiefship and its
emblems of office, such as the ceremonial adze or
ax and beaded regalia. RA

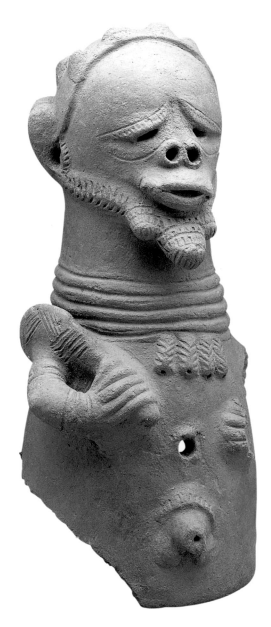

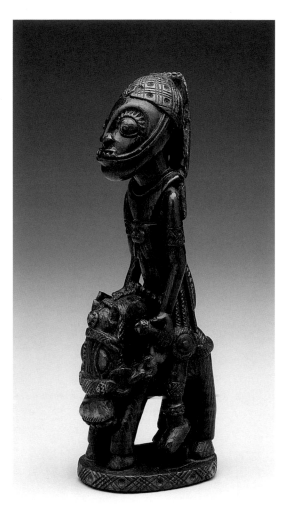

Equestrian figure
Southwestern Nigeria, Yoruba people,
Owo Yoruba, early 17th century
Ivory
6½ × 1¾ × 2⅜ in. (16.5 × 4.5 × 6 cm)
The Eugene and Margaret McDermott Art Fund,
Inc., 1994.197.McD

This miniature horse and rider from the Yoruba people, three centuries old, is a superb work carved with exquisite attention to detail. It has been attributed to the Owo Yoruba, although a very similar piece in a private collection has been designated as Oyo. The regalia of that figure, similar to the Dallas horse and rider in costume and style, resembles that of Oyo hunter-warrior chiefs. According to one Yoruba scholar, such figures could have been an emblem of office associated with palace officials at Oyo. A close reading of its costume, however, relates it to the equestrian figure of a well-known Owo Ifa divination cup from the collection of Mr. and Mrs. Robert Mnuchian. The Dallas figure is attributed to Owo based on its regalia that more closely recalls details of the figure on the Mnuchian cup.

The horse and rider motif is ubiquitous in Yoruba wood sculpture but rare in ivory. The equestrian figure is an important iconographic theme found on altars dedicated to Shango, a seventeenth-century king of the Yoruba city-state of Oyo-Ile. After his death, Shango became venerated as the deity of thunder and lightning. The mounted cavalryman was also an important personage in the armies of the various Yoruba kings. As a motif on house posts, the equestrian warrior is seen as a pillar of Yoruba society. The introduction of the horse from the north, across the Sahara, significantly influenced the imagery of Yoruba art. In this figure, the oneness of horse and rider and the largeness of the man compared to the compressed horse, which appears to be an extension of his body, underscore the military advantage of a mount to fighting men. The well-balanced details of the figure's teeth and the horse's bridle, the reins and helmet straps, reveal immediately the inventive aesthetic and intellectual decisions of the artist.

RA

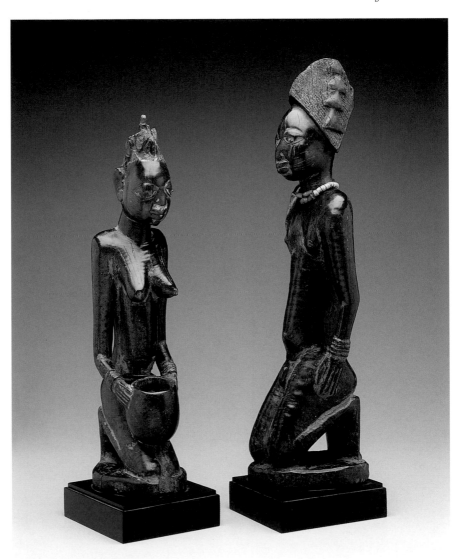

Kneeling male and female shrine figures

Nigeria, Yoruba peoples, 18th–19th century
Wood, indigo pigment, glass beads, coral(?) beads
Female: 18⅞ × 4⅛ × 5⅝ in. (47.9 × 10.5 × 14.3 cm)
Male: 21⅞ × 6 × 6 in. (55.6 × 15.2 × 15.2 cm)
The Eugene and Margaret McDermott Art Fund,
Inc., 1994.199.1.McD–.2.McD

This pair of shrine figures of two devotees may
or may not have been carved as a pair. They are
most certainly, however, by the same hand and
were carved at about the same time. Their age
is evident in their undulating surfaces, which
show the mark or "chatter" of traditional tools.
The luster of the pieces, the evidence of much

handling in the faded incised striations on the
surface, and the absolute sureness of the carving
are indications of earlier and extremely refined
work.

In the shrine context, the woman with offer-
ing bowl is the favorite theme of ideal female-
ness in Yoruba art and also indicates ideal
generosity. The figures were probably made for
a shrine to the deity Shango. This is supported
by the hunter's hat of the male figure, which
has thunder-celt motifs. Both the hunter's hat
and thunder celts are found on sculpture dedi-
cated to Shango. RA

Divination bowl (opon igede)

Southwestern Nigeria, Ekiti Yoruba people,
attributed to Arowogun of Osi Ilorin, c. 1920–40
Wood
20¼ × 17⅞ in. diam. (51.5 × 45.5 cm)
Gift of Carolyn C. and Dan C. Williams, 1984.57.a–b

This divination bowl is by the northern Ekiti
artist Arowogun (1880–1954), considered
among the greatest Yoruba sculptors of the
twentieth century. He not only carved these
massive bowls but also other shrine objects and
major architectural elements, such as verandah
posts and palace doors. Arowogun's works
repeat subjects and anecdotes he acquired under
the influence of some of the greatest Yoruba
carvers. On this bowl are found an equestrian
figure, flute players, drummers, soldiers with
guns, and a captive, all motifs associated with
royalty. The fezlike hats of the warriors recall
actual militia or cavalry that Arowogun saw

as a youth during years of slave raids in the hills
and forests of Ekiti. Arowogun conveys a won-
derful sense of the daily world and ritual life of
the northern Ekiti Yoruba of his time.

Figurated bowls are valued objects given,
for example, to the guests of a chief. In shrine
contexts they hold the equipment of a priest of
the cult. This bowl was possibly carved to hold
equipment used for Ifa divination, although it
lacks the customary arrangement of compart-
ments around a central circular element com-
mon to such bowls. It was intended for general
purposes in a shrine context. This appears to be
confirmed by the presence of figures related to
two different deities. On the lid is a figure which
can be interpreted as a priest of Ifa or Osanyin,
the medicine deity. The primary figure on the
base is a priest of Shango, the deity of thunder
and lightning, with his staff. RA

Pectoral plaque

Southwestern Nigeria, Benin,
Bini people, 1750–1800
Ivory
8 × 4⅜ × 2 in. (20.3 × 11 × 5 cm)
The Eugene and Margaret McDermott Art Fund,
Inc., 1994.201.McD

The Bini people and their kingdom of Benin flourished from the thirteenth to the nineteenth centuries. This rare ivory pendant displays an important and central theme of Benin art: the standing *oba* (king), arms raised by and resting on two attendants, his feet resting on a head with mud fish issuing from its nostrils. The mud fish is a royal symbol associated with Olokun, god of the sea. Olokun sometimes appears as an *oba*, and as a deity is associated with wealth and bounty, tying the *oba*'s temporal power to the metaphysical realm of spirits and the forces of nature.

Ivory plaques such as this magnificent example were probably worn for ceremonial occasions. They were sewn on ceremonial garments,

held in the hand, or suspended by cord. With superb detail, this plaque renders the heavy coral-beaded regalia worn by the *oba* to this day. The aesthetic brilliance of this piece rests in its active surface, which shows the strokes of the carving tool, in keeping with other important and old works in ivory. The position of the *oba* at the foreground of the composition is not only iconographically consistent with similar images, but the carver accomplished it by following the curve of the tusk. The use of ivory was controlled by kings and chiefs, and the amount of ivory lost to carve this piece manifests the opulence of the *oba*'s court. Only the court could afford to waste so much of a precious material.

RA

Figure of a chief

Southwestern Nigeria, Udo culture, 1600–1650
Bronze
19¼ × 6 × 4¾ in. (48.9 × 15.2 × 12.1 cm)
The Eugene and Margaret McDermott Art Fund,
Inc., 1994.196.McD

The village of Udo is approximately 40 miles
south of Benin City, and historically its artisans
competed with Benin in the production of metal
arts. Udo figural art is generally more lively in
expression than the more contained art of Benin,
which achieved great refinement in its early
period but grew more conventionalized over
time. Udo figural sculpture should be compared
with the middle period of Benin art from the
sixteenth to seventeenth centuries.

 This figure of an important personage has
the original oxidized laterite patina truly charac-
teristic of Benin and Benin-related bronzes and
plaques. (The shiny black surface popularly asso-
ciated with Benin art is actually the result of
the British penchant for cleaning and oiling
these works.) The iconography of costume and
gesture date it with a series of early seventeenth-
century plaques illustrating a similar figure.
The Udo artists appear to have specialized in
images of Europeans, but this figure clearly
chronicles the appearance and regalia of a local
royal personage. Like the art of Benin, the art
of Udo is a court art primarily concerned with
commemorating the important members of the
court and their lineages, and with documenting
beliefs, customs, dress, and regalia. The figure's
domed hat is a type seen at the *oba* of Benin's
court to the present day. RA

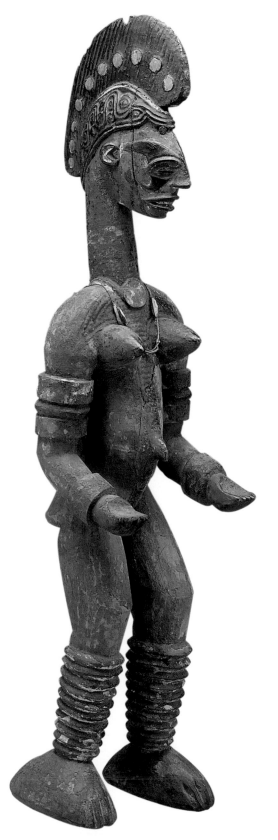

Standing female deity figure (alusi *or* agbara)

Nigeria, Igbo, 19th–20th century
Wood and pigment
36⅞ × 8¾ × 8½ in. (93.7 × 22.2 × 21.6 cm)
The Gustave and Franyo Schindler Collection of
African Sculpture, gift of the McDermott Foundation
in honor of Eugene McDermott, 1974.SC.29

This Igbo shrine figure represents a female
deity, one of a constellation of tutelary deities
called *alusi* or *agbara.* Encompassing places,
principles, and people, these unseen deities
include the earth, rivers, and other prominent
landscape features, markets (and the day on
which they are held), war, remote founding
ancestors, and legendary heroes. The deities
and their cults uphold the moral, social, and
ecological order.

 The head and scarifications of this figure are
very much like Igbo *mmwo* maiden masks, which
celebrate female beauty, and the scarifications
resemble patterns found on some Igbo pottery
vessels. Her heavy ivory bracelets and armlets
and metal leg bands are indications of high sta-
tus, accomplishments, and title. The red color of
the figure is camwood pigment, which is consid-
ered a beautifying agent. In the north-central
region of Igbo territory, for cult festivities, these
objects were repainted if necessary by women of
the cult, displayed publicly in groups of "fami-
lies," and given as gifts. The figure's outstretched
hands, palms up, indicate readiness to accept
sacrifices and identify the ancestor deity as al-
ways generous and honest. RA

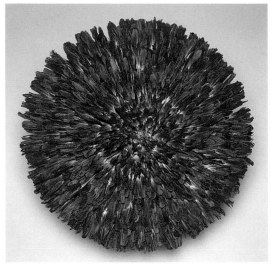

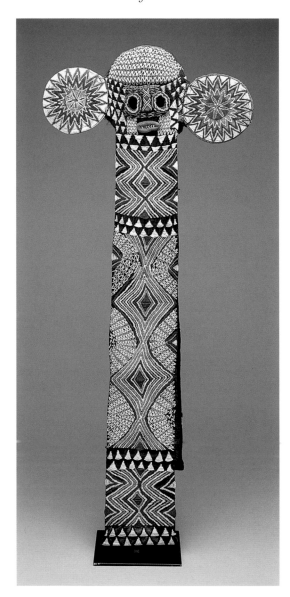

Elephant mask and hat

Cameroon Grasslands, Bamileke people, possibly village of Banjoun, c. 1910–30
Palm-leaf fiber textile, cotton textile, glass beads, palm-leaf ribs, wood, basketry, and feathers
Mask: 58 × 26 × 6½ in. (147.3 × 66 × 16.5 cm)
Hat: 9¾ × 32 in. diam. (24.8 × 81.3 cm)
Textile Purchase Fund, 1991.54.1–.2

Despite its disappearance in the wild across many landscapes of West and Central Africa, the elephant remains a potent image of political force and the accumulation of wealth by those in power. This has been and remains true for the art of the Cameroon Grasslands, the origin of this spectacular beaded elephant mask and feather hat. Such masks are from the Bamileke people, who have constructed a varied and impressive repertoire of beaded work.

The Bamileke elephant masquerade of beaded cloth is well known but has never been researched in depth. It probably began as the masquerade of regulatory societies connected to chiefs and later evolved into a symbol of prestige. It is danced at major festivals and at the funerals of chiefs and, probably, society members. The anthropomorphized mask of cloth trunk, stiff, round ears characteristic of the African elephant, and human face is only one part of a spectacular masquerade which also consists of a jacket of indigo-blue and white royal *ndop* cloth, trimmed with precious colobus monkey fur, a large skirt made also of *ndop* cloth, fly whisks decorated with beadwork, and rattle anklets. This ensemble is finished with a hat of the brilliant red feathers of the African gray parrot.

The elephant, python, and leopard are the familiars of chiefs and kings, and variously represent their authority, power, wealth, and military strength. The elephant is an especially apt metaphor for crushing might, a fundamental symbol of the court regalia and masquerades of kingdoms and chiefdoms. When displayed following campaigns of conquest, these works were meant to awe and impress vanquished peoples with the absolute might of their new rulers.

RA

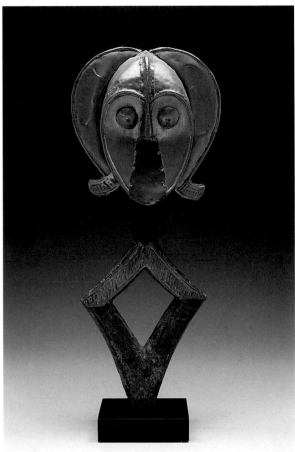

Reliquary figure (mbulu ngulu)
Gabon, Kota people, 19th–20th century
Wood and brass
19⅛ × 8⅛ × 3⅜ in. (48.6 × 20.3 × 8.6 cm)
The Gustave and Franyo Schindler Collection of
African Sculpture, gift of the McDermott Foundation
in honor of Eugene McDermott, 1974.SC.35

This figure represents a commemorative ances-tor figure, which surmounted a box of bark or a woven basket. These containers held the skull and other principal bones of a clan or lineage head. Reliquary figures were connected to the ancestor cult through lineages or associations. This work is from related groups of the Upper Ogowe region of Gabon collectively known as the Kota peoples.

The use of copper in the manufacture of reli-quaries indicates the paramount importance of this metal in the economy and status systems of the ethnic groups of Gabon. Copper and brass were introduced by European traders in the form of small bars, rolls of wire, and bowls called "neptunes." The forms in which they came con-tributed to techniques of manufacture and styles. As in this figure, copper sheets made from neptunes were beaten and applied over wooden forms.

In general, the skulls of important men—judges, chiefs, craftsmen, and ritual specialists—were thought to maintain their powers after death. Each figure is named and, according to its effectiveness, acquires a reputation. A late-nineteenth-century drawing shows elegant reliquaries in a simple elevated structure of poles and thatch with offerings below them on the ground. Usually kept in the houses of family heads, all the reliquary figures of a village were, upon occasion, brought together and danced for the benefit of the entire community. RA

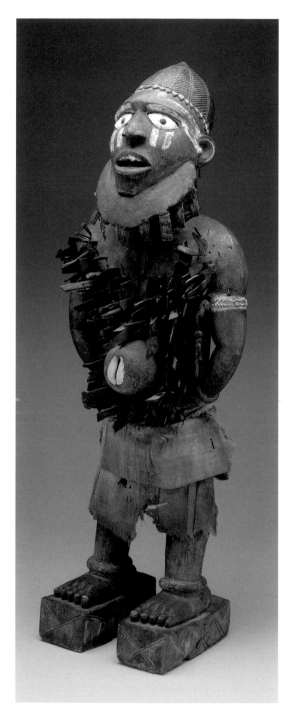

Standing male figure (nkisi nkondi,
Mangaaka *type*)

Zaire, Yombe, Chiloango River valley, 19th century
Wood, iron, raffia, pigment, kaolin, and red camwood
(tukula)
44 × 15⅝ × 1⅜ in. (111.8 × 39.7 × 3.5 cm)
Foundation for the Arts Collection, gift of the
McDermott Foundation, 1996.184.FA

This large, very rare, and monumental Kongo
figure is from a Yombe group residing in the
Chiloango River valley. It is a generic type
called *nkisi*, containers for medicines prepared
and inserted by a ritual specialist, a *nganga*. A
nkisi is a cloth bundle or carved figure, or even
the consecrated body of a chief. This figure
wears a chief's hat and anklets, and a type of
raffia skirt worn by mediators.

Medicines of graveyard earth and animal and
vegetal matter help the ritual specialist activate
the figure with spirit force that protects, heals,
or destroys. Specifically, this figure is a *nkisi
nkondi*, which is embedded with nails that repre-
sent sealed oaths taken in a law court, or *mambu*,
historically linked to chieftancies. It is a type of
nkisi nkondi with specific attributes: a large cow-
rie shell fixed at the center of a rounded resin
pack on the abdomen; a resin pack around the
chin; the *pakalala* stance (hands on hips, arms
akimbo); head thrust forward; mouth open; and
inlaid porcelain eyes. On the head is a chief's
hat of authority incised with specific geometric
motifs, and the face is painted with white kaolin
and red camwood pigment in specific patterns.
This style of *nkisi nkondi*, represented by an
important corpus of eight known works, is con-
sidered the product of one artist or workshop
and one ritual specialist. RA

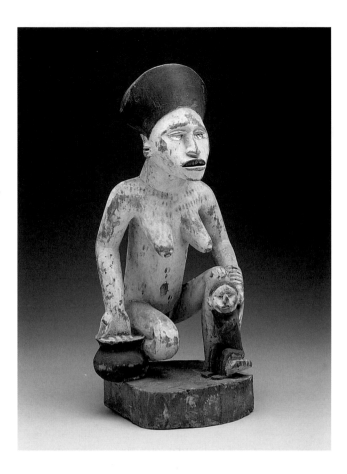

Female shrine figure (bitumba) *with ritual pot and child*

Zaire, Bas-Zaire region, Kongo peoples, Yombe, late 19th–early 20th century
Wood and kaolin
21½ × 10 × 9⅜ in. (54.6 × 25.4 × 23.9 cm)
The Clark and Frances Stillman Collection of Congo Sculpture, gift of Eugene and Margaret McDermott, 1969.S.22

This kneeling female shrine figure represents a departed ancestor who is the revered mother of a great clan or lineage. She supports a child who sits on her raised foot. This gesture becomes an act of balancing and supporting the clan between worlds, which is now her mission in the land of the dead. The white of her body is the color of the dead and their world. Her mitered coiffure, a traditional Yombe style, may be read in a larger context. It is black, and according to Kongo color symbolism, black refers to the daily social world. Thus the semicircular coiffure represents the world of the living, while the whitened fig-ure below represents the world occupied by all the clan's deceased ancestors. This interpreta-tion ultimately refers to the traditional Kongo image of the cosmos, which is formed by two hemispheres, the land of the living above, and the land of the dead below. The soul (the child) negotiates this cosmos like a sun circling from birth, to death, to the land of the dead, and back again, to reincarnate as a grandchild. This is a central and defining theme in Kongo art and thought.

When they take office, chiefs are anointed with white or yellow clay called kaolin, which is kept in a pot. These pots recall the original pot of kaolin sent from the capital of the kingdom of Kongo to anoint the traditional chiefs of the earth. Therefore, in addition to its cosmic sig-nificance, this figure honors and remembers an important woman through whom a great lineage or clan can claim the right to rule and to bury their dead in the land. RA

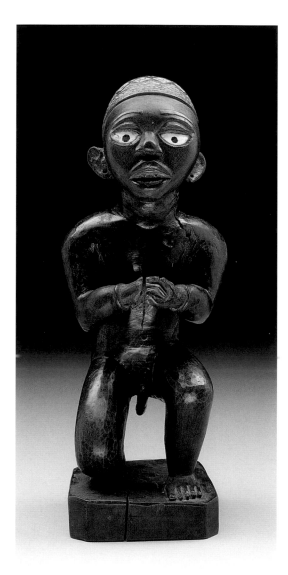

Male shrine figure (bitumba)
Zaire, Bas-Zaire region, Kongo peoples, Yombe,
19th–20th century
Wood, resin, and glass
12½ × 4¾ × 4¾ in. (31.8 × 12.1 × 12.1 cm)
The Clark and Frances Stillman Collection of Congo
Sculpture, gift of Eugene and Margaret McDermott,
1969.S.28

The houses of the Kongo people customarily
have been very simple affairs made of reeds and
thatch, and in modern times, of concrete block
with tin roofs. The graves and shrines for the
dead, however, have traditionally been more
elaborately constructed and dressed with sculp-
ture. The graveyard is considered the "capital"
of the village, and shrines of wood and thatch
housed wooden figural sculpture of important
male and female ancestors. Today, Kongo shrines
have evolved into imaginative concrete struc-
tures that continue to comment on the relation-
ship of the living to the dead.

It is clear that the departed person repre-
sented by this figure was an important person-
age because he wears a chief's hat, or *mpu*.
Imaginative in conception, this male figure is
an extraordinary example of its type. Kneeling
and clapping one's hands is a way to honor the
one who is addressed or petitioned. In this in-
stance the figure may be petitioning the ances-
tral dead for the benefit of the living. The
porcelain eyes, which see into the other world,
and the open mouth are typical of figures repre-
senting honored ancestors thought to be in com-
munication with the powerful spirits of
long-departed clansmen. RA

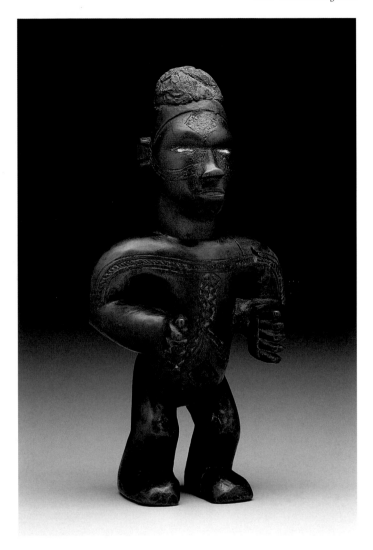

Standing male ancestor figure (mukuya)

Republic of the Congo, Bembe people,
late 19th–early 20th century
Wood, porcelain(?), and resin
8⅜ × 4¼ × 3¼ in. (21.3 × 10.8 × 8.3 cm)
The Clark and Frances Stillman Collection of Congo Sculpture,
gift of Eugene and Margaret McDermott, 1969.S.1

The Bembe are reputed to be descended from the ancient kingdom of
Kongo. Their art can be distinguished from Kongo art in the modeling
of the head and in the facial expression, posture, and the accoutrements
the figure holds. Bembe art, however, shows congruencies with Kongo
examples, from the use of medicine-filled resin packs to the naturalism of
renderings of the human body. As seen in this figure, dense scarifications
are part of their shared visual themes, as are porcelain-embedded eyes.
This figure is a *mukuya*, an honored ancestor who is asked to intercede
and mediate for the living. RA

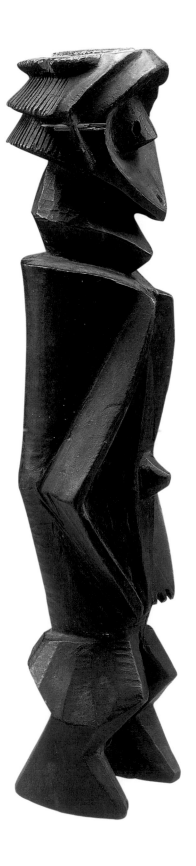

Standing figure (iwak)
Zaire, Bandunda region, Boma (also Buma) people,
19th–20th century
Wood
11¾ × 2¾ × 3 in. (29.9 × 7 × 7.6 cm)
The Clark and Frances Stillman Collection of Congo
Sculpture, gift of Eugene and Margaret McDermott,
1969.S.6

This rare figure from the Boma (Buma) people
is a masterful composition of angular forms. Not
much is known about Boma sculpture, but it is a
key style linking the Teke (Tio) of the Republic
of the Congo with the Sudanic peoples of the
Central African Republic. There are several
distinct Boma styles that are linked to various
Teke subgroups. This standing figure represents
a style borrowed by the Boma from the Teke.
The Teke are related to neighboring Zairian cul-
tures, which stylistically aligns this figure to
Zairian sculptural forms. It also displays affini-
ties with the art of the Yanzi and Sakata peoples
with whom the Boma have linguistic ties.

Boma statues are generically called *iwak*, of
which there are several types: *mate*, clan ances-
tors that protect members of the lineage and
the lineage as a whole, and sometimes come in
pairs; *nkwey*, which appear to be janus figures
that guard against thieves and evil spirits; and
mpwu, small figurines usually dressed in red that
return evil done to their owners. The Dallas
figurine appears to be a *mate*, the image of a
protective ancestor. RA

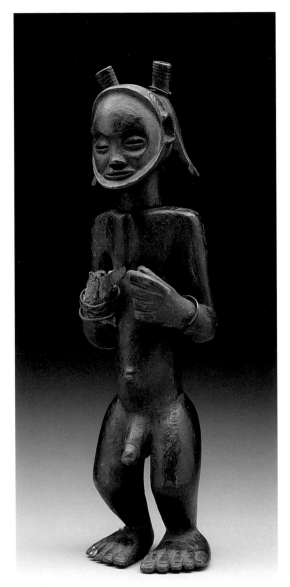

Standing male figure (mohamba)

Eastern Angola, Chokwe people, 19th–20th century
Wood and metal
5⅜ × 3⅜ × 3⅛ in. (13.7 × 8.6 × 7.9 cm)
The Clark and Frances Stillman Collection of Congo
Sculpture, gift of Eugene and Margaret McDermott,
1969.S.8.a–b

The Chokwe are known primarily for their
court art. This very fine male figure is the image
of an ancestral chief *(mohamba)* and was created
for the personal protection of the chief and his
community, a function which is underscored by
the blade in his right hand. The blade, a sign of
rank, indicates that the figure has the power to
cut out, or cut off, malefic afflictions or negative
actions. Only the chief could afford such a figure,
and only he was allowed to hold it. The figure
wears copper chief's bracelets, which are reputed
to be fashioned from an original pair and mark
his authority.

Various cults among the Chokwe venerate
figurative sculpture in shrines. The primary cult
is to the *mohamba*, who are intermediaries be-
tween man and the supreme creator god. These
spirits of the recently deceased roam the land of
the dead and must be properly propitiated or
they could harm the living, the spirits of clan
ancestors, and a variety of nature spirits called
akisi. RA

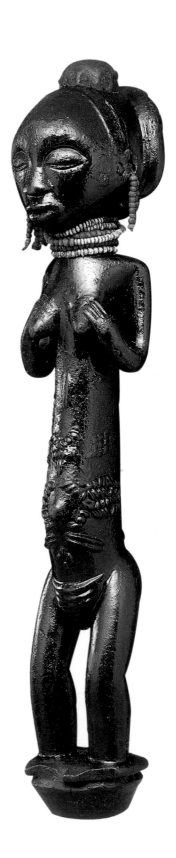

Standing female figure

Zaire, Shaba region, Luba people, 19th–20th century
Wood, leather, nails, beads, and oil
13 × 2⅝ × 3¼ in. (33 × 6.7 × 8.3 cm)
The Clark and Frances Stillman Collection of Congo
Sculpture, gift of Eugene and Margaret McDermott,
1969.S.96

Refined in its beauty, this female figure is a
masterpiece of elegance and restraint. It was the
finial of a ceremonial staff which once belonged
to a king, chief, or other dignitary. This image of
a lovely and fertile woman refers to the female
founder of the lineage or to the king himself.
It is unfortunate that the complete staff is not
present in this superb example. It would have
included an unadorned or copper-wrapped shaft
signifying uncultivated savanna and the roads
leading to the capital; a flat section carved in the
shape of a lozenge, triangle, or hourglass; and an
iron tip to be stuck in the ground during public
ceremony or to signify victory on the battlefield.

RA

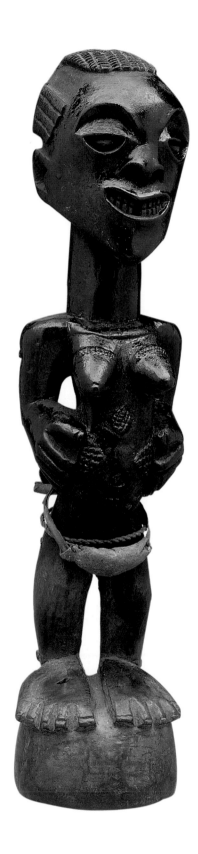

Standing female figure (nkishi)
Zaire, East Kasai region, Songye people,
19th–20th century
Wood, oil, metal, raffia, and horn
14⅛ × 4 × 3¾ in. (35.9 × 10.2 × 9.5 cm)
The Clark and Frances Stillman Collection of Congo
Sculpture, gift of Eugene and Margaret McDermott,
1969.S.174

The predominately patriarchal and patrilineal
Songye produce figures which are overwhelm-
ingly male; female representations such as this
occur infrequently and only where matrilineal
kinship systems exist as an influence of the
neighboring Luba people. Meant as personal or
communal devices for protection and healing,
Songye figures are charged with medicines by
a ritual specialist, or *nganga*, who places them in
an abdominal cavity or in horns at the top of the
head. In this figure the medicines are contained
in a pouch strung across the abdomen. A precise
reading of the figure and its medicines is impos-
sible. The *nganga*, although using medicines that
have a particular importance and usage, has a
certain improvisational freedom in the secret
ritual procedures he devises to employ the fig-
ure and the medicines it wears or contains.

RA

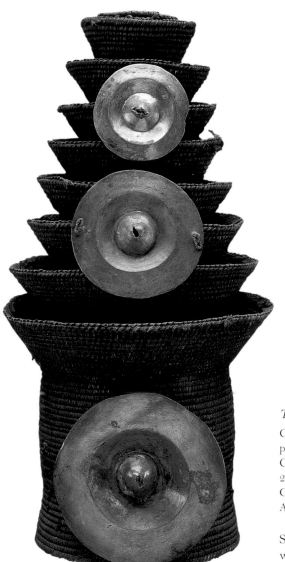

Tiered hat with brass disks (botolo)
Central Zaire, Equatorial region, Mongo-speaking
peoples, Ekonda, 20th century
Coiled basketry and brass disks
25 × 10 × 9¾ in. (63.5 × 25.4 × 24.8 cm)
Gift of the Friends of African and African-American
Art, 1992.511

Striking in its minimalist aesthetic, this hat was
worn by an Ekonda chief, or *nkumu*. A wealthy
Ekonda outsider elected to the post by village
elders, the *nkumu* paid for his invested authority
with currency in the form of brass rods. The
chief's hat, which only he had the right to wear,
was adorned with one or more brass disks cre-
ated by beating these rods into round shapes.
Before public ceremonies the hat would be
smeared with a mixture of red camwood pig-
ment and red palm oil, as red is a color denoting
power and force. The Ekonda do not possess
wood sculpture. In addition to coiled basketry
like this hat, they have created striking metal-
work in the form of knives that are part of the
regalia of the chief. RA

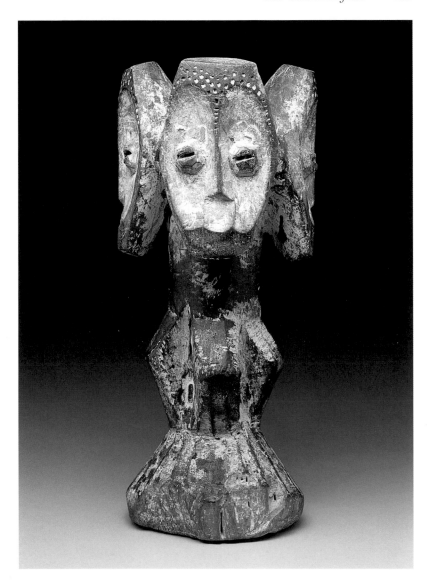

Four-faced half-figure (Sakimatwematwe)

Zaire, Kivu region, Lega people, 19th–20th century
Wood
$12^5/_8 \times 5^3/_8 \times 5^5/_8$ in. (32.1 × 13.7 × 14.3 cm)
The Gustave and Franyo Schindler Collection of
African Sculpture, the McDermott Foundation in
honor of Eugene McDermott, 1974.SC.49

Among the Lega people of eastern Zaire, art is
made in service of the Bwami initiation society.
Bwami is concerned with the social and moral
perfection of the individual. It was through
Bwami that the Lega organized and regulated
their traditional society. The objects made for
Bwami represent various levels of initiation and
are visual emblems of important knowledge
about Bwami and the initiate.

In Lega art, form does not necessarily follow
meaning. The classic multifaced or multiheaded
figure, of which this figure is a type, is known
as Sakimatwematwe, Mr. Many-Heads, and is
usually associated with the aphorism he who
"has seen an elephant on the other side of the
large river," a saying that refers to the wisdom,
fairness, and omniscience of the Bwami initiate.
Five additional meanings usually associated with
other figurines, however, have also been found
to be associated with Sakimatwematwe. RA

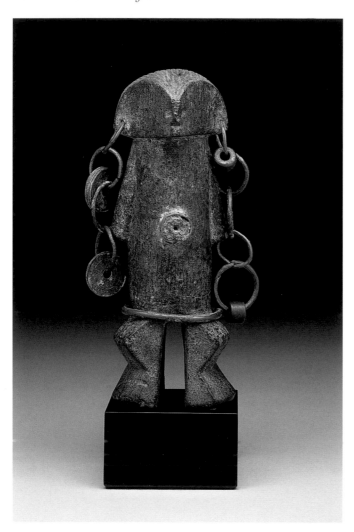

Standing female figure (Yanda, Nazeze *type*)

Zaire, Upper Zaire region, Uele subregion,
Zande people, 19th–20th century
Wood and metal
6½ × 2⅜ × 2⅛ in. (16.5 × 6 × 5.4 cm)
The Gustave and Franyo Schindler Collection of
African Sculpture, gift of the McDermott Foundation
in honor of Eugene McDermott, 1974.SC.50

This small cult statuette for the Zande people is a masterful rendering of form and materials. The green oxidized metal of the hooped rings plays successfully against the patination of the light wood surface. The figure is a superb example of the rendering of the human body in simple geometric shapes.

Among the Zande, *yanda* figures of this type are used by the Mani secret society in rituals concerning fecundity. Although the way the figure is constructed is dictated by ritual procedures, not aesthetic choice, there is ample evidence of a powerful aesthetic sensibility. RA

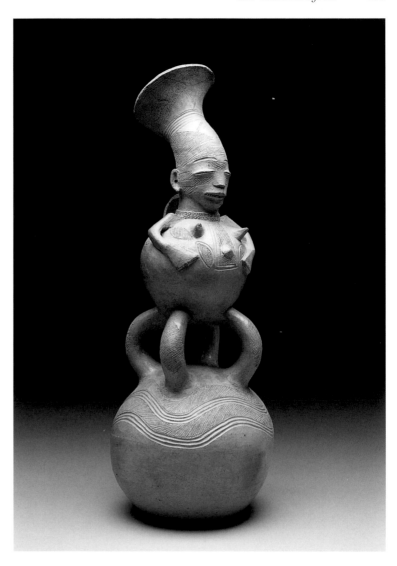

Double-chamber palm wine vessel

Zaire, Upper Zaire region, Uele subregion,
Mangbetu people, c. 1900–1930
Terra-cotta
25 × 8 in. (63.5 × 20.3 cm)
Gift of the Professional Members League, 1995.20

The primary purpose of Mangbetu art was the enhancement of political prestige through regalia, adornment, and official gifts. Mangbetu art exhibits a powerful aesthetic in the execution and adornment of even the most mundane objects. Figural art such as this vessel proliferated among the Mangbetu during the first two decades of the twentieth century as the result of European contact.

This figurated vessel, one of seven or eight examples by the same hand, is the only one to have articulated arms and hands, and one of three to take the double-chamber form, which is rarely seen in Mangbetu vessels. Three very similar vessels in the collection of the Ethnographic Museum of Estonia at Tartu were probably collected at the same time. Two are pale yellow, like the above example, and one is black. This pot and its related works represent the designation of a newly recognized hand that enlarges our understanding of the pottery traditions of the Mangbetu and their neighbors.

RA

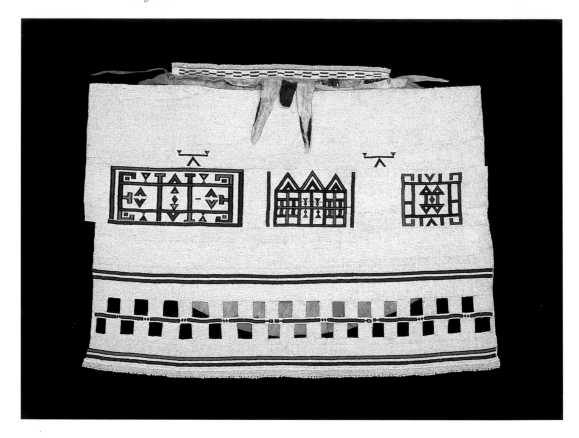

Beadwork cape (linaga)
South Africa, Ndebele people, probably early
20th century
Goatskin, glass beads, and cotton yarn
42½ × 57½ in. (108 × 146.1 cm)
The Otis and Velma Davis Dozier Fund, 1991.24

This woman's cape is an early example of the
decorative beadwork of the Ndebele people.
Until recently Ndebele beadwork was predomi-
nantly white, with colored beads displayed in
taut angular designs that were strong yet fairly
small. Today colorful, bright, and bold angular
designs are the hallmark of Ndebele art, both in
the wall paintings that have developed in the
last forty-five years and in the older beadwork
tradition. The name Ndebele refers to the people
of two chiefdoms in the southern part of Trans-
vaal province in South Africa—Ndzundza and
Manala. Both subgroups do beadwork, but only
the Ndzundza also paint murals. RA

The Americas

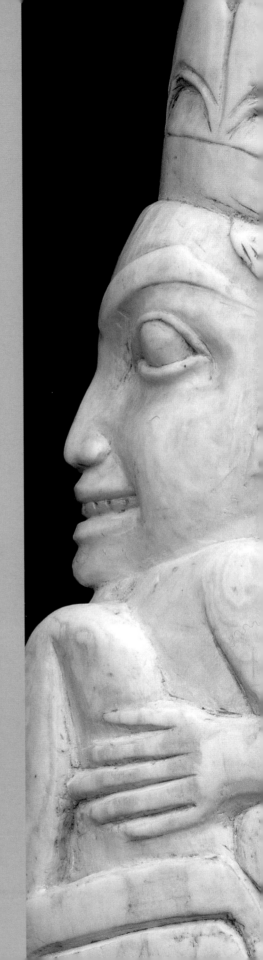

Stirrup-spout vessel

Peru, north coast, Chavín style, c. 900–200 B.C.
Ceramic
7¼ × 7¼ in. diam. (18.4 × 18.4 cm)
The Nora and John Wise Collection, gift of Mr. and
Mrs. Jake L. Hamon, the Eugene McDermott Family,
Mr. and Mrs. Algur H. Meadows and the Meadows
Foundation, and Mr. and Mrs. John D. Murchison,
1976.W.56

The Central Andes culture area lies essentially within the boundaries of modern Peru and Bolivia, on the western edge of South America. Paralleling the Pacific coastline, the high Andes mountains separate the world's driest coastal desert to the west from vast tropical forests to the east. Rivers intersecting the coastal plain provided life-sustaining water and the setting for cultural development along the coast. The earliest Central Andean art style with widespread distribution and influence is called Chavín, after the ceremonial center at the site of Chavín de Huántar in the northern highlands. The relief carving and monumental stone sculpture of its imposing temples express a fully developed religious iconography that features felines, birds of prey, serpents, and humanlike figures with feline attributes and serpents for hair.

The ceramics most closely associated with the Chavín style are monochromatic sculptural vessels with flat bottoms and stirrup-shaped spouts, a form that persisted in north coast ceramic traditions until the Spanish conquest. Contrasting surface textures are also quintessentially Chavín. On this characteristic example, the spout and circular elements with conical bosses are highly burnished, and the stirrup and vessel chamber are stippled with short strokes, creating a rough and earthy texture. CR

Vessel depicting a falcon

Peru, south coast, Paracas culture, c. 500–400 B.C.
Ceramic and resin-suspended paint
4⅜ × 5⅛ in. diam. (11.2 × 13 cm)
The Nora and John Wise Collection, gift of Mr. and
Mrs. Jake L. Hamon, the Eugene McDermott Family,
Mr. and Mrs. Algur H. Meadows and the Meadows
Foundation, and Mr. and Mrs. John D. Murchison, 1976.W.85

The Paracas peninsula, whose name means "sand falling like rain," is a
rainless, inhospitable area of frequent sandstorms on the south coast of
Peru. Its deserts have preserved fragile objects deposited in cemeteries
some two thousand years ago. During excavations on the peninsula in the
late 1920s, Peruvian archaeologists recovered more than four hundred
textile-wrapped funerary bundles. Ceramic vessels attributable to the
Paracas culture have been found on the peninsula and in the nearby Pisco,
Ica, and Nasca valleys.

Of the several pottery types associated with the Paracas culture, the best
known are incised vessels enhanced by the application of resin-based paints
after firing. This example, with its beautifully preserved paint layer, is also
characteristic in form: the vessel features a rounded base and two spouts
joined by a flat strap or bridge, which functioned as a handle. The body of
a bird spreads gracefully over the hemispheric chamber, while a modeled
head forms the base of one spout. A chevronlike motif below each eye iden-
tifies the bird as a falcon, a bird of prey known for its ability to apprehend
other adult birds in flight. The falcon is a frequent theme in Paracas art.

CR

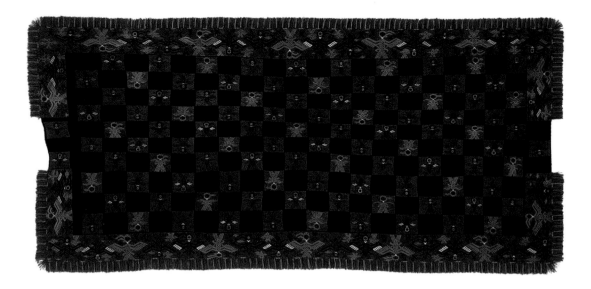

Mantle

Peru, south coast, Paracas culture, c. 300–100 B.C.
Camelid fiber
51½ × 110 in. (130.8 × 279.4 cm)
The Eugene and Margaret McDermott Art Fund, Inc.,
in memory of John O'Boyle, 1972.4.McD

In the funerary bundles recovered from Paracas burials, layer upon layer of handwoven cloth wrapped each body, which was placed in a basket, its limbs flexed in a seated position. Coarse cotton cloths separated embroidered garments and other objects into as many as six layers. One bundle included among its contents ten embroidered and eight unembroidered mantles, four headbands, thirteen headcloths, five ponchos, two tunics, and a loincloth. The same motif often appears on several different garment types, suggesting that they were worn together as a costume, probably by an aristocratic man.

The largest and most impressive of the Paracas garments is the mantle, which would have been worn as a shoulder cloth, the unfringed areas at each side falling across the wrists. Two separately woven rectangles of dark blue were seamed along the inner edges to form the ground cloth of this mantle. The red squares that frame the birds and the wide, bird-patterned border were embroidered on the ground cloth. Here, as in other ancient Andean textiles, the most vibrant colors represent yarns spun from the hair of the llama, alpaca, and vicuña, animals of the *Camelidae* family native to the Andean highlands, for these yarns readily accepted dyes. The embroidered birds—identifiable as male condors by the ruff of feathers (shown as a white collar) and the outspread wings—are repeated with a change in vertical orientation in the squares and a change in both orientation and scale in the border, characteristic Andean textile devices for achieving variety with a single motif. CR

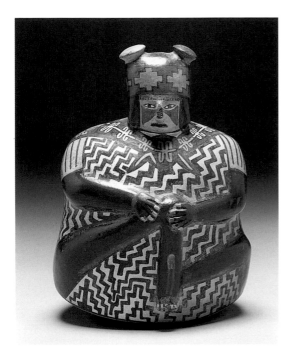 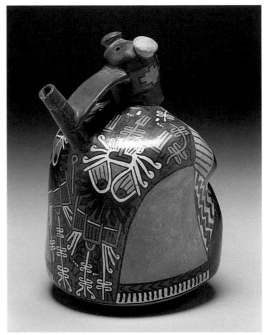

Vessel depicting a wounded warrior
Peru, south coast, late Nasca culture, c. A.D. 500–600
Ceramic
8 × 5¾ × 5⅞ in. (20.3 × 14.6 × 14.9 cm)
General Acquisitions Fund, 1971.58

The regional society called Nasca flourished in the Nasca and Ica River valleys on the south coast of Peru from about 200 B.C. until A.D. 700. The Nasca ceramic tradition continued the south coast preference for round-bottomed vessels with two spouts connected by a strap handle and decoration that emphasized color and painting. Nasca potters applied slip paints (mineral pigments suspended in a thin clay matrix) in as many as a dozen colors to their well-formed bowls, bottles, and jars before the pieces were fired, thereby creating a more durable surface than the post-fired, resin-suspended paints of earlier Paracas pieces. Edible plants, birds, animals, and mythic beings figure prominently in Nasca painted imagery.

Nasca effigy vessels depict costumed human figures, the head fully modeled, the limbs shown in low relief against the full, generalized shape of the body. The Dallas example represents a wounded warrior who holds his injured right leg. He wears a zigzag-patterned tunic and a headdress with stepped diamond motifs and two knoblike elements. Tied below his chin and spreading across his back is a mantle enhanced by two mythical figures, each dominated by an inverted face with huge eyes, a white mouth mask with whiskerlike extensions, and a long, protruding gray tongue. This masked, semi-human creature is associated with fertility and vegetation. Often called the Anthropomorphic Mythical Being, it is one of the most important religious subjects in Nasca art. The profusion of tendril-like elements in the painting, a feature often described as proliferous, identifies the vessel as late Nasca in style. CR

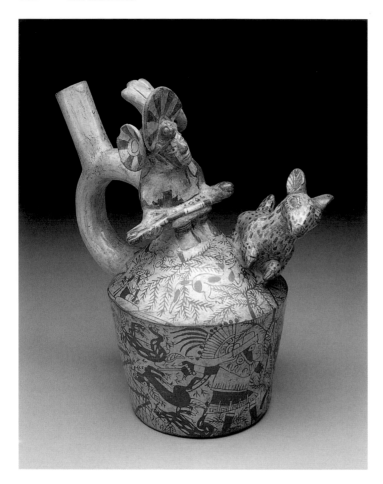

Stirrup-spout vessel with deer hunting scenes

Peru, north coast, Moche culture, c. A.D. 400–550
Ceramic
10 × 6¼ × 9⅛ in. (25.4 × 15.9 × 23.2 cm)
The Eugene and Margaret McDermott Art Fund,
Inc., 1969.2.McD

The regional Moche, or Mochica, culture was dominant on the north coast of Peru from the first to the eighth century A.D. At its peak, about A.D. 400, the Moche realm occupied an area about 370 miles long and encompassed ten contiguous river valleys. Moche art comprised enormous platform mounds constructed of adobe brick; sophisticated metallurgy in gold, silver, and bronze; and a prolific ceramic tradition that often made use of molds.

Moche potters favored flat-bottomed vessels with stirrup spouts and restricted color to red-brown and cream. They excelled at modeling, which they used to produce portrait heads, plants, animals, and figural compositions, all of considerable naturalism, and they were adept at fine-line painting, through which they documented events of ritual significance. This vessel combines the two approaches in treating an important Moche theme, the deer hunt. The modeled three-dimensional forms of hunter and deer complement the delicately painted scene that covers the vessel. Elaborate garments and headdresses suggest a ceremonial occasion and elite status for the three hunters, one of whom sits in a litter. Seen amid the lacy branches of acacia trees, the hunters have killed three deer trapped by the net that stretches across the top of the vessel, beneath the stirrup, and they have speared another that falls between them. Long-tailed spotted dogs in the painted scene seem to attack the modeled deer that leaps above them.

CR

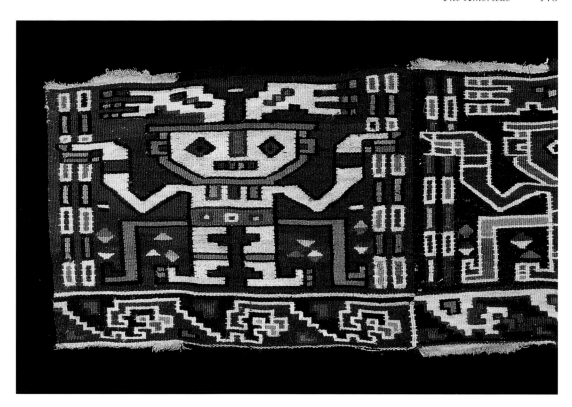

Border with standing frontal figures
holding double staffs (detail)
Peru, north-central coast, Huarmey Valley(?),
Moche-Huari style, c. A.D. 750–1000
Cotton and camelid fiber
8⅜ × 45¾ in. (21.3 × 116.2 cm)
The Eugene and Margaret McDermott Art Fund,
Inc., 1978.3.McD

The widespread distribution of similar artistic themes during the period A.D. 600 to 1000 represented the influence of two highland city-states, Tiahuanaco (Tiwanaku) in the Bolivian high plateau, south of Lake Titicaca, and Huari (Wari) in the south-central highlands of Peru. Tiahuanaco is famous for its monumental stone sculpture: huge columnar figures, massive crouching warriors with puma masks and trophy heads, and, on the Gateway of the Sun, the frontal staff-bearing figure flanked by winged running figures. Versions of the gateway motifs, together with profile faces and stepped frets, are especially prevalent on Huari-related ceramics and textiles.

The Moche-Huari textile style, also called Huarmey after the river valley where these textiles have reportedly been found, combines characteristics of the earlier north coast Moche culture with Huari features from the south. Weavers of both cultures favored the tapestry technique, in which weft yarns of different colors travel only as far across the loom as is necessary to create their respective solid-color shapes, completely concealing the warp yarns. Although greatly simplified from the Tiahuanaco Gateway of the Sun figure, the frontal figure bearing staffs is a Huari feature, as is the division of space into rectangular units that closely frame the repeated motifs. Color is the unique and unifying local contribution to the style, with rich reds, clear whites, and subtle yet vibrant blues and purples forming a distinctive palette.

CR

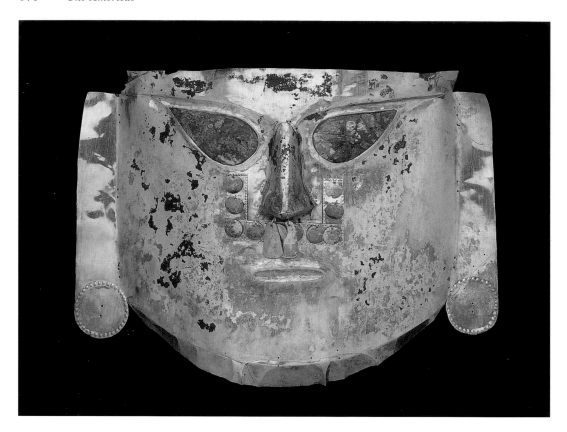

Ceremonial mask

Peru, north coast, La Leche Valley, Batán Grande
region, Sicán culture, A.D. 900–1100
Gold, copper, and paint
11¾ × 17⅜ in. (29.8 × 44.1 cm)
The Eugene and Margaret McDermott Art Fund,
Inc., 1969.1.McD

The Sicán culture flourished in the Batán Grande region of northern Peru between A.D. 700 and 1300. Extraordinary metallurgical production distinguished the Middle Sicán period (A.D. 900–1100), evidenced not only by the numerous Middle Sicán–style objects in museum and private collections but by the contents of an undisturbed tomb discovered by archaeologist Izumi Shimada in 1991. The Huaca Loro tomb, the first Sicán burial to be scientifically excavated, contained about 1.2 tons of grave goods. Analysis of its rich array of metalwork is providing valuable contextual information for other objects in the Sicán style.

Like a gold mask from Huaca Loro, Dallas's Sicán mask depicts the face of the most important human image in Sicán art, a mythic or religious figure called the Sicán Lord. The museum's mask is characteristically horizontal, with comma-shaped eyes, a prominent nose, and a rectangular flange at each side, which typically supported circular ear ornaments that were made separately and attached. The eyes of the mask are overlaid with copper, which has oxidized to a deep green, and traces of red on the forehead and cheeks show that it, like other masks, was painted with cinnabar. The Huaca Loro mask was accompanied by a bat-faced horizontal element and an arching parabolic headdress of silver and gold, indicating that a Sicán mask could form the principal component of more elaborate ceremonial regalia. CR

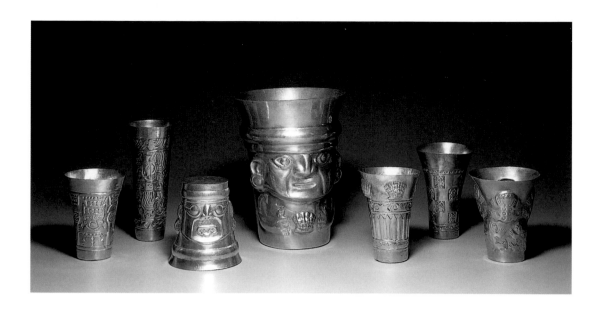

Group of beakers

Peru, north coast, La Leche Valley, Batán Grande
region, Sicán culture, A.D. 900–1100
Gold
Largest: 10¼ × 8⅛ in. diam. (26 × 20.6 cm)
The Nora and John Wise Collection, gift of Mr. and
Mrs. Jake L. Hamon, the Eugene McDermott Family,
Mr. and Mrs. Algur H. Meadows and the Meadows
Foundation, and Mr. and Mrs. John D. Murchison
Left to right: 1976.W.545, 1976.W.556, 1976.W.542,
1976.W.540, 1976.W.570, 1976.W.562, and
1976.W.569

A single tomb at Huaca El Corte at the site
of Sicán included 176 beakers among its gold
and silver objects. The beakers were reportedly
found scattered in the grave or stacked in
groups of about ten, each stack containing
beakers of similar size, weight, and design. Al-
though some examples are essentially undeco-
rated, most feature a dominant motif that is
repeated, sometimes in combination with other
elements, around the circumference: birds in a
checkerboard arrangement or horizontal band,
stylized frogs or toads, shells, a horizontal row
of staffs, and the face or complete figure of the
Sicán Lord, the principal deity. The beakers may

have been used in life as drinking vessels for
the corn beer called *chicha*. The largest Dallas
vessel, which depicts the Sicán Lord holding a
spondylus shell, has a capacity of five quarts.

Sicán goldsmiths favored the use of copper-
gold alloys *(tumbaga)* and sheet metal, which
they worked by hammering. Although a rela-
tively simple process, it required great manual
skill and a sound knowledge of the behavior of
the metal. Using a stone anvil and hammer, the
goldsmith laboriously beat a gold ingot to the
desired shape and thinness, periodically reheat-
ing it and quenching it in water (annealing it)
to prevent the metal from cracking as it became
brittle from hammering. To raise the design ele-
ments, the goldsmith placed the sheet metal on
a relatively soft surface, possibly thick leather or
a bag of fine sand, and worked it from behind
(repoussé). Turning the piece face up, the gold-
smith deepened (or chased) the depressed areas
to enhance the raised design. CR

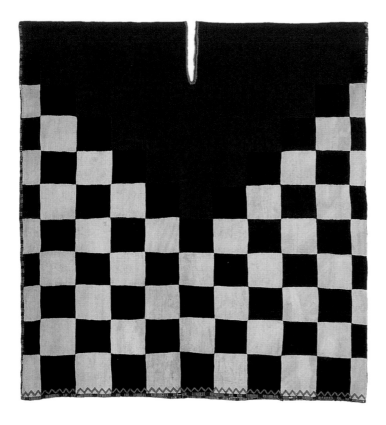

Tunic with checkerboard pattern and stepped yoke
Peru, Inca culture, A.D. 1476–1534
Camelid fiber
34¾ × 31½ in. (88.3 × 80 cm)
The Eugene and Margaret McDermott Art Fund,
Inc., in honor of Carol Robbins, 1995.32.McD

The Inca empire—called Tahuantinsuyu, or
Land of the Four Quarters—was a vast realm
built by forceful expansion and organizational
genius during the brief period between 1438
and 1532. From the capital city of Cuzco in the
southern highlands of Peru, the empire spread
along the western edge of South America to
encompass present-day Ecuador, Peru, Bolivia,
northern Chile, and northwestern Argentina,
its distant parts linked by an elaborate system
of roads. In 1532, when Francisco Pizarro cap-
tured the Inca emperor Atahualpa, it was the
largest state in the western hemisphere. The
standardization of design and technical preci-
sion that distinguish Inca art can be seen in
the mortarless stone masonry at Coricancha,
Ollantaytambo, and Machu Picchu and in
tapestry-woven textiles.

Tapestry-woven cloth *(qompi)* often had
an unusually high thread count and was so
carefully made that the cloth was reversible,
qualities that set it apart from contemporary
European tapestry. It was woven by several
types of specialists: religiously cloistered
women, wives of provincial administrative
officials, and a class of men who wove *qompi*
to meet their labor tax obligations. The entire
production of the male specialists went to the
Inca government for redistribution, for *qompi*
garments could be worn only if they had been
received as a gift from the ruler. Of the Inca
tapestry-woven garments that have survived,
the most impressive is the man's knee-length
tunic, and of the four standardized tunic designs,
the bold black-and-white checkerboard pattern
with a stepped red yoke is the most dramatic.
Sixteenth-century Spanish chroniclers described
men in Atahualpa's army as wearing tunics with
a chessboard pattern, suggesting that this de-
sign had military associations. CR

Disk with feline head

Ecuador, Milagro-Quevedo culture(?),
c. A.D. 800–1500
Gold
8½ × 8½ × 1⅜ in. (21.6 × 21.6 × 3.5 cm)
Foundation for the Arts Collection, gift of Sarah
Dorsey Hudson, 1983.6.FA

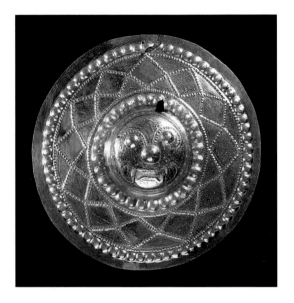

Often described as the crossroads of the Americas, Ecuador lies between Peru, in the Central Andes, and Colombia, with which it forms the Northern Andes culture area. An alternative classification groups Ecuador, Colombia, and Lower Central America as the Intermediate Area—intermediate between Mesoamerica to the north and the Central Andes to the south. Although Ecuador's contact with Mesoamerica is little understood, its inhabitants had extended interaction with Central Andean peoples who sought the prestigious shell of the *Spondylus princeps*, a spiny oyster found in Ecuadorian coastal waters.

The impressive objects in gold, silver, and copper that are attributed to the Milagro-Quevedo and Manta cultures of western Ecuador have much in common with ornaments made by the Capulí culture in the Nariño region of southwestern Colombia (c. A.D. 600–1000). Circular pectorals and ear ornaments with a central human or feline head in high relief are hallmarks of both styles. Hammered from sheet metal, these distinctive objects are often bordered by circles of spherical, beadlike elements and a diamond lattice that suggests a network of smaller beads. A small hole at the top of the Dallas disk (probably one of two originally), indicates that it could have been worn as a pectoral. The central feline image, one associated with power and authority, suggests that the wearer was someone of elite, probably chiefly status. CR

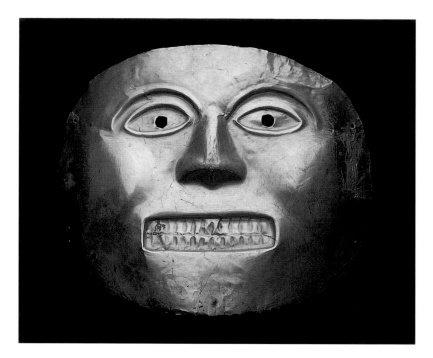

Ceremonial mask

Colombia, Calima region, Ilama period, c. 500–1 B.C.
Gold
7⅜ × 8¾ × 1¼ in. (18.7 × 22.2 × 3.2 cm)
The Nora and John Wise Collection, gift of Mr. and
Mrs. Jake L. Hamon, the Eugene McDermott Family,
Mr. and Mrs. Algur H. Meadows and the Meadows
Foundation, and Mr. and Mrs. John D. Murchison, 1976.W.321

The pre-Hispanic goldwork of Colombia is traditionally classified by
archaeological zones, or regions, each with stylistic associations: Sinú and
Tairona in the north, Muisca in the central highlands southeast of Bogotá,
and in the southwest, Quimbaya, Calima, Tolima, and Nariño. The Calima
region encompasses the upper Calima River valley and surrounding areas
of the Western Cordillera, extending east to the Cauca River. Calima
goldwork, like other styles of southwestern Colombia, is characterized
by the use of high-quality gold and a preference for working the metal
directly, by hammering.

Within the last ten years, research in the Calima region has established
several periods of occupation, and striking masks depicting human faces,
of which some thirty examples are known, are now attributed to the Ilama
period, the earliest in which gold was worked in this area. The masks have
in common an oval or rounded shape with a clean outline, almond-shaped
eyes, triangular nose, prominent mouth, and broad cheeks. Details distin-
guish one mask from another: the depth of the features; the size of the
pupil-like holes in the eyes; the smooth or ragged edges of cut-out areas;
and the shape of the mouth, which may form a rectangular grimace or a
crescentic smile. Although many of the masks have been found in burials,
they could also have been worn during life. CR

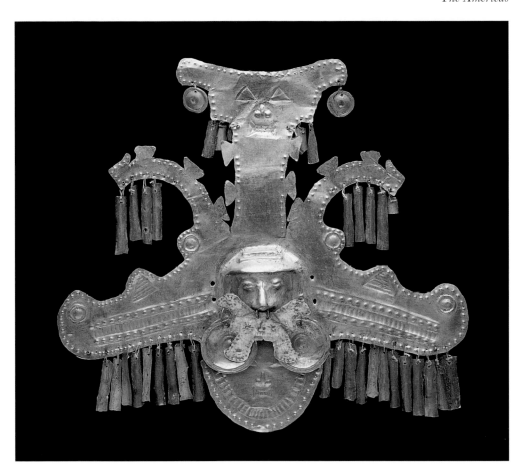

Headdress ornament with heads flanked by crested crocodiles

Colombia, Calima region, Yotoco period,
c. A.D. 1–700(?)
Gold
10 × 11½ in. (25.4 × 29.2 cm)
The Nora and John Wise Collection, gift of Mr. and
Mrs. Jake L. Hamon, the Eugene McDermott Family,
Mr. and Mrs. Algur H. Meadows and the Meadows
Foundation, and Mr. and Mrs. John D. Murchison,
1976.W.319

Calima goldsmiths achieved their foremost accomplishments during the period called Yotoco. The richly varied works made during this time are primarily objects of personal adornment, which probably functioned as ceremonial regalia for elite men: headdress elements, pectorals, bracelets, anklets, anchor-shaped nose ornaments with circular and rectangular dangles, and ear ornaments of circular, biconical, and bowl-shaped forms. Worn together, as many

undoubtedly were, they would have created a dazzling, golden image.

Among Yotoco gold ornaments, the pectoral and the headdress element, often called a diadem, are the largest and, iconographically, the most complex. The complicated yet symmetrical silhouette of the Dallas headdress ornament depicts multiple human and animal faces. Rectangular half-round dangles emphasize the crest and lower jaw of two crocodiles. Projecting from the lower center is a sculptural human head adorned with miniature versions of typical Yotoco gold pieces, an H-shaped nose ornament (itself a face), and two dish-shaped ear ornaments. The ornament could have been attached to a cloth headdress, possibly turbanlike in form, by means of the four holes beside the raised head. The pendant elements would have responded to the wearer's movements, reflecting light and producing gentle metallic sounds.

CB

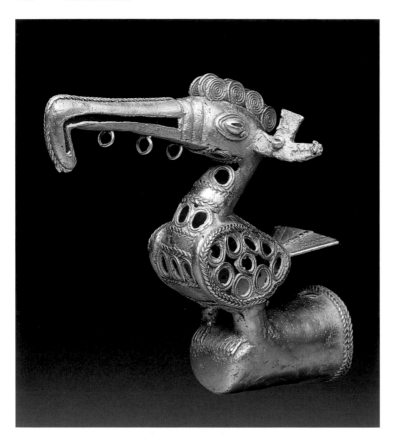

Bird-form finial

Colombia, Sinú region, Zenú culture, c. A.D. 500–1500
Gold
3⅞ × 2½ × 4¼ in. (9.9 × 6.4 × 10.8 cm)
The Nora and John Wise Collection, gift of Mr. and
Mrs. Jake L. Hamon, the Eugene McDermott Family,
Mr. and Mrs. Algur H. Meadows and the Meadows
Foundation, and Mr. and Mrs. John D. Murchison,
1976.W.438

Northwestern Colombia is a broad floodplain
through which the Sinú, San Jorge, Cauca, and
Nechi rivers meander to the sea. Here, in the
Sinú archaeological zone, the Zenú culture flour-
ished from about A.D. 500 to 1000. Gold was
worked in this area as early as the sixth century.
It continued to be worked and extensively traded
after the culture declined, about A.D. 1000, and
the population shifted from the Caribbean plains
to the surrounding higher savannahs. Groups of
goldsmiths could be found in certain communi-
ties along the Sinú river as late as the sixteenth
century. Although the Spanish conquerors did
not find gold in use here comparable to the

Aztec and Inca treasuries of Mexico and Peru,
they did discover that the tombs of the Sinú re-
gion held significant quantities of gold objects
that had been interred for generations with the
elite dead. This area thus became the first in
Colombia to be looted.

Of the various types of gold objects associated
with the Zenú culture, the best known are semi-
circular openwork nose and ear ornaments and
finials, often called staff heads after their pre-
sumed function. Birds are the dominant theme
for the finials, and this appealing example em-
bodies several characteristic features. The long
beak ends in a downward curve; decorative
spirals, solid on the crest and open on the body,
suggest showy plumage; and tiny wire loops
along the lower beak would have supported
dangles. Both the finials and the nose and ear
ornaments feature lost-wax casting, the use of
a gold-copper alloy *(tumbaga)*, and refined false-
filigree decoration made by skillfully manipulat-
ing thin threads of wax. CR

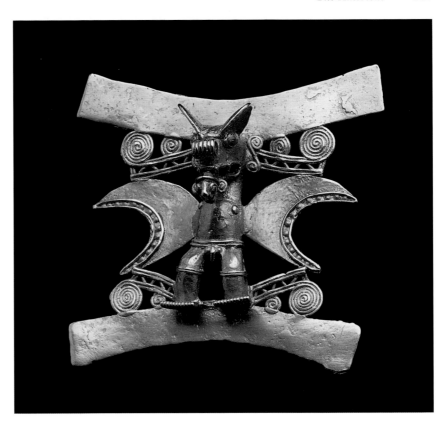

Pendant depicting a figure with batlike mask

Costa Rica, Diquís archaeological zone,
Palmar Sur area, c. A.D. 700–1550
Gold
3¼ × 3⅜ × 1 in. (8.3 × 8.6 × 2.5 cm)
The Nora and John Wise Collection, gift of Mr. and
Mrs. Jake L. Hamon, the Eugene McDermott Family,
Mr. and Mrs. Algur H. Meadows and the Meadows
Foundation, and Mr. and Mrs. John D. Murchison,
1976.W.237

The Diquís archaeological zone on Costa Rica's
southern Pacific coast became a major gold-
working area after the technology diffused
northward from the Northern Andes, probably
about A.D. 300 to 500. Goldsmiths of this region
favored casting and the depiction of birds and
animals of a dangerous or predatory nature.
Diquís art styles, both gold and ceramic, have
much in common with those of the adjacent
Chiriquí region of northwestern Panama.
Archaeologists often treat them together as
the Greater Chiriquí subarea.

This pendant represents a characteristic
Diquís type that features a central male figure
standing between two flat, essentially horizontal
bars that frame the composition. The columnar
torso, the narrow bands or cords that encircle
the waist and knees, and the projecting flat feet
are elements common to most examples, while
the type of mask worn by the figure, the object
held in the mouth of the mask, and whether the
figure has arms or winglike forms vary. On the
museum's pendant, the curled nose and promi-
nent ears suggest a bat identity for the mask,
which holds a tiny trophy head, a reference to
the importance of human sacrifice. Crescentic
wings extend from the torso. The configuration
of concentric spirals and diagonal lines flanking
the head and feet (above and below the wings)
is thought to represent a crocodile head. The
central figure may depict a shaman or a warrior-
chief, both intermediaries between earthly and
cosmic realms. Pendants of this type probably
functioned as emblems of rank or status or as
amulets. CR

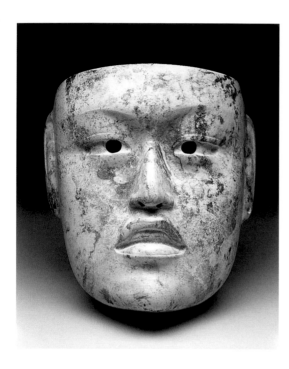

Mask

Mexico, state of Veracruz, Arroyo Pesquero,
Gulf Coast Olmec, 900–500 B.C.
Jadeite
7⅛ × 6⅝ × 4 in. (18.1 × 16.9 × 10.2 cm)
Gift of Mr. and Mrs. Eugene McDermott and the
Eugene McDermott Foundation and Mr. and Mrs.
Algur H. Meadows and the Meadows Foundation,
Incorporated, 1973.17

Mesoamerica, or Middle America, is a vast
culture area that encompasses most of what is
today central and southeastern Mexico, all of
Guatemala and Belize, and the western areas of
Honduras and El Salvador. Scholars have given
the name Olmec to Mesoamerica's first highly
developed civilization, the archaeological culture
that emerged about 1200 B.C. in Mexico's Gulf
Coast states of Veracruz and Tabasco. The
Olmec built Mesoamerica's earliest planned cer-
emonial centers, San Lorenzo and La Venta, and
carved the first monumental stone sculpture.
Through colossal stone heads and a range of
figural sculpture, they established the tradition
of portraits of rulers. They created a sophisti-
cated symbol system and a coherent art style.
Their long-distance trade networks provided
access to many of the raw materials for their art.

This life-size mask is one of a number recov-
ered from Arroyo Pesquero, near the town of
Las Choapas, Veracruz, after fishermen discov-
ered hundreds of Olmec jade and serpentine
objects there, underwater, in the late 1960s.
The quantity and quality of the ritually cached
objects, together with nearby evidence of cere-
monial architecture and monumental sculpture,
suggest that Arroyo (or Río) Pesquero was an
important Olmec ceremonial center from about
900 to 500 B.C. A distinctive feature of many
objects from the site is an alteration in surface
color which may indicate that they were burned,
possibly in ritual cremation. The mottled white
of the museum's mask represents such altered
color. The Arroyo Pesquero masks are predomi-
nantly human faces. With pierced eyes and holes
at the top and sides, they could have been worn
by living men. CR

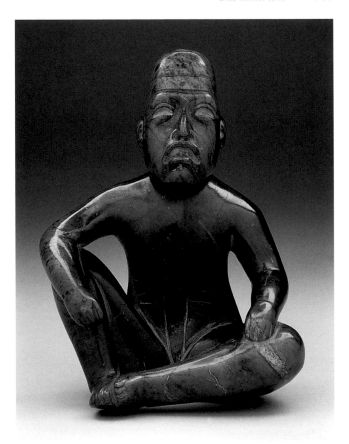

Seated figure with upraised knee

Mexico, state of Puebla, San Martín Texmelucan, Highland Olmec, 900–500 B.C.

Serpentine and cinnabar

7 × 5⅜ × 3⅛ in. (18.4 × 13.7 × 7.8 cm)

Gift of Mrs. Eugene McDermott, The Roberta Coke Camp Fund, and The Art Museum League Fund, 1983.50

About 900 B.C., jadeite and other varieties of greenstone acquired political significance for the Olmec elite and replaced clay as the preferred material for precious, small-scale objects that conveyed the Olmec symbol system. More difficult to obtain and to work than clay, jadeite and other greenstones derived ideological value from their color, which was associated with water, maize, vegetation, sky, and life. As one of several objects deposited in a burial cache, a greenstone figure such as this may have signified the renewal of life, especially when it was coated with cinnabar, a mineral whose red color represented the life force of blood.

This small sculpture embodies the consummate ability of Olmec sculptors to achieve monumentality even on a small scale. The economy with which the figure is realized emphasizes the gesture of the self-contained pose, which unites arms, upraised knee, and touching feet. Incised vertical and horizontal lines indicate a loincloth. The head is the focus of more specific detail: elongation above the headband (especially apparent in profile) indicates cranial deformation; the eyes, downturned at the outer corners, the narrow nose with flared nostrils, and the downturned corners of the trapezoidal mouth are quintessentially Olmec. Delicately incised motifs on the right side of the face (scarcely visible without magnification) include a rectilinear double scroll that Olmec scholar Peter David Joralemon has identified on several other jadeite and serpentine objects with similar features. This distinctive symbol may be associated with a specific person, perhaps a ruler—the Lord of the Double Scroll. CR

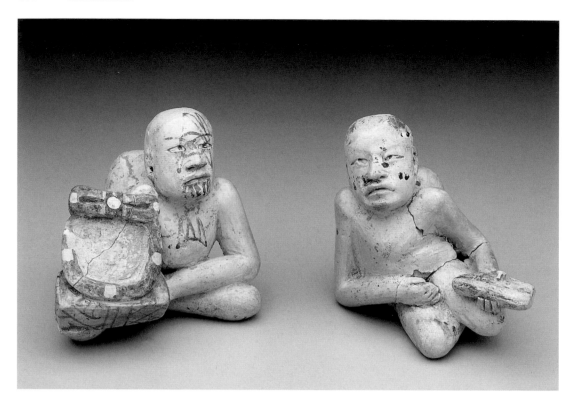

Seated hunchback holding mirror
Reclining hunchback holding rectangular object

Mexico, state of Puebla, Las Bocas, Olmec style,
c. 1000–500 B.C.
Ceramic and paint
Seated: 2⅝ × 2⅝ × 2½ in. (6.7 × 6.7 × 6.4 cm)
Reclining: 2½ × 2⅝ × 2½ in. (6.4 × 6.7 × 6.4 cm)
Gift of Carolyn C. and Dan C. Williams, 1993.81 and
1993.80

Objects that are Olmec in style have been
found in such distant areas of Mesoamerica as
Tlapacoya and Tlatilco in the Valley of Mexico,
Chalcatzingo in Morelos, and Teopantecuanitlan
in Guerrero. The relationship between the re-
gional cultures that made or used these items
and the Olmec archaeological culture of the
Gulf Coast, which is often described as the
Olmec heartland, is more debated than under-
stood. The site of Las Bocas, near the modern
town of Izúcar de Matamoros in western Puebla,
is also a source of ceramics in the Olmec style:
blackware bottles and bowls deeply incised with
Olmec symbols, animal effigy vessels, hollow
babylike figures, and small, solid figures with
polished white slip.

These deftly modeled miniatures epitomize
the refined naturalism of the Las Bocas style.
Physical deformity is a recurring theme in
Mesoamerican art, and a number of Olmec-
style objects depict hunchbacks and dwarves,
whom the Olmec accorded special status and
associated with the supernatural world. Each
figure holds an object for which Olmec scholar
F. Kent Reilly III has provided a tentative iden-
tification. The seated hunchback holds what is
probably a mirror. Actual Olmec mirrors are
made of iron ore (magnetite, ilmenite, or hema-
tite), with a highly polished concave surface that
both reflects and inverts an image. It is possible
that the Olmec, like later Mesoamerican cultures,
used mirrors as tools for shamanic divination
and considered them portals to the supernatural
world. The reclining hunchback holds a rectan-
gular object that may be a container for pigments
used for body painting. It might also be a ritual
implement, possibly a celt, or stone ax head.
Associated with agriculture and maize, celts
figured prominently in Olmec ritual and were
often deposited in caches. CR

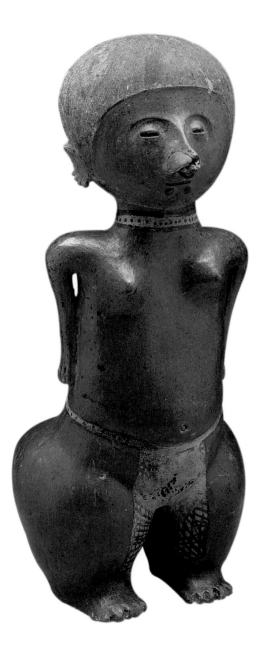

Standing female figure

Mexico, state of Nayarit, Chinesco style,
c. 100 B.C.–A.D. 250
Ceramic
22¾ × 9½ × 9 in. (57.8 × 24.1 × 22.7 cm)
Gift of Mr. and Mrs. Eugene McDermott and the
Eugene McDermott Foundation and Mr. and Mrs.
Algur H. Meadows and the Meadows Foundation,
Incorporated, 1973.52

A distinctive set of burial customs was present
in the Colima-Jalisco-Nayarit area of West
Mexico from at least 250 B.C. The characteristic
shaft-and-chamber tomb consisted of a vertical
shaft, some 10 to 60 feet deep, that connected
to an arched chamber, directly or indirectly,
by means of lateral tunnels. The revered dead
were accompanied by offerings of pyrite mosaic
mirrors, conch-shell trumpets, and large-scale
hollow ceramic sculptures of human beings and
animals. Although they vary in style from area
to area, these sculptures have in common a
distinctive vitality that derives in part from
gesture and pose. The humanness of the figures
suggests that the societies they represent were
less rigidly class-structured than those of other
areas of Mesoamerica. Religion seems to have
centered around the shaman, an intermediary
between the human and spirit worlds, and fig-
ures that resemble warriors may well have been
present to defend the soul against the powers of
the otherworld.

The word *chinesco* designates a hollow ceramic
figure style from southern Nayarit distinguished
by vaguely Asian facial features. The broad head
and circular face of this example are characteris-
tic, as are the incised caplike treatment of the
hair and the depiction of multiple rings as nose
and ear ornaments. The figure's ample hips
and legs, full and rounded, convey nurturing
abundance; her short, thin arms imply a life with
few manual tasks. The female figure, a favorite
theme for Mesoamerica's earliest ceramic artists,
probably alluded to hopes for human and agri-
cultural fertility. CR

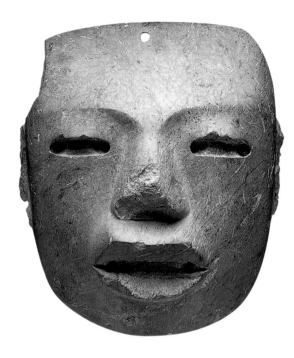

Face panel

Mexico, state of Mexico, Teotihuacan, c. A.D. 450–750
Stone
12⅝ × 11⅛ × 7¼ in. (32.1 × 28.3 × 18.5 cm)
Gift of Mr. and Mrs. Eugene McDermott and the
Eugene McDermott Foundation and Mr. and Mrs.
Algur H. Meadows and the Meadows Foundation,
Incorporated, 1973.49

During the period from 150 B.C. to A.D. 750,
Teotihuacan, northeast of Mexico City, was
the largest and one of the most influential city-
states in Mesoamerica. The later Aztecs, who
associated the center with the creation of the
world, called it Teotihuacan, "place of the gods."
The archaeological site represents a planned
urban complex distinguished by the huge pyra-
mids of the Sun and Moon, extensive residential
architecture, and impressive mural paintings.
Portable art forms characteristic of Teotihuacan
include cylindrical tripod ceramic vessels, some
frescoed and painted; composite ceramic censers;
and stone masks.

 Teotihuacan masks were carved from green-
stone, calcite, a white alabaster-like stone, and
other stones. The face is generally triangular in
shape and has a wide, low forehead. The eyes
are not pierced but their deep cavities were
originally inlaid with a contrasting, less perma-
nent material. The everted lips may once have
framed inlaid teeth. It is often thought that the
masks were funerary, yet none has been found in
a burial, and the mass and weight of the Dallas
example suggest another function. Drilled holes
would have allowed attachment, perhaps to an
image of the human figure made from perishable
material. Impersonal yet imposing, the masks
convey an emblematic sense of authority. CR

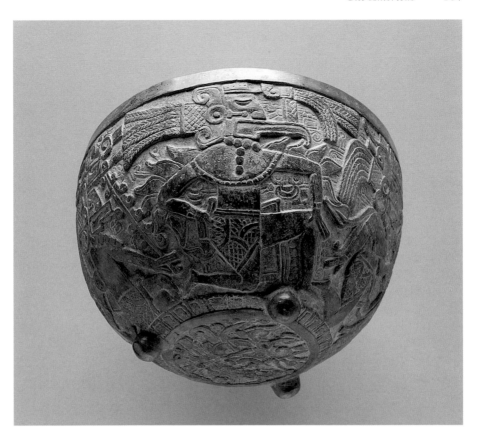

Bowl with ceremonially costumed figures

Mexico, state of Veracruz, Río Blanco region,
c. A.D. 600–900
Ceramic
5 × 8⅜ in. diam. (12.7 × 21.3 cm)
The Roberta Coke Camp Fund, 1977.52

From about A.D. 600 to 900, south-central Veracruz supported a prolific, predominantly figural ceramic tradition. Produced both by hand modeling and with the use of composite molds, the sculptures depict human figures, often elaborately costumed, in a variety of poses. The ceramics, often deliberately broken, were used ritually as offerings and were buried with the dead. Individual themes identify particular cults. Youthful figures with smiling faces probably represent the ritual drunkenness associated with the pulque cult. The near life-size sculptures excavated at El Zapotal—a seated skeletal image of Mictlantecuhtli, the Lord of Death, and thirteen female figures representing the Cihuateteo, women who died in childbirth—honor death.

Another distinctive Veracruz ceramic style, attributed to the Río Blanco region, features small, essentially hemispheric bowls with exterior relief decoration. The bowls depict scenes in which ceremonially costumed human figures engage in ritual activity. On the Dallas bowl six male figures are shown seated or kneeling on one knee. Each figure wears a patterned hip cloth, a necklace of circular beads (probably jade), a buccal mask (four have square noses and two have birdlike beaks), and an elaborate headdress with prominent ear panels and lavish feathers. Four of the figures wear a capelike shoulder garment. The two seated figures hold stafflike objects, while the kneeling figures have winglike elements along their arms. Other motifs that may prove significant in identifying the ritual are the dragonlike face and the leaf-and-stem element, both of which appear in several of the headdresses and in combination in the medallion on the base of the bowl. CR

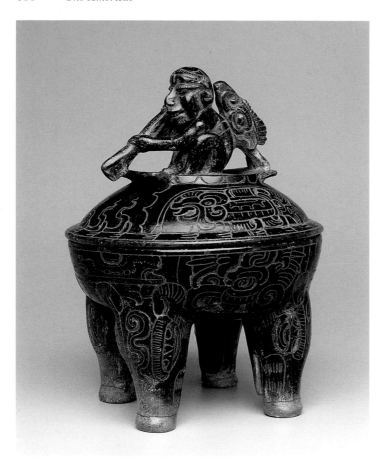

Lidded tetrapod bowl with paddler and peccaries

Mexico or Guatemala, southern Maya lowlands,
Maya, c. A.D. 250–550
Ceramic and cinnabar
12 × 9¼ in. diam. (30.5 × 23.5 cm)
The Roberta Coke Camp Fund, 1988.82.a–b

The ancient Maya inhabited a large, geographically diverse area that today includes southeastern Mexico, Guatemala, Belize, and parts of Honduras and El Salvador. Maya civilization, which attained its highest development between A.D. 250 and 900 (the Classic period), is known for the architecture of such cities as Palenque, Tikal, and Copán; its fully developed hieroglyphic writing system; achievements in astronomy and mathematics; and an incomparably refined art style.

 During the period between A.D. 250 and 550, Maya potters made distinctive lidded ceramic vessels from dark clays. Handles and legs are often three-dimensional figures, and deeply incised symbols enliven a highly burnished surface. These sculptural containers are eloquent expressions of the Maya cosmos. The figure atop the lid of this vessel sits in a small canoe, a paddle in his hands and a fish on his back. The four-petaled *kin* sign on his head, the symbol for day or sun, suggests that the paddler is the Maya sun god, Kinich Ahau. The waters that surround the paddler and his canoe are probably those of the underworld, through which the sun must travel each night before emerging again at dawn. Each of the four legs of the vessel depicts the head of the piglike peccary, shown with its blunt snout down. In Maya astronomy, two peccaries represent the constellation we call Gemini. Maya scholars Linda Schele and David Freidel have interpreted this vessel as depicting the sun god as he canoes past the peccaries in Gemini at the ecliptic, the path of the sun through the constellations. CR

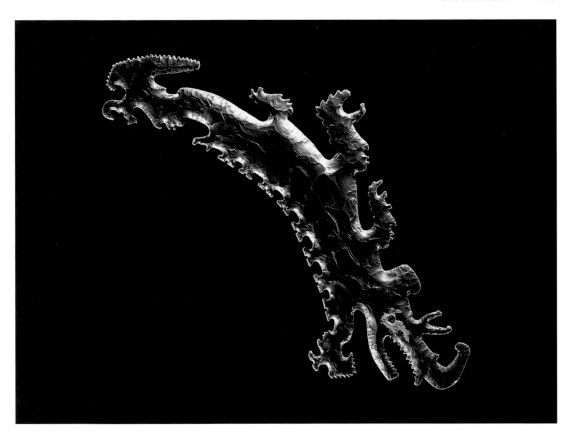

*Eccentric flint depicting a crocodile canoe
with passengers*

Mexico or Guatemala, southern Maya lowlands,
Maya, c. A.D. 600–900
Flint
9¾ × 16¼ × ¾ in. (24.8 × 41.3 × 1.9 cm)
The Eugene and Margaret McDermott Art Fund,
Inc., in honor of Mrs. Alex Spence, 1983.45.McD

The Maya perfected the art of chipping flint
to create thin, flat blades *(tok')* for sacrificial and
ceremonial use. The complex shapes of many
of these objects, which are too fragile for use as
cutting tools, have earned them the designation
"eccentric flints." Archaeologists have found
them in elite tombs and in offertory caches
associated with dedication and termination
rituals for architecture and stone monuments.
Such symbolically charged objects may also have
functioned as talismans for living kings.

 This particularly elaborate flint depicts a ca-
noe with the head of an open-mouthed crocodile
at the prow. Silhouetted human heads mark the
stern of the boat and the foreleg of the animal.

Three passengers, shown as profile heads facing
right, are thrust backward by the force of the
canoe's dramatic downward plunge. Maya
scholars Linda Schele and David Freidel have
interpreted this image as a moment in the Maya
story of creation (on the night of August 13,
3114 B.C.) when a crocodile canoe, paddled by
gods, takes the soul of the sacrificed Maize God,
or First Father, to the place where he will be
miraculously reborn. The creation story seems
to have been closely connected with Maya as-
tronomy, in which the movements of the stars
annually reenact these events. Looking skyward
on August 13, the Milky Way stretches from
east to west, resembling a cosmic monster, or
canoe. After midnight the Milky Way pivots to a
north-south position, and the canoe sinks to the
underwater spirit world. Just before dawn the
three stars of Orion appear overhead, signifying
the three hearthstones of creation where First
Father was reborn as Maize, the sustenance and
flesh of humanity. CR

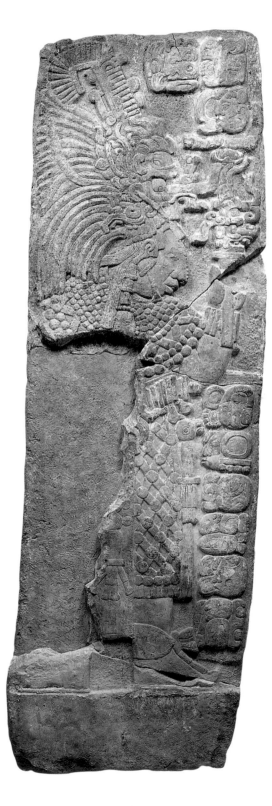

Wall panel depicting Na-Bolon-K'an in ritual dress
Mexico, southern Maya lowlands, probably state
of Tabasco, Maya, c. A.D. 650–750
Limestone, stucco, and paint
86¾ × 30¼ × 6 in. (220.3 × 76.8 × 15.2 cm)
Foundation for the Arts Collection, gift of Mr. and
Mrs. James H. Clark, 1968.39.FA

Maya stone sculpture often took the form of
freestanding vertical monuments (stelae) erected
in plazas; circular altars or pedestals; and a vari-
ety of low-relief carvings used in architectural
contexts as lintels and wall panels. These forms
have in common the integration of figural im-
ages and hieroglyphic texts. The figures usually
represent the principal participants in a ritual
event, while the text records the name of the
subject depicted, the nature of the event, and the
date on which it occurred.

The protagonist of the Dallas wall panel is
a woman, and in characteristic Maya style,
the emphasis is on ritual regalia rather than a
faithful likeness of the individual. The primary
costume elements are consistent with depictions
of elite women on other Classic period monu-
ments: symbol-laden headdress, beaded circular
neckpiece, shell belt ornament (fragmentary
here), openwork skirt of tubular and spherical
beads (probably jadeite), and scepter. In the
brief, undated hieroglyphic text, two glyphs at
the top record the action being performed, the
nature of which is uncertain, while the other
glyphs provide titles and names. The fifth glyph
from the bottom is the most easily deciphered.
The profile head is an honorific title for women,
which may be read as *na*. The circular element
with an interior cross represents *k'an*, which
signifies preciousness and often refers to jade
and shell, from which jewelry is made. The hori-
zontal bar and four dots indicate the number
nine, *bolon*, which has connotations of the uncon-
taminated and superlative. The noble woman's
name is Na-Bolon-K'an, or Lady Nine Precious.

CR

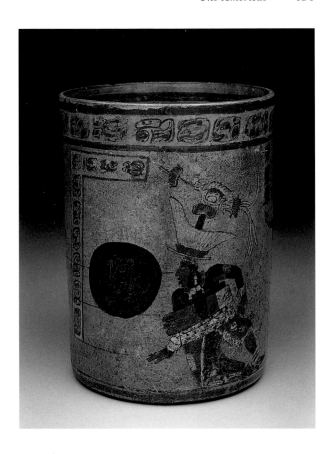

Cylindrical vessel with ritual ball game scene
Guatemala, northern Maya lowlands, Motul de
San José region, Ik' Emblem Glyph site, Maya,
c. A.D. 700–850
Ceramic
8⅛ × 6¼ in. diam. (20.7 × 15.9 cm)
Gift of Patsy R. and Raymond D. Nasher, 1983.148

The cylindrical vessel, a characteristic Maya ceramic form, was used for serving ceremonial beverages made from corn or chocolate. Its smooth, vertical wall provided an ideal surface for the work of Maya scribes and painters. The hieroglyphic texts on this vessel indicate that it was used for "tree-fresh cacao" (a drink made from the sweet pulp that surrounds the bitter seeds in the cacao pod) and that it belonged to a ruler named Sac-Muan, who was associated with a site in the Petén region of Guatemala, probably west of Lake Petén Itzá.

The painted scene depicts a game the Maya played with a solid rubber ball in a masonry court, striking the ball with their hips, not their hands. Here one player braces his right knee against the court floor as he prepares to return the ball with his padded right hip. Distinguished by water lily, deer, and bird headdresses, each of the four players wears a hip protector, a hide apron, a padded guard on one forearm, and a knee pad on one knee. For the Maya of the Classic period, the ball game was both a popular sport and a ritual event that had many levels of meaning and often involved human sacrifice. As a reenactment of the primordial game in which the mythical Hero Twins played ball against the lords of the underworld, it was a metaphor of life, death, and regeneration. The ritual game depicted on this vessel may have marked a critical phase in the career of Sac-Muan. CR

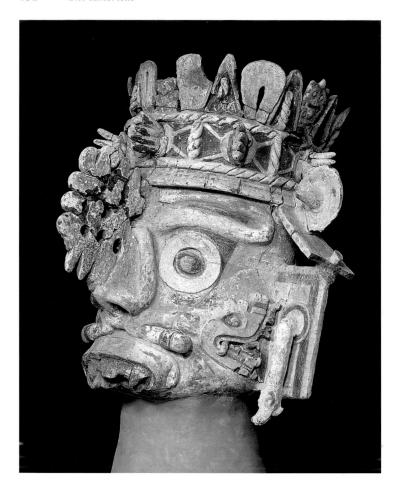

Head of the rain god Tlaloc

Mexico, state of Oaxaca, Teotitlan del Camino,
Mixtec, c. A.D. 1300–1500
Ceramic, tufa, stucco, and paint
68 × 45 × 41 in. (172.7 × 114.3 × 104.1 cm)
Gift of Mr. and Mrs. Stanley Marcus in memory of
Mary Freiberg, 1967.5

From about A.D. 1000 to 1400, the regional state
of the Mixtec people, distinguished by its strati-
fied society and the sophisticated skills of its spe-
cialized craftsmen, dominated western Oaxaca
and adjacent parts of Puebla. The Mixtecs were
defeated by the Aztecs in the fifteenth century,
and the tribute they subsequently paid included
the works of art in metal and turquoise mosaic
for which Mixtec craftsmen were famous. It was
in the Mixtec area that this monumental ceramic
head was reportedly found in a cave, accompa-
nied by two enormous ceramic toads and a large
ceramic hand (all in the museum's collection).

A similar head in the collection of the Museo
Nacional de Antropología in Mexico City was
reportedly found near Tehuacan, Puebla.

The prominent blue circles around the eyes,
the snakes on the cheeks and brow, and the
fangs that once streamed from the mouth iden-
tify the head as the Central Mexican god of rain
and lightning whom the Aztecs called Tlaloc.
Peoples of the time believed that Tlaloc lived
in mountain caves, the source of fertility and
wealth, and his helpers, the *tlaloque*, lived on
mountaintops, where shrines to the deity were
often built. Although generally considered
beneficent, Tlaloc could bring harm through
drought, lightning, floods, hail, and ice. The
offerings made to placate him included human
sacrifice, especially children. This head func-
tioned as a brazier for the burning of copal
incense, whose billowing smoke may well have
resembled rain clouds. CR

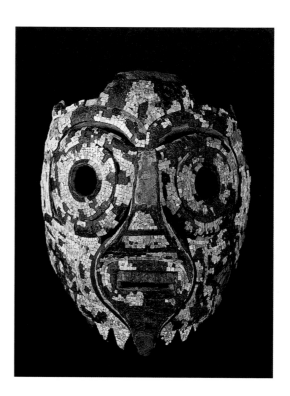

Mask, possibly of Tlaloc

Mexico, Mixtec-Aztec, c. A.D. 1485–1519
Wood, turquoise, *spondylus* shell, lignite, and resin
7¾ × 6⅜ × 3⅝ in. (19.7 × 16.2 × 9.3 cm)
The Roberta Coke Camp Fund, 1979.2

The Aztec Empire, founded in 1325 by semi-
barbarian nomads who settled in the Valley of
Mexico, was the last great indigenous state of
Mesoamerica. From the capital of Tenochtitlan,
Aztec authority spread by conquest to encom-
pass much of Mexico before the Spanish arrived
in 1519. Aztec stone sculpture, distinguished by
vigorous realism, often refers to human sacrifice,
a critical element in Aztec ritual. Another art
form associated with Aztec culture is turquoise
mosaic, which enhanced the surfaces of masks,
headdresses, shields, sacrificial knives, helmets,
pectorals, and staffs. The tedious process in-
volved grinding tiny tiles (tesserae), predomi-
nantly turquoise but including other precious
materials, by hand to a remarkable thinness
(0.40 to 0.75 mm), polishing them, and press-
ing them into a resin matrix applied to a carved
wood support. The mosaic skills of Mixtec
craftsmen were unsurpassed, and mosaic objects
used by the Aztecs were probably made as trib-
ute in Oaxaca or by Mixtec artists working in
the Valley of Mexico.

The concentric circles around the circular
eye-holes of the Dallas mask are an identifying
feature of the rain god Tlaloc. For the Aztecs,
turquoise itself symbolized the preciousness
of life, the blue of the daytime sky, and the blue
of water, which was associated with Tlaloc.
Mosaic masks may have functioned as ritual
regalia for images of deities, which were elabo-
rately dressed during festivals, or they may have
been worn by god impersonators. They were
also used in a funerary context, placed on the
wrapped body of a deceased ruler for his
cremation. CR

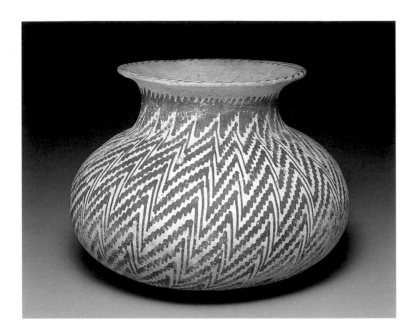

Jar with zigzag pattern

United States, Arizona, Hohokam culture,
c. A.D. 850–950
Ceramic; Santa Cruz Red-on-buff type
6 × 8½ in. diam. (15.2 × 21.6 cm)
Foundation for the Arts Collection, anonymous gift,
1988.105.FA

The Southwest culture area encompasses Arizona, New Mexico, and Utah and includes parts of Colorado, Nevada, and California, in the United States, and northern Sonora and Chihuahua in Mexico. Before the arrival of the Spanish in the sixteenth century, the Southwest was home to three major cultural groups: the Hohokam, the Anasazi, and the Mogollon. Each group had developed a significant pottery tradition by about A.D. 500, and it is through their ceramics that these cultures are most often represented in museum collections. Ceramic vessels functioned both in utilitarian ways—for carrying and storing water; for cooking, serving, and storing food—and in trade, religious ritual, and art.

The Hohokam lived in the desert valleys of south central Arizona, and the Phoenix Basin was their heartland. Responding to the arid conditions of their environment, they constructed sophisticated canal systems for irrigation. About A.D. 800, they began to build ball courts, probably as a result of their contact with Mesoamerican peoples, developing their own oval version of the structure (see p. 191). Their extensive trading networks reached distant Anasazi and Mogollon sites and far south into Mesoamerica. Hohokam ceramics are easily recognized by the buff color of the clay and the dark red of the painting. Fluid brushwork, spontaneous in effect yet precisely controlled, depicts both highly stylized life forms—human figures, birds, reptiles, and mammals—and a variety of geometric motifs. Designs are usually organized in concentric, circular bands or repeated to create an all-over pattern. On the well-formed body of this jar, the rhythmic repetition of vertical lines and diagonal zigzags resembles calligraphy. CR

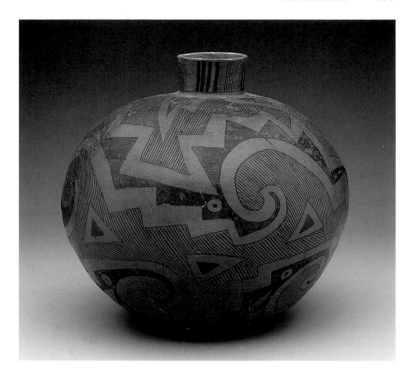

Storage jar
United States, Arizona, Anasazi culture,
c. A.D. 1125–1200
Ceramic; White Mountain Red ware, Wingate
Black-on-red type
12¼ × 13 in. diam. (31.1 × 33 cm)
Foundation for the Arts Collection, anonymous gift,
1991.336.FA

The Anasazi culture, ancestral to modern
Pueblo peoples, developed some two thousand
years ago in northern New Mexico and the
Four Corners area where Utah, Colorado, Ari-
zona, and New Mexico meet. Early Anasazi
people made decorated baskets whose precise
and highly structured designs represent the
beginning of a long tradition of geometric pat-
terning. More recently, between A.D. 950 and
1300, the Anasazi constructed the most elabo-
rate indigenous architecture of the Southwest—
the Great House communities at Chaco Canyon
(New Mexico) and the cliff dwellings of Mesa
Verde (Colorado) and Canyon de Chelly (Ari-
zona). Anasazi builders developed the pithouse,
or excavated dwelling, into a semi-subterranean
chamber, an architectural feature that has sur-
vived into the twentieth century as the kiva,
which Pueblo peoples use for sacred or social
purposes.

Anasazi pottery is predominantly a black-on-
white tradition, in which white slip provides a
surface for the rendering of essentially geomet-
ric designs in black paint. The Wingate style, of
which this vessel is an example, featured a red
background, which increased in popularity after
about A.D. 1000, as well as interlocking hatched
and solid figures. The ubiquitous stepped spiral
and the dotted circle were favorite motifs. Al-
though Anasazi painting is in general nonfig-
urative, occasionally, as here, the judicious
placement of the dotted circle turns the stepped
spiral into the head of a bird with a long, curv-
ing beak. The widespread distribution of ceram-
ics in the Wingate style suggests considerable
popularity or prestige for the type. CR

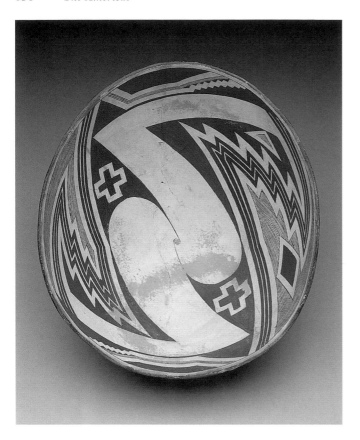

Bowl with geometric design

United States, New Mexico, Mogollon culture,
Mimbres people, c. A.D. 1000–1150
Ceramic
6⅜ × 13⅜ × 12 in. (16.2 × 33.9 × 30.5 cm)
Gift of Martin Matyas, Bob Rheudasil, and Mrs.
Edward Marcus in honor of Edward Marcus, 1982.94

The Mogollon culture, which flourished from about 300 B.C. to about A.D. 1350, encompassed at least six subgroups, of which the Mimbres people of southwestern New Mexico are probably the best known. Most Mogollon peoples seem to have depended more than other groups in the Southwest area on the hunting of small game and the gathering of wild foods. They lived mostly in excavated dwellings, or pithouses. Although much Mogollon pottery is unpainted, Mimbres potters developed one of the Southwest's most appealing painting styles, distinguished by dynamic geometric compositions and by representational and narrative imagery that provides an eloquent record of Mimbres life.

The most common Mimbres vessel form is a deep hemispheric bowl, the interior of which provided a concave surface for black-on-white paintings. The bowls often warped during the firing, at which time oxidation could turn the paint red-brown, as on this example. The vessels were used in life as serving dishes or food containers, but they also accompanied the dead as funerary offerings. A hole in the bottom of a bowl indicates that it was probably ritually killed before burial. The geometric painting of many Mimbres vessels suggests concepts of sacred space, or cosmic geography. The edge of the bowl may have marked the boundary of an orderly world, while the center space, which is often clearly defined yet empty and white, may refer to the Earth Center. Here, two delicate spirals emanate from that center. The crosses suggest the four cardinal directions, and the jagged angular forms convey the dynamic tension of lightning in a darkened sky. CR

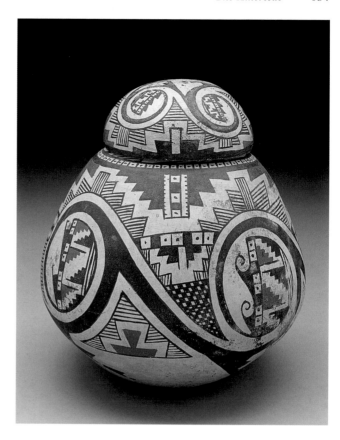

Lidded jar
Mexico, state of Chihuahua, Casas Grandes culture,
c. A.D. 1150–1350
Ceramic
10 × 8¼ in. diam. (25.4 × 20.9 cm)
Foundation for the Arts Collection, anonymous gift,
1990.96.a–b.FA

The Mogollon culture extended southward into the Mexican states of Chihuahua and northeastern Sonora. In Chihuahua, in the Casas Grandes valley of the northern Sierra, are ruins of an administrative and trading center that flourished from about A.D. 1150 to 1350. Called Paquimé by a sixteenth-century Spanish explorer, the site has provided evidence of contact with Southwestern peoples to the north and Mesoamerican peoples to the south. Turquoise, marine shells, exotic birds, copper bells, and decorative pottery figured in the extensive trade of this center, which may have been founded by Aztec merchant groups from Mesoamerica.

Casas Grandes potters favored the round-bottomed jar as the dominant vessel form, a highly polished surface, and painted decoration in black, red, and cream. Opposed stepped triangles, checkerboard patterns, and dotted squares, often in rows, are characteristic motifs, all of which occur in Mimbres pottery to the north. Lidded jars are quite rare, yet the short vertical neck on this vessel seems intended to accommodate a lid, and the convergence of motifs on the two pieces—the stepped triangles form a stepped diamond when top and bottom are aligned—indicate that they were conceived as a unit. Bold curvilinear spirals frame pairs of opposed stepped triangles and rows of dotted squares on the jar. The painting on the interior of the lid depicts three parrot or macaw heads, another prevalent motif in the pottery of Casas Grandes. **CR**

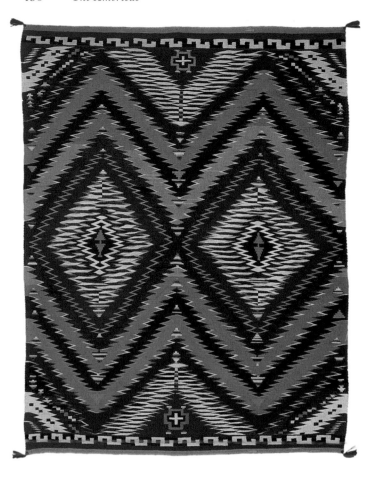

Eye-dazzler blanket

United States, Arizona, Navajo people, c. 1890
Cotton and wool
75 × 57 in. (190.5 × 144.8 cm)
Textile Purchase Fund and gifts from The Eugene
McDermott Foundation, Silas R. Mountsier III,
and an anonymous donor, 1990.229

Navajo weaving is the most distinguished of
modern Southwestern textile traditions. Using
an upright loom, Navajo women created rectan-
gular textiles that during the nineteenth century
evolved from the wearing blanket of the Classic
period (1800–1864/8) to the rug that encour-
aged the survival of the tradition into the twen-
tieth century. The internment of the Navajo by
the U.S. government between 1864 and 1868
at Bosque Redondo, in eastern New Mexico,
marked the end of the Classic period. These
four years of confinement were followed by a
period of dramatic changes in both design and
materials.

Aniline dyes (coloring agents obtained syn-
thetically from coal tar products) simplified the
process of achieving color and expanded the
range of hues, and machine-spun yarn from
Germantown, Pennsylvania, offered consistent
diameter as well as the new chemical colors.
Use of the new yarn in geometric compositions
that were at once bolder and more complex
produced "eye-dazzlers"—textiles with an
intense interaction of color. The weaver of this
blanket improvised brilliantly on the themes of
the Mexican Saltillo sarape (see p. 209), dou-
bling the sarape's serrate central diamond and
transforming the vertical zigzags of its field into
diagonal bands that emphasize the diamonds.
The use of complementary reds and greens, the
staccato alternation of dark gray-green and
white, and the shaded color of many of the nar-
row zigzags contribute to the dynamic optical
quality of this blanket. CR

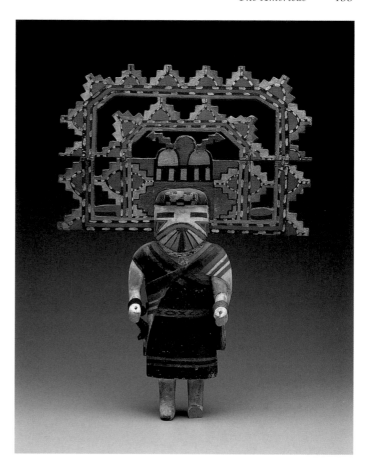

Kachina (tihu) *depicting Palhik' Mana*
(Water Drinking Girl)

United States, Arizona, Hopi people, probably 1920s
Wood, paint, and wool yarn
20 × 14⅛ × 4 in. (50.8 × 35.9 × 10.2 cm)
Given in memory of Congressman James M. Collins
by his family, 1993.71

For the Hopi, who live on three mesas in north-eastern Arizona, the word kachina *(katsina)* refers to three distinct but related entities: the invisible spirits who are an essential part of Hopi life; the personification of those spirits by Hopi men wearing masks and costumes in ceremonial dances; and the carved wood figures called *tihu* (small person or child) that Hopi men give to infants and to women of all ages. The kachina spirits are intermediaries between the Hopi and other supernaturals; they are also messengers of the gods and bringers of clouds and rain. The Hopi man who portrays a kachina spirit gives visual form to the invisible and becomes one with the spirit he represents. The *tihu* is a remembrance both of a dancer's portrayal and of the bond that exists between human beings and the supernatural.

This unusually large *tihu* depicts Palhik' Mana (Water Drinking Girl), one of the most beautiful kachina images. The Palhik' Mana's most distinctive feature is an elaborate wood headdress, carved and painted with symbols of clouds and lightning. This costume element, a *tableta*, is worn by Pueblo women along the Rio Grande during ceremonies. The *tihu* also wears the traditional black dress, narrow warp-patterned belt, striped blanket or manta, and calf-length boots or moccasins. On First and Second Mesa, when Palhik' Mana appears in dances, she is portrayed by women and is there-fore not considered a kachina. On Third Mesa, Palhik' Mana appears masked, portrayed by men. CR

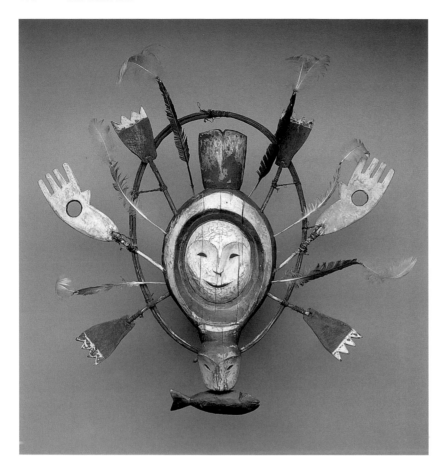

Mask with seal or sea otter spirit

United States, Alaska, Yukon River area,
Yup'ik Eskimo, late 19th century
Wood, paint, gut cord, and feathers
23½ × 22¼ × 2¼ in. (59.7 × 56.5 × 5.7 cm)
Gift of Elizabeth H. Penn, 1976.50

The Arctic coasts of Alaska and Canada are part of the Arctic, or North Pacific Rim, culture area. The resources of this rich maritime environment have played a significant role in the region's cultures. Birds, fish, shellfish, and many sea mammals—sea otters, whales, seals, sea lions, and walrus—provide food, and from the sea mammals come other products such as oil, skins, and ivory. The Yup'ik peoples who live on Alaska's western coast and adjacent islands see their relationship with animals as collaborative and reciprocal. Animals as well as humans have an immortal soul or spirit *(inua* or *yua)*, and both participate in an endless cycle of birth, death, and rebirth. The hunter who shows respect for his prey finds that the animal gives himself in return.

Traditional Yup'ik beliefs were expressed in seasonal festivals which honored the spirits of animals that had been hunted during the previous year. Held in the men's house *(qasgig)*, the social and ceremonial center of the village, these events often included masked dances. Masks with encircling hoops manifest shamanic visions of the spirit world. They represent a ringed center that connotes enhanced spiritual vision and movement between human and supernatural worlds. At the center of the Dallas mask is a seal or sea otter with a fish in its mouth. The smiling face on the animal's back represents its soul. The circular holes in the two white hands may symbolize a passageway between the human and spirit worlds, through which the spirits of animals returned to earth to replenish the supply of game. CR

Raven and crouching figure

Canada, Queen Charlotte Islands, British Columbia,
Haida, mid-19th century
Walrus ivory and shell inlay
4⅛ × 1⅝ × 3⅞ in. (10.5 × 4.1 × 9.8 cm)
The Eugene and Margaret McDermott Art Fund,
Inc., 1977.28.McD

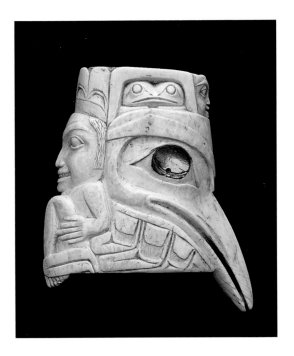

The raven is a ubiquitous figure in the art and
mythology of the cultures of the Northwest
Coast. Prominent among the legends associated
with him is the Box of Daylight, which Raven
opened at the beginning of time, thereby flood-
ing the skies forever with sunlight and, in the
process, scorching his white feathers black.

While the specific purpose of this handsome
carving of walrus ivory remains unclear—it
might be a knife handle or perhaps a cup—it
most certainly would have conferred consider-
able esteem upon its owner. Datable on stylistic
grounds to the mid-nineteenth century, it is
compositionally related to spoons fashioned
from horn and to figures carved from argillite.
Both these materials were readily available to
the Haida people of the Queen Charlotte Islands
off the coast of British Columbia. The tusk of
the walrus, however, had to come from Eskimo
country several hundred miles to the north,
presumably as an object of trade and through
several intermediaries. Only then could it have
come to the Haida master who, working with
tools crafted by native hands from European
metal, transformed it into an image of radiant
beauty. JG

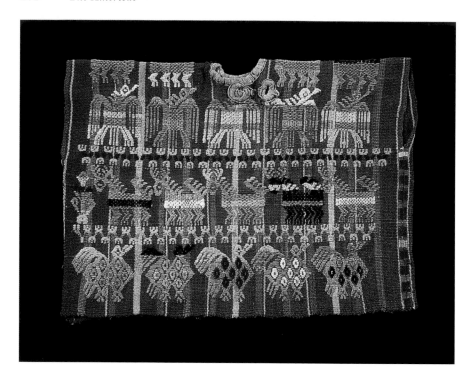

*Huipil, probably for a figure of the
Virgin of the Rosary*

Guatemala, department of Guatemala, San Juan
Sacatepéquez, Kaqchikel Maya, probably 1925–35
Cotton and silk
8½ × 11¾ in. (21.6 × 29.9 cm)
The Carolyn C. and Dan C. Williams Collection of
Guatemalan Textiles, gift of Carolyn C. and Dan C.
Williams, 1982.158

The cult of the saints came to Guatemala in the
sixteenth century when the invading Spanish
introduced Christianity. A Roman Catholic saint
became the patron of each town, and his or her
Spanish name was often coupled with the indig-
enous name of the community. Other saints were
also venerated locally, each served by a religious
brotherhood, or *cofradía*, whose members ar-
ranged feast day celebrations, carried images of
the saints in processions, and presented textiles
as offerings. Vestments for the saints were often
miniature versions of actual garments, including
the *huipil* or tuniclike blouse, the shirt, the head-
cloth, and the sash. Like their prototypes, these
textiles were woven on a backstrap loom—a
simple, portable combination of sticks, cords,
and strap, which is used today as it was in pre-
Hispanic times. Designs were usually achieved

by the addition of extra, or supplementary, wefts
during the weaving.

Colors, including their configuration in
stripes, and motifs often identify the commu-
nity where a textile was woven. A red cotton
ground with lengthwise (warp) stripes in purple,
yellow, and naturally pigmented brown are
characteristic of several textiles from San Juan
Sacatepéquez, a community northwest of Guate-
mala City, as are the frontal double-headed bird
(depicted here in an unusual variation with a
single head), profile deer, and profile bird with
flag wing. The tiny bound hole below the neck-
line, which represents a second neckline, sug-
gests that this *huipil* was intended for a figure
of the Virgin of the Rosary, who held a tiny
Christ Child. CR

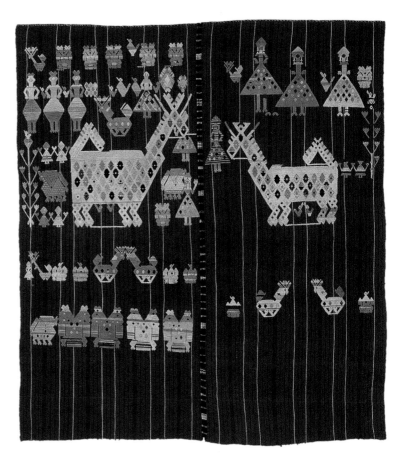

Woman's headcloth or carrying cloth (su't)

Guatemala, department of Quiché, Santo Tomás
Chichicastenango, K'iche' Maya, probably 1935–45
Cotton, silk, and wool
50 × 44 in. (127 × 111.8 cm)
The Patsy R. and Raymond D. Nasher Collection of
Maya Textiles from Guatemala, gift of Patsy R. and
Raymond D. Nasher, 1983.335

Chichicastenango, in Guatemala's highlands,
is famous for the church of Santo Tomás, a re-
gional market on Thursdays and Sundays, and
handwoven textiles. At their best, the textiles
exemplify the balance of technical skill and aes-
thetic merit that distinguishes Guatemala's
finest weaving styles. In Chichicastenango,
tradition guides both design and composition
for the woman's *huipil* and the man's ceremonial
headcloth *(su't* or *tzute)*. During the twentieth
century, these textiles have consistently featured
densely patterned rectangular blocks in a sym-
metrical composition, while the favored designs
have changed gradually from double-headed

birds to horizontal zigzags to, most recently,
floral fantasies. The square cloths that women
use, either folded atop their heads as sunshades
or as carrying cloths for babies and various
items, show greater freedom in the choice and
placement of motifs.

Chichicastenango textiles of this type are
invariably charming. Figures are whimsically
treated; feet, for example, are depicted similarly,
regardless of whether the bodies that develop
above them are human or animal. Motifs often
show unexpected juxtapositions and abrupt yet
compatible changes in scale. The female figures
with triangular skirts, diamond-spotted deer,
double-headed frontal birds, humpbacked ani-
mals, and elegant bird-topped plants of this ex-
ample are characteristic motifs for the woman's
su't. Individuality is apparent in the rendering
of the motifs, the asymmetry of the composition,
and in the attention to negative space. CR

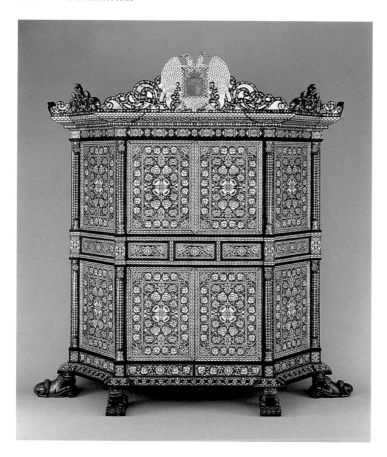

Cabinet

Spanish Colonial, Manila, the Philippines, c. 1685
Wood, mother-of-pearl, bone, tortoiseshell, pewter,
and gilding
102 × 89½ × 26 in. (259.1 × 227.3 × 66 cm)
Gift of The Eugene McDermott Foundation in honor
of Carol and Richard Brettell, 1993.36

This masterpiece of colonial cabinetry is truly
a global object. Its form and ornament are de-
rived from European and particularly Spanish
prototypes. Yet it was most probably made in
the Philippines for a powerful ruler of New
Spain who lived in Mexico City. Its first owner
was Don Melchor Portocarrero, third count of
Monclava, viceroy of New Spain from 1686 until
1688, and viceroy of Peru from 1689 to 1715.
It is likely that he commissioned this piece fol-
lowing his arrival in Mexico. At the time the
Philippines were Spanish colonies ruled from
Mexico City, and the European and Asian crafts-
men in the colonial city of Manila created ob-
jects destined for both Europe and New Spain.

Virtually the entire surface of this resplen-
dent cabinet is covered with precious material
from the sea. Its shimmering mother-of-pearl
and tortoiseshell surface is composed of count-
less carefully cut pieces arranged in elaborate
designs representing flowers and vegetation.
These designs cover cabinet doors that open
to reveal shelves, drawers, and even a dome,
all richly veneered with tortoiseshell, mother-
of-pearl, ebony, wood, pewter, and bone. The
interior, which adds materials from the earth
to those from the sea, features geometric forms.
These geometric patterns have double origins
in Moorish designs common in pre-Christian
Spain and seventeenth-century marquetry from
the Portuguese colony of Goa, in India.

The painted coat of arms framed within a
double-headed eagle is that of the Tagle family
of Peru, which inherited the cabinet in the late
eighteenth century. CV

La Dolorosa (The Virgin of Sorrows)
Spanish Colonial, probably Mexico, c. 1650–1750
Wood, paint, gilding, glass, and ivory
H. 33½ in. (85.1 cm)
Gift of Beatrice M. Haggerty, 1996.107

Beginning in the thirteenth century, the cult of the Seven Sorrows of the Virgin Mary became popular, and Mary was increasingly known as the Virgin of Sorrows, La Dolorosa. In this guise she clasps her hands together as if in prayer, is typically clothed in blue and red garb, and lacks a crown. This example exhibits all these characteristics as well as a sorrowful expression with eyes glancing heavenward. Especially noteworthy is the elaborate use of *estofado*, a combination of gilding and paint. This technique, used extensively in New Spain, involves the application of layers of background colors over which gold and silver leaf is applied. Texture is given to the gilt surface through tooling, with the result that the Virgin appears to wear damask robes richly ornamented with gold and silver threads.

Besides its high quality, this figure is notable for its size. Images of this height were typically created for use in churches or private chapels. Because of their potent religious associations and visual power, such pieces were often placed in niches high on a wall. In looking up at this particular figure, subtle details become apparent, such as its beautifully carved ivory teeth. CV

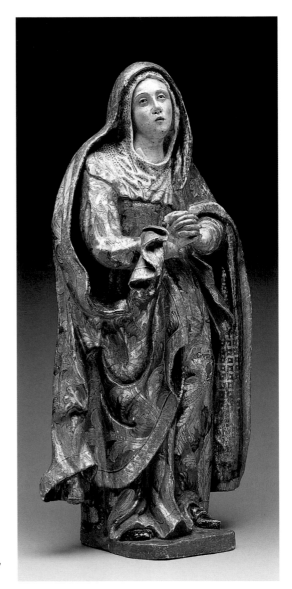

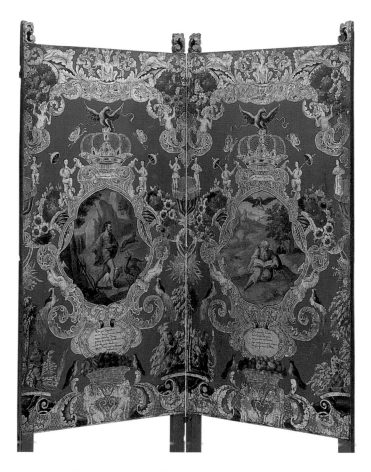

Screen (2 of 8 panels shown)

Spanish Colonial, probably Mexico City, c. 1740–60
Oil on canvas, pine, and gilding
59½ × 153 in. (151 × 388.6 cm)
Gift of the Stanley and Linda Marcus Foundation,
1993.74

The folding screen was perhaps the most inno-
vative furniture form made in colonial Mexico.
The first screens used in New Spain were
brought there in 1614 by Rokuemon Hasekura,
the Japanese ambassador. Greatly impressed
with these imported examples, the elite began
ordering screens from Asia and from local work-
shops for use in their homes. In Mexico the form
is called a *biombo* (from the Japanese *byo*, protec-
tion, and *bu*, wind—or protection from the
wind).

Although the earliest Mexican screens were
patterned after Asian examples, the form soon
came to reflect European ideas. The elaborately
painted and gilt chinoiserie decoration on this
example is characteristic of mid eighteenth-
century European and Mexican painting. Espe-
cially noteworthy is the depiction of traditional
Mexican fruit, flowers, and candy in the baskets
under the central reserves. The scenes in the
reserves are taken from a seventeenth-century
emblem book by Otto van Veen (1556–1629),
a well-known Flemish artist who worked at
several royal courts throughout Europe and
was a teacher of Rubens. He is best known for
a book of engravings entitled *Quinti Horatii
Flacci Emblemata* (Illustrated Sayings of Quintus
Horatius Flaccus; Antwerp, 1607). In it van
Veen illustrates moralizing quotations from
the classical writer Horace with his own engrav-
ings. The volume proved extremely popular,
and numerous editions in other languages were
issued during the next century, including one in
Spanish in 1669. Copies existed in libraries in
Spanish America, and probably one of them was
the source for the scenes painted on this elabo-
rate screen. CV

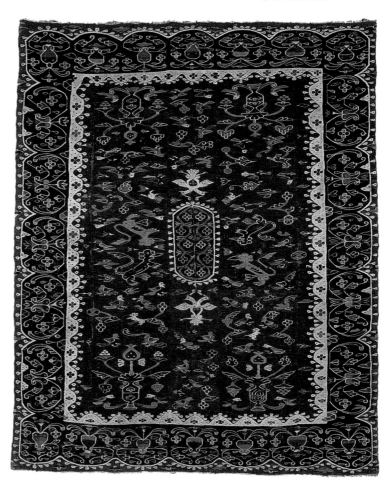

Poncho with central medallion and
double-headed birds

Spanish Colonial, Peru, 17th–18th century
Cotton and camelid fiber
75 × 61 in. (190.5 × 155 cm)
Gift of the Leland Fikes Foundation, Inc., 1975.61

The convergence of indigenous and European cultures that marked the Colonial period was distinctively expressed in Peruvian tapestry-woven textiles. Tapestry as a technique had had a long and distinguished history in the Andes, but most Colonial tapestries feature adaptations of foreign motifs and styles. The bordered layout and central medallion of this example are reminiscent of Oriental carpets, as are the birds, animals, and plants of the field and the meandering vine of the border. The white double-headed bird at each end of the medallion derives from the heraldic double-headed eagle of the Hapsburg kings, who ruled Spain from 1469

to 1716. The motif of a vase and plant, seen here in the four corners of the red field, is a recurrent theme in Islamic art, while the pomegranate, the central element in each vase, is native to Asia and an auspicious symbol in Chinese art.

The absence of contemporary references to these textiles leaves unanswered questions about who wove them, under what circumstances, and for whom. Dating is also a matter of interpretation. For some scholars, openness of composition and the use of the double-headed bird, as on this piece, suggest a seventeenth-century date. For others, the similarity to pile rugs woven in the Alpujarra region of Spain during the eighteenth and early nineteenth centuries indicates a later date. Most textiles of this style probably served as coverings for tables or beds or as rugs or carpets. The woven vertical slit in the central medallion of the Dallas textile identifies it as a poncho, an untailored garment for men. CR

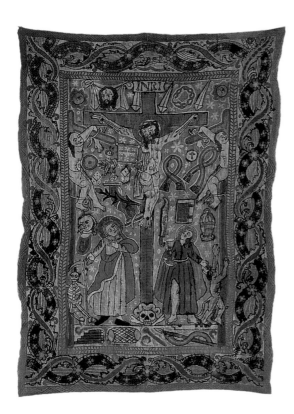

Lenten curtain depicting the Crucifixion and symbols of the Passion

Spanish Colonial, Peru, Loreto province, Chachapoyas area, probably 18th century
Cotton, painted with dyes or pigments
83½ × 60½ in. (212 × 153.7 cm)
Foundation for the Arts Collection, gift of Mr. and Mrs. Duncan E. Boeckman, 1990.149.FA

The Jesuits took Christianity to northeastern Peru, to the area around Chachapoyas where the ancient Inca road stopped. As late as the eighteenth century, this region remained uncharted on maps, and its ownership was disputed by Peru, Brazil, and Ecuador. Far from the trade routes that brought silver and other luxury materials to the churches of Lima and Cuzco, the missions of this remote area were humble and stark by comparison. The Jesuits and their followers used painted textiles, an ancient indigenous art form, to communicate the ideology of the church, with imagery probably inspired by European etchings or woodcuts.

This hanging represents a distinctive type of which few examples are known. The documented paintings have in common the theme of the crucifixion of Jesus Christ, suggesting that they veiled the altar of the church during Lent. Here, the right hand of Christ gives the sign of blessing, while blood on his arms graphically emphasizes his suffering. The artist placed the two thieves on their crosses, a skeletal Death with his scythe, and a groping devil at the very edges of the scene, where they seem to expand the composition. Among the symbols of the Passion depicted here are the veil with which Veronica wiped Christ's face on his way to Calvary (upper left, accompanied by a three-dimensional head); nails; the Crown of Thorns; a pair of dice, a reference to the soldiers' casting of lots for Christ's garment; and a cord-encircled column (curved to fit the space), which represents Christ's flagellation. CR

Classic Saltillo sarape

Spanish Colonial, Mexico, probably state of Coahuila, Saltillo, c. 1725–75
Cotton and wool
97¾ × 53½ in. (248.3 × 135.9 cm)
Gift of The Eugene McDermott Foundation, 1988.2

The Saltillo sarape is a large, elaborately patterned wearing blanket for men that was woven in several towns of northern Mexico from about 1725 to 1850. Of the weaving centers that produced these textiles—Saltillo, San Miguel de Allende, Guanajuato, Querétaro, San Luis Potosí, and Zacatecas—Saltillo was the best known, and its name became firmly associated with this tapestry-woven blanket. The extraordinary weaving skill and masterly design of the earliest pieces in this tradition have earned them the designation "classic." Characteristic design elements include a central lozenge of concentric diamonds, a field of narrow vertical stripes composed alternately of small diamonds and zigzags, and prominent geometric-patterned borders that act as a frame. Some sarapes have a field of tiny dots or an allover design of diamonds rather than the diamond and zigzag stripes. The dominant color is usually red or blue.

Although the classic period of Saltillo sarape weaving ended by about 1850, the popularity and legendary influence of the style continued. After Mexico gained independence from Spain in 1821, the sarape became a national symbol that was associated with patriotism and with Mexican horsemanship. To the north, weavers in the Rio Grande Valley of New Mexico and Colorado produced interpretations of the sarape, and Navajo weavers in Arizona adopted and redefined characteristic Saltillo designs (see p. 198). To the south, in Guatemala, men in San Miguel Totonicapán wore a variation of the sarape as a ceremonial poncho around 1900, and the Saltillo was the prototype for many twentieth-century blankets woven in the town of Momostenango. CR

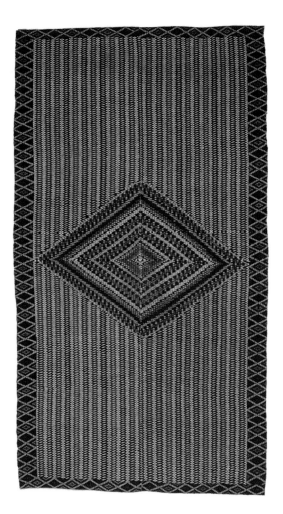

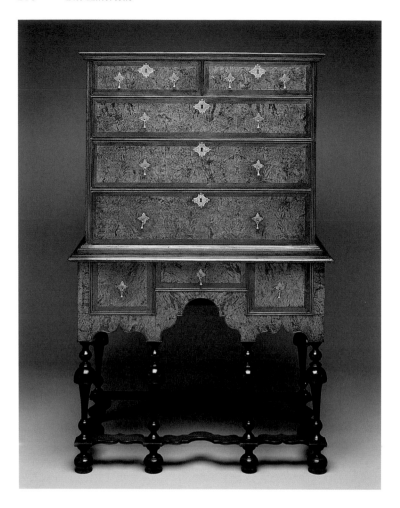

High chest of drawers

American, Boston, c. 1700–25
White pine, maple, walnut, and brass
77¾ × 63⅜ × 43⅜ in. (197.5 × 153.4 × 110.2 cm)
Gift of The Eugene McDermott Foundation in
memory of Helen Ulmer Van Atta, 1993.30.a–b

This high chest of drawers is an exceptional
example of early American furniture in the
William and Mary style. Unlike most furniture
of the previous century, this chest is decorated
with thinly cut veneers that reflected the change
which occurred in English court fashion follow-
ing the accession of Charles II in 1660. Charles
had been educated on the Continent, and his
taste was shaped by French and Netherlandish
fashion, which favored more delicate, veneered
furniture. This style was further developed by
William and Mary, who assumed the British
throne in 1688. Although these Continental

influences were slow to reach rural England
and the American colonies, cabinetmakers in
urban centers such as Boston, New York, and
Philadelphia were working in the taste by 1700.

Usually high chests of drawers were accompa-
nied by matching low chests or dressing tables
displaying identical turnings, patterning, and
matched veneers. While this chest does not
survive with an identical dressing table, it did
descend in the original owner's family with a
companion dressing table of the same period and
similar design, which is also in Dallas's collec-
tion. The dressing table could well have been
purchased along with the chest. Such a combina-
tion would have created the unified appearance
desired in the best bedchamber—a mark of
wealth and distinction in early colonial America.

SH

Tall case clock

American, c. 1730–45
Works by Benjamin Bagnall Sr. (American,
1689–1773), Boston
Walnut, maple, beech, cedar, and brass
98½ × 21⅞ × 10½ in. (250.2 × 55.6 × 26.7 cm)
The Faith P. and Charles L. Bybee Collection,
gift of Mr. and Mrs. H. Ross Perot, 1985.B.4

Tall case clocks were a luxury few could afford
in Boston in the late sixteenth and early seven-
teenth centuries. In fact no records have been
found to suggest that Boston even had a profes-
sional clockmaker before the turn of the eigh-
teenth century. Clockmakers then began to
appear, but their numbers were small and there
were few customers. The majority of Boston's
small group of clock- and watchmakers strug-
gled to make a living during the first fifty years
of the 1700s. Benjamin Bagnall Sr. seems to
have been the only one who ran a thriving clock
business. He also imported English watches and
probably clocks for resale in the colonies. Like
other successful artisans, Bagnall became influ-
ential in Boston's government and also engaged
in widespread mercantile activities; he had ties
to England, the West Indies, Philadelphia, Long
Island, and the North Shore of Massachusetts.
Trained in England, Bagnall first appears in
Boston records in 1712 and lived there all
his life.

Bagnall was responsible for creating the most
costly part of the clock, the clockworks. The
case was made by an unidentified local cabinet-
maker. This eight-day striking clock follows
English design closely. For example, the arched
face plates and cast corner elements and dol-
phins can be seen in numerous English clocks.
In both design and construction, the case also
follows English examples. This clock is ex-
tremely rare and represents the pinnacle of
clockmaking when the craft was in its infancy
in the British colonies. Only four tall case pen-
dulum clocks by Bagnall are known to survive,
and this one appears to be in the best condition.

DH

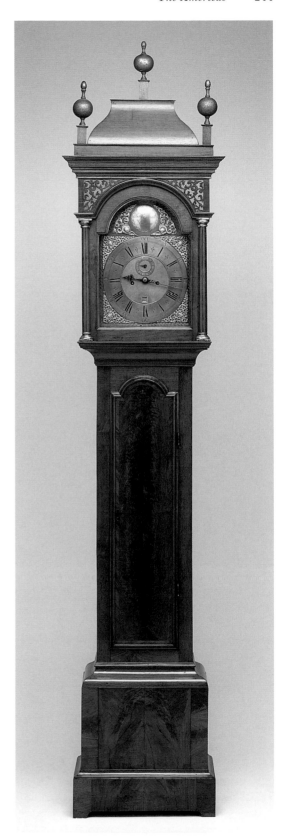

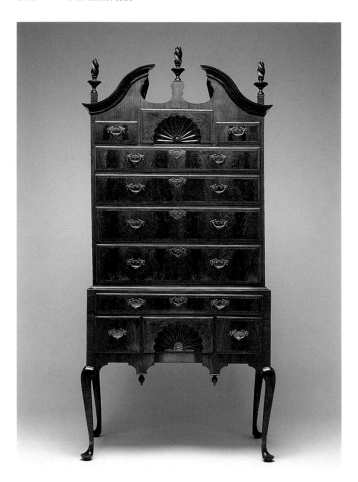

High chest of drawers

American, Ipswich or Salem, Massachusetts,
c. 1735–57
Walnut, pine, maple, and brass
82 × 40¼ × 23 in. (208.2 × 102.2 × 58.4 cm)
excluding finials
The Faith P. and Charles L. Bybee Collection, gift of
Mr. and Mrs. Vincent A. Carrozza, 1985.B.18.a–b

This high chest is related to a group of furni-
ture known to have been made in Essex County,
Massachusetts, in the second and third quarters
of the eighteenth century. Ipswich, Salem, and
Newburyport all possessed fine cabinetmaking
shops, but unfortunately, no piece from this
group can currently be attributed to a specific
shop in Essex County. Pieces from this group
all have similar construction techniques and
stylistic characteristics. Study of the entire
group has revealed that numerous customizing
options were available to the purchaser.

The original owner of this high chest, Ipswich
merchant Daniel Staniford (d. 1757), chose spec-
tacular crotch-grain veneers of black walnut
for the drawer fronts as well as a pair of richly
carved shells instead of inlaid ones, and decided
not to have them gilded, as others had done.
These options added expense, and other custom-
ers chose to leave the drawer fronts plain. Stani-
ford requested that drops be added to the skirt
instead of rounding them off. An arched pedi-
ment instead of a flat one completed the well-
proportioned piece. At Staniford's death, his
estate of £570 included a "Mansion House[,]
Barn & Garden in Ipswich Town." The "Hall
Chamber" contained this "Case of Drawers"
with a matching dressing table; they were the
items of greatest value in his house. DH

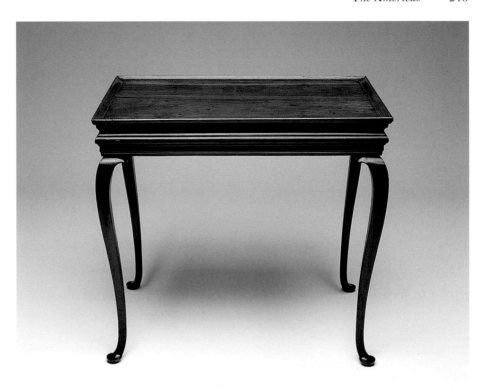

Tea table

American, probably Connecticut, c. 1730–50
Cherry and pine
26⅜ × 28¾ × 19 in. (67 × 73 × 48.3 cm)
The Faith P. and Charles L. Bybee Collection,
anonymous gift, 1985.B.13

During the late 1600s, the wife of King Charles
II of England, Catherine of Braganze, became
fascinated with oriental products and popular-
ized tea drinking. By the end of the seventeenth
century, England imported twenty thousand
pounds of tea annually. Accompanying the tea
were new rituals for its consumption, resulting
in specialized pots, cups, kettle stands, and tables
for serving and display. Tables with raised rims
designed to prevent expensive tea accoutre-
ments from falling developed around 1700.
This particular table is among the earliest
forms made in colonial America. The gracefully
S-curved cabriole legs, known as "horsebone
feet" from colonial documents, form a pleasing
contrast to the rectangular top. The emphasis
here is on excellence of form rather than orna-
ment or color. Though the origin of this table is
uncertain, evidence suggests it was produced
in Connecticut, where cherry was frequently
used to make formal furniture. Only one other
surviving table is identical to this one, and it
was owned by an early-twentieth-century collec-
tor from Connecticut. Several related examples
are also documented as coming from the Con-
necticut River valley. DH

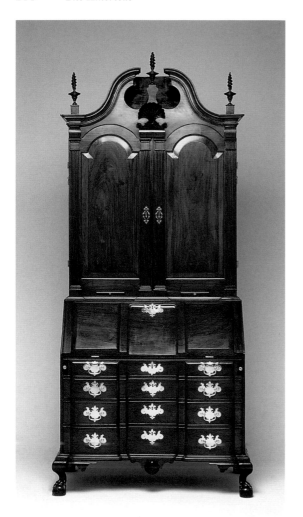

Desk and bookcase

American, Salem, Massachusetts, c. 1760–80
Attributed to Henry Rust (American, 1737–1812)
Mahogany, pine, poplar, and brass
97¾ × 45⅜ × 24½ in. (248.3 × 115.2 × 62.2 cm)
The Faith P. and Charles L. Bybee Collection, gift of
the Tri Delta Charity Antiques Show, 1985.B.27.a–b

The design and construction of this desk and
bookcase are firmly rooted in English cabinet-
making practices. By the second quarter of the
eighteenth century, craftsmen from London had
introduced the important characteristics of the
design: a slant-lid desk topped by a bookcase
with paneled doors, an arched, broken pediment,
ball-and-claw feet, and Greco-Roman architec-
tural details such as Corinthian pilasters. Such
desks and bookcases were unusual in the colo-

nies and were extremely expensive. They served
mercantile elites as organizational centers and
symbols of power.

Col. Joseph Sprague (1739–1808), one of
Salem's most prominent merchants, probably
owned this desk. Important papers and account
books from his distillery, import-export busi-
ness, and two farms could be kept under lock
and key in a variety of compartments behind
the paneled bookcase doors and the slant lid.
Sprague left an estate valued at $86,925.69 at
his death in 1808, a tremendous sum at the time.
This piece is probably the "Book Case" noted in
the inventory of his "mansion house." Valued at
$31.00, it was the most costly piece of furniture
in his home. DH

Needlework picture

American, Boston, c. 1750
Wool, silk, and linen
28½ × 23½ in. (72.4 × 59.7 cm)
The Faith P. and Charles L. Bybee Collection,
gift of Faith P. Bybee, 1991.B.313

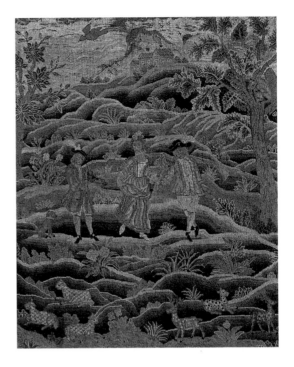

This picture is part of a large group of related
needlework pictures done in and around Boston
in the mid-eighteenth century. The unknown
girl who made this example was likely influ-
enced by Susanna Hiller Condy (1686–1747).
Condy, a professional needleworker, advertised
in the *Boston Evening-Post* on March 15, 1742:
"She draws Patterns of all sorts, *especially*,
Pocket-Books, House-Wives, Screens, Pictures,
Chimney-Pieces, Escrutoires [*sic*], & c. for
Tent-Stitch, in a plainer Manner, and cheaper
than those which come from *London*." During
the second quarter of the eighteenth century,
Condy ran a school in which girls were taught
fancy sewing. The use of tent stitch (a diagonal
stitch which covers one "square" of the canvas
support) and the nature of the imagery suggest
that the young woman who created this picture
either studied with Condy or was taught by
someone who had.

Like the other examples in the Condy tradi-
tion, this picture is worked in silk and wool
threads on linen canvas and portrays an idyllic
scene replete with flora and fauna. Here a
couple strolls through a garden while a violinist
serenades them. Other pieces within this group
depict women fishing or using a distaff to spin
yarn. CV

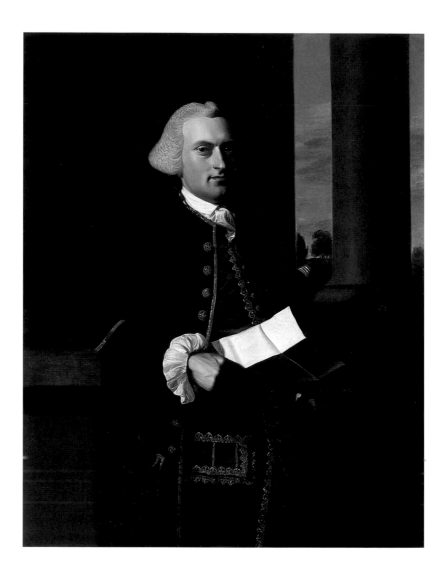

JOHN SINGLETON COPLEY
(American, 1738–1815)

Woodbury Langdon, 1767
Oil on canvas
49¾ × 40 in. (126.4 × 101.6 cm)
The Eugene and Margaret McDermott Art Fund,
Inc., 1996.70.1McD

Sarah Sherburne Langdon, 1767
Oil on canvas
49¾ × 39¾ in. (126.4 × 101 cm)
The Eugene and Margaret McDermott Art Fund,
Inc., 1996.70.2McD

John Singleton Copley emerged as the leading portrait painter in Boston during the colonial period. Primarily self-taught, Copley benefited from his early work in mezzotints with his stepfather, Peter Pelham, and from exposure to the paintings of the portraitist John Smibert, whose studio was located only a few blocks away. From the 1740s Robert Feke, John Greenwood, and Joseph Blackburn all worked in Boston, forming with the young Copley a network of up-and-coming artists who would define American painting as a rich blend of cosmopolitan style and provincial mannerisms.

Throughout the 1750s Copley's style became increasingly fluid, leaving behind the more wooden conventions common to early colonial art. The decade of the 1760s represents Copley's

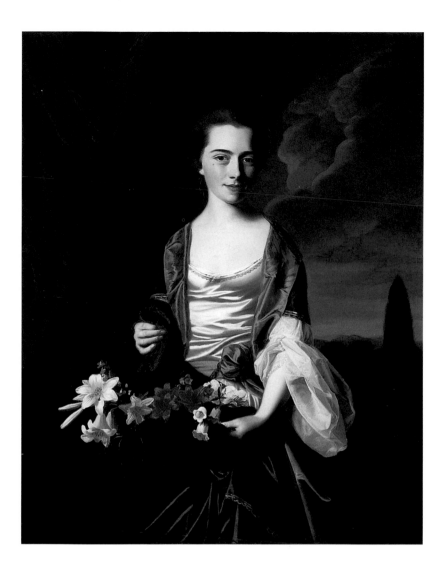

arrival at a mature style with an emphasis on sumptuous fabrics and lifelike flesh tones. Between 1765 and 1774 Copley created the best of his American portraits, paintings more accomplished than any he could have seen in Boston or New York. The Langdon portraits were painted the year before Copley's masterpiece, *Paul Revere* (Museum of Fine Arts, Boston).

Woodbury Langdon was among the youngest and the wealthiest of the merchants of Portsmouth, New Hampshire. The same age as Copley, Langdon had married Sarah Sherburne when she was sixteen, in 1765. Copley's portraits of the Langdons demonstrate the young artist's growing command of his medium. Woodbury Langdon's casual stance, his elbow resting on a pedestal topped by a large antique urn, bespeaks the ease with which he ran his thriving mercantile business and his household affairs. Sarah Langdon, dressed in an uncorseted satin gown, stands demurely before a curtain and formal landscape, projecting a warmth and directness found in Copley's most accomplished work. The Langdons prospered in subsequent years. Following the Revolution, Woodbury Langdon served first as a delegate to the Constitutional Congress, and later as a Supreme Court judge in New Hampshire. Sarah Langdon raised ten children, five sons and five daughters, and outlived her husband by twenty-two years. These portraits remained in the family until their purchase for the museum. EJH

CHARLES WILLSON PEALE
(American, 1741–1827)

Rachel Leeds Kerr (Mrs. David Kerr), 1790
Oil on canvas
36 × 27 in. (91.4 × 68.6 cm)
Gift of the Pauline Allen Gill Foundation, 1989.23

Charles Willson Peale is credited with establishing Philadelphia as a center of portraiture for the new Republic, a tradition ably continued by his brother, his children, and later contemporaries, notably Thomas Sully. Peale was apprenticed to a saddler at age nine, but his broad interests and restless curiosity pushed him to explore science and art. A fascination with painting led him to seek lessons with local artist John Hesselius, and in 1763 Peale advertised himself as a painter. From 1767 to 1769 he studied in England with the expatriate Benjamin West, the only American artist to become president of the Royal Academy. Peale returned to America in time to join the Sons of Liberty and winter with the Continental army at Valley Forge.

During the economic recession that followed the Revolution, Peale traveled extensively in Maryland and Pennsylvania seeking patronage. In December 1790 he began this portrait of Rachel Leeds Kerr, wife of Lt. David Kerr, a member of the House of Delegates and a justice of the peace in Talbot County, Maryland. Peale's rendering of Rachel Kerr reflects the late-eighteenth-century emphasis on the wife and mother as the head of the household. Dressed in her finest clothing and seated in a carved wooden chair, she looks out with a calm, contented smile, her arms resting on the chair and nearby table. Her elaborate headdress, embroidered shawl, fan, and handkerchief bespeak family comforts and nominal wealth; through the window sheep graze on the family property. Her tilted, oval face and pleasant expression are hallmarks of Peale's style, as are the careful draftsmanship and delicate brushwork.　EJH

RALPH EARL
(American, 1751–1801)

Captain John Pratt, 1792
Oil on canvas
46½ × 36⅛ in. (118.1 × 91.8 cm)
Gift of the Pauline Allen Gill Foundation, 1990.146.1

During the 1790s Ralph Earl traveled throughout Connecticut painting portraits of prominent residents in each successive township. Often working in the sitter's home, Earl opted for rapid execution over lengthy sittings, using bold colors and brushwork. By this time full-length portraits were no longer in style in more fashionable locales such as New York, but they remained popular in Connecticut until the end of the century.

In 1792 Earl painted this portrait of Capt. John Pratt, who served as an assistant commissary general during the Revolution and subsequently fought in the Indian wars in Connecticut's Western Reserve (now Ohio). In 1791 George Washington appointed him captain of the First Regiment of the United States Army. Settling in Middletown, Connecticut, Pratt headed the army recruiting service there and later was elected to the state legislature. Pratt's pride in having served under Washington is readily apparent, for in his left hand he holds his commission papers with Washington's signature clearly visible. Pratt was a member of the Society of the Cincinnati, a patriotic group formed by officers who had fought in the Revolution. Earl painted Pratt in his Continental army uniform, including the eagle badge and single epaulet of the society, a daring move, as in Connecticut it was considered an elitist organization, and membership was not often openly discussed. The inclusion of the local town hall in the background alludes to Captain Pratt's continued public service as state senator. EJH

THOMAS SULLY
(American, born England, 1783–1872)

Mrs. Paul Beck, Jr. (Mary Harvey), 1813
Oil on canvas
36 × 28½ in. (91.4 × 72.4 cm)
Gift of the Pauline Allen Gill Foundation, 1989.100

Like many of America's first artists, Thomas Sully emigrated from England with his family, settling in Charleston, South Carolina. Early evidence of his artistic abilities led Sully to travel to Boston in 1807 to study with Gilbert Stuart, who was considered the most accomplished portraitist of his day. Although Stuart was a difficult master, Sully was an apt pupil, learning to work quickly and still capture the personality of his sitter. Two years later Sully sailed for England to further refine his skills with Sir Thomas Lawrence, England's premier society portraitist. In 1810 Sully returned to America and settled in Philadelphia, embarking on a career that would make him the region's most sought-after portrait painter until about 1850.

In April 1813 Sully received a commission to paint portraits of Paul Beck Jr. and his second wife, Mary Harvey Beck. A Philadelphia merchant and philanthropist, Beck wanted likenesses that would reflect their emergence into the city's high society. Sully worked on the portraits simultaneously, painting rapidly enough to complete Mrs. Beck's portrait in forty-seven days. Seated on an Empire sofa, Mrs. Beck leans gently against its scrolled arm. Her dress is of the latest fashion from Paris, its high waist and neoclassical details distinctly Napoleonic in taste. Sully's deft brush picks out the textures of lace and satin, his touch softening where he turns to the dark ringlets framing her face. Sully's training and his facility with a brush make this a portrait of style and sophistication well suited to America's new elite merchant class. EJH

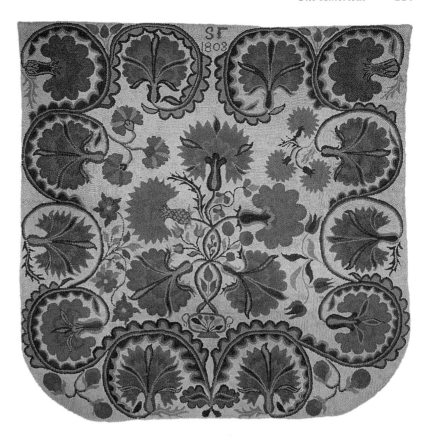

Bed rug

American, Lebanon, Connecticut, 1803
Wool and linen
92 × 87 in. (223.7 × 221 cm)
Gift of Mrs. Addison L. Gardner Jr. in memory
of Richard W. and Anna L. Sears, and of Mr. and
Mrs. Alfred L. Bromberg in memory of Mr. and
Mrs. I. G. Bromberg by exchange, 1992.11

American carpeting was not produced in signifi-
cant quantity until the 1830s. Prior to that time
the American textile industry was small. Most
homes had bare floors, and textiles were gener-
ally considered too valuable to be walked on.
Before the middle of the eighteenth century,
wealthy families who could afford carpets im-
ported from Europe or Asia typically displayed
these expensive textiles draped on chests and
tables. Even woven straw mats and painted
canvas floorcloths were imported and affordable
only by the wealthy. Sand, which absorbed grease
and dirt, was often used as a floor covering. It
was spread evenly over the floor and sometimes
brushed into designs with a broom.

Before approximately 1820, the word "rugg"
referred to a type of coarse woolen cloth used as
a bedcover. Most of the rugs made in America
before the early 1800s were intended for beds.
The bed (with its furnishings) was one of the
most valuable pieces of household furniture,
and its coverings often provided an important
indication of a woman's sewing skills. Abundant
written evidence survives for the use of bed rugs
in America, from the first settlements, yet only
about forty are known today. Most bed rugs
were made on a woolen base (this one is on
linen) with thick, home-dyed, woolen yarns of
multiple plies that were sewn with a running
stitch to create the design. Most of the surviv-
ing bed rugs come from Connecticut, and virtu-
ally all were made in New England. The earliest
one known dates from 1724. This bed rug is
typical in design; most have exotic floral decora-
tions in the style of English and East Indian
textiles. The formal symmetry of the small
decorated urn (bottom center) with its towering
bouquet suggests the elegance of very genteel
surroundings. DH

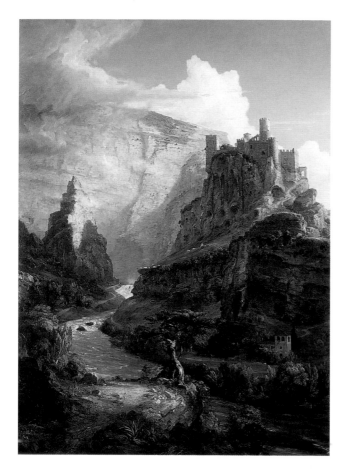

THOMAS COLE
(American, born England, 1801–1848)

Landscape—The Fountain of Vaucluse, 1841
Oil on canvas
68¾ × 48¾ in. (174.6 × 123.8 cm)
Gift of J. E. R. Chilton, 1992.14

Thomas Cole is best remembered as the founder of the Hudson River school, the term used to describe the many artists who followed his example and painted the American landscape during the middle decades of the nineteenth century. Cole and his contemporaries viewed travel in Europe, especially Italy, as crucially important to their artistic education. In 1841, on his second trip to Europe, he made a pilgrimage to Vaucluse to the house where Petrarch, the fourteenth-century humanist and poet who is considered the first Renaissance man, had retreated from the papal court in exile. Cole's initial disappointment as he approached the site turned to excitement as he noted "the rapid stream, which descended a steep ravine in a tortuous course, dashing and foaming over its rocky bed." After making sketches in pencil and pen at the site, he continued to Rome, where he immediately set about painting *The Fountain of Vaucluse.*

To inspire awe in his audience, a desired effect of the sublime, Cole altered the actual landscape by compressing the steep sides of the ravine. He also restored the ruined castle to its fourteenth-century glory. Initially Cole placed the scarlet-robed Petrarch in the lower foreground, where he gestured up at the castle, but Cole's lifelong difficulty in painting figures in proper scale to the landscape may have prompted him to paint the figure out. *The Fountain of Vaucluse* has a grandeur and intensity that strongly influenced Cole's brightest pupil, Frederic Church, whose *Icebergs* (p. 228) draws its own awesome majesty from Cole's example. EJH

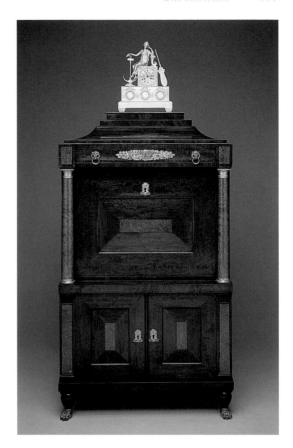

Fall-front secretary

American, Philadelphia, c. 1815–30
Mahogany, cherry, yellow poplar, pine, maple, ebony,
and gilt bronze
62⅞ × 35⅞ × 21⅛ in. (159.8 × 91.1 × 53.7 cm)
The Faith P. and Charles L. Bybee Collection,
anonymous gift in memory of Frederick M. Meyer,
1985.B.51

Mantel clock

French, c. 1830–40
Paris and St. Nicolas d'Aliermont, France
Gilt bronze and glass
16¼ × 12⅜ × 4¼ in. (41.3 × 31.4 × 10.8 cm)
Gift of the Professional Members League, 1995.56

In the early nineteenth century this type of
fall-front secretary was called a *secrétaire à
abattant*, or French secretary. The form achieved
maturity in Paris in the mid-eighteenth century
and subsequently spread to other parts of Eu-
rope. Although never popular in England, such
desks were especially favored in areas dominated
by Biedermeier design, namely Germany, Aus-
tria, and Scandinavia. The appearance of the
fall-front secretary in Philadelphia was likely
the result of Continental influence. Some
Continental-made examples are known to have
been imported into Philadelphia early in the
century, as were German and possibly French
furniture designs featuring the form.

Unlike other Philadelphia examples, which
are very French in their strongly unified design,
the Dallas desk is based on Germanic proto-
types. At present eight closely related secretar-
ies from the same unidentified shop are known.
All these pieces reflect a Germanic predilection
for imaginative design in which the facade is
an amalgamation of parts, not a unified whole.
Here, for example, the columns do not extend
the length of the piece, as in a typical French
example, but stop halfway, becoming pilasters
in the lower section. The upper and lower halves
are further differentiated by the orientation of
the doors—the central fall being horizontal,
those below vertical. Both the use of contrast-
ing burl veneers, inset at various places on the
facade, and the emphatic horizontal banding at

top, middle, and bottom further fragment the
facade.

The desk's relationship to German aesthet-
ics is further suggested by other features. For
example, Germanic and Nordic appreciation
of contrasting light and dark wood veneers on
both interior and exterior surfaces is seen here.
A preference for furniture decorated with light-
wood was especially prevalent in northern
Germany and Scandinavia. Another Germanic
trait is the imaginative top; while some desks
in this group are surmounted by templelike
drawers, the Dallas desk has a sloping plinth
intended to support a light fixture or clock.

The timepiece crowning this desk has finely
cast and finished ornaments. The decorative
program includes a draped classical female fig-
ure, a cornucopia, oar, anchor, shell, and wreaths,
suggesting the theme of the sea's bounty. The
clock was originally owned in Baltimore, Mary-
land, by the jeweler and watchmaker John A.
Roche. Few French clocks now in the United
States can be traced to early American owners.

CV

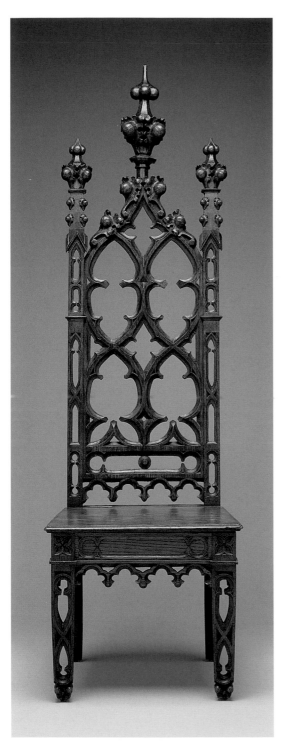

Hall chair

American, c. 1850–60
Oak and eastern white pine
69⅜ × 20½ × 21½ in. (176.2 × 52.1 × 54.6 cm)
The Faith P. and Charles L. Bybee Collection,
gift of Faith P. Bybee, 1988.B.68

The Gothic revival taste became fashionable in
the 1830s in Europe as architects and designers
began to look back at medieval churches for
inspiration. In America the use of Gothic details
in architecture and furnishings reached its apex
in the mid-nineteenth century. Tastemakers
such as Andrew Jackson Downing advocated the
Gothic revival style as particularly suitable for
use in halls and entryways. This chair, which is
part of a larger group of hall furniture, is one
of the most exuberant expressions of the style
in America. It was originally purchased for Hard
Times Plantation, near Vicksburg, Mississippi,
and is identical to another group of Gothic
revival hall pieces likely bought in New Orleans
in 1859 for the great mansion Stanton Hall,
in Natchez.

New Orleans was the cultural and economic
fulcrum of the South during this period, and
many wealthy planters in the Mississippi River
valley purchased their best home furnishings
from the fashionable dealers there who adver-
tised that they maintained "the largest assort-
ment constantly on-hand."

Very little if any of these goods were actually
made there. Both before and after the Civil War,
most boats sailing to New Orleans from the
Northeast came laden with furniture, a cargo
then replaced with cotton bound for the mills of
Rhode Island and Massachusetts on the return
trip. It is therefore likely that this chair, like so
much of the mid-nineteenth-century furniture
thought to have been manufactured in New
Orleans, was actually made in the Northeast
for the southern market. SH

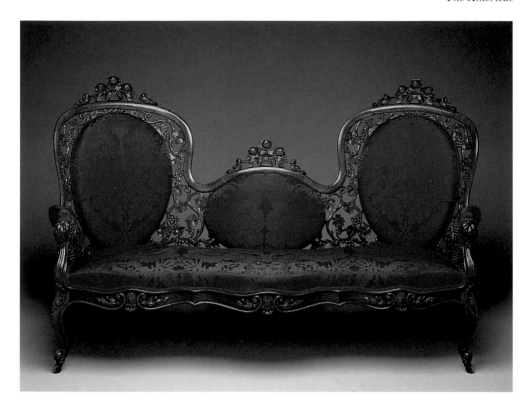

Sofa

American, New York, c. 1850
Rosewood and ash
43 × 74 × 34 in. (109.2 × 188 × 86.4 cm)
Gift of the Friends of the Decorative Arts, 1992.30

Andrew Jackson Downing, writing in 1850, described American cities as
"mad for the French taste." While his statement could be true for many
different aspects of cultural life, Downing was alluding in particular to
the French influence on furniture design at the time. Variously known
as the French antique or Louis Quatorze style, the rococo revival became
the most prevalent furniture style of the mid-nineteenth century. Parisian
designers published influential design plates in serial form that were widely
disseminated in America, yet in practice German emigré cabinetmakers
and carvers dominated the furniture trade, especially in New York and
Philadelphia.

 This sofa seems to have been made in such a shop as fragments of a
German newspaper published in New York City in 1849 were found on
the backboards of the rear upholstered panels. One of the most successful
of these German-born cabinetmakers was John Henry Belter. He later
patented a system of laminating wood sheets together to form a strong
composite plywood that could be bent under steam heat and carved and
pierced extensively. While this particular sofa is constructed of seven
layers of rosewood, as are many of Belter's documented pieces, other
cabinetmakers were known to have copied his patents, making attribution
very difficult. SH

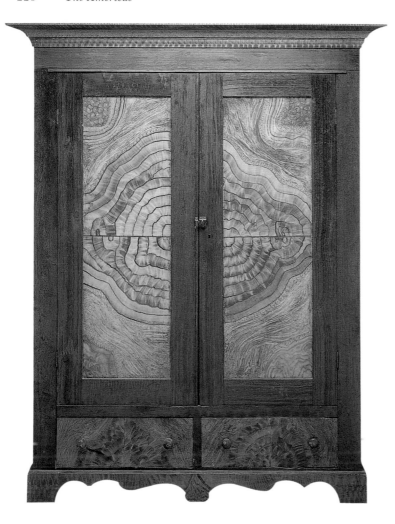

Wardrobe

American, Fayette County, Texas, c. 1860–70
Cedar and paint
76½ × 61 × 23 in. (194.3 × 160 × 58.4 cm)
The Faith P. and Charles L. Bybee Collection,
gift of Faith P. Bybee, 1992.B.116

This wardrobe is one of the finest pieces of furniture made in Texas during the nineteenth century. While the wardrobe form was relatively common in the central and eastern parts of the state, examples decorated with faux wood graining are extremely rare. This piece features a variety of graining techniques. The door frames and sides of the case are striped to simulate rosewood, while the doors and drawers are painted to look as if they are covered in matching sheets of elaborately figured veneer. The pronounced cornice is spotted with paint to give the appearance of its being cut from burled wood.

From the 1820s on, Texas was settled by Europeans, Americans, and Mexicans of various heritages. The German immigrant population, however, had the largest impact on the region's cabinetmaking. In central Texas, where this wardrobe was made, Germans produced virtually all the furniture from the 1840s until the 1880s, when the coming of the railway made possible the shipment of factory-made furniture from the Midwest. As seen in this example, much of the cabinetwork done in mid-nineteenth-century Texas was in the late classical taste. The so-called German Biedermeier style was especially important and lingered in Texas long after it was passé in Central Europe.

CV

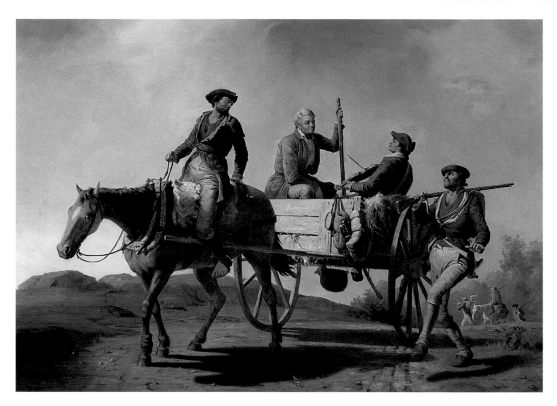

WILLIAM TYLEE RANNEY
(American, 1813–1857)

Veterans of 1776 Returning from the War, 1848
Oil on canvas
34⅛ × 48⅛ in. (86.7 × 122.2 cm)
The Art Museum League Fund, Special Contributors,
and General Acquisitions Fund, 1981.40

The United States' war with Mexico from 1846 to 1848 was the nation's first foreign conflict since the Revolution, and prompted a remarkably high level of patriotic fervor linking the two wars. Survivors of the Revolution recalled their exploits, and in paintings, books, and songs, parallels were drawn between the wars of 1776 and 1846, inspired undoubtedly by hopes that this war would turn out as well as the last.

In *Veterans of 1776 Returning from the War* Ranney took great care to weave together allusions to both conflicts. Painted at the close of the war and exhibited in June 1848, the painting marks the jubilation and relief felt by the entire country. The soldiers return to civilian life in a cart on which are scrawled the names of five major Revolutionary War battles: Bunker Hill, Trenton, Monmouth, Saratoga, and Yorktown.

Their horse, however, bears a U.S. brand which appeared on army remounts in 1846. This subtle blending of past and present would not have gone unnoticed by Ranney's audience.

Ranney had firsthand experience of the war with Mexico, having enlisted in the Texas army the week after the stand at the Alamo. His particular brand of history painting might best be termed anecdotal, in which the subject is the anonymous common man rather than an identifiable historical figure. The volunteers who formed the backbone of the armies of both 1776 and 1846 are here celebrated for their patriotism instead of their exploits: Ranney makes his point by celebrating their return to private life rather than presenting the gory climax of victorious battle. EJH

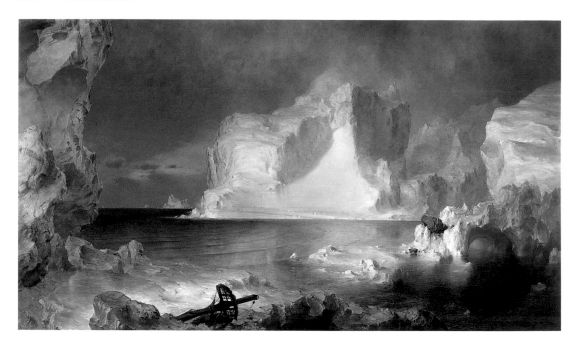

FREDERIC EDWIN CHURCH
(American, 1826–1900)

The Icebergs, 1861
Oil on canvas
64½ × 112½ in. (163.8 × 285.8 cm)
Anonymous gift, 1979.28

In the summer of 1859 Frederic Church embarked on a monthlong sketching trip aboard a chartered schooner exploring the waters off the coast of Newfoundland and Labrador. Buffeted by high seas and afflicted with seasickness, Church sketched icebergs as they appeared on the horizon until the moment they threatened to capsize the small boats used to draw near them. These sketches inspired Church as he embarked on what was his largest canvas to date. Church's interest in the Arctic stemmed from the disappearance of the Franklin expedition, which was lost while searching for the Northwest Passage in 1847. The ensuing hunt for Franklin and his crew stimulated American interest in the frozen North as an irresistibly beautiful yet deadly frontier.

Church completed this painting during the first months of the Civil War. A Union supporter, he exhibited it in April 1861 to benefit the Union's Patriotic Fund with the title *The North—Church's Picture of Icebergs*. Hailed in press accounts as "the most splendid work of art that has yet been produced in this country," the painting nonetheless failed to find a buyer. In 1863 Church shipped the canvas to London, where it was retitled *The Icebergs* in deference to Britain's confederate sympathies. Between the New York and London showings Church added the broken mast in the foreground, presumed by many to be a reference to Franklin's ships. Enormously popular in England, the painting was purchased by Sir Edward William Watkin, a railroad magnate and member of Parliament. The ambitious composition and grand scale of *The Icebergs* are a worthy legacy of the eighteenth-century tradition of the sublime which is powerfully represented by two other paintings in the museum's collection: Claude-Joseph Vernet's *Mountain Landscape with Approaching Storm* (p. 95) and Thomas Cole's *Landscape—The Fountain of Vaucluse* (p. 222).

EJH

GEORGE INNESS
(American, 1825–1894)

View of Rome from Tivoli, 1872
Oil on canvas
29⅞ × 45 in. (75.9 × 114.3 cm)
Foundation for the Arts Collection, gift of Mrs.
John B. O'Hara in memory of Robert B. O'Hara,
1974.14.FA

A prime ambition of many American artists of the nineteenth century was to make a pilgrimage to Italy to absorb the artistic traditions of the classical and Renaissance past. For landscape painters, this sojourn also offered the opportunity to paint the moods and seasons of the Italian countryside. Inness arrived in Italy in 1870 on his second trip, which would last four years. Based in Rome, he traveled extensively throughout the surrounding region, visiting lakes and hilltowns. The nearly two hundred recorded paintings from this trip are ample evidence of its powerful effect on his life.

Despite its descriptiveness, the title *View of Rome from Tivoli* is something of a misnomer; in fact, the city on the hill resembles Tivoli more than it does Rome. Inness's landscape is carefully composed to lead the viewer's eye from the portal of the monastery tower in the foreground down along the low stone fence descending into the left corner of the painting. Inness has masterfully captured the atmospheric haze that causes the deep background to shimmer under a soft pink and blue-gray sky.

The artist was more concerned with a sense of place than with identifiable locations. When asked about the sites depicted in his work, Inness once replied that they represented "nowhere in particular; do you suppose I illustrate guidebooks?" His testy response calls attention to the dilemma facing landscape artists—whether to satisfy the demand for souvenirs of places visited or imagined by patrons or to serve the artist's purpose of painting a generalized aspect of a place. In *View of Rome from Tivoli*, Inness's focus on the timeless quality of daily life supplants the need for a more specific reading of the landscape. EJH

ALFRED THOMPSON BRICHER
(American, 1837–1908)

Time and Tide, c. 1873
Oil on canvas
25½ × 50 in. (64.8 × 127 cm)
Foundation for the Arts Collection, gift of Mr. and
Mrs. Frederick M. Mayer, 1976.40.FA

Time and Tide is considered Bricher's finest painting. In its title and mood it reflects the shift toward literary and psychologically potent themes in landscape painting at the end of the nineteenth century. Reflecting the generation's emphasis on the written word, readily understood literary allusions became popular in painting titles. For *Time and Tide* Bricher, an avid reader, drew on a line from Sir Walter Scott's *The Antiquary* (1816)—"Time and tide tarry for no man"—which Charles Dickens recast in *Martin Chuzzlewit* (1844) to read, "Time and tide will wait for no man, saith the adage, but all men have to wait for time and tide."

Bricher's title establishes the mood of the picture, a meditation on the inevitability of the passage of time, marked by the eternal cycle of the ocean. The tide ebbs and flows without regard to passing events, even a gathering storm. The painting's full title, inscribed on the back of the canvas, reads "TIME AND TIDE/ TIME—A September Afternoon, the approach of the Equinoctial./ Tide, Turning, the long swell before the storm." The late afternoon light on the rugged cliffs emphasizes the darkening sky over the ocean. Bricher originally painted clouds close to the water line; their traces are still visible under what is now a sheet of rain. Tiny boats dot the horizon, the only evidence of human activity in an otherwise isolated scene. Bricher's love of the ocean's moods provided the power with which he painted the sea, seeking to invest in its timeless rhythms a spiritual depth his audience would understand. EJH

JOHN SINGER SARGENT
(American, 1856–1925)

Study for the *Spanish Dancer*, 1882
Watercolor and graphite on paper
11¾ × 7⅞ in. (29.8 × 20 cm)
Foundation for the Arts Collection, gift of Margaret J.
and George V. Charleton in memory of Eugene
McDermott, 1974.1.FA

John Singer Sargent spent his life as an expatri-
ate, making intermittent visits to the United
States while maintaining studios in Paris and
London. He received his earliest training in
Paris, from 1874 to 1879, in the studio of painter
Carolus-Duran, from whom he learned bravura
brushwork and an appreciation for the works of
the Spanish master Velázquez. For five months
in 1879 Sargent toured Spain and North Africa,
at a time when Spain in particular was consid-
ered an exotic land with links closer to Africa
than Europe.

Sargent returned from his travels with
sketches of Spanish gypsy dancers and the germ
of an idea for his first full-scale salon painting,
El Jaleo. Completed in 1882, *El Jaleo* (meaning
"ruckus" or "uproar") depicts a dimly lit hall in
which a lone dancer pounds out her dance to the
accompaniment of guitars and shouts. Sargent
developed his composition over three years
through a series of drawings and watercolors.
His principal effort went into the figure of the
dancer, especially her gesture and dress.

This study of the *Spanish Dancer* was thought
to be the final preliminary work for *El Jaleo* un-
til the recent discovery of a full-size oil painting
of this dancer. It is to this work, titled *Spanish
Dancer* (private collection), that the museum's
watercolor most directly relates, as the attitude
and dress of the figure confirm. Sketching the
basic forms in pencil, Sargent deftly applied
watercolor washes to give substance to the
dancer's body and shawl, and to suggest the
murky background. EJH

WILLIAM MICHAEL HARNETT
(American, born Ireland, 1848–1892)

Munich Still Life, 1882
Oil on canvas
24⅝ × 30¼ in. (62.6 × 76.8 cm)
Dallas Art Association Purchase, 1953.56

Harnett trained first as a silver engraver but turned to painting after successful experimentation with the medium. He studied briefly at the Pennsylvania Academy of Fine Arts, where he met and developed a friendship with fellow still-life painter John Frederick Peto. Harnett spent six years in Europe, from 1880 until 1886, four of them in Munich, where he met fellow American artists Frank Duveneck and William Merritt Chase. In Europe Harnett was exposed to the richness of the still-life tradition, fostering his emphasis on minutely observed realism. While in Germany Harnett painted numerous tabletop still lifes, many of them arrangements of newspapers, pipes, books, vegetables, and tankards.

For *Munich Still Life*, painted relatively early in his sojourn, Harnett placed a newspaper on a rough-hewn table, along with a half-full glass, a stoneware beer pitcher, a pipe and tobacco, bread, and turnips, carefully arranged to present a scene of casual disarray. On the rear wall an opera poster advertises a performance in Vienna, next to the table, Harnett placed a crudely drawn doodle of a man smoking a pipe. They are the elements of a tavern scene, a place for the leisure activity of men who gather to eat and drink, smoke, and exchange news. The act of smoking and the burning of matches and tobacco replace the candles common to *vanitas* still lifes. The newspaper, dated August 2, 1882, alludes to the passage of time. Except for the masthead, the paper cannot be read. Harnett blurred the type, ultimately destroying the illusion of reality promised by the faithful rendering of surface textures. EJH

JOHN FREDERICK PETO
(American, 1854–1907)

Fish House Door, c. 1905
Oil on canvas
30 × 22 in. (76.2 × 55.9 cm)
Dallas Art Association Purchase, 1953.17

Peto's work was long confused with that of
William Harnett. Both men received their early
training at the Pennsylvania Academy of Fine
Arts, and a photograph shows the two artists
in Harnett's studio surrounded by objects that
appear in their paintings. Although Peto started
out painting small tabletop still lifes, he soon
began to depict assembled objects hanging from
letter racks or weathered doors. Such works are
called trompe l'oeil (meaning "to deceive the
eye"), acknowledging the artist's ability to fool
the viewer into perceiving the painted objects
as real.

Fish House Door brings together the tools of
the eel fisher; his lamp and eel spear hang from
a central nail along with what appears to be
an oil cloth. A mug is suspended from another
protruding nail, below a horseshoe added for
luck. A blurred photograph and several pieces
of paper are tacked to the door, along with a
slate that appears to float in space. The rusted
and broken door hinge and weathered green
surface read convincingly from a distance. Peto
often painted in a softly abstract manner, captur-
ing the feel of dented metal, worn wood, and
used paper.

Peto painted three variations on *Fish House
Door*, all undated. This work is the smallest of
the three, arguing for its status as the earliest,
in which Peto worked out his composition. *Fish
House Door* bears several hallmarks of Peto's
late style, which coincided with his 1889 move
to Island Heights, New Jersey, and his gradual
withdrawal from the New York art world.
Marked by a greater degree of melancholy, his
late works are typified by a darkening palette
and a heavier handling of paint. EJH

WINSLOW HOMER
(American, 1836–1910)

Casting in the Falls, 1889
Watercolor on wove paper
14 × 20 in. (35.5 × 50.7 cm)
Dallas Art Association Purchase, 1961.11

Winslow Homer was an avid fisherman, and, with his brother Charles, he spent many summers in the Adirondacks. In 1886 the brothers joined what would become the North Woods Club in Minerva, New York, which catered to sport hunters and fishermen. *Casting in the Falls* was painted during Homer's summer trip to Minerva in 1889 and is one of nearly thirty watercolors dated to that year.

Homer rarely painted his works on-site, relying instead on rapid pencil sketches and an acute visual memory to guide him in his studio. For this watercolor the artist places the viewer at the base of the falls, looking upstream at a fisherman in the midst of his cast. By deliberately rendering the fisherman in broad washes with minimal detail, Homer emphasizes the graceful motion of the cast. As the fisherman leans back, his body acts as a counterbalance to the rushing cascade, boldly painted in blue. The reserved white paper is artfully employed in the highlighted foam of the current. Touches of Homer's signature red in the foreground water and the fisherman's belt contribute to the picture's visual unity.

Homer helped found the American Water Color Society in 1865, at a time when the medium was considered the province of women and amateurs. His strong colors and brilliant execution increased the respect accorded the medium, as did his then daring prediction to a friend, "You will see, in the future I will live by my watercolors." EJH

Library table

American, c. 1865
Pottier and Stymus Manufacturing Company
(act. 1860–1919), New York
Walnut, ebony, gilt bronze, and baize
28¼ × 62 × 39 in. (71.8 × 157.5 × 99 cm)
Gift of the 1992 Silver Supper and an anonymous
donor in honor of Charles L. Venable, 1993.16

The influence of Egyptian motifs in decorative furnishings during the nineteenth century began with Napoleon's Egyptian military campaign of 1798 and was reinforced periodically through archaeological discoveries widely published in newspapers and journals. In the 1860s and 1870s, the taste for Egyptian motifs was popularized by developments as diverse as the construction of the Suez Canal and the premiere of Verdi's opera *Aïda*, which featured elaborate Egyptian-style sets and costumes. Interior spaces, particularly libraries, soon reflected this renewed interest in exotic ancient cultures.

This library table is an excellent example of Egyptian-style furniture. The ox-hoof feet, pylon-shaped bronze plaques, and winglike central pendant on the sides of the table all derive from ancient sources. As well as for its splendid gilt and ebonized ornament, this table is also important for its innovative design, with its unusual placement of drawers that pull out diagonally from each corner. Special care was also taken with the design of the top, which was covered in soft baize fabric so that books and papers used in the library would not be damaged by a hard surface. SH

Sideboard

American, probably Chicago, c. 1875
Walnut, brass, and earthenware
85 × 61 × 21 in. (215.9 × 154.9 × 53.3 cm)
Anonymous gift, 1992.308

In 1868 the English writer Charles Locke Eastlake (1836–1906) published *Hints on Household Taste in Furniture, Upholstery and Other Details.* The work proved to be highly influential, especially in the United States. Taking Eastlake's advice to discard the crowded and elaborately decorated interiors of the mid-nineteenth century, designers and consumers simplified their living spaces. This fine sideboard reflects this phenomenon. Here one sees relatively clean and functional surfaces ornamented with relatively little carving. Color is added to the composition through inset tiles made by the English firm Minton & Co. (est. 1796). The tiles on the upper doors depict figures engaged in seasonal chores—gathering firewood (February) and cutting hay (May). The medieval garb of these figures reflects an interest in the Gothic past shared by Eastlake and his contemporaries. By reviving what they believed to be the spirit of Europe's golden age, designer-critics like Eastlake and fellow Englishmen William Morris (1834–1896) and John Ruskin (1819–1900) sought to improve both the consumers' taste and their moral well-being. Eventually this effort evolved into what is now known as the arts and crafts movement.

Although related examples were made in New York City, this sideboard is believed to come from Chicago. Not only were pages from Chicago's trade journal the *Western Furniture Trade* found behind the upper row of tiles, but local designers such as Isaac E. Scott (1845–1920) are known to have created similar pieces.

CV

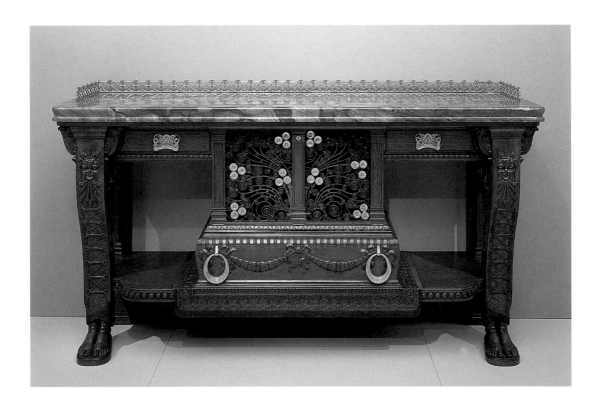

Vanderbilt console

American, c. 1880–82
Herter Brothers (act. 1864–1906), New York
Oak, marble, silverplate, and bronze
44½ × 83 × 24 in. (113 × 210.8 × 61 cm)
Gift of an anonymous donor and the Friends of
the Decorative Arts, 1996.213.a–e

William H. Vanderbilt, son of Cornelius Vander-
bilt, founder of the family's steamship and rail-
road empire, began construction in 1879 on a
house at 640 Fifth Avenue, New York. This con-
sole, commissioned for the ground floor atrium
of the residence, is one of the finest creations
of the Herter Brothers, a prestigious American
design firm of the last third of the nineteenth
century. With its combination of rich materials
and mammoth scale, the console, originally one
of a pair, conveyed to any visitor the power and
wealth of the Vanderbilt household.

The console related aesthetically to every
room adjoining the atrium. The massive slab
top was of the same red African marble used to
fabricate the giant central fireplace and to clad

the eight square pillars that framed the atrium.
The central cupboard section of the console,
with its grill of wrought-iron scrollwork and
silver stylized chrysanthemums, echoed the
motifs of the adjoining "Japanese parlour" and
the stair rail leading to the second floor. The
carved, ribbon-tied husk swags ending in large
silvered loops below the grill could be found in
architectural friezes and furniture decoration
in both the atrium and library. Finally, the great
thermae with carved masques ending in pairs
of sandaled human feet supporting each end of
the console reflected the so-called Greek Renais-
sance theme of the overall interior design as
well as the specific Egyptian and Grecian
elements of the drawing room.

While Mr. Vanderbilt lived to see his palace
completed in 1882, he died just three years later,
in the library. After undergoing extensive reno-
vation in 1915, the house—a crumbling relic of
its glorious past—was torn down in 1946.

SH

Fruit plate

American, 1881
Gorham Manufacturing Co. (est. 1831),
Providence, Rhode Island
Silver and gilding
2½ × 12 in. diam. (6.4 × 30.5 cm)
The Eugene and Margaret McDermott Art Fund, Inc.,
1989.6.McD

Following the opening of Japan to Western trade in the 1850s, Europeans
and Americans became increasingly enamored of Japanese art and design,
especially in the medium of metalwork. Inspired by the naturalism found
in many imported Japanese products, American firms produced silver wares
that relied on natural forms for decoration and sometimes shape. As this
fruit plate attests, Gorham, perhaps more than others, excelled at natural-
istic trompe l'oeil work.

 This custom-ordered plate is one of three types made by Gorham in
1880 and 1881. Depicting the seasonal cycle, a traditional motif in Japa-
nese art, one example features the spring scene of apple branches in blos-
som. This version has branches in full fruit in summer; the third type has
branches supporting a spiderweb in late fall. Because of the plates' complex
applied decoration, their production was labor intensive and thus expen-
sive; each cost $150 to make. Requiring forty-seven hours to create, the
appliqués on the Dallas plate are particularly fine. The leaves, for example,
are engraved with veins and feature "worm holes." The branch border
along the rim may well have been cast from a real apple tree twig. CV

Humidor

American, 1889
Robert Francis Hunter (American), artist; Tiffany
& Co. (est. 1837), maker, New York
Silver
9¼ × 12¾ × 8⅛ in. (23.5 × 32.4 × 20.6 cm)
Foundation for the Arts Collection, Mrs. John B.
O'Hara Fund, 1993.69.1–3.FA

By the 1880s Tiffany's expertise in creating presentation objects was legendary; the firm had produced acclaimed pieces for many of the world's most famous individuals. Both the presenter and the recipient of this humidor were well known in the nineteenth century. August Belmont (1853–1924), who commissioned the piece, was a German immigrant who made his fortune in New York City representing the financial interests of Europe's Rothschild family. Lionel Walter Rothschild (1868–1937), who received the box upon the occasion of his graduation from Cambridge in 1889, was the young heir of one of England's greatest fortunes.

Obviously Belmont knew Rothschild well, because the humidor's decoration reflects the young man's interest in sports and nature. The cast buffalo atop the composition would have been intriguing because the American bison had reached the verge of extinction in the late 1880s. Similarly, New York artist Robert Hunter's

scenes of American sports would have appealed to Rothschild. Etched on the box's exterior are images of the outdoor pursuits of lacrosse, tobogganing, baseball, bronco-busting, duck hunting, trotting-horse racing, ice-boat racing, and buffalo hunting. Hunter's original drawings for these scenes survive with the box, as does its original traveling case of California laurel wood and leather.

Because of its exceptional quality and size, this humidor was expensive to make. Tiffany & Co. spent $511 to complete the commission. This figure suggests that the retail cost to Belmont was over $1,000, a huge sum in 1889.

CV

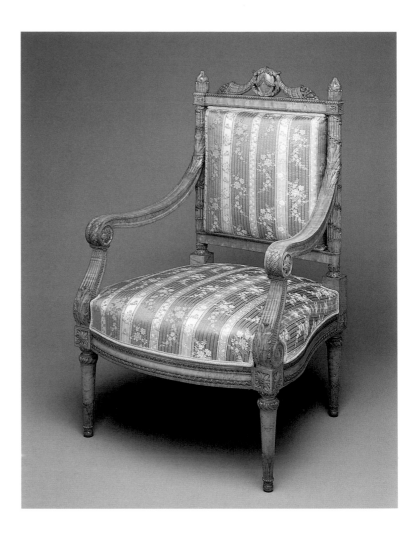

Armchair

American, probably New York, c. 1885
Maple, horsehair, and fabric
43⅜ × 27¾ × 26 in. (110.2 × 70.5 × 66 cm)
The Hamon Fund, 1990.1

During the late nineteenth century, furnishings in many revivalist styles were available throughout Europe and the Americas. New York City, with its many exceptional craft shops, was the North American production center for the finest quality cabinetwork. Although the maker of this chair is not yet known, it was probably made in one of New York's most important cabinet shops. Made entirely of bird's-eye maple, an extremely hard wood, the quality of the carving seen here is truly breathtaking. Every leaf is exquisitely rendered, every bead clearly articulated. Several New York firms, including Herter Brothers, Leon Marcotte, Pottier and Stymus,

and Herts Brothers, were capable of executing such superb work. Leon Marcotte's workshop, for example, is known to have created a carved maple bedroom suite of similar quality around 1880 for the New York millionaire Henry G. Marquand. (Pieces from that set are now in New York's Metropolitan Museum of Art and the Art Institute of Chicago.)

The suite from which the Dallas chair came originally contained another armchair (now in the Museum of Fine Arts, Houston), a pair of ottomans, and a music cabinet. Each piece was executed in the late eighteenth-century French neoclassical style known as Louis XVI. Characterized by garlands of flowers, swags, fluted columns, oval ornaments, and flame finials, the Louis XVI revival style was extremely popular during the late nineteenth and early twentieth centuries. CV

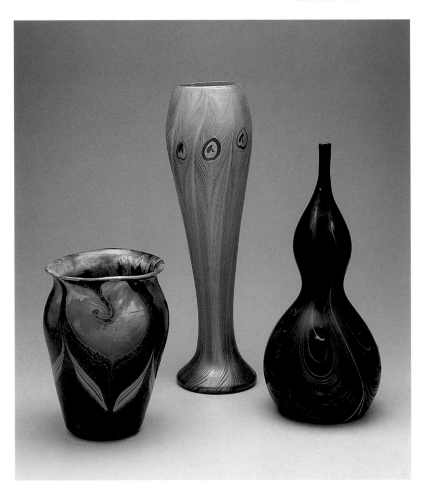

Three Favrile vases

American, 1894, 1901, and 1913
Louis Comfort Tiffany (American, 1848–1933),
designer; Corona Furnace (act. 1892–1928),
maker, Corona, Long Island, New York
Glass
Tulip vase: 11¾ × 9 in. diam. (29.9 × 22.9 cm)
Peacock vase: 23⅛ × 6⅞ in. diam.
(58.7 × 17.5 cm)
Gourd-shaped vase: 19½ × 8½ in. diam.
(49.7 × 21.6 cm)
Gift of Mr. and Mrs. Nelson Waggener,
1983.27–28, 32

Louis Comfort Tiffany was one of America's
most important designers at the turn of the cen-
tury. The glass produced at his Corona Furnace
on Long Island was especially famous. Besides
being purchased in this country, Tiffany glass
was also sold at L'Art Nouveau, the Paris shop
of Siegfried Bing. This gallery not only gave the
style its name but showcased the work of the
finest art nouveau designers. Because of its rich
colors, organic shapes, and sinuous decoration,
Tiffany glass was considered among the best in
the world.

Although the term was also used for metal-
work and ceramics, Favrile is generally associ-
ated with the blown glass produced at Corona
Furnace. First registered in 1894, the Favrile
trade name was derived from the old English
word "fabrile," meaning to belong to a craft.
By using such a name, Tiffany associated his
expensive glassware with the romantic image
of glassblowers using hand techniques. While
working in a glass works was hardly romantic,
the Corona Furnace did employ numerous tal-
ented craftsmen. The chief blower and designer,
Arthur Nash (American, b. England, 1849–
1934), for example, was responsible in many
ways for its international success. CV

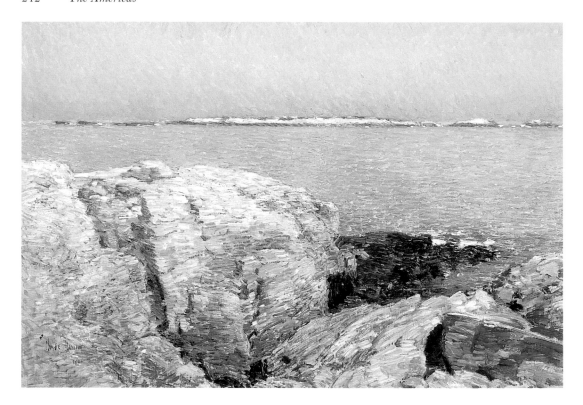

CHILDE HASSAM
(American, 1859–1935)

Duck Island, 1906
Oil on canvas
20½ × 31½ in. (52.1 × 80 cm)
Bequest of Joel T. Howard, 1951.41

Duck Island is one of the Isles of Shoals located off the New England coast near Portsmouth, New Hampshire. Well known to ships' captains for its treacherous waters, the region, with its ancient granite outcroppings and magnificent ocean views, became a popular vacation spot by the end of the nineteenth century. Tourists were drawn in particular to the island of Appledore, where Celia Thaxter's salon was a magnet for Boston's artistic elite. During the summers her parlor and her equally well-known gardens became an artists' colony whose frequent visitors included Hassam and William Merritt Chase.

Hassam had spent much of the 1880s in Paris studying at the Académie Julian and observing the impressionists at work. Like his French counterparts, who often painted a single view in different atmospheric conditions, Hassam recorded many views of the Isles of Shoals, although not in a sequence tied to hours of the day or seasons of the year. Hassam's approach to *Duck Island* is reminiscent of Monet's treatment of the cliffs at Étretat and Pourville, a lesson Hassam clearly absorbed in France. His colorful mosaic, reading as rocks, water, and sky from a distance, shifts to flickering strokes of color and light when viewed close at hand. Warm pink tones capture the mineral-flecked surfaces of the granite cliffs and impart a feeling of solidity despite the vibrant play of the brush. In the middle distance, Hassam's brushwork creates the illusion of scattered light glistening on the water; at the horizon his brush leaves smoother tracks denoting the hazy atmosphere. There is no hint of a dangerous reef or wave; the artist's concern is for the play of light and color on these vibrant surfaces rather than for the sea's storied past. EJH

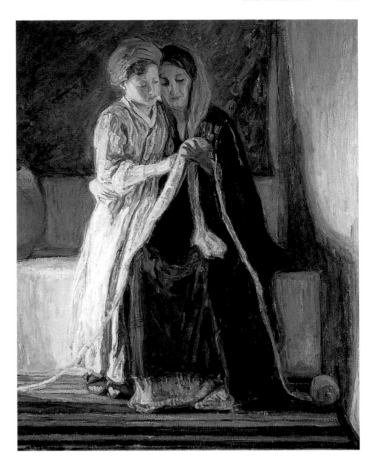

HENRY OSSAWA TANNER
(American, 1859–1937)

Christ and His Mother Studying the Scriptures, c. 1909
Oil on canvas
48¾ × 40 in. (123.8 × 101.6 cm)
Deaccessioning Funds, 1986.9

Born of English, African, and American Indian ancestry, Tanner grew up in a home that served as a locus for black culture and intellectual achievement in Philadelphia. His father was a bishop in the African Methodist Episcopal Church; his mother, a former slave, had made her way north on the underground railroad. Tanner studied from 1880 to 1882 with Thomas Eakins at the Pennsylvania Academy of Fine Arts, where his obvious talents shielded him only superficially from prejudice. In 1891 Tanner left for Paris, studying at the Académie Julian and spending his summers as a member of the Pont Aven art colony. A trip to Palestine in 1897 forever changed Tanner's life, shifting the focus of his paintings toward a symbolist interpretation of biblical scripture.

Christ and His Mother Studying the Scriptures presents a dramatic yet intimate scene. The figures of Christ and Mary clasp each other tenderly as they each hold the scroll from which they read, their physical bond an outward acknowledgment of their spiritual unity. Tanner's lush, densely painted surface is in a tonalist palette restricted to shades of blue, purple, and gold, bathing the figures in a warm, golden light, a metaphor for the illumination gleaned from the scroll. Adding to the poignancy of the composition, from existing photographs we know that Tanner's wife, Jessie, and their son, Jesse, were the artist's models. Tanner later painted a smaller version of this scene titled *Christ Learning to Read* (Des Moines Art Museum). In changing the title of the subsequent work, Tanner shifted the emphasis from a spiritually deep moment between Christ and Mary to an episode from Christ's early childhood. EJH

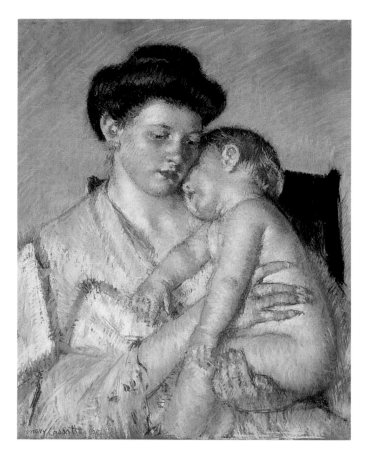

MARY CASSATT
(American, 1844–1926)

Sleepy Baby, c. 1910
Pastel on paper
25½ × 20½ in. (64.8 × 52.1 cm)
Munger Fund, 1952.38.M

Cassatt is best known for her tender and insightful portrayals of mothers with their children. Her exploration of the domestic realm and her particular emphasis on maternal themes mark some of her best work. Although she spent much of her adult life in Paris, Cassatt always considered herself an American artist, and she campaigned tirelessly to introduce the French impressionists to American audiences. Cassatt arrived in France in 1866, and in 1872 she began a long and fruitful association with Edgar Degas. This period proved exceptional in her career, and from 1877 until 1881 she exhibited her work alongside the impressionists in France.

Cassatt's developing interest in motherhood reflected a significant change in child-rearing customs at the time. In the past, children were routinely raised by a series of wet nurses and governesses. The new practice emphasized the benefits experienced by children who were nursed by their natural mothers and raised by their own parents.

Sleepy Baby is the last of five pastels Cassatt devoted to this theme during the early 1900s. Although this work has been called *John Asleep, Resting on his Mother's Shoulder,* neither mother nor child has been identified. Cassatt chose rural women as her models, preferring their robust health and strength to Parisian standards of beauty. Her compositions recall Renaissance paintings of the Madonna and Child, and in a letter defending her choice of models, Cassatt reminded her correspondent that even Botticelli used peasant women as models for the Virgin.

EJH

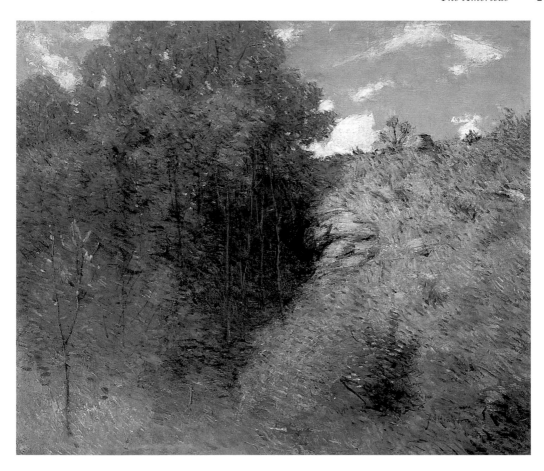

JULIAN ALDEN WEIR
(American, 1852–1919)

Ravine near Branchville, c. 1910–1919
Oil on canvas
25 × 30½ in. (63.5 × 77.5 cm)
Bequest of Joel T. Howard, 1951.10

In 1883 Julian Alden Weir exchanged one of his paintings for about 150 acres of farmland and orchards near Branchville, Connecticut. He often set out for walks through his fields with his sketching materials, bringing back ideas for paintings. Weir's frequent guests at Branchville included fellow artists Childe Hassam, John Twachtman, Theodore Robinson, and Albert Pinkham Ryder.

Much of Weir's early work is figurative and closer in feel to the paintings of tonalist artists like Thomas Dewing than to the work of Hassam and the American impressionists. It is primarily in his late works that Weir turned to the landscape for his subject. *Ravine near Branchville*, with its high horizon and broad, painterly touch, can be dated to the final decade of Weir's life. Pinholes in each corner of the painting suggest Weir had worked *en plein air*, tacking the canvas to an easel or other portable support. Weir's interest was in the play of light and shadow across the ravine, his flickering brushwork mimicking the movement of a light breeze across the leaves and grasses. As is typical of his late works, the artist confined his palette to shades of blue and green, primarily in pastel tones. Weir's absorption with the landscape at Branchville may have been his antidote to ever present pressures of official duties related to his participation in two important organizations: the breakaway Society of American Artists, established in protest of the restrictive guidelines of the National Academy of Design, and The Ten, a group of American impressionist and tonalist painters. EJH

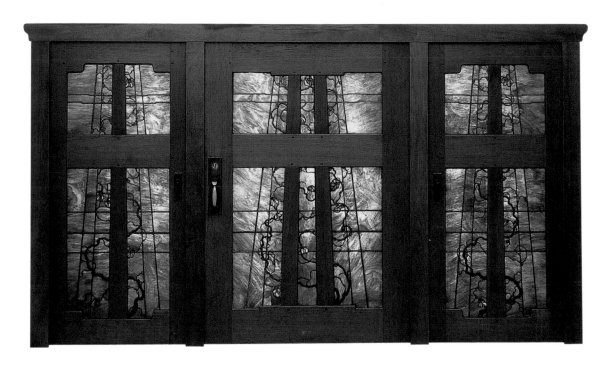

Front doors from the Robert R. Blacker house

American, 1907
Charles Sumner Greene (American, 1868–1957)
and Henry Mather Greene (American, 1870–1954),
designers; Sturdy-Lange Art Glass Studios and
Peter Hall Manufacturing Co. (act. 1907–21), maker,
Pasadena, California
Teak, glass, lead, and bronze
Middle door: 77½ × 54 × 2 in.
(196.9 × 137.2 × 5.1 cm)
Side doors: 77½ × 35¾ × 1½ in.
(196.9 × 90.8 × 3.8 cm)
General Acquisitions Fund with additional support
from Friends of the Decorative Arts, 20th-Century
Design Fund, Dallas Symposium, Professional
Members League, Decorative Arts Acquisitions Fund,
and the Dallas Glass Club, 1994.183.a–c

The Greene brothers were preeminent among
the West Coast architects who worked in the
arts and crafts style. Of all their buildings, the
Blacker house of 1907, from which these doors
come, is one of the most significant. It was the
first and largest of a series of bungalows dating
between 1907 and 1909. Located in Pasadena,
California, the Blacker estate consisted of a
main house, garage, gardener's cottage, green-
house, and a garden pergola. The long, heavy
timbering, the numerous porch railings, and
the interior hanging lanterns make the Blacker
house the Greenes' most Asian-inspired work.
Its lighting fixtures, including the living room
lantern (now in the Metropolitan Museum of
Art, New York), are all created of leaded glass
and feature plant images.

Of all the features that made the Blacker
house exceptional, the art glass doors and
windows are of special significance. These front
doors consist of three large leaded-glass panels
framed in teak, which depict vines meandering
up trellises. In their complexity, size, and color,
the only other examples of Greene and Greene
glass that rival them are the front doors of the
Gamble house of 1908, with their large, central
tree motif. CV

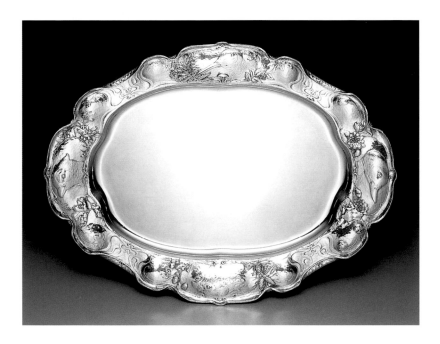

Meat dish

American, 1899
William C. Codman (American, born England,
1839–1921), designer; Gorham Manufacturing Co.
(est. 1831), maker, Providence, Rhode Island
Silver
2½ × 19⅜ × 14⅛ in. (6.4 × 49.2 × 35.9 cm)
The Oberod Collection, anonymous gift, 1995.64

The Dallas Museum of Art has an exceptional collection of American-made silver in the art nouveau style. Examples executed by the Gorham Manufacturing Co. form the core of this collection. In 1896 Gorham established a special "school" within its huge manufactory for the production of art nouveau silverware. Using hand techniques, gifted silversmiths wrought pieces of such quality that they even impressed European critics. In 1900, for example, Gorham was awarded the *grand prix* for its art nouveau–style creations at the Paris International Exposition. To emphasize that the pieces were handmade and to strengthen the connection between its products and Paris, the fountainhead of art nouveau design, Gorham named this line Martelé, a French word meaning "hammered." Martelé was felt to be an

appropriate name because silver in this line was ornamented by hand using various sizes of hammers.

This dish predates the bulk of Gorham's production in the art nouveau taste that was most popular between 1900 and 1909. Nevertheless, the dish features all the hallmarks of the finest wares in the Martelé line including an undulating outline, shimmering surface, and exceptionally fine chased decoration. Believed to have been ordered by Albert Augustus Pope (1843–1909), a wealthy bicycle and automobile manufacturer from Hartford, Connecticut, this dish was used for serving meat. Featured around the rim are the heads of various wild birds and flowers. CV

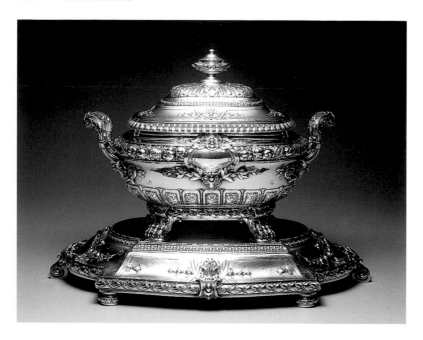

Tureen on stand

American, 1910
William C. Codman (American, born England,
1839–1921), designer; Gorham Manufacturing Co.
(est. 1831), maker, Providence, Rhode Island
Silver
Tureen: 10½ × 14¾ × 8½ in. (26.7 × 37.5 × 21.6 cm)
Stand: 3 × 19 × 12¾ in. (7.6 × 48.3 × 32.4 cm)
Gift of the Sunny and Abe Rosenberg Foundation
with additional support from Friends of the Decorative Arts, 1996.51.a–c

This tureen and stand were originally part of a large table service ordered by William Andrews Clark (1839–1925), who served as a senator from Montana from 1901 to 1907. While Clark had extensive properties in Montana, this service was commissioned for his Louis XIV–style residence in New York City. To complement the house, the design of the tureen and stand was inspired by seventeenth-century European silver. The grotesque masks, paw feet, and bands of fruit and flowers were all derived from this earlier work. The use of this historical ornamentation on a conservative shape in 1910 is most interesting. Although the reductivist aesthetics of the arts and crafts movement were at their height in the United States at that time, this tureen and stand demonstrate that the vast majority of Americans were not interested in that more restrained style, but rather believed historical styles to be far more beautiful and desirable.

The Clark commission was one of Gorham's most important. Not only did the firm's chief designer execute the drawings for the service, but its finest workmen labored on each piece. In all, the entire service took more than two years to complete. The tureen and stand alone required 1,056 man-hours to create. Consequently, Clark paid dearly for these two pieces; the retail cost is believed to have been over $2,100. CV

GEORGE WESLEY BELLOWS
(American, 1882–1925)

Emma in a Purple Dress, 1920–23
Oil on canvas
63 × 51 in. (160 × 129.5 cm)
Dallas Art Association Purchase, 1956.58

George Bellows gave up a promising career in baseball to pursue his first love, painting. Arriving in New York City in 1904, he studied for two years with Robert Henri, who stressed the importance of capturing direct observations on canvas and working rapidly in paint so as not to lose the immediate response to a subject. Bellows's bold brushwork and dark, glowing color take their cues from his study of Édouard Manet and Frans Hals, as does his interest in portraiture. He became a member of The Eight, informally known as the Ashcan school, whose members chose socially charged urban scenes for their subjects.

In addition to his well-known boxing scenes, Bellows painted numerous portraits. Among the best of these are his portrayals of his wife and daughters. Bellows married Emma Story in 1910; *Emma in a Purple Dress* is the artist's last and, in some respects, most successful painting of her. Emma Bellows recalled her husband's terrific struggle to paint her face, as he scraped out each successive effort to capture her character as well as her likeness. A drawing in the museum's collection indicates the relative ease with which the artist handled the dress, but the paper ends at Emma's neck. Bellows also experimented with this composition in a series of lithographs that spans the three years in which this portrait was in progress.

In the finished painting, Emma's eyes are cast to one side, her gaze distant. The light falling on Emma's face softens the resolute frontality of the composition, while in her averted gaze may be read the tedium of innumerable sittings.

EJH

GERALD MURPHY
(American, 1888–1964)

Razor, 1924
Oil on canvas
32⅝ × 36½ in. (82.9 × 92.7 cm)
Foundation for the Arts Collection, gift of the artist,
1963.74.FA

Gerald Murphy was part of the so-called Lost Generation, expatriate artists and writers who flourished between the world wars in Paris. With his wife, Sarah, Murphy arrived in the city in 1921. They quickly became fixtures in a cosmopolitan group that included poet Archibald MacLeish, writers Ernest Hemingway and F. Scott Fitzgerald, composer Cole Porter, and painters Fernand Léger and Pablo Picasso.

Paris energized Murphy as America could not; the city, Murphy wrote in a letter, was "fresh, new, and invented." Inspired by the cubists and Russian constructivists, Murphy created paintings in which line, color, and form dominate the depiction of familiar objects. His background in mechanical and architectural drawing supported this tendency toward abstraction. Murphy often recorded ideas in a notebook, waiting for his thoughts to crystallize before beginning the painting. His entry for *Razor* reads: "Picture: razor, fountain pen; etc. in large scale nature morte big match box." In the painting Murphy paired a fountain pen and a safety razor (both recent American inventions), crossed in heraldic fashion, in front of a matchbox cover. Although Murphy declared a lack of interest in modern advertising art, *Razor*'s dependence on graphic design principles is clear. His vision may stem, however, from his passion for folk art, notably trade signs that pictured items for sale. Murphy appreciated their bold designs and strong colors. *Razor* is, in this sense, a thoroughly modern update of an earlier American advertising idiom. EJH

GERALD MURPHY
(American, 1888–1964)

Watch, 1925
Oil on canvas
78½ × 78⅞ in. (199.4 × 200.3 cm)
Foundation for the Arts Collection, gift of the artist,
1963.75.FA
© 1997 Estate of Gerald Murphy, New York

In March of 1925, Murphy exhibited *Watch* at the Salon des Indépendants in Paris. His largest surviving canvas, *Watch* may be viewed as a synthetic cubist interpretation of a watchmaker's trade sign. In a letter, Murphy wrote that he was "always struck by the mystery and depth of the interiors of a watch—its multiplicity, variety, and feeling of movement, and man's grasp at perpetuity." Beginning with a carefully limned drawing on graph paper, Murphy exploded and pieced together two specific timepieces: a railroad watch, designed for the Mark Cross Company (run by Murphy's father, and eventually by Murphy himself), and a gold pocket watch, which his daughter Honoria recalled was often left propped open to reveal its inner workings.

Murphy's composition retains the outline of a pocket watch; however, the artist has fractured, rotated, and overlapped its individual components. Even the palette contributes to the resulting visual tension, as vibrant shades of orange and yellow share boundaries with a range of cooler blues and grays. Compressing simultaneous glimpses of face, back, springs, and gears, *Watch* examines the dichotomy between the resolute predictability of time and the fragility of the mechanism for measuring it.

EJH

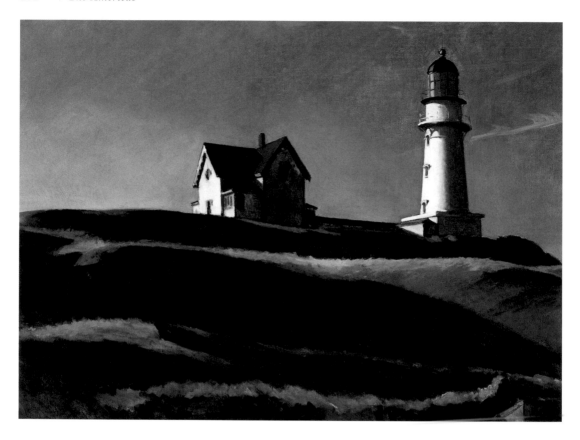

EDWARD HOPPER
(American, 1882–1967)

Lighthouse Hill, 1927
Oil on canvas
28¼ × 39½ in. (71.8 × 100.3 cm)
Gift of Mr. and Mrs. Maurice Purnell, 1958.9

While many of his colleagues painted the daily routine of urban life, Hopper preferred to investigate emotions of quiet melancholy and pensiveness in both urban views and landscapes. Lighthouses in particular drew his attention, and they appear in many of his drawings, prints, and paintings. During the summer of 1927 Hopper vacationed at Cape Elizabeth, Maine, where he sketched the lighthouse called Two Lights. Situated on Lighthouse Hill, the monumental structure was operated by Captain Upton, whose cottage also appears in several of the artist's works.

Hopper's self-stated mission as an artist was to capture his personal impressions of nature; he acknowledged that he took special pleasure in painting sunlight against the side of a house. He was also particularly interested in order and proportion, and paid careful attention to the relationships between forms in his paintings. Hopper's principal focus in *Lighthouse Hill* is the play of light on the buildings, viewed from a dramatically foreshortened angle near the water's edge. Although the surf near Lighthouse Hill was often dramatic and rough, Hopper turned his back to the water and chose a viewpoint that eliminated the rocky shoreline. The effect is one of moody introspection, lending a melancholy majesty to the lighthouse and, by extension, to its solitary task. During the same year Hopper also painted *Captain Upton's House* (private collection), featuring the keeper's cottage, returning to the subject two years later, painting *Lighthouse at Two Lights* (Metropolitan Museum of Art, New York), in which he reversed the vantage used in *Lighthouse Hill*. In each, the buildings are strongly silhouetted against a brilliant blue sky, conveying Hopper's love of lighthouses and light. EJH

GEORGIA O'KEEFFE
(American, 1887–1986)

Grey, Blue, Black, Pink, and Green Circle
(Kachina Abstraction), 1929
Oil on canvas
36 × 48 in. (91.4 × 121.9 cm)
Gift of the Georgia O'Keeffe Foundation, 1994.54
© 1997 The Georgia O'Keeffe Foundation, New Mexico

Georgia O'Keeffe's early abstractions, although not as well known as her later southwestern paintings, played a pivotal role in the development of American modernism. *Kachina Abstraction* is the culmination of O'Keeffe's *Special* series, a body of abstract drawings and paintings that she made during the 1920s. She created these works outside the influence of the New York mainstream and before her initial contact with the works of Wassily Kandinsky, whose treatise *On the Spiritual in Art* had a measurable impact on her later abstract style.

The nodes in the center of the painting recall the headdresses of Hopi kachina dancers (and the headdresses of the eponymous kachina dolls); the surrounding whorls of color amplify the suggested motion of the dance and the consonant rhythms of the universe. O'Keeffe's works in this manner attracted the attention of the painter Lawren Harris, leader of the Group of Seven, Canadian artists who celebrated the spiritualizing energy of the landscape. His arrival in Santa Fe in 1938 sparked a growing movement called the American Transcendental Painting Group, which included Harris, Raymond Jonson, and Emil Bisttram (the latter two are well represented in the museum's collection). Their stated philosophy was to create "a focal point for the development of a type of art vitally rooted in the spiritual need of these times and expressing the most truly creative, fundamental, and permanent impulses emerging from the American continent." Although she was never a member of the group, O'Keeffe's early abstractions embody its philosophy. *Kachina Abstraction* is a prototypical work in this vein, capturing the spiritual essence of the Hopi celebration as a flowing miasma that coalesces into a tunnel of light and color. EJH

Height and weight meter (model S)

American, c. 1927

Joseph Sinel (American, born New Zealand, 1889–1975), designer; International Ticket Scale Corporation, maker, New York

Steel, iron, brass, chrome, paint, glass, and rubber

77 × 15 × 25 in. (195.6 × 38.1 × 63.5 cm)

Anonymous gift through the 20th-Century Design Fund, 1996.46

Although industry had long had in-house designers and master craftsmen to design products, the 1920s saw the advent of professional industrial designers who worked as consultants to manufacturers to design specific products. This new phenomenon was led by individuals such as Raymond Loewy (1893–1986) and Walter Dorwin Teague (1883–1960). Joseph Sinel, who designed this scale, was one of these new professional designers.

This meter is perhaps Sinel's most famous design. The overall form derives from Manhattan's most potent symbol, the skyscraper. In 1916 the New York zoning code was modified to require all buildings over a certain height be set back at the top to allow light and fresh air to reach pedestrians below. As a result, structures such as the Chrysler Building (constructed 1928–31), had a profound effect on New York's skyline. Sinel and others incorporated these new icons of American modernity into their work. The silhouette of this piece, for example, features a tall shaft with stepped-back top. To further enhance the boldness of the design, Sinel used art deco typefaces on the facade. The weighing platform reads "STEP / ON / IT." When placed inside contemporary art deco–style buildings like Radio City Music Hall, the effect must have been striking indeed. CV

CHARLES DEMUTH

(American, 1883–1935)

Buildings, c. 1930–31
Tempera and plumbago on composition board
29¾ × 24 in. (75.6 × 61 cm)
Dallas Art Association Purchase Fund, Deaccession
Funds/City of Dallas (by exchange) in honor of
Dr. Steven A. Nash, 1988.21

Charles Demuth began and ended his brief
career painting the industrial landscape around
his hometown of Lancaster, Pennsylvania. In
the face of an increasingly urban environment,
Demuth, like his colleague Charles Sheeler
(p. 257), explored the relationships between man
and his inventions. His exposure to the abstract
work of American and European artists gave
him the vocabulary that dominates his composi-
tions, in which he links buildings with a web of
angular lines, creating zones he then filled with
pale hues. Recalling stained glass in its beauty,
the resulting fragmentation is also reminiscent
of the "force lines" found in Italian futurist
paintings.

In *Buildings* the chimney, silo, and water
tower are caught in a crossfire of radiating lines
that anchor the predominantly vertical composi-
tion. Demuth filled many of the resulting zones
with pale colors echoing the stronger red and
pinks of the buildings. Most of the structures
in Demuth's Lancaster scenes are specific, iden-
tifiable landmarks, and the vantage point from
which the artist worked can be verified. *Buildings*
is an exception. The individual structures ap-
pear as archetypes of the actual silos, chimneys,
and water towers that dominated the local hori-
zon and form a complex abstraction of elements
familiar to his other landscapes. Although
Demuth did not date *Buildings*, its close similar-
ity to *Chimney and Water Tower* (Amon Carter
Museum, Fort Worth) of 1931 helps establish
its place in Demuth's oeuvre. EJH

ALEXANDRE HOGUE
(American, 1899–1994)

Drouth Stricken Area, 1934
Oil on canvas
30 × 42½ in. (76.2 × 107.3 cm)
Dallas Art Association Purchase, 1945.6
© 1997 Estate of Alexandre Hogue, courtesy Cline Gallery of
Fine Art, New Mexico

Hogue, a staunch advocate of the arts, was a founder of the Dallas Artists League in 1932, yet he was one of the few artists of the Depression era who did not work for the government's Work Projects Administration. Scorning the regionalist label, Hogue denied the cheery face of American Scene painting favored by federal arts administrators. More important, he refused to ennoble the element of human misery prevalent in so many dust bowl images. Hogue blamed the region's problems on inept and thoughtless overcultivation of the land, and he viewed the plow as the principal agent of disaster. In his words, prime grazing lands had been destroyed "first by fence, then by overplowing, now by drought." Between 1933 and 1936 Hogue examined variations on this theme in six paintings he called his Erosion series.

In *Drouth Stricken Area* a dry, hot wind has sculpted the formerly verdant land into sand dunes. Under a searing sky, a starving cow waits numbly for water that will not come; perched on the rickety well, an equally patient buzzard awaits the cow's inevitable death. The only movement in this arid landscape is the dust massing on the horizon, an ominous portent. Using a device he termed "psychoreality," Hogue deliberately intensified the conditions in his paintings to generate empathy within his viewers. Drawings for the emaciated cow and the windmill (also in the museum's collection), affirm the artist's careful abstraction of each component of the painting. In doing so, Hogue sacrificed naturalistic detail to achieve the emotional keynote of the landscape. EJH

CHARLES SHEELER
(American, 1883–1965)

Suspended Power, 1939
Oil on canvas
33 × 26 in. (83.8 × 66 cm)
Gift of Mr. Edmund J. Kahn, 1985.143

In 1938 *Fortune* magazine commissioned Sheeler to create a series of six paintings on the theme of power as a showcase of America's technological advances. Sheeler's paintings, illustrated in the December 1940 issue of the magazine, delivered a clarion call to its readers that America's industrial strength would be a new source of might in the post–World War II era. Sheeler chose six subjects: the railroad, the airplane, a steam engine, the Hoover Dam, a hydroelectric turbine, and, curiously, a nineteenth-century waterwheel. He spent a year traveling to the sites that would represent his themes, photographing them in preparation for his paintings.

Suspended Power depicts a new hydroelectric turbine being lowered into place at the Tennessee Valley Authority dam in Guntersville, Alabama. Sheeler humanized the impersonal machine by rendering its hard, metallic surfaces in a palette of warm, flesh tones. The artist's feelings about mechanization were mixed: far from embracing industrialization with untempered approval, he expresses a tension in the precarious position of the turbine looming over the workers below. In contrast, Sheeler's rendering of a waterwheel in *Primitive Power* (The Regis Collection, Minneapolis), testimony to the lasting power of nineteenth-century innovation, seems a deliberate counterpoint to the enormous machine which will now perform the same service.

The title *Suspended Power* alludes to the actual suspension of the machine as it is lowered into place and to the status of the dam until the turbine begins generating power. Sheeler's workmen are not actively engaged in the installation and seem to be remote observers. Their attitudes recall paintings from the previous century in which viewers perched on the rim of Niagara Falls—a symbol of America's might linked to nature—witnessed what was then the most powerful source of hydroelectric power. EJH

THOMAS HART BENTON
(American, 1889–1975)

The Prodigal Son, c. 1941
Oil and tempera on panel
26⅛ × 30½ in. (66.4 × 77.5 cm)
Dallas Art Association Purchase, 1945.1

© 1997 T. H. Benton & R. P. Benton Testamentary Trusts/
Licensed by VAGA, New York, NY

Thomas Hart Benton's artistic talents were matched by his ability to insult or outrage his audience. Already an artist of some prominence in New York during the 1930s, Benton drew criticism for his paintings of rural midwestern life. Stubborn in his belief that he was representing his home region fairly, Benton was stung by the accusation that his portrayals were demeaning. His strong, lyrical rhythms and bold palette, combined with his focus on the rural Midwest, contributed to his being tagged with the regionalist label.

In 1935 Benton decided to accept a teaching position at the Kansas City Art Institute. The homecoming was not entirely successful, as Benton continued to make inflammatory comments about his critics which led to his dismissal in May 1941. That same year in New York he exhibited *The Prodigal Son*, a painting based on a lithograph he had made two years before. In both the print and this painting, Benton gives a dust bowl context to the biblical story in which an errant man's return comes too late. The homestead is in ruins, the chimney stands aslant like a tombstone over a dilapidated grave, and the cow is but a skeleton. Between the print of 1939 and the painting of 1941, Benton himself experienced the bittersweet side of homecoming, and in the painted version the clouds take on the shapes of howling dogs. This ironic and self-referential twist underscores both the grim reality of conditions in the Midwest during the 1930s and 1940s and the personal ordeals of the artist. EJH

GEORGIA O'KEEFFE
(American, 1887–1986)

Bare Tree Trunks with Snow, 1946
Oil on canvas
29½ × 39½ in. (74.9 × 100.3 cm)
Dallas Art Association Purchase, 1953.1
© 1997 The Georgia O'Keeffe Foundation, New Mexico

For O'Keeffe, 1946 was a turbulent year in which she painted few works. At the end of 1945 she had acquired the property at Abiquiu, New Mexico, that would become her winter studio and lifelong home, and was busy with its renovation. Throughout the early winter of 1946 she worked steadily with the curators at the Museum of Modern Art, New York, to select and install a major retrospective of her work—the first ever one-woman exhibition at the museum—which opened in March. These busy months culminated in the sudden death of her husband, Alfred Stieglitz, in July.

It is not entirely clear whether O'Keeffe painted *Bare Tree Trunks in Snow* before or after Stieglitz's death. In either case it is a hauntingly beautiful image of tree trunks, their roots blanketed in snow. O'Keeffe abstracted the essence of these forms by pulling in close to the trees without focusing on details; the forms are smooth, the bark dissolving into areas of soft grays and warm beige. The shallow space and cropped trees lend an ambiguity to the subject resolved only by the descriptive title (on first viewing, critic John Canaday apparently thought they were Marlene Dietrich's legs). O'Keeffe buried Stieglitz's ashes at the base of a stand of trees near his beloved Lake George, New York, making this work a fitting memorial to his life.

EJH

RUFINO TAMAYO
(Mexican, 1899–1991)

El Hombre, 1953
Vinyl emulsion with pigment on three Masonite
panels
18 ft. × 10 ft. 6 in. (5.4 × 3.2 m)
Commissioned by the Dallas Art Association through
Neiman-Marcus Exposition Funds, 1953.22
© 1997 Fundación Olga y Rufino Tamayo, A.C.

A Zapotec Indian, Rufino Tamayo was largely
self-taught. Fascinated by folkways, he spent
much of his youth drawing Mexican folk art in
museums. Tamayo also derived inspiration from
Georges Braque and Pablo Picasso, whose inter-
est in African and Oceanic art struck a similar
chord. Tamayo lived and worked in Paris and
New York for much of his life, returning to
Mexico permanently in 1964.

To strengthen the ties between Mexico and
the United States, in 1953 the Dallas Art Asso-
ciation commissioned Tamayo to paint a mural
to celebrate the universality of the human condi-
tion. Tamayo chose as his theme "man excelling
himself," which he shortened to the title *El
Hombre*. The mural is the culminating statement
of the artist's lifelong interest in the aspirations
of mankind, a theme Tamayo had explored in
several earlier, smaller works. In these the artist
had painted a figure against a starry sky, work-
ing out the symbolism of humankind's search
for our place in the cosmos. When he turned to
El Hombre, Tamayo universalized his theme: his
abstract figure is of no particular race, but its
tawny ochre color associates it with the earth
and affirms our unbreakable link with the planet.
The figure's heavy legs are angular trunks
rooted firmly in the rich brown earth. The at-
tenuated form grows longer and thinner as it
reaches for a comet streaking across the starry
sky. A black dog, heedless of the wonders in the
night sky, turns to a bone, his presence a symbol
of man's baser instincts. EJH

JACOB LAWRENCE
(American, born 1917)

The Visitors, 1959
Egg tempera on hardboard
20 × 24 in. (50.8 × 61 cm)
General Acquisitions Funds, 1984.174

Culturally rich, if economically impoverished, Harlem in the 1920s and 1930s was the intellectual and artistic nexus of the Harlem Renaissance, within whose vital community Jacob Lawrence came of age. His keen observations of daily life in the tenements provided the foundation for his mature vision. Lawrence's talent was noted by the painter Charles Alston, who became his first mentor, and Augusta Savage, a sculptor who championed local artists. She provided encouragement, instruction, and, whenever possible, job opportunities. With her help Lawrence spent part of 1938 painting under the auspices of the federal Work Projects Administration. This crucially important experience provided not only a steady income and patronage, but gave Lawrence time to concentrate on learning his craft.

Drawing on his avid interest in history, especially that of black Americans, Lawrence worked in series of images when the subject could not be encompassed in a single painting. This impulse to create large-scale, sequential stories has been attributed to the legacy of storytelling cycles central to his upbringing. In addition to his best-known series on Harriet Tubman and Frederick Douglass, Lawrence worked on individual paintings that together form a loose confederation of scenes chronicling his life in Harlem. These works resonate with a power that is enhanced by the artist's manipulation of perspective and daring juxtaposition of colors. In *The Visitors* a minister confers last rites to a bedridden person, while family and friends assemble to pay their respects and offer consolation. The angular walls convey the anxiety of the gathered family; the vivid purple next to olive green sets up an uneasy vibration of color, adding to the poignancy of the moment. EJH

ANDREW WYETH
(American, born 1917)

That Gentleman, 1960
Tempera on panel
23½ × 47¾ in. (59.7 × 121.3 cm)
Dallas Art Association Purchase, 1962.27

Andrew Wyeth is the youngest son of artist and illustrator N. C. Wyeth, who encouraged Andrew's interest in art. In his choice of representational subject matter, Andrew Wyeth stands for an alternative tradition of painting amid the predominantly nonrepresentational schools that have dominated American art since the late 1940s. Although his works acknowledge the influence of Rembrandt, Dürer, and Winslow Homer, they also contain a strong element of abstract design that aligns him with Charles Sheeler and Charles Burchfield.

That Gentleman evokes the pensive mood and quality of repose that are hallmarks of Wyeth's best work. The artist's model was Tom Clark, a fellow resident of Chester County, Pennsylvania. Impressed with his sitter's quiet strength, Wyeth wrote: "His voice is gentle, his wit keen, and his wisdom enormous. He is not a character, but a very dignified gentleman who might otherwise have gone unrecorded."

Wyeth's emphasis on the attributes of patience and calm draws attention to the exactitude demanded by his technique. Tempera paints are made by mixing powdered dry pigments with egg yolk, thinned with water. This medium, most often associated with fifteenth-century Flemish painting, demands careful draftsmanship and precision. Between the 1930s and 1950s tempera enjoyed a renewed popularity with American artists. Wyeth learned the technique from his brother-in-law, Peter Hurd, and believing that the textures achieved in tempera held "a power of mysterious suggestion beyond representation," he reserved the medium for his most ambitious works. EJH

Centerpiece and pair of candelabra

American, 1949
Tiffany & Co. (est. 1837), New York
Silver
Centerpiece: 10 × 14 × 9¼ in. (25.4 × 35.6 × 23.5 cm)
Candelabra: 8½ × 10¾ × 9 in. (21.6 × 27.3 × 22.9 cm)
Gift of the 1995 Silver Supper, 1995.72.1–3

Intended to hold flowers and candles, these pieces are exceptional examples of post–World War II American silver. The bold silhouettes, slick surfaces, and use of stylized natural elements such as pinecones are characteristic of avant-garde work from this period, especially Scandinavian pieces. In the United States, however, such overt modernism was rare. During the 1940s and 1950s, most of Tiffany's commercial production was in the colonial revival style, which drew inspiration from eighteenth-century silverware. Because this design is so radically different, one must conclude that it was either ordered by a customer who appreciated modern design, or else was created by the firm to dem-

onstrate that it could produce work as stylistically advanced as its European rivals. It is even possible that the centerpiece and candelabra were created for display at an exhibition. In 1939 Tiffany & Co. had shown a related set in its display at the New York World's Fair.

This set was extremely expensive to produce because of the enormous amount of hand labor involved. Not including work by other individuals, the silversmith Karl A. Danielson, who worked for Tiffany between 1909 and 1950, labored seven hundred hours on the pieces. Consequently the set cost the firm $3,900 to produce. The retail price thus was set at the then-huge sum of $7,800. CV

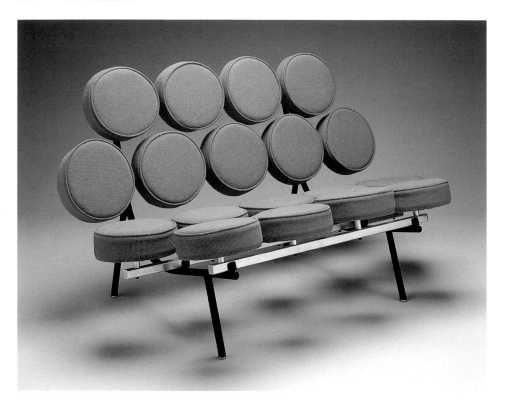

Marshmallow sofa

American, designed c. 1954–55
George Nelson Associates (United States,
act. 1947–83), designer; Herman Miller, Inc.
(est. 1905), maker, Zeeland, Michigan
Steel, paint, foam rubber, plywood, and fabric
33 × 51 × 30 in. (83.8 × 129.5 × 76.2 cm)
20th-Century Design Fund, 1995.41

During the 1950s and 1960s, the influence of
science fiction literature and the space race
between the United States and Russia was
pronounced in industrial design. Thanks to
new materials such as plastic, and to innovative
manufacturers, including the American firms
of Herman Miller and Knoll International, the
"modern" look was brought into the workplaces
and homes of millions of Europeans, Americans,
and Asians.

George Nelson and his design associates
were important in the creation of a modernist
aesthetic during the mid-twentieth century. This
extraordinary sofa is a fine example of their
work. According to Irving Harper, who worked
in Nelson's New York firm, the idea for this sofa
was based on an unusual concept of assembly.

Whereas a traditional sofa consists of a wooden
frame entirely covered by upholstery, the Marsh-
mallow design consists of an exposed metal
frame to which separate circular cushion units
are attached in strategic positions. Although
chairs had been made this way, the idea that one
could rest comfortably on independent units as
opposed to a solid surface was a radical one.

Unfortunately the production of this model
proved costly because it required a great deal
of hand labor to upholster and mount the many
cushions. Furthermore the design was so radical
that few private consumers accepted it. Conse-
quently Marshmallow sofas were produced in
small numbers and were most often used in
offices and hotels, rather than in homes. CV

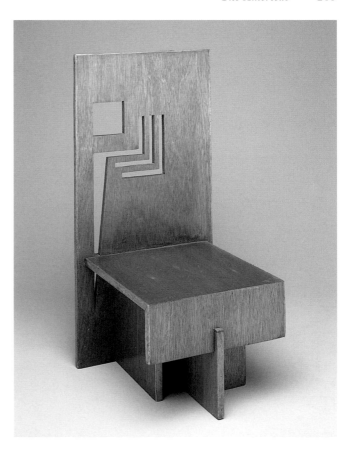

Side chair

American, c. 1956
Frank Lloyd Wright (American, 1867–1959), designer
Plywood
37⅛ × 18½ × 19¾ in. (94.3 × 47 × 50.2 cm)
Anonymous gift through the 20th-Century
Design Fund, 1994.5

Designed in 1956 for the Paul J. Trier House in Des Moines, Iowa, this side chair follows the Usonian concept that Frank Lloyd Wright espoused in the 1940s and 1950s. He described furnishings appropriate to such a house: "Rugs, draperies, and furnishings that are suitable for a Usonian house are those . . . that are organic in character, that is, textures and patterns that sympathize in their own design and construction with the design and construction of the particular house they occupy and embellish." Like many of the architect's late commissions, the Trier House was characterized by bold geometry and simple materials. This was reflected in the furniture through the choice of inexpensive plywood as the primary material, to which a simple upholstered foam rubber cushion was stapled. The square and angular patterns cut into the back reflect the geometry of the Trier House and also bring to mind the work Wright did for earlier structures. Similar motifs appeared in the bases of chairs for the Paul R. Hanna House in Palo Alto, California (1937) and in the clerestory panels of Wright's Usonian houses. Chairs identical to this one were originally designed in 1953 for the Usonian Pavilion in New York City. CV

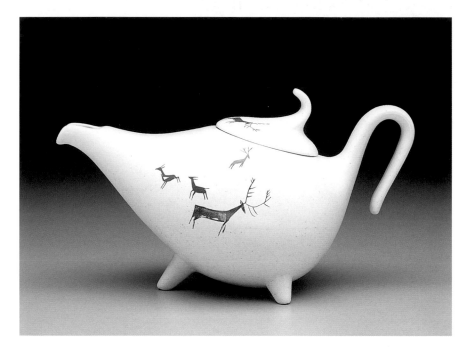

*Free Form shape teapot with Primitive
pattern decoration*

American, designed 1955
Viktor Schreckengost (American, born 1906),
designer; Salem China Company (est. 1898),
maker, Sebring, Ohio
Glazed earthenware
6 × 10½ × 5 in. (15.2 × 26.7 × 12.7 cm)
20th-Century Design Fund, 1996.7.a–b

The Dallas Museum of Art has one of the finest collections of industrially produced ceramics made in the United States. Particularly well represented are pieces dating between 1925 and 1965. During this period, American potteries reached their peak in both production and importance in the marketplace. Serving this industry were many world-famous designers, among them Viktor Schreckengost. He was raised in the Ohio Valley in a family of potters; both his brothers, Paul and Donald, also became important ceramic designers.

This teapot design is one of Viktor Schreckengost's most radical creations. Developed to fit the casual lifestyle that had developed in post–World War II America, the Free Form line, to which this pot belongs, is characterized by non-traditional shapes—cups that stand on three legs, oval plates, and teardrop-form salt and pepper shakers. The teapot with its loop handle, tripod feet, and extended spout is the most avant-garde piece in this line. Several of the decorative patterns applied to these forms were also unusual. Primitive, seen here, derived from prehistoric cave painting. Interestingly, the manufacturer hoped this pattern would appeal to male consumers, rather than just to females, who represent the vast majority of ceramics buyers. CV

Contemporary

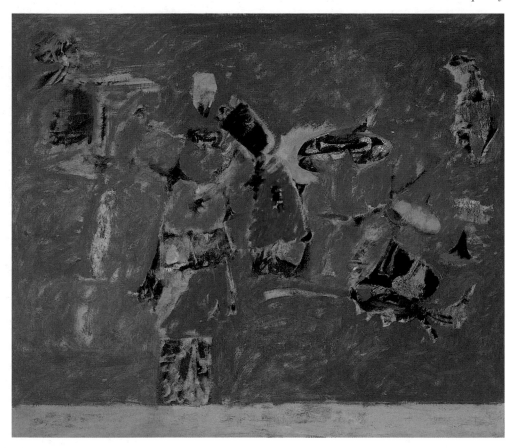

ARSHILE GORKY
(American, born Armenia, 1905–1948)

Untitled, 1943–48
Oil on canvas
54½ × 64½ in. (138.4 × 163.8 cm)
Dallas Art Association Purchase, Contemporary
Arts Council Fund, 1965.17

Arshile Gorky was the most influential of the American artists who translated European cubism and surrealism into an original artistic vocabulary that would become abstract expressionism. Born in Armenia, Gorky became a refugee during the Turkish invasions of the 1910s; his mother died of starvation in flight from advancing Turkish armies. This experience set the emotional tone for a series of nearly unbearable travails that the artist somehow managed, for a while, to master and even incorporate into his work. But, finally overwhelmed, Gorky ended his own life just at the point that abstract expressionism was poised to achieve international renown.

In this untitled painting, we see traits of Gorky's art that younger artists, especially Willem de Kooning, found compelling. It suggests figures and forces slowly coming into being or expiring against a background of charged color which recalled European traditions but broke forward into new psychological territory. Particularly impressive is the underpainting, a technique of layering areas of color so pigments show through in harmony and dissonance. Here Gorky sets up a traditional land, figure, and sky composition but confounds this premise by using indeterminate shapes that are his private signs and symbols. The idea that such personal and abstract symbols could communicate universal emotions represents a crucial bridge between European art of old and the American art just emerging at the time of Gorky's tragic end. CW

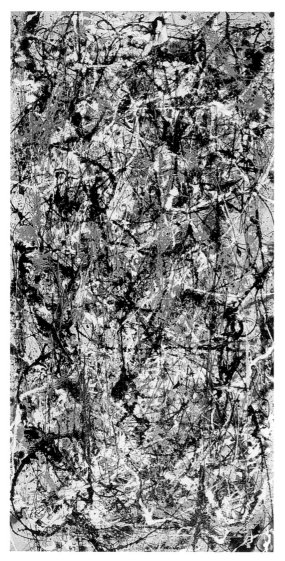

JACKSON POLLOCK
(American, 1912–1956)

Cathedral, 1947
Enamel and aluminum paint on canvas
71½ × 35⅛ in. (181.6 × 89.2 cm)
Gift of Mr. and Mrs. Bernard J. Reis, 1950.87
© 1997 Pollock-Krasner Foundation/Artists Rights Society (ARS),
New York

Portrait and a Dream, 1953
Oil and enamel on canvas
58½ × 134¾ in. (148.6 × 342.3 cm)
Gift of Mr. and Mrs. Algur H. Meadows and the
Meadows Foundation, Incorporated, 1967.8
© 1997 Pollock-Krasner Foundation/Artists Rights Society (ARS),
New York

In a series of photographs taken by Hans
Namuth in 1950, Jackson Pollock is seen hover-
ing over a number of immense pieces of canvas
that lie on his studio floor, as he lets paint flow
from the end of a brush or stick in gestures that
required considerable acrobatic facility. Pollock's
Cathedral dates from his first series of paintings
of 1947–50, in which the artist perfected this
drip technique that forever changed the way art
was created and perceived. The term "drip,"
though descriptive, is somewhat misleading, as
it implies that Pollock merely flung paint onto
his canvases. In fact his technique was extremely
controlled. Evidence of this can be seen in the
deliberate placement and layering of paint that
covers the surface of *Cathedral* in an overall
composition, a hallmark of abstract expression-
ist painting. Likened to the facade of a Gothic
cathedral by the poet and curator Frank O'Hara,
Cathedral's tight yet dynamic interlacings of
black, white, and silver also suggest an energy
made visible: here Pollock has recorded in paint
the actions that went into the work's very
making. Such protean ideas of the artist as
grand creator—Pollock famously stated, "I *am*

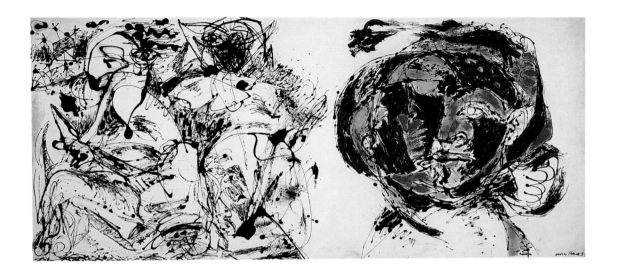

nature"—would influence the course of art through the rest of the century.

Portrait and a Dream has been the subject of widespread interpretation, yet no single theory has surfaced to explain this mysterious work. Here we see Pollock in the later part of his career returning to the figure, yet retaining the freedom of line and composition he perfected in his earlier abstract work (such as *Cathedral*). It has been suggested that the head on the right is a self-portrait covered by some kind of mask that partially obscures its features. At this time, this face appears in numerous drawings that relate to Pollock's experiences with Jungian analysis, a branch of psychiatry that regards some symbols as universally present in the human subconscious. Here Pollock was perhaps looking back to his own earlier symbols, as the figure on the left appears to be the "moon woman" that appeared in his work of the 1930s and 1940s. A crescent shape obscures the face of this sketchily painted reclining female figure, who might perhaps embody the "dream" of the painting's title.

Jackson Pollock made his interior life grandly exterior, creating a body of work which, in its mix of psychological power and outsized scale, sounded a new vocabulary in depicting the individual in an increasingly unsettling and destabilized world. Baring his self in a way few other American artists could (or would), Pollock redefined the very character of what it meant to be an artist and to make art in the contemporary world. Nothing that came after him could remain the same.

CW

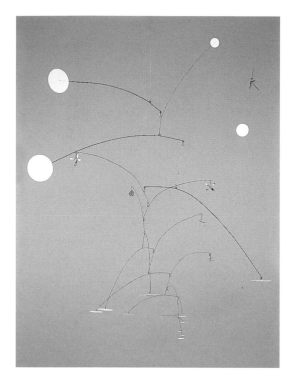

ALEXANDER CALDER
(American, 1898–1976)

Flower, 1949
Iron, silver, aluminum, and paint
102 × 90 in. (259.1 × 228.6 cm)
Gift of the Dallas Garden Club in honor of
Mrs. Alex Camp, 1949.13

Alexander Calder's mobiles have brought delight and pleasure to millions. Informed by the most important art movements in early-twentieth-century Europe, Calder's work has always been greatly inspired by the rhythms and movements of nature. Liberating sculpture from its pedestal, Calder revolutionized the medium and introduced motion to modern art.

Calder, trained as a mechanical engineer, turned to art in 1923. Enrolled in the Art Students League, New York, he studied under Ashcan painters George Luks and John Sloan. Two years later he accepted a freelance assignment that proved a turning-point in his life: for two weeks, he sketched the people and animals at the Ringling Brothers' Barnum and Bailey Circus. In 1927, using bits of wire, string, cloth, yarn, and wood, he began to translate his sketches into a miniature circus. Later, in Paris, he gave "performances" of it accompanied by recorded music for a group of intellectuals and artists, many of whom—Arp, Léger, Miró, and Mondrian—became lifelong friends.

In the early 1930s, Calder took up abstraction and the use of primary colors. He produced his first mobile, so named by Marcel Duchamp, after a visit to Piet Mondrian's studio in 1930. Calder said he wanted to make Mondrian's colored rectangles oscillate. His first abstract, geometrical constructions moved by electric motors or hand cranks. Dissatisfied, he then turned to balanced, hanging structures moved by random currents of air. In 1932 he also began creating stationary sculptures that imply movement, which Jean Arp called stabiles.

Dallas's mobile, *Flower*, combines a constructivist's love of the mechanical, a dadaist's sense of play, a futurist's celebration of movement, and a surrealist's exploration of the organic and biomorphic. *Flower* is a unique universe of forms, turning, moving, and dancing, quietly and gently. It represents not only the earth, said Calder, but also "the miles of gas above it, volcanoes upon it, and the moon making circles around it."

SW

JOSEPH CORNELL
(American, 1903–1972)

Grand Hôtel de la Boule d'Or, early 1950s
Wood, paint, newsprint, and glass
19¼ × 13¾ × 3⅞ in. (48.9 × 34.9 × 9.8 cm)
Foundation for the Arts Collection, gift of Mr. and
Mrs. Alan M. May, 1976.73.FA

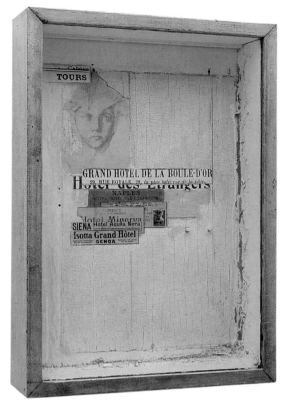

With his "shadow boxes," simple box construc-
tions containing such objects as seashells,
bottles, cordial glasses, driftwood, maps, photo-
graphs, and surrealist-inspired collages, the
reclusive and reticent Joseph Cornell created
a private world of transcendent poetic power.
He made these intimate private universes in
the simple family home in Queens, New York,
where from 1929 on, he lived with his family and
worked. Although he had no formal schooling in
art, Cornell cultivated a taste for French litera-
ture and a lifelong passion for symbolist painters
such as Odilon Redon and the poets Charles
Baudelaire and Stéphane Mallarmé. He had con-
tact during the 1930s with the artistic climate in
New York, where many of the city's artists and
Europe's expatriate artists frequented the few
avant-garde galleries. At the Julien Levy Gallery,
Cornell became involved with many painters
and writers connected with the surrealist move-
ment in the United States before and during
World War II. In 1937 he was included in the
seminal exhibition *Fantastic Art, Dada, Surreal-
ism* at New York's Museum of Modern Art.

Throughout his productive career, which
included experimentation with film, Cornell
investigated motifs such as hotels, constellations,
bees, and Renaissance paintings of children. In
the shadow box *Grand Hôtel de la Boule d'Or*,
letterheads of various hotels and a photographic
reproduction of a drawing, *The Artist's Daughter*,
by Jusepe de Ribera, are collaged on the front of
aged, faded blue wood; on the back he collaged
pages from a French anthology, *Oeuvres Diverses*.
With grace and subtlety, Cornell combines the
everyday and the extraordinary to evoke a
Proustian, dreamlike world devoted to old places
and possessions—the remembrance of things
past. SW

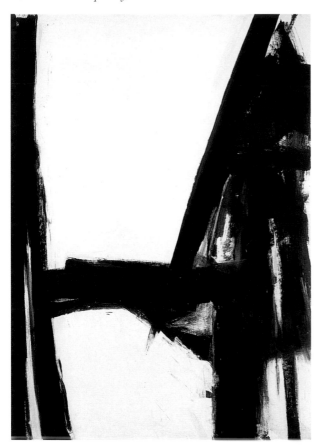

FRANZ KLINE
(American, 1910–1962)

Slate Cross, 1961
Oil on canvas
111¼ × 79 in. (279.2 × 200.7 cm)
Gift of Mr. and Mrs. Algur H. Meadows and the
Meadows Foundation, Incorporated, 1968.18

In 1950 Franz Kline dramatically abandoned his figurative style to arrive at his elemental architectonic abstractions. These signature structural dramas, like Pollock's drips, Rothko's blurred floating forms, and de Kooning's sneering women, have become icons of contemporary art. Kline's sweeping, lunging, and colliding brushstrokes were not attempts to discover the tragic, timeless, or spiritual; with his roots in the coal country of eastern Pennsylvania, he distrusted spiritual claims. Like his early, heavily gestured, richly colored city streets, bar scenes, and alienated clowns, which acknowledge his admiration of Rubens, Reginald Marsh, and English cartoonists, Kline's powerful, almost brutal, abstractions embody the energy and excitement of the city.

Slate Cross is a commanding masterpiece of Kline's mature style. Bold black brushstrokes traverse this brutishly elegant work, evoking the dynamic thrusts and angles of a bridge's steel girders silhouetted against the city sky. Kline has applied commercial paint rapidly, almost violently, with a house painter's brush. Black-and-white forms clash, then interlock, creating a tense equilibrium. Critics have mistakenly suggested that Kline's interest in black and white is influenced by calligraphy. Rather, it directly relates to his early sketches, which reveal his passion for the drawings of Goya and Rembrandt. Essentially Kline wanted his whites to be seen as equivalents to the blacks, not as backdrops or voids. With *Slate Cross*, he created a compelling dramatic space reminiscent of the gritty energy of the New York streets he loved. SW

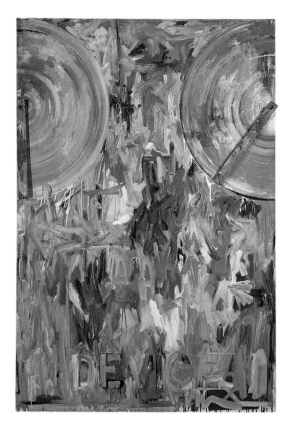

JASPER JOHNS
(American, born 1930)

Device, 1961–62
Oil on canvas with wood and metal attachments
72⅛ × 48¾ × 4½ in. (183.2 × 123.8 × 11.4 cm)
Gift of the Art Museum League, Margaret J. and
George V. Charlton, Mr. and Mrs. James B. Francis,
Dr. and Mrs. Ralph Greenlee Jr., Mr. and Mrs. James
H. W. Jacks, Mr. and Mrs. Irvin L. Levy, Mrs. John W.
O'Boyle, and Dr. Joanne Stroud, in honor of Mrs.
Eugene McDermott, 1976.1

The art of Jasper Johns refuses easy summary,
and *Device* offers no exception. Here Johns has
fastened to his canvas with butterfly screws two
short stretcher bars, normally parts of the frame
over which canvas is stretched to create the
"body" of a painting. He then rotated these slats
through wet oil paint, leaving two half-circles
that show their path. Across the canvas Johns
painted a riot of reds, yellows, blues, and oranges
mixed with black, white, and gray, in a work
that resembles more than embodies the famous
all-over compositions of abstract expressionism.
In the lower section, Johns painted the word
"device" in plain block capitals. These elements
form a kind of rote painting machine that none-
theless bears all the traits of a traditional work
of art.

In his early paintings, sculpture, and graphic
work, Johns combined the ironic drollery of
Marcel Duchamp, the French artist who rein-
vented everyday objects into "readymade" sculp-
ture, with the gesture, scale, and ambition of the
abstract expressionists, and the role of chance
championed by the American composer John
Cage. Clearly Johns's is as much an art of the
mind as of the eye. We are asked to assimilate
various bits of information and then produce
a synthesis—that is, a meaning. Does *Device*
illustrate art's devices—elements (stretcher bar,
brushstroke, color, title) exposed for all to see?
Or is it a wry rejoinder to the heroic excesses of
abstract expressionism? Or could it arise from
the complex game of word and image that Johns
has played throughout his career, one that ques-
tions the veracity of sign, symbol, language, and
ultimately, knowledge itself? Such questions,
not their answers, are most probably the very
point of this inscrutable and uncompromising
painting. CW

MARK ROTHKO
(American, born Russia, 1903–1970)

Orange, Red and Red, 1962
Oil on canvas
93⅛ × 80⅛ in. (236.5 × 203.5 cm)
Gift of Mr. and Mrs. Algur H. Meadows and the
Meadows Foundation, Incorporated, 1968.9

Mark Rothko's vast fields of glowing color voice one of the great statements of twentieth-century abstract art. Like those of Jackson Pollock and Barnett Newman, Rothko's early mature paintings featured loosely geometric forms that the artist found in dreams, nature, and non-Western art. By the late 1940s, all three had abandoned the use of such biomorphic forms—organic shapes of cellular, plant, and human and animal life—for a completely abstract style that signaled an irrevocable change in the way art was made and perceived. Now the mere elements of a painting, its colors, forms, and scale, were employed to bring about a confrontation between the viewer and the work meant to evoke the vitality, ecstasy, anguish, and tragedy of the post–World War II era.

Orange, Red and Red, a classic Rothko painting, induces this abstract and powerful way of experiencing art. Here Rothko laid down three contrasting color stains on an enormous raw canvas. Standing before this work, the viewer experiences the large, rough, orange square as an almost living force or power that seems to break out of the limits of any traditional concept of "picture." In this way, Rothko evokes an experience rather than illustrates one, relying on color, form, and scale to move his viewers to contemplate things transcendent, evanescent, and ultimately metaphysical. CW

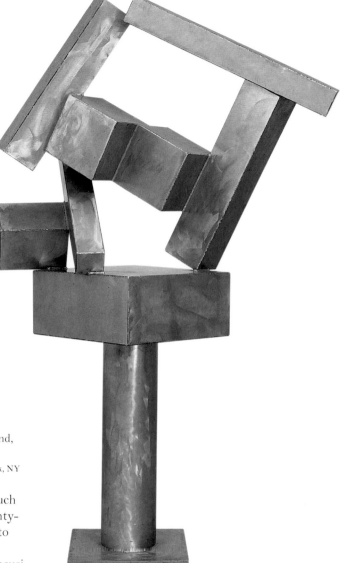

DAVID SMITH
(American, 1906–1965)

Cubi XVII, 1963
Polished stainless steel
107¾ × 64⅜ × 38⅛ in.
(273.7 × 163.5 × 96.8 cm)
The Eugene and Margaret McDermott Art Fund,
Inc., 1965.32.McD

David Smith transformed sculpture with such works as *Cubi XVII*. One of a series of twenty-eight Cubi sculptures that date from 1961 to 1965, *Cubi XVII* presents Smith's fusion of European ideas of abstract form, from Brancusi, Arp, and other modernists to the psychological content of Giacometti, with the newfound freedom of scale and gesture of post–World War II American art. The Cubi works are considered among the artist's supreme statements for their unprecedented force and great scale, which represented a new paradigm for contemporary art, that of a grand and eloquent abstract sculpture.

Cubi XVII is composed of a precarious jumble of simple metal shapes set atop an elegant round column. Smith proudly brought to his art the talents of the welder and the mechanic, readily evident not only in this piece's shiny, even luxuriant surface of brushed metal, but in its engineering as well. Smith's juxtaposition of myriad burnished shapes creates a dynamic composition that becomes fully apparent only upon seeing it in the round: angles converge and split off as the viewer walks around the work, while light plays on and over the form's elegantly crafted surfaces. Here Smith prompts an active, participatory relationship between his viewers and his abstract forms. This type of interaction would play an important role in minimalist, process, and conceptual art of the 1960s and 1970s, attesting to Smith's influential importance in postwar art.

CW

MARK TOBEY
(American, 1890–1976)

Echoes of Broadway, 1964
Tempera on paper
52¼ × 25½ in. (132.7 × 64.8 cm)
Gift of the artist, 1967.18
© 1997 Artists Rights Society (ARS), New York/Pro Litteris, Zurich

In his art and life, Mark Tobey gracefully blended Eastern and Western beliefs and values, seeking to join the physical and the spiritual worlds. As a young boy growing up along the banks of the Mississippi in Wisconsin, Tobey developed his keen observation of and deep respect for the outer, visible world of nature. He was equally dedicated to his spiritual life. This commitment led him to convert in 1918 to the Baha'i World Faith, which emphasizes the unity of all creation; similar values are to be found in Zen Buddhism, which he studied in Japan. While in a Buddhist monastery in Kyoto in 1934, Tobey practiced Japanese calligraphy, which inspired his invention of what came to be known as white writing, the foundation of his abstract, mature works of the 1930s. He pioneered a particular kind of overall, defocused composition that anticipated Jackson Pollock's all-over compositions of the late 1940s.

Small in scale but exploding with the energy and vitality of the city, *Echoes of Broadway* is an excellent example of how Tobey used white writing as a formal device and as a way to reveal the dynamic force of light. An intricate network of fine white lines, flowing but controlled, moves forward and backward in a sensuous field of blue; thick, short, white lines create surface tension and depth. Here Tobey captures the congestion and complexity of city life. The viewer is looking at the lights of the city at once from above and on the streets, experiencing its pulsating energy. Since he first saw the crowded streets of Hong Kong and Shanghai, the interconnection and interdependency of urban life was an important theme for Tobey, who found the city to be a vital, living organism. SW

WALLACE BERMAN
(American, 1926–1976)

Untitled, 1964
Verifax collage
48 × 45½ in. (121.9 × 115.6 cm)
General Acquisitions Fund, 1974.49

Wallace Berman created his most important work in Los Angeles and was part of that city's Beat Generation artists and writers. His collages of pictures from newspapers, magazines, and other popular sources may seem reminiscent of those by fellow Californian Jess (p. 287), but Berman is ascetic and precise by comparison. His early forays into popular culture's trove of imagery roughly paralleled those of Andy Warhol, who in the late 1950s began the photomechanical investigations that resulted in the pop art explosion of the 1960s. Wallace Berman investigated the same territory, but for very different ends and with radically different and idiosyncratic results.

Berman used an early photocopy machine, the Verifax, to reproduce his carefully selected, cut-out images; often they appear solarized, or reversed in tonality. Berman then lay down these images in a regular grid that suggests some rationale but definitively states none. His works refuse to give up their secrets. Interested in the Kabbala, a text of Jewish mysticism (hence the small Hebrew letters placed around his pictures), Berman seems to be sending some kind of supernatural message; we see it transmitted by the small transistor radio framing the images. The radio appears in the hand of the artist, attesting to the work's creation and a trace of a human presence. Berman's mysterious work lets us consider our everyday culture as an archive for the future. Here he has already begun to codify it according to his own enigmatic system, which we can only intuit. CW

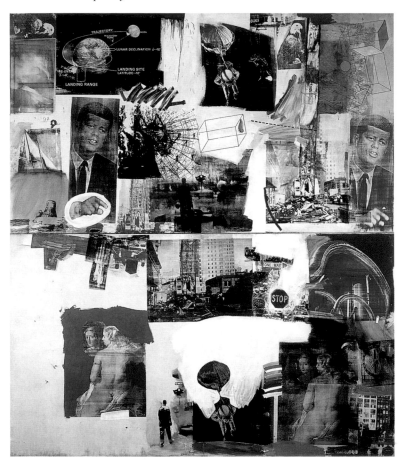

ROBERT RAUSCHENBERG
(American, born 1925)

Skyway, 1964
Oil and silkscreen on canvas
216 × 192 in. (548.6 × 487.7 cm)
The Roberta Coke Camp Fund, The 500, Inc.,
Mr. and Mrs. Mark Shepherd Jr., and the General
Acquisitions Fund, 1986.8.a–b
© 1997 Robert Rauschenberg/Licensed by VAGA, New York, NY

Robert Rauschenberg's gigantic *Skyway* appeared on the facade of the United States pavilion at the 1964 World's Fair in New York, along with paintings by Andy Warhol and Robert Indiana, leaders of the pop art movement. All three shared an interest in popular culture that arose partly as a reaction to the grand existential claims made by abstract expressionist artists and critics. Despite their similarities of subject and process, Warhol tended to concentrate on the iconic and the repetitive, while Rauschenberg sought to include as large a slice of the messy and rich condition of contemporary American life as he could.

In *Skyway,* Rauschenberg collages images of floating astronauts and spinning planets, a pointing John F. Kennedy, a man in the street, an urban construction site with a stop sign, Titian's Rokeby Venus, a freeway cloverleaf, the American eagle, and a drawing of a rectangular box. *Skyway* represented an important commission for Rauschenberg; he responded by creating the largest of a series of silkscreen paintings in which he abandoned the sculptural elements of his earlier, groundbreaking "combine" paintings in favor of the flat plane of the canvas. Highly evocative of American history after only thirty years, Rauschenberg's silkscreen paintings of the early 1960s connect him to the traditions of history painting of centuries past and are an important record and reflection of a mythical era in the American imagination. CW

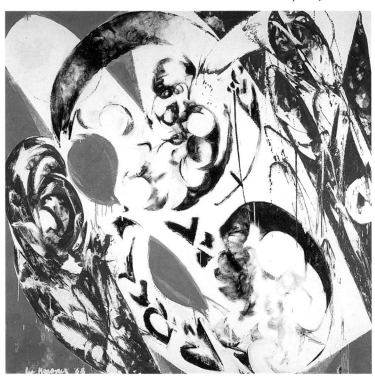

LEE KRASNER
(American, 1908–1984)

Pollination, 1968
Oil on canvas
81¼ × 83 in. (206.4 × 210.8 cm)
Gift of Mr. and Mrs. Algur H. Meadows and the
Meadows Foundation, Incorporated, 1968.10

Lee Krasner has few equals in her critical and
uncompromising approach to creating art. After
graduating from Washington Irving High
School for Girls, the only school in New York
where girls could major in art, she studied at the
Women's Art School of Cooper Union, the Art
Students League, and the National Academy of
Design. In the 1930s and 1940s, while support-
ing herself by working for the WPA Federal
Art Project's mural division, Krasner rigorously
studied and assimilated the tenets and traditions
of modernism as set forth by Picasso, Matisse,
Mondrian, and, most particularly, Hans Hof-
mann, her teacher, from whom she absorbed the
theoretical basis of cubism. She participated in
discussions of the most challenging concepts
and ideas of her contemporaries and friends, and
in the "exquisite corpse" game, a surrealist exer-
cise in automatic drawing, with Baziotes,
Motherwell, and her husband, Jackson Pollock.
Beginning in 1940 she exhibited with the
American Abstract Arts group; her first solo
show was in New York at the Betty Parsons
Gallery in 1951.

Krasner's work over time shows a variety of
styles and range of themes and techniques. In
the mid to late 1940s, she made all-over hiero-
glyphic paintings, which she called Little Images
paintings. In the 1950s she produced large-scale
gestural works and collages of cut and reworked
earlier canvases. Twenty years later, she made
collages from cut-up drawings done in her days
as Hofmann's student. All these innovations
have consistently revealed her mastery of line
and color.

In *Pollination* Krasner's sensuous curving
forms, hard lines, and jarring colors create a
highly charged space and a dynamic rhythm of
organic movement—the space continuously
opens up and closes in. This work is an external
expression of the artist's innermost emotions
at the time she made the gesture on the canvas.
And although they are intensely personal, even
autobiographical, Krasner expresses universal
emotions with immediacy and force. SW

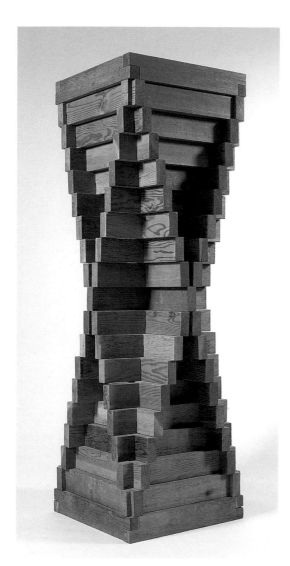

Carl Andre's clearly articulated sculptures comprised of unfinished, standard-cut horizontally extended timbers, stacked bricks and styrofoam units, or identical metal squares assembled on the floor, defined minimalism in the 1960s and redefined three-dimensional works of art in the twentieth century. These seemingly simple and straightforward sculptures composed of interchangeable units belie a complex assimilation of influences from both art and life.

Andre grew up in Quincy, Massachusetts, near granite quarries and shipyards with stacks of sheet steel. He attended Phillips Exeter Academy in Andover, where he met teachers Hollis Frampton and Frank Stella. From Stella's early stripe paintings, Andre discovered that the materiality or physicality of a work of art can be underscored by repetition of modular units or "particles," a concept further reinforced by the years (1960–64) he spent shuttling freight cars as a Pennsylvania Railroad conductor and brakeman. Andre's move from notching, serrating, or cutting into beams of wood, to cutting into space, or cutting across mass with "particles" (a process he calls "clastic") parallels his theoretical view of the development of sculpture from form to structure, and from structure to place.

Pyramid is one of the first works Andre made by piling up identical wooden shapes in a geometric construction. With rough, restrained, graceful power, it asserts the final evolution of "sculpture as place." The unfinished fir modules, held together only by their weight in an interlocking double pyramid pattern, have a primitive, handmade feel. For Andre, articulation of parts and their relationship maintains the integrity of the material and all its symbolic implications. In this way, parallel to constructivist tenets and Andre's leftist leanings in politics (he always dresses as a "worker" in bib overalls), he makes art that is accessible, "involved with maintaining life, and feeding life . . . very simple things." sw

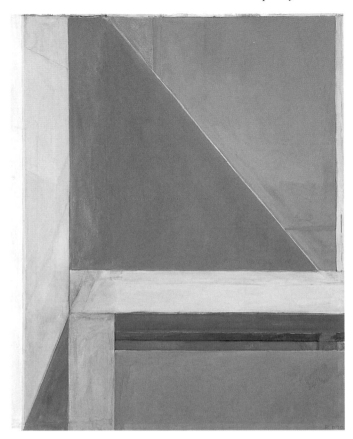

RICHARD DIEBENKORN
(American, 1922–1993)

Ocean Park No. 29, 1970
Oil on canvas
100¼ × 80⅛ in. (254.6 × 203.5 cm)
Gift of the Meadows Foundation, Incorporated,
1981.106

For more than four decades, Richard Dieben-
korn created works of art that synthesized his
impression of his immediate surroundings and
the most important modernist imperatives. After
World War II, he studied art at San Francisco's
California School of Fine Arts (now San Fran-
cisco Art Institute). He and his teachers David
Park and Elmer Bischoff became the leaders of
the Bay Area figurative school (late 1940 to
mid-1960s). Artists Ad Reinhardt, Mark Rothko,
and Clyfford Still were also on the CFSA faculty.

Diebenkorn's artistic career falls loosely
into three phases of a continuum: expressionist
abstractions (1948–55), which include seventy
works of the vibrant, lush Berkeley series; figu-
rative works (1955–67), an adaptation of an ex-
pressionistic, gestural style to still lifes, interi-
ors, and cityscapes; and beginning in 1967, over
one hundred serene, light-filled abstractions of
the Ocean Park series, named for a section of
Santa Monica, California. In essence, he wanted
to create a harmonious unity of formal elements
of color and line and also a poetic evocation of
his visual experience.

Ocean Park No. 29, elegantly composed of
horizontal, diagonal, and vertical planes of
luminous color and lines, evokes the light and
landscape of Santa Monica. The ordered
atmosphere is lyrical and serene, yet charged.
Diebenkorn's fluid working process—erasures,
corrections, changes, visible under a softly lay-
ered surface—creates an illusion of varying
depth; in his words, "tension beneath calm." Ac-
knowledging Matisse, Diebenkorn has created a
subtle play of flatness and depth. We are seduced
by the sensuousness of a sun-filled interior space
and awed by the outside view of Santa Monica's
hazy, sunlit air. SW

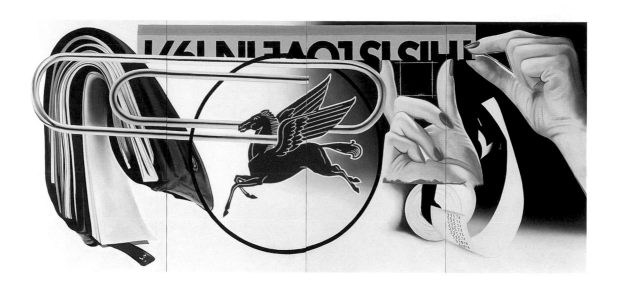

JAMES ROSENQUIST
(American, born 1933)

Paper Clip, 1973
Oil and acrylic on canvas
102¼ × 224 in. (259.7 × 569 cm)
Gift of The 500, Inc., Elizabeth B. Blake, Mr. and
Mrs. James H. W. Jacks, Mr. and Mrs. Robert M.
Meltzer, Mr. Joshua Muss, Mrs. John W. O'Boyle,
Dr. Joanne Stroud, and two anonymous donors,
in honor of Robert M. Murdock, 1978.28

James Rosenquist's *Paper Clip* prominently features the red flying horse, corporate logo of the Mobil Oil Company and a beacon to travelers for decades, that adorns a high-rise in downtown Dallas. This integration of a commercial symbol into a gigantic field of diversely scaled objects typifies Rosenquist's work. Like Rauschenberg (p. 280), Jess (p. 287), and Berman (p. 279), Rosenquist suggests narrative by combining images and text. Upside-down letters at the top of the canvas read "THIS IS LOVE IN 1971." Below appear a wallet, a roll of cash-register tape and a receipt, a pair of gesturing hands (one holding the band bearing the message), and the paper clip that seems to bind the work together. The painting is composed of four equal-sized vertical rectangles artfully fused into a single plane.

Rosenquist's career as a billboard painter is clearly evident in this painting. His knowledge of the techniques and meanings of billboard-sized images gave him a crucial insight into the seductive power of imagery at massive scale. He became one of the most important pop artists of the early 1960s to scan the new consumerist media industry for inspiration. In *Paper Clip*, the power of money is strongly suggested by the stuffed wallet, and the price of life in our time tallies symbolically with the cash-register tape. Here we see only the raw materials of the good life promised by advertising, ironically enlarged to roadside scale. In this provocative jumble of advertising and feature-story pictures, Rosenquist creates possible meanings where none before existed in the simple act of selling. CW

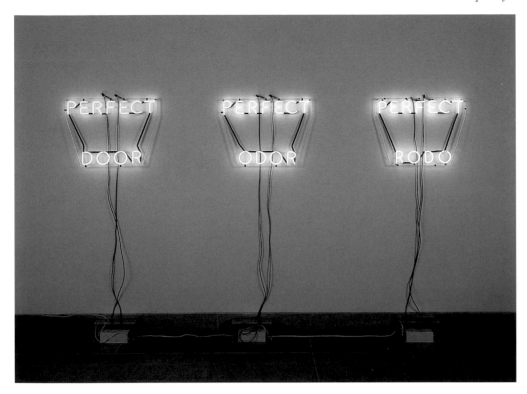

BRUCE NAUMAN
(American, born 1941)

Perfect Door/Perfect Odor/Perfect Rodo, 1973
White glass tubing with clear glass tubing suspension frames
Each unit: 21½ × 28¾ × 1½ in. (54.6 × 73 × 3.8 cm)
General Acquisitions Fund, The 500, Inc., Dorace M. Fichtenbaum, Mrs. Edward W. Rose III, an anonymous donor, the Friends of Contemporary Art, and a matching grant from the National Endowment for the Arts, in honor of Sue Graze, 1989.76

For nearly three decades, Bruce Nauman has consistently produced art that eliminates borders between art and life. In his process and conceptually based art, he employs traditional materials such as plaster and wax and nontraditional materials such as fiberglass and latex, neon, holography and video. His humorous and confrontational work has continued to raise questions of social, moral, and cultural import; it deals with issues of life and death, faith and fear —the human condition and spirit at the end of the twentieth century. In essence, from his early videotapes of himself in his studio (*Wall-Floor Positions*, 1968), to his *Carousel* (1988),

in which taxidermy casts of animals hang by their necks from a rotating device resembling a slaughtering rack, Nauman has consistently challenged the definition of a work of art and the role of the artist.

Since his earliest neon word-game sculptures of the mid- and late 1960s, an important, recurring theme of Nauman's work explores how the meaning of language is never fixed but always contextual. Nauman uses language as he uses his body in video and performances, as a formal tool and as a way to derive meaning from life's superficialities and absurdities.

With *Perfect Door, Perfect Odor, Perfect Rodo*, a simple word play and letter inversion in three shades of commercial white neon tubing, Nauman seamlessly joins form and content. His rhythmic and repetitive use of lettering creates a haunting, meditative investigation into the meaning of perfection and the importance of context in determining meaning. Is a perfect door one that opens and closes? Is a perfect odor one that allures or one that warns? Is there a perfect rodo? Is there perfection? SW

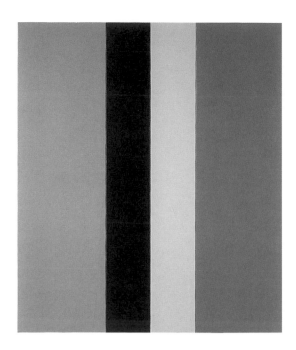

BRICE MARDEN
(American, born 1938)

To Corfu, 1976 (right)
Oil and wax on canvas
84 × 72½ in. (213.4 × 184.2 cm)
Foundation for the Arts Collection, anonymous gift,
1976.23.FA

No Test, 1968–70 (below)
Oil and beeswax on canvas
72½ × 33¼ in. (184.2 × 84.5 cm)
Anonymous gift in honor of Sue Graze, 1992.313

Brice Marden's two paintings demonstrate that abstract art, particularly what has been termed minimalism, need not be coldly clinical nor removed from sensory pleasure. From the beginning of his career in the mid-1960s into the early 1980s, Marden used oil and wax as his painting medium, applying this mixture to simple vertical rectangles of canvas. Upon

sustained scrutiny, these paintings resonate with an interior light and call to mind things far outside the realm of purely abstract form. In the four-panel *To Corfu*, Marden summons colors associated with the land and sea of a Greek island in the Aegean Sea. Here tones of blue and green refer to water and sky in a distilled and quiet yet supremely deliberate manner.

Rather than draw topography according to the traditional landscape genre, Marden recreates the experience of being in a landscape by setting similar yet distinct planes of color next to each other. As these colors interact, ocean, sky, and field begin to register in the viewer's eye and mind without ever appearing outright. In *No Test*, Marden creates with a single panel a field of seductively indeterminate color—it could be tan or brown, but it can never be pinned down. Related to a series of paintings that take their tones from the breathing, warm presence of skin, *No Test* is further proof that Marden's paintings from the first part of his career, while remaining true to the tenets of abstract art, extend the realm of the abstract into the experience of everyday sensory life. CW

JESS
(Jess Collins, American, born 1923)

*Arkadia's Last Resort; Or, Fête Champêtre Up
Mnemosyne Creek (Autumn)*, 1976
Paste-up
47 × 71 in. (119.4 × 180.3 cm)
General Acquisitions Fund, 1977.15

The fantastic collages of San Francisco artist Jess represent a different history of post–World War II American art than is traditionally told. Though a student in San Francisco of the abstract expressionist painter Clyfford Still, Jess did not rely on Still's ethos of the painter's heroic individuality. Rather, he turned to literary and mystical themes, reveling in the visual products of popular culture. Jess was one of the Beat Generation artists active in the 1950s who found in American popular culture a rich storehouse of themes and imagery. *Arkadia's Last Resort* is a prime example of his mind-boggling art of collage and juxtaposition, part of a series of works titled Paste-Ups, which originated in the early 1950s.

Here Jess has collaged dozens of images lifted from jigsaw puzzles, art books, advertisements, and store catalogues (among many other sources), ordering them into the rudiments of an idyllic landscape. In this Arcadia a rushing river flows in the lower center; under a blue sky and white clouds, rowing figures, boats, swimmers, and bathers create a semblance of a picnic. But confounding this sense of "real" space are reproductions of other artworks—including Dallas's *Cubi XVII* by David Smith (p. 277), flowers, kittens, playing cards, and myriad other things that evoke a multitude of wildly varying stories.

Jess, like Joseph Cornell, is considered an individualist, but his art represents a broad and important strain of postwar American art that relies not on abstraction but on the amazing array of photographically derived images that infiltrate our daily lives. CW

CINDY SHERMAN
(American, born 1954)

Untitled Film Still #28, 1979
Gelatin-silver print
8 × 10 in. (20.3 × 25.4 cm)
Gift of Fredericka Hunter and Ian Glennie, Houston,
1984.177
© 1997 Cindy Sherman, courtesy Metro Pictures, New York

In this photograph, part of the celebrated Untitled Film Stills series of
black-and-white photographs Cindy Sherman created in the late 1970s, a
pathetic female figure is seen cowering in the corner between two doors of
an apartment building, her feet bare, her hair in disarray, and an imploring,
suffering look on her face. This scene was completely staged. Sherman her-
self appears as a character who could be the Little Match Girl, or someone
from a Dickens novel, or a deranged hospital inmate from an exploitation
horror movie. As viewers, we are presented with all the details of a narra-
tive we can never know, relayed by a medium, photography, that we think
we know all too well.

 As the character most often featured in her photographs, Sherman takes
the helm in creating her tableaux, transforming her literal self for each
shoot. Sherman is one of many women in the late 1970s who investigated
the terrain of constructed images, particularly those taken from low
culture. The continually asserted truths of high modern art with which
these artists grew up, such as the primacy of abstract form, failed to satisfy
their desire to make an art that reflected contemporary experience in a
postmodern world. Like many artists of the era, Sherman returned to the
human figure, which had largely been banished by modernism, and reintro-
duced subject matter that mimicked the conventions of Hollywood but
which, in its strangeness and imperfection, suggested a world far more
complex and disturbing than the mass media would ever let on. CW

ROBERT MOSKOWITZ
(American, born 1935)

Untitled (Empire State Building), 1980
Graphite and pastel on paper
106 × 31¼ in. (269.2 × 79.4 cm)
Gift of Mr. and Mrs. Robert K. Hoffman, 1995.147
© 1997 Robert Moskowitz, New York

Robert Moskowitz has blended the border
between literalness and abstraction since the
1960s. In the 1970s, he became a prominent
leader of the New Image movement (from the
Whitney Museum's 1978 exhibition *New
Image Painting*). Following a decade dominated
by minimalism, this group of artists, which
included Nicholas Africano, Neil Jenney, and
Susan Rothenberg, brought back figurative
imagery as a vital formal tool as well as a psy-
chologically charged instrument.

Moskowitz is interested in architectural
structures as a means to explore the balance
between abstraction and representation. In the
1970s he created "rooms," an arrangement of
doorways, corners, and beams on a single color
field, which relates to American precisionism,
most notably the work of Demuth and Sheeler.
In the late 1970s and early 1980s, Moskowitz
began to create epic-scale works of Western
cultural and popular icons—Rodin's *Thinker*,
Brancusi's *Bird*, the Empire State Building, the
World Trade Center, the Flatiron Building—as
well as smokestacks and lighthouses. These con
cise, familiar images on elusive, textured back-
grounds reveal Moskowitz's connections to both
pop art and abstract expressionism.

Tall and thin, the iconic *Empire State Building*
appears to rise endlessly against a dark back-
ground. It contains a wonderful tension between
surface and depth. Parts of the building, alter-
nately solid and dappled, are luminous. Of both
monumental and human scale, this image ironi-
cally elicits feelings of grandeur and intimacy.

SW

ELLSWORTH KELLY
(American, born 1923)

Red Panel, 1980
Oil on canvas
118½ × 130¼ in. (301 × 326.9 cm)
General Acquisitions Fund and gift of Robert
Meltzer, by exchange, 1985.99
© 1997 Ellsworth Kelly, New York

Ellsworth Kelly's austere abstract paintings, sculptures, and drawings have paralleled and anticipated critical movements in contemporary art, including color-field painting and minimalism. Kelly lived in Paris from 1948 to 1954, studied at the École des Beaux Arts, and had contact with Francis Picabia, Jean Arp and his wife, Sophie Täuber-Arp, Alexander Calder, and Joan Miró. Kelly was inspired by the idea of chance determining composition and color, which Arp, in collaboration with his wife, explored with collage, and John Cage with music. Brancusi's simple, often solitary sculpture, economically expressing the essence of movement, strengthened Kelly's desire to focus on a single form.

In 1949 Kelly abandoned figurative art, and from then the content of his work became form— an extracted fragment "found" in his surroundings. In his early collages, reliefs, and simple panel paintings of the 1950s and early 1960s, a crisp pattern or shape, a simple curve or line, are based on forms he has observed: the play of light on water; the arch of a bridge and its reflection in the water below; a shadow falling on a stairway; the shape of pipes and chimneys on city walls. In these works, Kelly investigated the interaction between the edge of the canvas and the shape of the image. Kelly eliminated art's traditional figure/ground relationship, producing multipaneled works in black and white or in brilliant primary colors as well as eccentrically shaped monochrome works; ground essentially became the wall or space around the work. Color, for Kelly, was the means by which to add sculptural elements of mass and weight.

Emptied of any meaning beyond itself and the space it commands, *Red Panel* vibrates with an energy barely contained by its edges. Seamlessly integrating color, scale, and shape, Kelly created a powerful, sensuous, and seemingly soaring form that seems to dissolve the boundaries between painting and sculpture. SW

SUSAN ROTHENBERG
(American, born 1945)

Hourglass, 1982
Oil on canvas
88 × 80 in. (223.5 × 203.2 cm)
Anonymous gift, 1983.54

Susan Rothenberg's paintings of horses, done from 1973 to 1979, established her as a pioneer of the New Image movement. In this now famous series, the profile of a powerful horse, set against a monochrome ground, is sliced vertically or diagonally by one or two rough lines; these lines flatten the horse, grounding it in the canvas. Rothenberg incorporated horses in her work as a way of establishing a human presence without using the human figure. With these iconic images of horses, she not only revitalized the vocabulary of abstraction, but also set a stage for the dynamic interplay of two of the most defining traditions in twentieth-century painting: abstraction and figuration.

Eventually Rothenberg's horses became dismembered, and animal heads and legs began to float freely on the canvas. By the end of 1970s, she abandoned the horse motif and began using a wider range of images: heads and hands, the human form, boats, swans, trees, and even cartwheels performed by her daughter Maggie. Since the 1980s, eerie floating "human" figures—isolated, spare and anxiety ridden, which reveal Rothenberg's admiration for Giacometti—often appear in her work.

In *Hourglass*, a dark, lonely human figure moves in and out of a luminous, ambiguous space; another spectral figure hovers off to the right, deepening the space further. As in her early work, Rothenberg builds her images with a dense flow of brushstrokes; tones of gray and white create not a background, but a strange sense of location or place. *Hourglass* contains a continuous play between the abstract and the figural. It is a highly charged place that seems real, and also dreamed. SW

ELLSWORTH KELLY
(American, born 1923)

Untitled, 1983
Stainless steel
120 × 228 × 204 in. (304.8 × 579.1 × 518.2 cm)
Funds donated by Michael J. Collins, and matching
funds from The 500, Inc., and the 1982 Tiffany &
Company Benefit Opening, 1983.56
© 1997 Ellsworth Kelly, New York

Ellsworth Kelly created this imposing yet play-
ful sculpture specifically for the 1984 opening of
the Dallas Museum of Art's Edward Larrabee
Barnes building. The sculpture is part of a series
of works informally called "rockers," which Kelly
began in the late 1950s. Based on the form of a
child's rocking toy, the first of these sculptures,
dating from 1959, is titled *Pony*, an unambiguous
reference to the shape of a hobby horse. This un-
titled piece of similar form is made of two simple
joined arcs that rise at one end to a height of
nearly 10 feet.

In almost all his work, whether painting or
sculpture, Kelly takes his formal cues from an
object (such as a kite) or from a certain phenom-
enon (such as a shadow on a wall) that he finds
outside his studio. In the Dallas sculpture, Kelly
retains the functional aspect of a rocking toy
(this work could rock back and forth if it were
not bolted to the ground) and pares down its
form to a series of simple outlines. Viewing the
work head on, its two arcs seem to be symmetri-
cal. Moving around the work, one becomes
aware that they are not: Kelly's curves play with
the viewer's perception by swinging outward
into space and then back again in graceful juxta-
position. By exploiting the way static shapes can
seem to move in space, and by executing the
work at this scale, Kelly has conceived a sculp-
ture that, for all its origin in real life, functions
only according to its own rules. The result is a
beautifully proportioned, refined, and endlessly
challenging work of art. CW

JAMES SURLS
(American, born 1943)

Through the Point Cloud, 1984
Graphite on paper
48 × 84 in. (121.9 × 213.4 cm)
Foundation for the Arts Collection, anonymous gift,
1991.125.FA

James Surls, son of a carpenter, grew up in the Piney Woods of East Texas.
For two decades, he has cut, chopped, carved, burned, and whittled wood
gathered from the forests surrounding his home and studio on 32 acres in
Splendora, Texas, near Houston. Surls either lets the shape of the wood
guide him, or with an image of the work in mind, he finds the wood that
can translate it. His surrealist-inspired sculptures recall ritualistic and
religious aspects of folk, Mexican, and African art. Some dance lyrically,
suspended from the ceiling; others stand stationary on the floor. With a
visual vocabulary of spiraling shapes, eyes, paddles, petals, branches, torna-
does, houses, and knives, Surls creates a symbolic cosmology, a poetic
metaphor for the natural processes of life.

 Surls affirms that drawing is not only closely related to his sculptures
but is the essence of his art, the key to his thinking. His drawings, like his
sculptures, are what he calls registered mental pictures or psychic images.
In *Through the Point Cloud*, reminiscent of a surrealist automatic drawing
(a nonrational, uncontrolled method used to tap the subconscious), an array
of rich symbolic and narrative imagery—radiating heads and multiple eyes,
hands, and needles—are formed by energetic but elegant lines that vary
from light to dark. Seer, shaman, and storyteller, Surls threads a layered
tale of quiet, pulsating power that rhythmically combines the real and
imagined, the visible and invisible, the physical and spiritual. SW

SOL LEWITT
(American, born 1928)

Wall Drawing #398, 1983, drawn April 1985
Color ink wash on paper
23 ft. × 35 ft. 6 in. (6.9 × 10.7 m)
Gift of The 500, Inc., Mr. and Mrs. Michael J. Collins, and
Mr. and Mrs. James L. Stephenson Jr., 1985.3

Sol LeWitt, a seminal figure in the development of conceptualism in the 1960s, has consistently created work that explores the very meaning and underlying structure of art. His austere work—from his stark, white cube sculptures and spare wall drawings of graphite, white chalk, or black ink in a variety of configurations of the 1960s, to his wall drawings of recognizable geometric shapes drawn in a restricted palette of the early 1980s—is based on elaborations of elementary geometric systems and mathematical calculations.

Although LeWitt's conceptual work is often considered cold, cerebral, and obsessively rational, it can be surprisingly sensual, as Dallas's monumental wall drawing attests. Located above the ceremonial entrance end wall of the museum's 44-foot-high barrel vault, *Wall Drawing #398* is composed of a series of star-shaped elements, each in a four-sided shape or colored field. A special type of pigmented ink was rubbed on in layers, then rinsed with clear water; for each color application, the design was carefully masked to achieve a crisp edge. Acting as a composer, LeWitt conceived and planned the wall drawing, which was then realized and interpreted by draftsmen. Subtle variations in surface texture and color soften the strict symmetry of the composition, creating a romantic quality and hand-worked feel. Elegantly echoing the vault's arch, this wall drawing evokes the transcendent spirituality of early Italian fresco paintings. SW

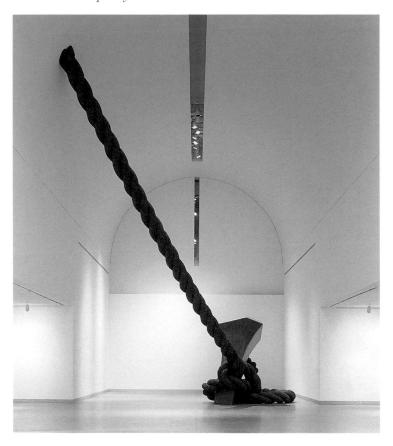

CLAES OLDENBURG
(American, born Sweden, 1929)

COOSJE VAN BRUGGEN
(American, born The Netherlands, 1942)

Stake Hitch, 1984
Aluminum, steel, urethane foam
642 × 182 × 534 in. (1630.7 × 462.3 × 1356.4 cm)
Commissioned to honor John Dabney Murchison Sr.,
for his arts and civic leadership, and presented by his
family, 1984.52.a–b
© 1997 Claes Oldenburg/Coosje van Bruggen, New York

Like the *Lipstick Monument* at Yale University
in New Haven, the *Batcolumn* in Chicago, and the
Shuttlecocks in Kansas City, Dallas's *Stake Hitch*
has become an icon in its hometown. Commis-
sioned for the museum's Edward Larrabee
Barnes downtown building, which opened in
1984, *Stake Hitch* wittily appears to anchor the
museum's vast barrel vault by extending into
the loading-dock area located a floor below it.
Husband and wife Oldenburg and van Bruggen,
who have long worked as a team, took their in-
spiration for *Stake Hitch* from seeing such de-
vices at numerous building sites they observed
during visits to Dallas in the early 1980s. They
designed this work to make it appear as if a rope
attached to the barrel vault's ceiling were being
pulled taut by the gigantic red stake driven into
the museum's granite floor.

Claes Oldenburg, one of the best-known art-
ists of the pop art movement, began his career
in the late 1950s by staging Happenings, hybrid
events of theater and art which were humorous,
often raucous demonstrations of the absurdity
of life. He performed one of his Happenings in
1962 at the Dallas Museum for Contemporary
Arts. This engagement with the absurd carried
over into his wry replications of humble things
transformed to exist as if in a parallel universe
of recognizable yet nonfunctional objects.
Oldenburg and van Bruggen continue to con-
found expectations by elevating the humdrum
experience of contemporary life to the, at least
in size, monumental. CW

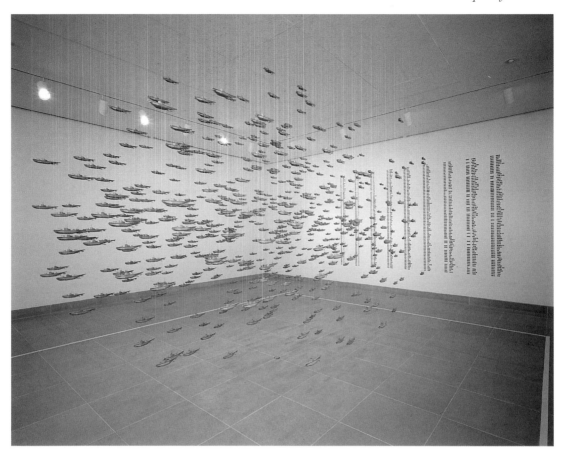

CHRIS BURDEN
(American, born 1946)

All the Submarines of the United States of America, 1987
625 cardboard models, vinyl thread, and typeface
158 × 216 × 144 in. (401.3 × 548.6 × 365.8 cm)
Funds donated by the Jolesch Acquisition Fund,
The 500, Inc., the National Endowment for the Arts,
Bradbury Dyer III, Mr. and Mrs. Bryant M. Hanley
Jr., Mr. and Mrs. Michael C. Mewhinney, Mr. and
Mrs. Edward W. Rose, and Mr. and Mrs. William T.
Solomon, 1988.81

Chris Burden's gallery-sized installation consists of 625 identical cardboard models that represent the entire United States submarine fleet dating from the late 1890s, when submarines entered the navy's arsenal, to the late 1980s. The wall behind them lists the names of each submarine in black sans-serif type. Burden designed this installation as an amalgam of elements rather than as a discrete object. He suspended the cardboard models from the ceiling, placing them at various heights so that as a group they appear, quite aptly, to be a school of fish swimming through the ocean of the gallery space.

In its scale and impact, *All the Submarines of the United States of America* follows in the line of Burden's other installation work. Visually spectacular, this piece neither celebrates nor condemns military might, but presents in physical form the full range and history of an essential component of the United States' power that, when this work was created, was still pitched in cold war struggle with the Soviet Union. Burden's work can be seen either as a reassuring statement about the United States' naval superiority, or as a questioning of the need for such an extensive, yet mostly submerged and invisible arsenal. This work intrigues and delights while raising a host of questions and thoughts about security, politics, warfare, and history that become all the more resonant by Burden's refusal of any easy polemical stance. CW

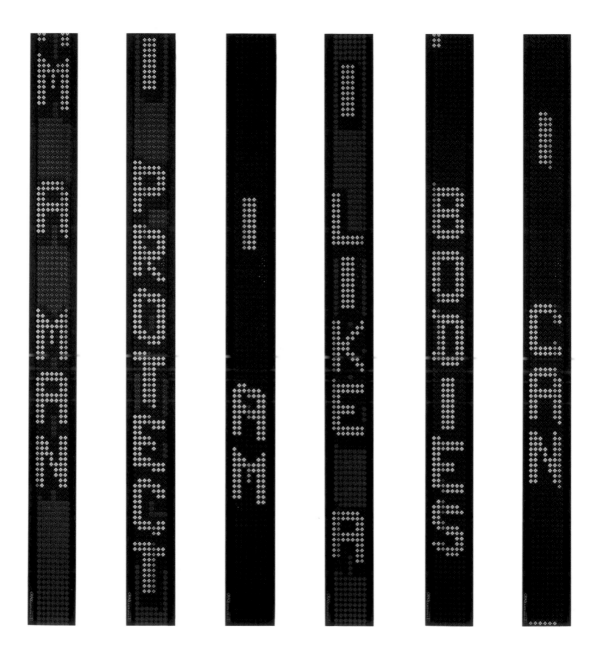

JENNY HOLZER
(American, born 1950)

I Am a Man, 1987
Electronic LED sign with red and green diodes
112½ × 10 × 4½ in. (282.4 × 25.4 × 11.4 cm)
General Acquisitions Fund and matching grant from
the National Endowment for the Arts, 1988.57
© 1997 Jenny Holzer, courtesy Barbara Gladstone Gallery, New York

No other socially or politically oriented American artist of the 1980s has risen to greater prominence in the international art world than Jenny Holzer. With her populist posters, T-shirts, plaques, and signature LED electronic display signboards, Holzer has engaged, provoked, and challenged audiences that reach well beyond the white walls of the museum or art gallery.

From her earliest series, Truisms (1977–79) —posters of forty to sixty aphorisms arranged alphabetically and posted around SoHo— Holzer has used words as images and language as a medium. Her messages—deadpan aphorisms to dark meditations about the human condition, embossed on plaques, engraved on granite benches and sarcophagi, or computer-programmed into visual spectaculars of moving lights—are presented in an authoritative, anonymous, often nongendered voice. In this way, she brings our most private thoughts on sex, life, death, identity, and disaster into the public realm.

I Am a Man was part of Holzer's installation in the 1987 *Documenta VIII* exhibition in Kasel, Germany. Like all her LED signboards, it is clear, direct, and accessible. It combines the familiar and unfamiliar, the expected and unexpected—a commercial medium that announces, advertises, and entertains in urban streets and sports arenas has a serious message: "I AM A MAN. I ENTER SPACE BECAUSE IT EMPTIES ME. I CHASE PEOPLE AROUND THE HOUSE . . . I WILL KILL YOU FOR WHAT YOU MIGHT DO." Mesmerizing and hypnotic, the words move upward; their color, rhythm, and speed change. Unable to walk away, we become acutely aware of our relationship to the surrounding technological landscape. Embodying the power of this landscape to manipulate and alter consciousness, *I Am a Man* both seduces and threatens. SW

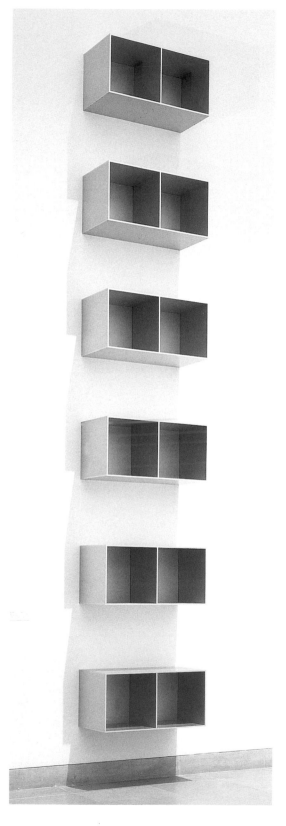

DONALD JUDD
(American, 1928–1994)

Untitled, 1988
Six units of aluminum and Plexiglas
141⅜ × 39 × 19½ in. overall (359 × 99 × 49.5 cm)
Museum League Purchase Fund, General Acquisitions Fund, H. Harold Wineburgh Fund, and gift of an anonymous donor, 1990.137.a–f
© 1997 Estate of Donald Judd/Licensed by VAGA, New York, NY

With its strict geometric forms and cool industrial surfaces, Donald Judd's work appeared in the early 1960s as a challenge both to the art of its time and to the history of sculpture. Forging an oeuvre that resolutely bypassed references to the outside world, Judd affirmed that form and its place in space could stand as the subject and meaning of a work of art. Many saw Judd's sculpture as the logical, if bleak, final result of the revolution of abstraction that began in the early twentieth century. Others described Judd's work as embodying the perfection of absolute geometry and creating order out of an increasingly disordered world.

In *Untitled*, Judd affixed six symmetrically divided, rectangular boxes to a wall in a series to form a column nearly 12 feet high. Judd lined the boxes with yellow Plexiglas and bisected each box with an identical central dividing plane. Such elements enforce continuity and cohesion among the work's six elements. At first glance *Untitled*, though composed of parts, is seen as an entire work with an uncanny immediacy. These and other aspects of Judd's art are brilliantly evident in the numerous large-scale, industrially forged works that Judd installed in the west Texas town of Marfa, particularly at Marfa's old army base. Judd's Marfa installations, like Dallas's *Untitled*, forcefully explore the physical and perceptual experience of space, presence, and viewer, and constitute one of the most rigorous and profound treatments of sculpture in contemporary art. CW

GERHARD RICHTER
(German, born 1932)

Äpfel (Apples), 1988
Oil on linen
36½ × 26⅜ in. (92.1 × 67 cm)
Lay Family Acquisition Fund, General Acquisitions
Fund, and gifts from an anonymous donor, Howard
Rachofsky, Mr. and Mrs. Edward W. Rose III, Mr.
and Mrs. Paul Stoffel, and Mr. and Mrs. William T.
Solomon, 1997.1

This painting is of two apples on a window shelf in Richter's studio in Cologne, Germany. These are the facts of the work's subject matter, but what the artist actually depicts remains ambiguous. Richter complicates our understanding of this simple scene by blurring the contours and colors of the things he presents. In a virtuoso performance of painting, Richter re-creates the experience of looking at a photograph on which this painting is based, and at the same time makes a traditional painting in ingredients (oil on linen canvas) and subject (a still life).

In *Äpfel* the atmosphere in the room is heavy as daylight comes in murkily from a barely registered open window frame on the left side. On the wall in the background, Richter has indicated a telephone with the faintest of smudged gray, while the corner of the room becomes visible only when the eye registers a subtle shift in orange-reds expertly brushed in as shadow and light. *Äpfel* is beautiful yet somehow empty. Richter has divested the apple of its usual importance and has limited the details in the painting to near-monochromatic extinction. Here the apple does not signify the Fall of Man, or a bringer of health, or even an excuse for a painting. Richter presents a scenario of pictorial "facts" made suspect by mechanical reproduction and aesthetic manipulation. Wary of any kind of ideology or dogma, Richter demonstrates his skepticism about the truth of images by exploring both abstraction and realism, two aesthetic approaches that become blurred in his commanding, questioning art. CW

LOUISE BOURGEOIS
(American, born France, 1911)

Sainte Sebastienne, 1992
Drypoint etching on paper 43/44
47½ × 37½ in. (120.7 × 95.3 cm)
Gift of an anonymous donor, 1993.3

© 1997 Louise Bourgeois, courtesy Robert Miller Gallery,
New York

Louise Bourgeois produces singularly sensuous and uncompromising sculptures and environmental installations. Made from a wide range of materials—wood, latex, plaster, bronze, marble, and found objects—these works are profound manifestations of childhood memories and psychic wounds. For nearly six decades, she has relentlessly pursued conflicting psychological and emotional impulses to create intense autobiographical statements that also address universal themes—alienation, identity, sex, death. Her diaristic experiments and disturbing imagery related to the body anticipate the postminimalistic aesthetic arena in which form and style carried associations of human experience and meaning.

Bourgeois learned to draw as a young woman by executing drawings for her family's tapestry restoration business in Paris. She studied mathe-matics at the Sorbonne beginning in 1932 but soon turned to art. For the next six years, she studied painting in Paris at various art schools, including the Académie Julian and the studios of Fernand Léger. In 1938 Bourgeois married Robert Goldwater, an American art historian, and moved permanently to New York City.

Sainte Sebastienne has a directness and immediacy that reveals the artist's sensitive relationship to material and process. It is an excellent example of Bourgeois's mastery of the print medium, a primary vehicle for her since the late 1940s. In this provocative work, she recasts the martyred saint as a Rubenesque headless woman. Instead of piercing the body, arrows point to its various parts—perhaps erogenous zones, or perhaps areas of pain. This *Sainte Sebastienne*, like life itself, is playful and serious, humorous and tragic. SW

DAVID BATES
(American, born 1952)

Seated Man #4, 1995
Painted wood
88 × 37½ × 45½ in. (223.5 × 95.3 × 115.6 cm)
Texas Artists Fund and gift of Mr. and Mrs. Bryant
M. Hanley Jr., the Professional Members League,
Mr. and Mrs. I. D. Flores III, and Mr. and Mrs. John
Ford Lacy, 1996.103

The mature work of David Bates, one of the
most widely recognized of Texas artists, has
always been informed by a deep knowledge and
love of art history, folk art traditions, and the
people and places of the Southeast, most par-
ticularly the Texas coast and the Grassy Lake
area of Arkansas. With his dogs, fishermen, and
swampland flora and fauna, Bates creates an
evocative and richly textured sense of place. Like
the work of William Faulkner or the East Texas
writer William Goyen, who used the language
and landscape of their locales, Bates's work is
regional and strongly connected to place, but
touches on the universal.

A dynamic relationship exists between Bates's
objects and paintings. His early wood wall re-
liefs of the late 1970s can be viewed as three-
dimensional paintings coming out from the wall,
and the heavy, angular lines and patterns of rich
color in his paintings, which recall those of
Max Beckmann and Marsden Hartley, produce
a sculptural effect.

In late 1993 Bates began working exclu-
sively on creating sculpture at the Walla Walla
Foundry in Walla Walla, Washington. Using an
assemblage technique, he collected and wired
together disparate materials; some of these con-
structed sculptures were cast in bronze and then
painted. In sculpture, Bates lets his materials
motivate and guide him.

Seated Man #4, 1995, a stunning and spirited
work, successfully embodies Bates's profound
and poignant artistic vision; it reveals his con-
cerns and convictions with clarity. Echoing cub-
ism, *Seated Man* is composed of found materials
that retain traces of their former use and func-
tion. With *Seated Man*, which is both folksy and
funny, yet elegant and graceful, Bates has cap-
tured the human spirit in ways that are both
intimate and monumental. sw

PHOTO CREDITS:
All photography by Tom Jenkins, except pp. 39, 59,
100, 211, 212, 213, 214, 251, 271 by Lee Clockman;
pp. 97, 256, 288, 292 by Alex Contreras; pp. 113, 229,
230, 283, 285 by Bill Strehorn; pp. 54, 125, 130, 135,
177, 193, 202, 207, 249 by David Wharton.